VISUAL PLAGUE

VISUAL PLAGUE

THE EMERGENCE OF EPIDEMIC PHOTOGRAPHY

CHRISTOS LYNTERIS

The MIT Press
Cambridge, Massachusetts
London, England

The MIT Press would like to thank the anonymous peer reviewers who provided comments on drafts of this book. The generous work of academic experts is essential for establishing the authority and quality of our publications. We acknowledge with gratitude the contributions of these otherwise uncredited readers.

This book was set in Bembo Book MT Pro by Westchester Publishing Services. Printed and bound in the United States of America.

Library of Congress Cataloging-in-Publication Data

Names: Lynteris, Christos, author.
Title: Visual plague : the emergence of epidemic photography / Christos Lynteris.
Description: Cambridge, Massachusetts : The MIT Press, [2022] |
 Includes bibliographical references and index.
Identifiers: LCCN 2021052837 | ISBN 9780262544221 (paperback)
Subjects: LCSH: Epidemics—History. | Documentary photography.
Classification: LCC RA649 .L96 2022 | DDC 614.4—dc23/eng/20211130
LC record available at https://lccn.loc.gov/2021052837

10 9 8 7 6 5 4 3 2 1

For Voula

CONTENTS

LIST OF FIGURES

LIST OF ABBREVIATIONS

AIP	Archives de l'Institut Pasteur
ANOM	Archives Nationales d'Outre-Mer
Apollo/VR3PP	Apollo—University of Cambridge Repository, Visual Representations of the Third Plague Pandemic Photographic Database
BANC	Bancroft Library
BL	British Library
HCPP	House of Commons Parliamentary Papers
HKUL	The University of Hong Kong Libraries (Special Collections)
IEM	Institute of Experimental Medicine
NARA	National Archives and Records Administration (United States)
NLM	National Library of Medicine (United States)
NLS	National Library of Scotland
NRI	Joseph Needham Research Institute Library and Archives
NYAML	New York Academy of Medicine Library
PIP	Photothèque, Institut Pasteur
WL	Wellcome Library

ACKNOWLEDGMENTS

Visual Plague is the principal monograph output of my research as the Principal Investigator of the *Visual Representations of the Third Plague Pandemic* project at the Centre for Research in the Arts, Humanities and the Social Sciences (CRASSH) of the University of Cambridge and the Department of Social Anthropology of the University of St Andrews. I would like to thank Lukas Engelmann, Branwyn Poleykett, Nicholas Evans, Abhijit Sarkar, and Maurits Meerwijk for their wonderful support and contribution to the project, and for over five years of inspiring and challenging discussions on epidemic photography. I would also like to thank Emma Hacking, Teresa Abaurrea, Samantha Peel, Esther Lamb, Nadiya Yefimova, Imke van Heerden, Michelle Maciejewska, Glenn Jobson, Mike Arrowsmith, Gillian Symon, Trish Starrs, Ines Pio, Tim Lewens, Simon Goldhill, and Catherine Hurley for their generous support of and assistance to my project, Oliver Wright and Marie Lemarie for their help with organizing and running the project's annual conferences, Judith Weik for her help in organizing the project's exhibition at the Alison Richard Building, Ted Krawec for his tireless patience and legal advice on the project's database, and Huw Jones, Grant Young, and Peter Sutton-Long for their help and guidance in generating the database as part of Cambridge's online institutional repository.

I would also like to thank the project's advisory board members, Sam Barzilay, John Henderson, David Napier, and Frédéric Keck, and the speakers and discussants at the project's five annual conferences and associated events for the in-depth dialogue on plague, epidemics, and photography over the course of the project: Ann Carmichael, Jennifer Tucker, Adia Benton, Liora Bigon, Nükhet Varlık, Prashant Kidambi, Justin Champion, Marta Hanson, Andrea Janku, Pavla Jirkova, Diego Ramiro Farinas, Neil Cummins, Carlo Caduff, Maria Antonia Almeida, Annamaria Motrescu-Mayes, Valentina Kharitonova, Nayanika Mathur, Robert Peckham, Romola Davenport, Carole Rawcliffe, Vanessa Harding, Jeremy Boulton,

Samuel Cohn, Alison Bashford, David Arnold, Shirlene Badger, Kathryn Berger, Genese Sodikoff, James Fairhead, Rebecca Redfern, Shawn Phillips, Teodora Daniela Sechel, José Ramón Marcaida López, Joelle Rollo-Koster, Richard Baxstrom, Irene Galandra Cooper, Amanda Morton, Sheila Barker, Ezra Barzilay, Edna Bonhomme, Nandini Bhattacharya, Amanda Sciampacone, Dionysios Stathakopolous, Lizzie Oliver, Rupert Stasch, Michael Anton Budd, David Luesink, Stan Frankland, Deborah Nadal, Maryon MacDonald, Mathieu Corteel, Meike Wolf, Kevin Hall, Silvia Casini, Luisa Reis Castro, Jacob Steere Williams, Ann H. Kelly, Dora Vargha, Alex Nading, Graham Mooney, Freya Jephcott, Nida Rehman, Stefan Kramer, Anna Afanasyeva, Hannah Brown, Mary Augusta Brazelton, Jacqueline Martinelli, Michael Kosoy, Nils Christian Stenseth, Alexandra Kurlenkova, Lys Alcayna-Stevens, Tamara Giles-Vernick, Guillaume Lachenal, Karen Sayer, Ian Harper, Ilana Löwy, Marissa Mika, John Manton, Saurabh Mishra, Freddie Stephenson, Rohan Deb Roy, Marlee Tichenor, Clare Chandler, Leirs Herwig, Kenneth Gage, Boris Schmid, Michael Begon, Graham Twigg, Rosemary Horrox, and James Bolton.

This book has also benefited from over one hundred invited talks around the world and feedback from organizers and the audience as well as from sustained dialogue with scholars in the fields of plague history and photographic history. From among those not already mentioned above, special thanks are due to Elizabeth Edwards and Lucie Ryzova for their generous feedback on the history of photography, Grégory Delaplace for discussions on the epidemic corpse, Angela Leung, Guenter Risse, and Myron Echenberg for their advice on the history of the third pandemic, Anne Marie Moulin, Jules Skotnes-Brown, and Matheus Alves Duarte da Silva for discussions of Pasteurian and British colonial approaches to plague, Ruth J. Prince, Sonya deLaat, Todd Meyers, Jesse Olszynko-Gryn, and Ari Heinrich for discussions on medical visuality, John Henderson for many years of close collaboration and ever expanding the horizons of plague historical research, and Caroline Humphrey for her most generous support and inexhaustible inspiration in the field of historical anthropology.

This book would not have been possible without the help and collaboration of librarians and archivists across the globe. I would particularly like to thank Arlene Shaner at the New York Academy of Medicine Library, Nguyễn Đăng Dũng and Jacques-Henri Penseyres at the Alexandre Yersin Museum (Nha Trang), Takayuki Mori at the Kitasato Memorial Museum

(Tokyo), Meiyu Lee at the Lee Kong Chian Reference Library (Singapore), John Moffett at the Needham Research Institute (Cambridge), Timothy L. Pennycuff at the University of Alabama at Birmingham Archives, John Falconer, Antonia Moon, and Malini Roy at the British Library, Daniel Demellier, Dominique Steinmetz and Michaël Davy at the Institut Pasteur archives, Christina Moretta and Susan Goldstein at the San Francisco Public Library, Iris Chan at Hong Kong University Libraries, Brian Stanley at the Centre for the Study of World Christianity (Edinburgh), Tatiana Smirnova and Irina Vinkenshtern at the Scientific Library of the Institute of Experimental Medicine (Saint Petersburg), Nathacha Regazzini Bianchi Reis at the Casa de Oswaldo Cruz, Faith Ho at the Hong Kong Museum of Medical Sciences, and Rachel Row and Kevin Greenbank at the Centre of South Asian Studies (Cambridge). I also thank the librarians and archives staff at: Wellcome Library, Cambridge University Library, SOAS Library, and the National Archives (United Kingdom); the Bancroft Library, the New York Public Library, the National Library of Medicine, the Library of Congress, and the National Archives and Records Administration (United States); the Biblioteca Nacional Mariano Moreno and the Archivo General de la Nación (Argentina); the Biblioteca Nacional de Chile; the Western Cape Archives and Records (South Africa); the Archives Nationales d'outre-Mer, the Bibliothèque Nationale de France, the Bibliothèque Interuniversitaire de Santé (France); the Staatsbibliothek zu Berlin; the Bibliothèque de Genève; the Centro Português de Fotografia and the Biblioteca Nacional de Portugal; and the Russian State Library and the National Library of Russia. I particularly would like to thank libraries and archives that have granted permissions for the inclusion of photographs held in their collections in this book.

Research leading to this book was funded by a European Research Council Starting Grant (under the European Union's Seventh Framework Programme/ERC grant agreement no. 336564) for the project *Visual Representations of the Third Plague Pandemic* (Principal Investigator Christos Lynteris) and research funding from Cambridge Humanities Research Grants for the projects *Visual Empires* and *Epistemic and Material Transformations of the Counter-Epidemic Mask* (Principal Investigator Christos Lynteris). Research leading to chapter 4 of the book was also funded by the Wellcome Trust with a Wellcome Investigator Award (217988/Z/19/Z) for the project *The Global War against the Rat and the Epistemic Emergence of Zoonosis* (Principal Investigator Christos Lynteris). The Wellcome Trust supplied

additional funding to publish chapter 4 as open access. I would like to thank the European Research Council, the Wellcome Trust, the Cambridge Humanities Research Grants Scheme, and the Universities of Cambridge and St Andrews for their generous support of this research. I would also like to express my gratitude to my colleagues at the Centre for Research in the Arts, Social Sciences and Humanities (CRASSH) of the University of Cambridge and at the Department of Social Anthropology of the University of St Andrews for their generous support of and engagement with this project.

Chapter 5 of this book was previously published as an article in *Medical Anthropology*. I would like to thank Taylor & Francis for their permission to reproduce this work here in a revised and expanded form.

INTRODUCTION

The first decades of the twenty-first century have been marked by epidemic events that have enjoyed wide media coverage: the severe acute respiratory syndrome (SARS) pandemic in 2002–2003, the swine flu pandemic of 2009, the Ebola epidemic in West Africa in 2014–2016, the Zika epidemic of 2015–2016, and most recently the COVID-19 pandemic. Key to the general public's exposure to these events and to their integration into a Global Health narrative has been the employment of photography.[1] This has been used to identify the sources of individual outbreaks, including animals from where viruses "spill over" to humans, spaces where viral emergence occurs, or behaviors that supposedly facilitate infection.[2] Following well-established disaster and humanitarian visual tropes, photography has also been used to portray human suffering in the course of epidemics, and efforts to alleviate it.[3]

Most spectacularly perhaps, photography has been employed to depict anti-epidemic operations. This includes the portrayal of a range of practices and technologies of epidemic control: fumigation and disinfection, quarantine, isolation, vaccination, hygienic burials, and the ubiquitous use of personal protective equipment (PPE) in the course of tracking, containing, and caring for patients and contacts.[4] More often than not, such photographic images are used in dialogue with a range of other modes of visualization: maps, diagrams, statistical or modeling graphs, and scientific illustrations, video, and film.[5] This complex visual culture is linked to well-established narratives of global interconnectedness and tends to foster ideas about the existential risk posed by emerging pathogens, thus rendering infectious disease outbreaks into sources of anxiety and fear across the globe, but also into drivers of biosecurity as a new form of governmentality.

But what sort of photography is the one that defines the visual field of epidemics? This book argues that it is not, as may be expected, medical photography but an autonomous genre of visualization: *epidemic photography*. To

understand the characteristics, uses, and impact of this photography, and what sets it apart from the general corpus of medical photography, we need to examine the way in which it emerged, more than a century ago, in the context of the first chain of infectious disease outbreaks to be captured by the photographic lens: the third plague pandemic (1894–1959).[6] *Visual Plague* explores the emergence of epidemic photography with the aim to elucidate the historical importance of this photographic genre and the role it played in the formation and negotiation of ideas about a key epidemiological and biopolitical notion as well as social experience: the "pandemic."

The idea of the pandemic plays a key role in the way in which we approach infectious diseases within the framework of Global Health and in how we envision and anticipate the future of humanity. As regards Global Health, approaching disease outbreaks as actual or potential pandemics (with SARS and COVID-19 as actual cases and Ebola in 2014–2016 as a case of potential pandemic) has led to unprecedented medical, political, and symbolic investments in infection events. Critical studies of this notion and its implications have shown how the idea of the pandemic sets in motion scalar politics of intervention and investment, which tend to promote neoliberal biopolitical frameworks of surveillance and preparedness in anticipation of "the next pandemic."[7] At the same time, over the past twenty-five years the epidemiological specter of the next pandemic has contributed to mythocosmological visions of the end of the world.[8] Pandemics have thus come to be narrativized, dramatized, and symbolized—in novels, films, and video games as well as preparedness and epidemic-response campaigns—as events that could threaten humankind with extinction.[9]

In this book, I will argue that, in the context of the third plague pandemic, photography did much more than simply illustrate news items about plague outbreaks or provide evidence in scientific papers about specific aspects of plague epidemiology.[10] Instead, photography played a key role in reconceptualizing infectious diseases in their interaction with humanity by visualizing the "pandemic" as a new concept and as a new structure of experience: one that frames and responds to even the smallest, local outbreak of an infectious disease as an event of global importance and consequence. *Visual Plague* argues that, besides visualizing individual outbreaks, epidemic photography transformed the way in which we relate to infectious diseases as both biological and historical agents.

The emergence of epidemic photography, I argue, has fostered medical and lay attention on the global dynamics of disease transmission, thus contributing to the emergence of notions of the "global" by visualizing a (micro)biological version of connectivity and integration. In this respect, photography was entangled with other technologies, such as the telegraph or steam power, in a process of rendering the "global" medically intelligible and actionable.[11] Where the telegraph communicated news about outbreaks on a global scale, and steamboats became understood as spreading germs across countries and continents, photography's global work consisted in visualizing outbreaks as part of the same epidemiological event. This not only aided bacteriological narratives of disease, dispelling localist etiologies, but also underlined the need for universally agreed and coordinated methods of epidemic control. As a result, trade, migration, pilgrimage, urban planning, farming, general hygiene, burial practices, and any other social activity were framed as contributing to the spread of the particular disease and in need of regulation.

At the same time, this book argues, epidemic photography transformed the way in which we understand the historical importance of epidemics by inaugurating the visual field of a wider pandemic imaginary through the lens of which we have eventually come to perceive infectious diseases no longer as simply drivers of social change but as agents of existential risk to humanity. If, to paraphrase Charles Rosenberg, a pandemic "is at once a biological event, a generation-specific repertoire of verbal constructs reflecting medicine's intellectual and institutional history, an aspect of and potential legitimation for public policy, a potentially defining element of social role, a sanction for cultural norms, and a structuring element in doctor/patient interactions," *Visual Plague* shows that it is also a fundamentally visual event and process.[12]

THE THIRD PLAGUE PANDEMIC

The third plague pandemic (a term used to describe the event both today and at the time of its occurrence) has been the subject of extensive historical study.[13] It designates the third time in recorded human history that the bacterium *Yersinia pestis* caused a pandemic of devastating, cross-continental proportions.[14] Emerging in all probability in the Chinese province of Yunnan in the early to middle nineteenth century, what started as

a slow-spreading regional epidemic reached the British Crown Colony of Hong Kong in the spring of 1894.[15] The Hong Kong outbreak was immediately perceived as a threat to British colonial power and to the Empire's world-leading maritime trade.[16] A catalyst of tensions between colonizers and the colonized, and a platform for intense scientific competition, the Hong Kong epidemic triggered medical studies of the disease, leading to the identification of the bacterial pathogen, though not of the way of its transmission or maintenance in a given area.[17]

From Hong Kong the disease initially spread to British India (1896) where it established itself and led to recurring epidemics for over three decades. Plague would soon after make its appearance in a rapidly increasing number of countries, developing into a global pandemic within the next four years. By 1900 it had arrived for the first time in North, Central, and South America, Australia, and sub-Saharan Africa, while also affecting urban and rural areas in Europe, the Maghreb, the Middle East, and across East, South, and Southeast Asia.

The pandemic quickly became the subject of systematic scientific study, governmental concern, and public fear. Though the actual toll of the disease was geographically uneven (ten million out of the twelve million victims of the disease by the end of the pandemic were located in British India), plague often outweighed other diseases (such as malaria) in scientific, governmental, and lay attention and consciousness, leading to large-scale interventions with an often catalytic impact on the social, economic, and political life of affected areas.[18]

BEYOND MEDICAL PHOTOGRAPHY

Although the invention of photography preceded the Hong Kong outbreak of 1894 by several decades, there is no evidence to date of a systematic use of the technology in the depiction of any infectious disease outbreak preceding this event. This makes the outbreaks composing the third plague pandemic, from 1894 onward, the first epidemic events to be captured by the photographic lens. This is in itself striking because by 1894 photography had already been extensively employed to document medical conditions, including the generation of pathographies of infectious diseases such as syphilis.[19] Yet plague photography differed considerably from what is more generally understood as medical photography and its forms of visual

knowledge. In the main, at the turn of the century the latter consisted of clinical photography, which was focused on the depiction and examination of symptoms or human physiology and pathology, in the strict sense of the term, and on the spaces (wards, operating theaters) and methods of medical intervention (examination, surgery, autopsy) on the human body.

According to Erin O'Connor, by the end of the nineteenth century clinical photography was employed "as both documentary and diagnostic device" through the development of "a uniquely scientific mode of representation, a semiotics of the body that positioned individual subjects in typological relation to a standardized corporeal norm."[20] In its narrow "clinical" definition, medical photography involved an exercise of the medical gaze and formed part of a broader medical visual knowledge that included "an expanded notion of semiosis that moves on from the patient's words to incorporate intervening tools of signification, from the stethoscope to the scanner."[21] As Monika Pietrzak-Franger has argued for the case of syphilis in Victorian England, clinical photographs of diseased bodies were not simply tools of medical knowledge but contributed to an overall sense of *fin de siècle* social and moral crisis.[22] This they did by focusing on and exposing the patient's body and its pathology in ways that classified, objectified, and othered the disease in question.[23]

By contrast with medical photography and the clinical focus of the visual knowledge it involved and generated, epidemic photography was not exclusively or primarily concerned with exposing the patient's body or the methods of examination and operation on it. Its main focus, as developed during the third plague pandemic, was not on the symptomatology of the disease; nor was it concerned with human suffering as a subject, as has been underlined in humanitarian photography since the 1970s.[24] Though photographs of plague patients do exist, these form an extremely small part of the third plague pandemic visual archive.[25] Epidemic photography was focused not so much on the ontology of plague—on what O'Connor has called "the what of it"—as on its how and why.[26]

This is not to say, however, that epidemic photography should be approached solely as *epidemiological* photography. At the time of its emergence, epidemic photography was not the monopoly of public health professionals. Instead the visual field of plague was constituted, negotiated, and developed through a dialogue between multiple agencies, forms of knowledge, and agendas, which included but were not limited to medical

or public health ones. Following visual anthropologist Deborah Poole, we may say that the rise of epidemic photography depended on a global "visual economy" that allowed for the public negotiation of the meaning, cause, and impact of epidemics, in which photographic images played a key evidentiary and narrative role.[27] In this visual economy, no agency, expertise, or agenda held a lasting hegemonic position in terms of authenticity or authorship. This is not to say that the visual economy in place was egalitarian; rather, the meaning, truth value, and evidentiary uses of different photographic corpuses on plague were not predetermined or overdetermined by the source of representation.

To give one example, in the course of the Manchurian pneumonic plague epidemic of 1910–1911, a host of opposed agencies became embroiled in a struggle to determine the zoonotic source of the disease, its transmission pathway, who was responsible for the outbreak, and who was able to stop it.[28] As the visualization of an event unfolding in an area controlled by three rival empires (China, Russia, and Japan), the photography of the Manchurian plague reflected conflicting sovereign, etiological, and public health narratives. Moreover, nonsovereign agencies came to complicate this picture: French and British reporters, American, French, and German doctors, as well as a range of missionaries operating in the region provided their own visual narratives, which were presented in different formats and forms.

On the one hand, imperial-sovereign plague narratives primarily took the form of well-designed, expensive albums.[29] A number of these were presented at what was considered as the key arena for international arbitration over the epidemic, the First International Plague Conference (Mukden, April 1911). On the other hand, foreign missionaries and doctors provided a less monumental photographic output, with photographs used in public lectures (as lantern slides), memoirs, and scientific publications.[30] As for photographs taken by or for journalists, these appeared in newspapers as well as in the illustrated press across the globe, often mixed with photographs derived by the above imperial and medical sources. The result was a polyvocal, dialogical, intermedial, and highly agonistic visual field, which did not simply illustrate the Manchurian epidemic but rather contributed to the negotiation of the source of the disease, its mode of transmission, the distribution of scientific authority between rival agents, and the distribution of blame across human communities.

In the course of the third plague pandemic, photography allowed different agents to visualize outbreaks in ways that framed them as total social facts. First, photography was employed to identify and negotiate the causes, agents, media, and sources of outbreaks. These involved not only nonhuman hosts and vectors of the disease (rats, marmots, fleas, etc.), but also social behaviors and customs (e.g., burial rites, pilgrimage, hunting, rag-picking) as well as material structures and forms of habitation (earthen floors, bamboo beams, blind alleys, etc.), with a pronounced racial inflection consistent with colonial medical frameworks at the time.

Second, photography was employed to identify and negotiate the means of containing and stamping out plague from infected locations, and of preventing its spread or recurrence in the future (e.g., quarantine, isolation, disinfection, fumigation, rat-proofing, incineration). In this way, photography allowed opposing authorities and communities, expert and lay alike, to praise or discredit old or emerging etiological frameworks as well as methods and technologies of epidemic control, to associate them with particular forms of governance, and to claim credit for them when they were successful.

To achieve these aims, epidemic photography, on the one hand, diverged from the norms, subjects, and tropes of medical photography. On the other hand, it brought these in dialogue with other photographic genres (ethnographic, architectural, expeditionary, urban, forensic, military, and disaster photography) so as to constitute a "profoundly hybrid genre." [31] In so doing, it could capture plague as a total social fact whose prevention and containment required not simply public health interventions but the transformation and modernization of society.

WHY PLAGUE?

The question of why it was plague rather than any other disease that led to the emergence of epidemic photography at the turn of the nineteenth century cannot be ignored, but it is also a question that can only be answered in a speculative manner. First, unlike most other diseases prevalent at the time, plague enjoyed a centuries-long history in European, Asian, and North African experience, which had formed, at least since the Middle Ages, a rich corpus of iconography and iconology. [32] In the course of the nineteenth century, when Europe was largely free from plague for the first time in five

centuries, historical studies such as Justus Hecker's *The Black Death in the Fourteenth Century* (1832) portrayed plague not only as a source of illness and death but as bearing a unique significance on "the image of an age."[33] As will be examined in more detail in chapter 1, the result of this was the development and diffusion for the first time of the notion of "the Black Death," not only to reference the first years of the second plague pandemic (1347–1351) but also to invoke catastrophic, world-historical consequences. Although severe outbreaks of plague in the Middle East, India, and the Volga region between 1800 and 1880 maintained medical and public fascination, in Western Europe the disease became less and less associated with direct experience and more and more invested with attributes of an ancient and distant enemy that did not properly belong to the modern world. This mystification of plague was further fostered by Romantic configurations of the disease, both in literature and in the visual arts, culminating in what Faye Marie Getz has described as a "gothic epidemiological" imagination (see chapter 1).[34]

Second, following the recent material turn in the history of medicine and the life sciences, as well as biohistorical approaches to infectious diseases, it is important to recognize that, as a disease, plague has certain characteristics that made it particularly good for the development of epidemic photography.[35] On the one hand, by July 1894 plague was an ontologically stabilized disease in the sense that its pathogenic agent (known today as *Yersinia pestis*) had been identified in the course of the inaugural outbreak of the third plague pandemic, in Hong Kong. This meant that subsequent outbreaks across the globe could be bacteriologically identified and verified as ones of "true plague" through laboratory tests (although this far from obviated disputes over the validity of the latter). On the other hand, the complexity of plague on several epidemiological levels meant that bacteriological identification amounted to little more than knowledge of the fact that the disease affecting a particular group or individual was indeed plague. Most importantly, scientists were uncertain about the way in which plague was transmitted to and between humans and the way in which it was maintained in any given area (see chapter 1).

Carried by over 200 animals, plague can be symptomatic or asymptomatic in different species; it can establish short- or long-term reservoirs in commensal and wild rodents and can even persist in the soil inside amoebas.[36] So complex is the disease ecology of plague that a leading plague

scientist at the US Centers for Disease Control and Prevention (CDC) has concluded that it signals a threshold of "epistemological entropy," where what we know is that we can never fully know how plague is preserved and how it circulates in nature.[37] At the time of the third plague pandemic, this complexity, though not fully understood, necessitated recording and archiving images of the disease in its global spread in an effort to solve the mystery of its transmission and maintenance. No other human disease preoccupying scientists at the time may be said to possess such a complex epidemiological profile or unfathomable disease ecology. At the turn of the century, plague experts were thus confronted with the elusiveness of plague, not simply as what Priscilla Wald has described as an "outbreak narrative," but as an epistemological condition triggered by the complexity of the actual disease.[38]

What photography did was to highlight and connect different aspects of plague's complexity in a manner that both created visual pathways for epidemiological reasoning about plague's transmission and maintenance patterns and facilitated governmental intervention. The value of epidemic photography may then be said to have been accrued (to use a term developed by Poole) through the way in which it was able to amplify and combine epistemological and symbolic/affective investments of plague.[39] By visually entangling the dread that plague inspired in the general public as an actually occurring disease and as a disease invested with world-catastrophic properties, together with scientific concerns over the complexity and elusiveness of the disease, photography not only produced medical knowledge but actually helped institute a new kind of epidemiological reasoning whose defining characteristic, as Lukas Engelmann has argued, was its focus away from singular epistemic objects (the sick body, the infected house, the pestilential corpse, the plague vector) and toward their pathogenic interrelations.[40]

PANDEMIC VISIONS

The third plague pandemic marked the first instance of the employment of photography in the depiction of an infectious disease outbreak. But it also marked the first time that such events were photographically recorded as part of a global pandemic. Thus the emergence of *epidemic photography* marked, at one and the same time, the emergence of *pandemic photography*. The two visual registers became interconnected and interconstituted in the

course of the events examined in this book, thus contributing to the institution and dissemination of the notion of the "pandemic."

A term hitherto infrequently and unsystematically used in medical publications, the idea of the pandemic rose to prominence at the end of the nineteenth century as a result of new, bacteriologically informed ways of understanding the interconnectedness of infectious disease outbreaks. The third plague pandemic was the first series of epidemiological events to be systematically subsumed under this epidemiological descriptor.[41] The identification of the pathogen causing the outbreaks, an increased focus on how the disease might be spreading from one location to the next (markedly by maritime trade), international involvement in plague research in affected areas, and the unprecedented interest in the disease by the press quickly transformed plague into a global protagonist.

Fostered by "the mass-potential of the Kodak revolution" but also by the fact that since the mid-1890s newspapers could for the first time carry photographs cheaply in their pages, photographs of plague outbreaks were featured in local and national newspapers of affected countries as well as in the international press.[42] This created a peculiar scalar effect, where even outbreaks of very small capacity would receive extensive medical, governmental, and media attention. Outbreaks were seen, first, as part of a global march of plague and, second, as potentially being inaugural events of a pandemic of truly catastrophic proportions: the return of the Black Death on a global scale. As Mark Harrison has noted, "many of the publications aimed at the masses contained regular reports on outbreaks of disease and the apparent course taken by what were increasingly termed 'pandemics.'"[43]

Plague thus quickly transformed from a spatially and temporally distant disease into an imminent one: a disease that could soon strike one's own town or city, or indeed may be already lurking unseen in its undecipherable "breeding grounds" or "elusive forms." And nothing contributed to this sense of global interconnectedness, anticipation, and fear more than photography. As the disease struck more and more countries, often in what appeared to be a simultaneous eruption, the international dissemination and circulation of plague photographs in both the daily and the illustrated press generated an unprecedented spectacle of imminent global threat. At the beginning of the third plague pandemic, when the idea of the pandemic was still not fully developed, the press would restrict the representation of a given outbreak to images from the afflicted location; however, as the pandemic

progressed and the notion of the pandemic became more pronounced and refined, a more "interconnected" narrative started to emerge.

First, the visual field of the pandemic relied on a chronological juxtaposition between photographs of current outbreaks and earlier, nonphotographic depictions of plague, thus creating a symbolic continuum between the depicted epidemic and past events like the plague of London or the plague of Marseille and, ultimately, the Black Death. Visual tropes, such as the juxtaposition of early-modern beaked plague doctors with contemporary mask or PPE-wearing anti-epidemic staff, invited viewers to compare the two and draw out their supposed similarities.[44] Such comparative tropes would become engrained in the visual language of the pandemic; they would foster, on the one hand, a vision of progress from protoscientific to modern means of combating this ancient enemy of humanity and, on the other hand, a sense of anticipation, as if modern plague was about to transform into a catastrophe similar in scale and impact to the Black Death.

Second, this visual field also relied on combining photographs of the given outbreak under examination with those of other plague outbreaks from across the globe so as to create panoramas of global infection. Such syntheses fostered the integration of individual outbreaks into a unified, global pandemic event, even when these were, in fact, stand-alone epidemics that were biologically unconnected to the ongoing pandemic (e.g., the Manchurian plague of 1910–1911). It did this by a visual overview of the universal aspects of plague: its hosts and vectors, its modes of transmission, its infrastructural drivers, the cultural habits believed to foster its spread, and the efficacious measures of its control and prevention. Of course, photography was also used to portray and discuss local or regional specifics of individual outbreaks, such as the implication of marmots in the Manchurian outbreak, or the importance of bamboo structures in the case of plague in Java, or of Hindu cremation in India.[45] But even in these cases it was deployed in a manner that connected such local elements or questions with the global parameters of the pandemic, either as variants or as examples of the latter. In this manner, the actual subject of the depicted photograph became entangled with the causal relations the photographs were meant to depict, which were understood as being universal.

Photography visually conjured the "pandemic" as an etiological reality (by linking the depicted outbreak with the ones immediately preceding it across the globe), an epidemiological potential (by pointing to a possible

role of the depicted outbreak in the spread of the disease to as yet unaffected areas of the globe), and a global theater of epidemiological study and public health operations of epidemic control. What connected these three registers of epidemic photography was the framing of plague's fundamental elusiveness, as a blind spot that could be invested with anticipations and fears. In this way, epidemic photography contributed to the emergence of the pandemic as a scientific category and as a symbolic form. Entangling together already prominent visual tropes of the Black Death with a new visual field of infectious diseases as a threat to human health and social order, and of epidemiology and public health as frontline defenders of human societies against the menace of epidemics, photography contributed to the establishment of the pandemic as a potent terrain for epistemic, imaginary, and historical investment.

ORGANIZATION OF THE BOOK

Research leading to this study involved five years dedicated to the examination of the global third plague pandemic archive. Generously funded by the European Research Council, the project leading to this book involved myself as its Principal Investigator and five postdoctoral researchers, Lukas Engelmann, Branwyn Poleykett, Nicholas Evans, Abhijit Sarkar, and Maurits Meerwijk, in the collection, classification, and analysis of plague photographs. Three project administrators, Emma Hacking, Samantha Peel, and Teresa Abaurrea, were involved in the images' processing and curation into the Visual Representations of the Third Plague Pandemic Photographic Database, made available on Open Access basis by the University of Cambridge in September 2018.[46] What made it to the database depended very much on not only the project team's discoveries in archives and libraries across the globe, but also copyright legislation particular to the United Kingdom and the ability to execute memoranda of understanding with archives and libraries (which all maintained their copyright and intellectual property of the images whose digitization was funded by the project) within the financial and operational parameters of the project.

The resulting database holds 2,281 images out of the 11,000 collected by the project. Hence two things should be kept in mind when reading this work. First, although database links to images are provided where possible, several images discussed in this book are not included in the database.

Second, the database should not be taken to be representative of the full photographic corpus of the third plague pandemic as it contains less than a fourth of the images identified and collected by the project.[47] To give but one example, the database contains no photographs from Hawaii or Los Angeles (which are, however, discussed in the book) because it was not possible to clarify the status of these images sufficiently under UK copyright legislation. As a consequence, the absence or prevalence of themes in the database should not be taken as indicative of the full photographic corpus of the pandemic, and is not treated as such in the book.

How were the photographs I discuss selected? This work is not structured around outbreaks. In other words, its chapters do not follow a chronological order representing major plague outbreaks, from Hong Kong 1894 to Los Angeles 1924, nor do they try to cover the third pandemic and its photographic output in an exhaustive or proportional way. Some outbreaks, like the Manchurian one, are discussed more than others. In the case of Manchuria, this is both due to my expertise in the region, which allows me to provide a more in-depth reading of epidemic photography as applied to this outbreak, and due to the importance of the outbreak's visual coverage in establishing pandemic tropes and imaginaries. In some cases, rather than focusing on a plague outbreak, I instead discuss photographs of preparing for an epidemic or trying to prevent it.

This means that, given the pragmatic length limitations of this work, some epidemic events are not discussed even though they produced a large corpus of photographs or they played an important role in the medical, social, and political history of the affected area. The second Manchurian plague outbreak (1920–1921), the plague epidemic in Porto (1899), and the plague outbreaks and anti-plague work in South Africa and Brazil are some examples. The reason for the first omission is that Manchuria is already extensively covered in this book. The reason for the second and third is that these outbreaks form complex historical cases for which I lacked sufficient research experience at the moment of completing this work.

The first chapter of the book lays out the key operations of epidemic photography. Chapter 1 discusses how photography made plague visible and knowable even while maintaining an image of plague as a disease that fundamentally—in spite of the various means and methods employed to reveal and visualize it—remained unseen, elusive, and unknowable. In this manner, I will argue, photography contributed to the development of plague's

assertive ontology, understood both in terms of *what plague is* and *what plague can do* (its transmissibility, maintenance, attenuation, recrudescence, and latency patterns) and in terms of the way in which plague connected or related different aspects of social and material life. At the same time, chapter 1 argues that, besides asserting what plague is or can do, photography also became implicated in another ontological operation: determining what plague *must be*. Through the example of the photographic depiction of the epidemic corpse and its cremation in plague pits in Manchuria, I argue that the imperative ontology of plague photography was instituted through the latter's ability to relate to and bring together into a new, pandemic field of vision two epidemic temporalities: understandings of pandemics as a world-historical events and understandings of plague as a disease with a catastrophic potential for human societies.

After the theoretical foundations of this study are set, the next four chapters each focus on a key theme of epidemic photography as these emerged in the course of the third plague pandemic. Chapter 2 examines photographs of disinfecting the city of plague. The chapter discusses the ways in which the visualization of disinfecting the city developed in the course of the third plague pandemic, reflecting and contributing to shifting understandings of infection and disinfection. Examples of photographing chemical disinfection, fumigation, urban demolition, and urban incineration as plague control measures in British India, Manchuria, Australia, the Gold Coast (today's Ghana), San Francisco, and Hawaii are brought into focus. The question posed by this global photographic corpus, I argue, concerns not simply how it visualized or rendered visible disinfection as a necessary and efficient means of epidemic control, but also how it configured understandings of infection and its relations to space.

Chapter 3 examines the visualization of quarantine by the photographic lens, focusing on two forms of the practice during the third plague pandemic: lazarettos and plague camps. Examining examples from the Ottoman Empire (Beirut and the Hejaz), I highlight epidemic photography's contribution to the development of a technoscientific framing of quarantine in the context of interimperial struggles for controlling the flow of goods and people. By contrast the photographic coverage of the quarantining of illustrious passengers of a scientific cruise in the Frioul lazaretto, France, in 1901 is seen as being part of a performance of class superiority in the context of the French Third Republic. Finally, through the examination

of plague quarantine camps around Karachi in 1898, in British India, the chapter argues that photography was used to foster colonial control, but perhaps in ways not immediately made obvious through a reading of camp photographs simply as "tools of empire."[48] The chapter thus underlines the situated, political, epistemological, and ethical dimensions of epidemic photography when employed to frame quarantine and its meaning and function in the age of bacteriology.

Chapter 4 focuses on the best-known animal host of plague, the rat, and the way in which it was photographically framed. Discussing examples from British India, the United States, Indonesia, Argentina, and Japan, the chapter argues that photography helped institute the rat as both a pandemic infrastructure and an agent of epistemological uncertainty: on the one hand, a species that spread and maintained plague across the globe and, on the other hand, an animal whose exact role in plague epidemics remained elusive and thus continued to fuel epistemic uncertainty, scientific research, and technological innovation in ways that integrated the globe in unprecedented ways.

Finally, chapter 5 examines the emergence of the face mask as a personal protection device in the context of the Manchurian pneumonic plague epidemic of 1910–1911 and the way in which the adoption of this by health staff as well as by affected communities depended on the simultaneous production of this anti-epidemic device as a visual object through the use of photography. Arguing that anti-epidemic face coverings should be taken seriously as masks, in the anthropological sense of the term, the chapter makes the case that this key epidemic control apparatus needs to be understood as an irreducibly visual device whose aim is as much the protection of its wearer as the transformation of his or her social milieu.

This does not mean that these are the only themes or topics covered by epidemic photography. Important topics such as the epidemic corpse, vaccination, laboratory work, and scientific research are covered across the chapters of the book. Still other topics or themes of epidemic photography at the time of the third pandemic, including missionary involvement in epidemic control, are not discussed in the book, but I do not consider them insignificant. The aim of the book is to highlight modes of visualizing plague that maintained a productive tension on two levels: between representations of outbreaks in their local particularity and their role in framing a global pandemic and between what I call the assertive and the imperative ontology of plague, or *what plague is* and *what plague must be*.

It is important here to briefly note what this book does not aim to do. First, deviating from the norm in visual histories of medicine, the photographs discussed here are not those used in posters or exhibitions. Although plague photographs were sometimes used in what historians of medicine and media studies scholars have more broadly identified as didactic settings, this was neither their most prevalent nor their most innovative use. In this respect, the book deviates from histories that have taken as their subject public health campaigns against infectious or so-called tropical diseases.[49] As a result, while being aware of such approaches and their importance for the analysis of medical and public health media, especially in the aftermath of World War II, the book argues that the emergence of epidemic photography was a political, aesthetic, and epistemic process for which we need to develop proper analytical tools, rather than borrow ones developed for understanding television and film-related medical and health cultures.

Second, *Visual Plague* does not discuss to the degree usually expected from works in visual history the reception of plague images or the reflections of their makers on producing them. Finally, while the book may also be useful to readers in media studies or visual culture more broadly, it has not been written with these audiences in mind. This is because the book was not conceived and is not delivered primarily as a study in visual history, something outside the expertise of its author. Instead its analytical scope is nested at the anthropological and historical crossroads of the medical humanities. The aim of *Visual Plague* is not to reconstruct a historical ethnography or social history of the making and receiving of these images, but to examine their global historical framework, paying close attention to the epidemiological, epistemological, and biopolitical situation of their production in given localities. The book was not written retrospectively so that we can understand the ways in which epidemics or pandemics are visualized today; rather, it assumes a historical anthropological perspective that is aimed at understanding the emergence of epidemic photography as a process that made sense to those developing and deploying it at the time across different social contexts.

A book on the global photographic output of the third plague pandemic might have focused on individual photographers such as Frank Davey in Hawaii or F. B. Stewart in Bombay, or on analyzing in depth the production and reception of albums such as Captain Moss's *Plague Visitation, Bombay, 1896–97* or Wu Liande's *Views of Harbin*.[50] It may have equally been dedicated

in part or as a whole to different photographic techniques employed in capturing plague, or how specific newspapers or illustrated press outlets covered the pandemic across the decades, or the interrogation of institutional visual cultures of plague as these may be, for example, evident in the archives of the Institut Pasteur or the British Library's India Office Records and Private Papers. I have followed such methodological lines in other publications on plague photography, and the reader may also find these employed in the works by other researchers, who have provided in-depth views of photographic corpuses from India, North Africa, the United States, and Java (discussed and acknowledged throughout this book). In *Visual Plague* I have opted for an approach that is less orthodox but can bring together in discussion material from different areas and periods of the third pandemic. Read together with the project's online database, my hope is that this work will be able to introduce the concept and the analytical field of "epidemic photography" to a wide audience and invite it to engage with the more detailed social, biographical, political, and epistemic histories on the subject.

PLAGUE BETWEEN VISIBILITY AND THE UNSEEN

In the course of the third plague pandemic, epidemic photography emerged not simply as a way of representing epidemics but more importantly as an apparatus that brought together forms of epidemiological reasoning and pandemic imagination. This synthesis allowed photography to render plague visible by acting as "a tool for making knowledge and producing scientific objects rather than to merely illustrate them."[1] Photography contributed to configuring *what plague is*—the causative bacterium of the disease—but also *what plague can do*—its transmission and maintenance mechanisms, its symptoms and pathology, its vectors and natural ecologies. In other words, photography played a key role in the apophantic ontology of plague, asserting what was "true plague." Defining plague depended upon an ability to ascertain and demonstrate the ways in which the disease connected and interrelated different aspects of social and material life, and the ways in which these connections could be interrupted so as to halt the spread of the disease and mitigate plague's impact on affected communities.

Yet, at the same time, the aforementioned synthesis of reasoning and imagination also required something less positivistic of photography: to configure the ways in which plague remained unseen or elusive. This contributed to an ontology of "true plague" as a disease that fundamentally, and in spite of the various means and methods employed to reveal and visualize it, remained unknowable, mysterious, or, to borrow from Shawn Michelle Smith's work, at the edge of science's sight.[2] If, rather than simply revealing the world, photography also revealed the world as composed "of what one could not and did not see," this chapter will show how this visual epistemology centrally concerned plague's supposed ability and indeed agency to remain unseen and unknown in its essential traits.[3]

As Monika Pietrzak-Franger has argued in relation to syphilis in Victorian Britain, at the turn of the century the tension between the visibility and invisibility of infectious diseases was a major source of scientific and

lay anxieties.[4] Nested in this preexisting medical-visual complex, epidemic photography revealed plague as a knowable and actionable disease. At the same time it showed plague in its enduring unknowability: as a disease that, in spite of constant scientific research, eluded and suspended epistemological closure. In examining epidemic photography, it is helpful to consider the relation between visibility and the unseen as forming part of a process involving what anthropologists have more broadly defined as the dialectics of revelation and containment. Rather than pointing at an "ontological reconciliation between what we [or rather, epidemiologists at the time] thought we reliably knew and what we are told that we need to know," in the case of the third plague pandemic this involved a "controlled revelation."[5] A revelation whose reach, veracity, and significance were constantly negotiated, inflated, doubted, and contested within and between medical institutions and governmental agencies at imperial, national, and local levels.

This was a revelation whose semantic and pragmatic imports were often controlled for more than just scientific purposes as they formed part of broader biopolitical and geopolitical agendas. Yet this was also a "revelation that controls" or, to be precise, one that aimed to master humanity's relation to plague. Sander Gilman has argued that the emergence of medical photography was underlined by a desire to contain the sense of lack of control over disease through the control of visual images of illness and the regulation of "seeing the patient."[6] Yet, in the case of epidemic photography, images of disease outbreaks need not be limited to "a means for dealing with the anxieties about the illness represented."[7] For instead of acting as a hermeneutic palliative, epidemic photography was and continues to be deployed so that infectious diseases (in our case plague) can be contained and prevented, but also so as to help expand the scope of that technoscientific mastery to an open-ended range of social and human/nonhuman relations. At the turn of the century, epidemic photography formed part of processes of colonization and medicalization and fostered their mutual entanglement in the ideological field of modernity as a project for mastery, thus becoming instrumental to a process of globalization that unfolded with reference to a common enemy: pandemic plague.

At the same time, configuring plague in the course of the third pandemic involved a second ontological operation of epidemic photography: one pertaining not to an ontology of plague as *what is* or as *what is hidden*, but to an ontology of plague as *what must be*.[8] The second part of this chapter will

examine this imperative ontology of epidemic photography. It will show how the common symbolic ground required for the emergence of a global framework through which experiences, narratives, and approaches to plague could become entangled relied on the sense of plague being an essentially world-catastrophic event. This was not so much forged through a series of epistemic "truisms," such as the rat as plague's vector or the seasonality of outbreaks, for such concepts remained extremely unstable and contested in the course of the pandemic.[9] Rather, I argue, it was fostered through the identification of plague with the Black Death.

Epidemic photography played a pivotal role in this configuration of plague. By visually forging together the third pandemic with the Black Death, hitherto held images and concepts of plague could be updated, related to, and rendered continuous with new understandings of infectious diseases while at the same time actually existing plague outbreaks were rendered intelligible in ways that depended on the projection of the specter of plague past into the future.

IMPERIAL FRAMES, CLINICAL QUESTIONS

Marking the first time that the camera attempted to record an infectious disease epidemic, photographing plague exceeded the scope of established medical photographic tropes. As Erin O'Connor has argued, medical photography involved "a uniquely scientific mode of representation, a semiotics of the body that positioned individual subjects in typological relation to a standardized corporeal norm."[10] Epidemic photography's focus, by contrast, was not primarily the human body or disease pathology but the drivers of infection, the mechanisms of transmission and maintenance, and the ways of containing the disease. From the 2,281 photographs included in the University of Cambridge's Visual Representations of the Third Plague Pandemic Photographic Database, only 178 show patients or their symptoms.[11] This is not, however, to say that clinical photographs from the third plague pandemic did not contribute to the emergence of epidemic photography.

In the early years of the pandemic, but also as late as the 1930s, several medical doctors produced what Jeffrey Mifflin has called portraits of symptoms "in isolation," focusing, as one might expect, on the telltale buboes (swellings in the groin, neck, or armpit resulting from the infection of

lymphatic nodes).[12] The bubo formed a regular trait of prephotographic representations of plague in etchings and paintings, even in such cases where no such symptom was actually made visible. For, as Christine Boeckl has argued, several early modern paintings of plague involved the characteristic symptom of the disease but did not actually visualize it.[13] Instead the bubo was connoted, particularly in its axillary form, through the raised arm of a patient seen from an angle that hid his or her armpit.[14] However, any reluctance to portray buboes appears to have waned by the nineteenth century where the most iconic plague painting of the century, Antoine-Jean Gros's monumental *Bonaparte Visiting the Plague Victims of Jaffa* (*Les pestiférés de Jaffa*, 1804), centrally figures an axillary bubo borne by a French soldier that is touched by a fearless (and hence supposedly immune) Napoleon (see chapter 5).[15]

Photographs of plague buboes began to make their appearance by 1897 but remained very limited in number, considering the twelve million victims of the pandemic and the comparative volume of the photographic corpus covering other aspects of the disease. Though I have not been able to identify any response to their publication, these clinical photographs must have been scarcely surprising or shocking to medical and lay audiences at the time; they would have been used to clinical portraits of patients of syphilis, elephantiasis, and leprosy. If Chris Amirault is correct in claiming that "by posing the subject, medical photography both constructs and thereby asserts the pathology of the patient," here we note that patients were generally directed to pose in ways that rendered symptoms more visible and, in the case of buboes, emphasized their volume in a manner reminiscent of and possibly inspired by tumor photography developed in the same period.[16] This is, for example, evident in the photograph of a plague patient in British India, circa 1897.[17] The photograph, which appeared first in the three-volume report of the Austrian Plague Commission, shows the patient from the groin down lying on a *charpoy* (rattan bed) and exposing a large left inguinal bubo.[18] The objectifying nature of this image consists not simply in the way in which the angle and the exposure reveal the volume and shape of the symptom, but also in the fact that the photograph unnecessarily exposes the patient's genitals.

Often paired with fever charts and statistical tables showing how many cases in a given outbreak bore axillary, inguinal, or cervical buboes as well as with histological microphotographic plates, pathographic photographs

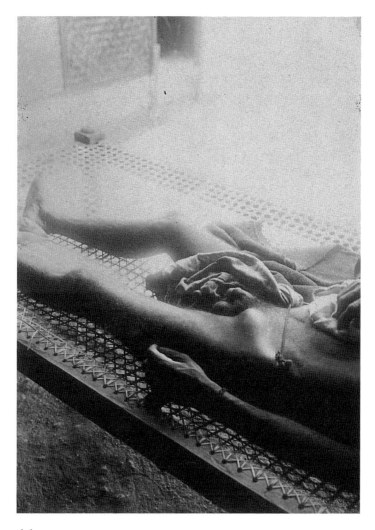

Figure 1.1
An Indian man, a victim of plague in Bombay, lying on a rattan bed in the sunshine, circa 1897. Courtesy of Wellcome Collection.

aimed to generate a visual ensemble able to stabilize plague as a causative and symptomatological agent.[19] Clinical photographs of plague buboes, in other words, provided not simply illustration or evidence but a visual framework for statistical discussion on the frequency of symptoms and their location and prevalence.

By following broader nineteenth-century medical visual culture and "captur[ing] pathology as surface," photography was thus able to classify plague symptoms and pathologies, provide proof of infection, and dramatize the disease on the stage of ailing bodies and in the context of clinical spaces.[20] As tools for sensing and making sense of plague, clinical photographs were not part of "salvage" photography, nor did they directly aim to depict plague symptoms through the lens of exotic pathology or link plague pathology to "racial types."[21] They involved no anthropometric measurements or "land-scanning" of bodies.[22] Clinical photographs finding their way to the medical and popular press were more concerned with producing another kind of "regularity": recognizable "types" of symptoms.[23]

This is not, however, to deny the colonial frame of the vast majority of clinical photographs of plague. A number of clinical plague photographs fit framings identified by historians of colonial photography, even if their focus was not the portrayal of "racial types" or "typical scenes."[24] Aimed at propagating an image of the supposedly civilizing and curative impact of colonial medicine, photographs often focused on the depiction of plague hospitals. Expanding from Christopher Pinney's broader analysis of photography in British India as a "prosthetic eye," in his examination of the photographic framing of Bombay's plague hospitals in the crucial epidemic years of 1896–1897 (Captain Moss's photographs in the album *Plague Visitation, Bombay, 1896–1897*; see chapter 2) Abhijit Sarkar has noted the gender dynamics of visualizing care in a Christian missionary context.[25] At the same time, the posed aspect of doctors, nurses, and patients "'created' the photographs rather than simply allowing the camera to 'capture' the human subjects in their hospital setting."[26] As sites of "imperial phantasmagoria," plague hospitals and wards embodied and fostered the complex hierarchies of situated colonial polities.[27] Photographs of plague hospitals were spectacles of colonial benevolence, efficiency, and order that directly contradicted the reality of forced hospitalization, the inefficacy of care, the enormous death toll in these institutions, the fact that many hospitals at the time functioned as superspreading infrastructures, and the noncompliance

and resistance to hospitalization on the part of the colonized who refused to be admitted to these alienating and dangerous spaces.[28]

However, established analytical frameworks for understanding colonial photography may not always be helpful in the examination of epidemic photography. This is because their focus on the undeniable impact of photography on fostering colonial hierarchies risks drawing our attention away from the equally important role of the practice in the field of interimperial antagonism. Take, for example, a much-reproduced image from Karachi, 1898, depicting the Pasteurian luminary Paul-Louis Simond delivering an injection of "his curative serum" to an Indian patient (figure 1.2).[29] The French doctor is surrounded by a subaltern medical retinue of men who are patiently holding utensils for him. Simond is seen injecting the serum into the patient's pelvis area with his right hand while lightly but confidently touching the patient's abdomen with his left hand.[30]

There is no doubt that the image, which rhymes with the imagery of blood transfusion at the time, is meant to convey a sense of colonial superiority and reproduce a hierarchy between the masterful European doctor and the powerless India patient.[31] As Anne Perez Hattori has argued in her

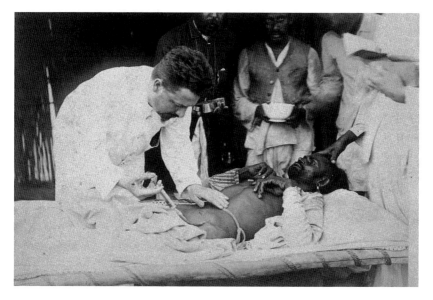

Figure 1.2
Injection of anti-plague serum by Dr. Paul-Louis Simond in Karachi, Vishandas Hospital, June 4, 1898. Courtesy of Wellcome Collection.

examination of leprosy photographs in Guam, "medical photographers
more than most exemplify the unequal relationships of power between
simultaneously doctors and patients, colonisers and colonised, and healthy
and diseased."[32] Focusing solely on the doctor-patient relation in this image,
however, risks overlooking the wider imperial context of this photograph.
The image needs to be situated within the intense international debate and
competition about plague sera and vaccines at the time. Simond's work on
the plague serum originally developed by Alexandre Yersin played a piv-
otal role in the Institut Pasteur's efforts to establish itself as the institution
that discovered not only plague's cause but also its cure.[33] This claim was
fervently contested by the British who favored vaccination in the form of
the plague vaccine developed by Waldemar Haffkine, whose efficacy was
propagated in the "experimental theatres of vaccines" by numerous British
photographs at the time, including at least one that enjoyed several itera-
tions as a postcard.[34]

As a prophylactic against plague, vaccination was, according to the Brit-
ish, far superior to curative sera because it could be delivered in advance to
entire communities and prevent outbreaks in neuralgic areas of the Empire.
The two epidemic control technologies, vaccination and serotherapy, formed
part of rival medical traditions and imperial ideological apparatuses that
would contend not only in the colonies but also in independent states such
as Brazil, Argentina, and Russia. India, however, formed a privileged site
for this contestation. This is because it was globally recognized as a locus
where plague took a more violent form and was thus considered to be the
true testing ground for vaccination and serotherapy against the disease.[35]

Together with other visual devices employed as apodictic tools (graphs
and tables in particular), photographs played an important role in this piv-
otal medical and imperial antagonism. This is the proper frame within
which we have to consider images of vaccination and serotherapy as well
as vaccine and serum production depicting Pasteurian extractions of sera
from horses or Haffkine's workshop in Bombay. In the case of the latter, an
iconic photograph, which enjoyed wide circulation at the time, framed the
production of "one million doses of the plague vaccine" by the Haffkine
Institute in Bombay (figure 1.3).[36]

Seen outside their specific context, figures 1.2 and 1.3 may simply appear
to be reiterations of a colonial trope of representing medical intervention;
a "screen" onto which were projected, in the case of figure 1.2, an active,

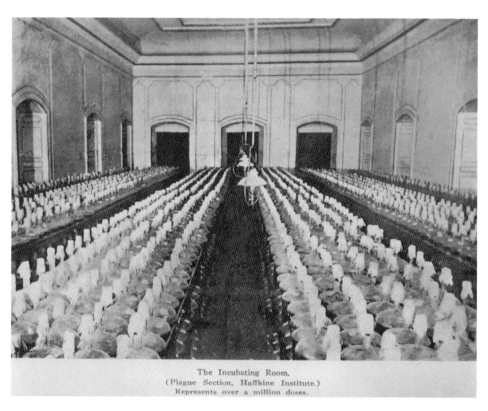

Figure 1.3
"The Incubation Room. (Plague Section, Haffkine Institute.) Represents over a million doses." Source: Wikimedia Commons.

heroic agency by European doctors and a passive one on the part of native subjects or, in the case of figure 1.3, the industrious technoscientific agency of the British Empire.[37] However, in their situated visual economy, the two photographs actually depicted two distinct and indeed antagonistic processes: figure 1.2 is the image of a French imperial promise of a cure for plague whereas figure 1.3 is an image of a British imperial promise for prophylaxis against the disease. Here our rejection of colonialism should not lead us to dismiss the enacted differences between these images as imperial phantasmagorias of mastery in favor of their formal commonalities as representations of colonizer-colonized hierarchies. Whereas the latter are undeniable, the former are indispensable if our aim is to not simply reproduce existing condemnations of medical colonialism but to deepen our critique

of the latter and understand how it was advanced through competing impe-
rial agendas, epidemic control technologies, ideas about mastering human-
ity's relation with the nonhuman world, and the visualization of all these
factors.

So far we have seen how photographs of buboes depicted an iconic form
of plague pathology, how photographs of plague hospitals reproduced colo-
nial hierarchies, and how images of serotherapy and vaccination fostered
interimperial antagonism. At the same time, photographs of plague symp-
toms could be part of the contestation of the disease's ontology.

A number of photographs, mainly from British India and the Dutch East
Indies, focused on plague symptoms involving skin necrosis. In this case,
clinical photography was used by European scientists to frame symptoms that
were of pathological as well as historical interest because doctors at the time
often assumed plague-induced necrosis to be what plague treatises and tracts
since the Middle Ages described as "carbuncles."[38] Yet this interpretation was
not left uncontested by indigenous medical doctors. On February 1, 1908,
Nasarwanji Hormusji Choksy, the Parsee medical luminary and editor of
the *Indian Medico-Chirurgical Review*, posted eighteen photographs to Paul-
Louis Simond, explaining that these included five photographs (10×14.5 cm)
of "the type of plague which I have called cellulo-cutaneous"—in other
words, images of skin necrosis resulting from plague.[39] The photographs
depict patients with advanced symptoms of skin necrosis in different parts
of their body, with the most commonly reproduced photograph depicting
a man whose face is largely covered by a large necrotic area (figure 1.4).[40]

Did Choksy, an avid author on plague pathology, take these photographs
himself? The Parsee physician never laid claim to this in his letters to Simond,
where, on January 11, 1908, he promised to "find out some [photographs]
and send them to you in a week or fortnight."[41] The fact that these images
were included in an album published in 1902 by Vasily Pavlovich Kashkad-
amov, the envoy of the Russian Plague Commission to India (1897 and 1899),
raises the question of whether Choksy borrowed the photographs from
Kashkadamov, who in 1899 spent a month and a half as a doctor at the Arthur
Road Hospital and the Martha Hospital in Bombay, or whether these were
taken by Choksy himself when he was the Medical Superintendent of the
Arthur Road Hospital in Bombay (1897–1899).[42] Kashkadamov claimed
that his album "contains the most typical photographs from my collection,

Figure 1.4
Photograph of plague-induced necrosis in patient in India, included with Nasarwanji
Hormusji Choksy's 1908 letter to Paul-Louis Simond. © Institut Pasteur/Musée Pasteur.

taken in Bombay under my leadership," but he also noted that, "of the 20
photos, 15 were taken from my patients, and 5 were bought ready-made."[43]
However, the overlap between Kashkadamov's album and the photographs
sent by Choksy to Simond is far greater: nine photographs, all depicting
symptoms, of which three feature skin necrosis.[44]

The difficulty in identifying the authorship of these photographs with any
certainty is characteristic of the record of epidemic photography at the time:
extremely lacking in information about provenance or any direct discussion
of photographs by those who may have taken them. Whatever the case may
be, Simond did not appear to know that these photographs had already been
published six years earlier in Russia. Simond was clearly thrilled by the "loan"
(Choksy had asked Simond to copy the photographs and send them back to
him) as he was at the time preparing an important work on plague pathology:
"the information I draw from the works you have published is particularly
useful to me and I have had reproduced for the illustrations the photographs
that you kindly provided me with."[45]

Grateful as Simond appears to have been, and although he declaimed that Choksy had "treated and seen more cases of plague than any doctor in the world," when the photographs were finally published five years later in Simond's authoritative, 200-page chapter on plague in the sixth volume of the prestigious *Traité de pathologie exotique, clinique et thérapeutique*—which was dedicated to the disease—no acknowledgment of their supposed authorship or to Choksy was included.[46] In Simond's publication, the photographs functioned as evidence for differentiating between carbuncles and what Choksy called "cellulo-cutaneous necrosis," with the latter being portrayed by Simond as a sort of residue of the former when the patient survived.[47] Nothing could be farther from Choksy's own view of this symptom, in whose identification he considered himself to be a pioneer: "Modern writers have classified plague as bubonic, pneumonic, septicaemic and ambulant, but they have failed to recognise the cellulo-cutaneous type, because of the comparative rarity or its being considered as a complication of bubonic plague under the old designation of carbuncles."[48] In his definitive article on cellulocutaneous plague, Choksy would use five of the images included in his letter to Simond as well as an additional image of "a small necrosis on the back in the lumbar region" so as to debunk the idea of carbuncles and to "demonstrate the necrosis in different cases."[49]

We can thus see that pathographic photographs were used not only to illustrate iconic plague symptoms or frame patients through and within colonial hierarchies and imperial antagonisms, but also to foster specific arguments about their classification. As the case of Choksy shows, in some cases this allowed subalterns to contest the opinion of international medical luminaries and the retrospective classification of scientifically observed symptoms through historically established, Eurocentric categories of plague pathology such as the "carbuncle." Clinical photographs of plague were thus not simply "tools of empire" but also the means through which the colonized could contest and recuperate colonial medical knowledge in a process of asserting alternative ontologies of plague.

HEROIC AND INTIMATE LABORATORIES

The 1894 discovery in Hong Kong of plague's causative agent was an event celebrated across the globe although opinions differed as to whether this was first achieved by Alexandre Yersin or Kitasato Shibasaburō.[50] If today

the image of Yersin posing outside his "matshed laboratory" (a photograph included in Yersin's diaries of the events in Hong Kong and taken as a souvenir for his mother) is a visual staple of historical and celebratory accounts of Pasteurianism, the image did not witness wide circulation at the time.[51] More common, especially in the Francophone press, were studio portraits of the discoverer of the bacillus that underlined his masculinity, following broader Pasteurian aesthetics.[52] Still, in the years following the discovery of the etiological agent of plague, photographs of laboratories engaged in plague research proliferated. These included photographs of doctors posing with microscopes, images of laboratory settings and plague-related research, and images of vaccine and serum production, which promoted the work of competing scientific teams at the time.

At the height of the third plague pandemic (roughly 1894–1924), laboratory-based plague research formed an important part of the ability of research institutions, nations, and empires to claim a place at the forefront of medical research. The success of the Institut Pasteur in identifying the bacillus in 1894 was followed by an international race of discovery. This involved the identification of transmission pathways, natural hosts, and vectors as well as the development of cures and prophylactics.[53] In some cases, such as India, Portugal, and Manchuria, this included not only the research teams of the sovereign state or empire but also foreign plague commissions from various countries.[54] Whether ephemeral or long-term, plague research teams and commissions copiously photographed their laboratory-based research.[55] Often this was not so much to showcase their research results but to advertise their scientific skills and dedication. Working with plague—as lethal accidents in plague laboratories aptly demonstrated—was a dangerous task; hence, the work was imbued with the late-nineteenth-century values of self-sacrifice and heroism.[56] At the same time, accusations of outbreaks being the result of plague escaping from faulty laboratories—such as the allegations that tormented Alexandre Yersin in his Institut Pasteur laboratory in Nha Trang (1898)—made it necessary for laboratories across the globe to advertise their soundness and deflect similar accusations and rumors.[57]

An excellent example of representing plague-related laboratory work as a heroic imperial endeavor can be found in the photographic coverage of the "Special Commission for the Prevention of the Introduction of Plague Infection and the Struggle Against It in the Event of Its Appearance in Russia" (in short, the Russian Plague Commission or KOMOCHUM). The

commission was instituted under the auspices of the Imperial Institute of Experimental Medicine in 1897 by Duke Alexander Frederick Constantin of Oldenburg, and it would, up until the October Revolution, develop plague sera, conduct experiments, and undertake field studies of the disease across the Russian Empire and abroad. In examining the published works and photographic albums produced by the Russian Plague Commission we are confronted with an image of scientific achievement, heroism, and self-sacrifice. From the albums and photographs of expeditions to remote, plague-stricken areas of the Empire such as Anzob in the Tajik highlands and areas lying outside the Empire (India or Arabia), to the records of the work of plague stations within it, the photographic corpus of the Russian Plague Commission underlined these traits.[58] The careful editing of these photographs and the intentionalities involved in it, however, become obvious only once we take a closer look at the unpublished archive from which these public-facing visual representations were drawn.

Comparing the visual coverage of the Russian Plague Commission's most celebrated achievement the "Special Laboratory," better known as the "Plague Fort" (*chumnoy fort*), in Russian publications at the time with the photographic archive of this scientific institution offers a tantalizing contrast. Plague Fort was a retrofitted, kidney-shaped naval fortress-island (known as *Emperor Alexander I*) off the port of Kronstadt in the Baltic Sea; it became fully operational in August 1899 as one of the largest plague laboratories in the world at the time.[59] Featured in various newspapers, the photographic coverage of Plague Fort highlighted its laboratory work in carefully curated panoramas of scientific virtue and achievement. These included photographs of researchers at work, sometimes alongside microphotographic images of the plague bacterium and photographs of infected human and animal organs preserved in formaldehyde.

In a richly illustrated article by I. M. Eyzen from 1900 for *Niva*, Russia's most popular illustrated weekly at the time, we encounter Plague Fort as a scientific dreamland. After arriving by sea and passing through Plague Fort's enormous bronze gates, Eyzen was met by a vision of nature and the Orient being mastered by Russian science:

> There was a small courtyard in front of me, surrounded by fortifications, already converted in a peaceful manner, in which camels walked peacefully, silently. I was expecting something, but not this. I thought I would meet guinea pigs,

rats, squirrels, monkeys—in a word, all that animal trifle, which, apparently, was destined to suffer for the human race and fulfill its Biblical purpose—"to exist for the needs of man." But to see in the middle of the water, among rushing ships in all directions—"desert ships," that I did not expect with all the richness of my imagination, vividly as this may be tuned in anticipation of the unknown, which was supposed to be hidden behind these thick fortified walls, behind the doors tightly shut to any non-bacteriologist. It turned out that these camels also serve as experiments.[60]

The article carried two photographs of camels, one showing a herd gathered in the aforementioned courtyard and the other depicting the autopsy of a plague-infected camel tied upside down on the operation table and surrounded by two doctors and their assistants, posing defiant around the enormous animal (figure 1.5).[61]

For Russian audiences of the newspaper, camels had definite oriental connotations that rhymed with the idea of plague as an exotic, Eastern disease ("oriental plague"). As Jennifer Mary Keating has shown in her examination

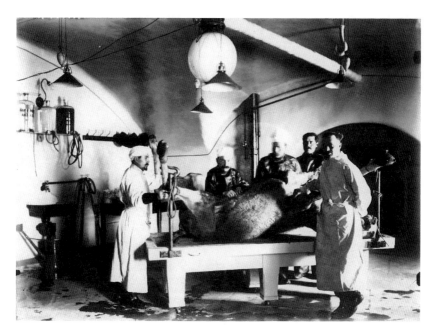

Figure 1.5
Russian plague scientists conducting an autopsy on a plague-infected camel in Plague Fort. Courtesy of the Institute of Experimental Medicine, Saint Petersburg.

of imperial Russian representations of Central Asia in the final decades of the nineteenth century, contrasting images of camels with those of techno-scientific "progress" formed a popular trope to "reiterate the idea of Russia as the harbinger of transformative modernity."[62] The images studied by Keating are those of the colonization of Central Asia, where, for example, Russian trains are shown as penetrating the Kazakh steppes, scaring camels and eventually rendering them obsolete; in the image from Plague Fort, the iconic animal of the southeast frontier has been transported and mastered on the surgical table at the heart of modern, European Russia just a few miles away from Saint Petersburg.[63] This then was, at one and the same time, an image of human mastery over nonhuman life and an image of Russian mastery over the Orient during the height of imperial expansionism to the southeast, a frontier that had figured for decades in imperial Russian imagination and the Russian "imperial uncanny" as a repository of the double peril of disease and barbarity.[64]

In their effort to produce an image of scientific achievement and of human/imperial mastery, publications about Plague Fort also covered the martyrological side of plague-related laboratory work. Nothing could be more conducive to this than the demonstration of the perils of plague research, albeit with an always already foreclosed conclusion of the containment of danger within the stone walls of the laboratory. The most exemplary photographs in this regard concerned the death of one of Russia's leading plague experts, Dr. Manuil Fedorovich Schreiber (1866–1907), who became infected with the disease and died in the care of his colleagues in Plague Fort on February 14, 1907.[65] Writing seven years after his original article for *Niva*, Eyzen published a shorter but no less evocative piece on the doctor's death: "In the martyrology of science this year added another bright name for the victims of duty. This name is Manuil Fedorovich Schreiber."[66] Eyzen lamented how the "young doctor" (aged fifty-one) fell in "the struggle against the 'Black Death'"; "he looked it straight in the face and continued to peer inquisitively at its destructive power until his eyes were completely dimmed."[67]

There is no evidence that Eyzen visited the Fort for the occasion of the doctor's burial. This did not stop him from composing an epitaph to Schreiber, stressing the risk posed by plague experiments with animals, "constantly breathing the atmosphere poisoned by plague in the laboratory and in the stalls where horses infected with plague cultures stand, from which they extract blood that delivers the healing serum" for which Plague Fort

was known.[68] Only by men such as Schreiber taking enormous risks, Eyzen mused, can "the whole world [be] completely safe from infection."[69] The familiar heroic narrative, which demonstrated the dedication of Russian scientists and the ability of the fortified laboratory to contain any unfortunate leaks, was propped by an intricate photographic collage of the doctor's death.

The first half of the composite on Schreiber's death contained three photographs: the upper half is arranged around the photograph of Schreiber on his deathbed (figure 1.6).[70] Seen from left to right, the three photographs may be said to represent Schreiber's progress from life to immortality through death. The first photograph from the left shows Schreiber alive and posing outdoors in uniform. The central photograph is a close-up of the doctor on his deathbed in Plague Fort; we can assume the man is dead by the fact that the photograph has been cropped in an oval shape framed by a black strip, like the border of mourning stationery used at the time. Finally, the photograph to the right shows the dead man's ashes in a transparent glass urn.[71] The second half of the composite, positioned below the first, consists of a

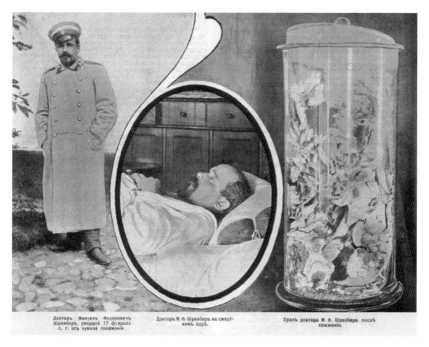

Figure 1.6
Dr. Manuil Fedorovich Schreiber's necrology. Source: Wikimedia Commons.

large photograph of the laboratory's crematorium with its doors left wide open.[72] This necrological photoessay thus fostered a notion of heroic commitment to the advancement of science. At the same time, it underlined that the death of scientists was not simply an event to be mourned but also one to be celebrated as the fertilizer of a disease-free future, when human mastery over its bacterial adversaries would be complete and triumphant.

The photographs included in both Eyzen's articles form part of a larger body of work, which is preserved in the archives of the Institute of Experimental Medicine in Saint Petersburg. In the 189 surviving photographs of Plague Fort in this collection, we can decipher several themes: general exterior views of the fortress-laboratory and its surroundings, photographs depicting construction works for retrofitting the fort into a laboratory, photographs of laboratory work, experiments, animals, and instruments, photographs of plague-infected doctors, their recovery, or their death and funeral, and portraits of laboratory scientists and workers outdoors or in auxiliary spaces. Although the photographs of the laboratory include some striking images (also those used in Eyzen's first article) and record Dr. Schreiber's illness and death (including the photographs in Eyzen's second article), the main corpus of the archive consists of photographs that recorded the daily life of Plague Fort: researchers chatting around a table (figure 1.7), out walking their dog, or enjoying the sun by the sea.[73]

This casts an interesting light on the heroic imagery of the published photographic corpus on Plague Fort. In fact, the visual record of daily life—frolicking, loitering, enjoying each other's company, walking by the sea, leapfrogging by the quay, and so on—forms the majority of the archive. Assuming that the photographs were taken by the researchers themselves over a period of time (there is no actual record of who took the photographs or which photographs were taken when), this indicates that in terms of their self-presentation the latter relied more on the everyday, the convivial, the intimate, and the joyous than on scientific achievement, discovery, peril, or martyrdom.

What appeared in the published record of Plague Fort in terms of its photographic coverage was at odds with how the researchers chose to visualize and commemorate their life in this vast fortified laboratory. Images of the everyday were completely absent in publications; in a manner consistent with the broader published photographic corpus of the Russian Plague Commission, publications focused exclusively on the extraordinary, heroic, and self-sacrificial elements of plague-related research.

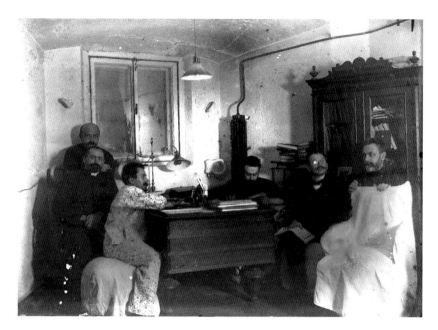

Figure 1.7
Laboratory staff in Plague Fort. Courtesy of the Institute of Experimental Medicine,
Saint Petersburg.

The "culling" of these intimate photographs from the published record
of Plague Fort, to use a an evocative term introduced by Jennifer Tucker, is
anything but surprising given the broader politics, ethics, and aesthetics of
imperial science. The practice of photographic "selection" has been shown
by Richard Vokes to involve choosing which photographs are included in
albums and publications but also how photographs are paired, ordered, and
reordered.[74] The fact that the actual corpus of photographs from which the
public-oriented images of the laboratory were selected and extracted was
so much focused on the everyday and the ordinary comes to show that the
contribution of plague photography to imperial propaganda often relied on
the systematic elision of the voice of the researchers lionized in that very
propaganda. The "elided past" contained in what, following Vokes, we may
call the "concealed archive of meaning" of epidemic photography may not
have enjoyed a national or international audience but it is at least as impor-
tant as the manifest past contained in its published, public-facing record.[75]

WHAT THE MICROSCOPE COULD NOT DEMONSTRATE

If in the course of the third plague pandemic microscopes and laboratories were visually celebrated tools and sites of imperial medicine, as Jennifer Tucker has shown in her history of scientific visualization at the turn of the century, they were also widely accepted as not being able to show "bacteria in action."[76] The role of the microscope in scientific investigations in the course the third plague pandemic was extremely limited insofar as, at best, these instruments could only show whether a given organism had been infected by a known bacterium. *At best*, as in the years immediately following the discovery of the plague bacillus, scientists and officials charged with containing the disease were often uncertain about what was the true plague bacillus, and many continued to diagnose plague based on clinical characteristics. Even as eminent a bacteriologist as Ernest Hanbury Hankin remained skeptical about the ability of the microscope to render plague bacteria visible in humans and animals; Yersin himself did not hesitate to diagnose plague based solely on the examination of symptoms.[77] This approach to the microscope's powers runs counter to historical readings of the "laboratory transformation of plague," whose proclamation of the microscope's monopoly on deciding what is and what is not plague has for the most part relied on sources shown in more recent historiography to be inadequate or not understood within their proper context.[78]

As the pandemic spread across the globe, doubts regarding the validity and ability of the microscopal identification of plague led to high-profile public debates and confrontations between competing authorities.[79] From an epidemiological point of view, the greatest limitation of the microscope was that it could not, in Tucker's words, show "whether or not, and how, bacteria caused disease."[80] What Lukas Engelmann has described as "layering and condensing functional representations, such as morphological descriptions, or diagrams detailing the procedures of infection with microphotographs of the bacteria" could indeed foster scientific certainty regarding the causal nature of a given "microbiological agent."[81] However, what such visual ensembles could not demonstrate or prove was how the bacteria were transmitted to humans or how they were maintained in animals. There is no question that the discovery of the plague bacillus was rhetorically celebrated as "so epoch-making that it divides [plague's] history into two distinct periods of very unequal length," but in practice plague's

maintenance and transmissibility, which formed the core of scientific investigation and administrative concerns and anxieties, could not be determined by the microscope or inside the laboratory.[82]

The key questions about plague that troubled medicine and government alike varied in kind and intensity as the pandemic progressed. This was both because some of the questions had received more or less widely accepted answers and because developments in anti-epidemic technologies and techniques had rendered some of the questions less urgent. Questions also varied per region as they emerged within the context of different medical, bacteriological, and epidemiological schools (Pasteurian, British tropical medicine, Russian/Soviet, and other), which possessed diverse conceptual toolkits and technological apparatuses and promoted different scientific and imperial agendas. Classifying these questions for the purposes of this study (whose object is not the epistemology of plague) risks being insensitive to synchronic and diachronic differences, ambiguities and transformations, and yet it becomes necessary on a heuristic level so that we can broadly approach some of the overarching concerns regarding plague's epidemiology and control.

First, the most pressing question in plague epidemiology concerned the transmission pathways of the disease. Was plague contagious? In other words, was it directly transmissible between humans? Did it involve animal vectors or other means of transmission such as soil, grain, or clothes? In turn, questions arose regarding what human behaviors facilitated or restricted transmission. For instance, behaviors that became epidemiologically suspect included individual habits such as walking barefoot on supposedly plague-carrying soil and cultural practices such as pilgrimage. Colonial authorities at the time also saw the supposed national or racial "character" of different populations as implicated in the spread of the disease (most commonly identified as fatalism and uncleanliness).

Second, of paramount interest during the pandemic was what we would today call the maintenance of plague—in other words, the way the disease persists through time in a given environment. Was this achieved by the bacillus becoming attenuated? And if so, where and how did this process occur, and what led to the microorganism's eventual "natural recrudescence"? Were seasonal patterns of plague outbreaks caused by natural patterns in host organism demographics? And how were these impacted by climatological conditions? Such questions were fostered by the periodic, often annual return of plague in several affected areas. Did outbreaks

result from reimportation, or were they due to silent human carriers, or was there a shift from enzootic to epizootic patterns in animal hosts? Did repeated outbreaks in a given location point to the existence or emergence of endemic foci of plague? Did plague establish natural reservoirs in animals or persist in objects or the soil? Was there such a thing as chronic or latent plague in rodent reservoirs of the disease? And what exactly was the relation between plague's endemicity and epidemicity?

Nothing could be more mistaken than the notion that questions concerning transmission and maintenance subsided after the stabilization of the rat and its flea (*Xenopsylla cheopis*) as plague's host and vector. On the one hand, nearly a decade intervened between the first scientific demonstrations of the connections of rat, fleas, and human plague and the universal acceptance of this transmission pathway.[83] On the other hand, even when this became generally (which is not to mean universally or exclusively) accepted, from around 1910 onward the relation between this transmission pathway and other means of transmission and maintenance continued to pose pressing questions for plague's epidemiology and control. Moreover, the gradual recognition of sylvatic plague—or plague affecting wild rodents and other mammals—as a primary object of scientific interest would further complicate epidemiological reasoning about plague as well as public health control measures against it.[84]

Deployed in the service of articulating, revising, and responding to questions regarding plague's transmissibility and maintenance, photography did not merely illustrate medical theory or knowledge, nor did it simply provide scientific evidence. It also helped institute a new kind of epidemiological reasoning whose defining characteristic was a focus away from singular epistemic objects (the sick body, the infected house, the pestilential corpse, the plague vector) and toward their "pestigenic" interrelations.[85] The work of photography as an apparatus of and for epidemiological reasoning was to make these interrelations not simply knowable but also actionable and hence to contribute to the expansion of human mastery through techno-scientific control over endemicity and epidemicity as fields of social and interspecies relations.

Photography proved particularly useful in demonstrating and indeed drawing complex portraits of the real or supposed hosts and vectors of plague's transmissibility and maintenance. In chapter 4 we will see how the rat was framed as the principal host of the disease in human settlements. At the same time, a large and important section of plague photography focused

on what we would today call the natural ecology of plague. Scientific expeditions aimed at determining plague's natural reservoirs formed an important if historically neglected component of the development of medical knowledge. Across the globe, efforts to identify how plague was naturally maintained in given environments and to understand how it spread from its sylvatic abodes to human settlements attracted some of the most prominent life scientists of the time.[86]

It is important to note that plague did not fit within the nomenclature of "tropical diseases." Although we find the disease tacitly included in a number of tropical medical manuals, such as that by Patrick Manson, the term "tropical" is not used in the *Encyclopaedia Britannica*'s key entries on plague (1889, 1903, 1910). Moreover, the disease is never discussed as a tropical one in key cumulative works on plague published in the course of the pandemic, such as Simpson's 1905 *Treatise on Plague* or Simond's plague essay in *Traité de pathologie exotique, clinique et thérapeutique*.[87] More importantly, scientific research of the disease did not pivot around questions that defined tropical medicine in its various imperial and national guises.[88] Although a number of doctors and plague commissions were interested in the impact of climate on the relation between endemic and epidemic plague, attempts to determine a "medical topography" of the disease or to develop a "geographical determining" around it remained peripheral.[89] The environmental determinism that David Arnold has identified as "tropicality" did not play a determining or significant role in framings of plague in the course of the pandemic.[90]

It is not surprising, as a result, that the photographic records of investigations into the natural reservoirs of the disease do not replicate or rhyme with pathological framings of tropical landscapes.[91] Rather than framing tropical nature as the source or the determining factor of the disease or producing "the morbific visualization of the tropics," the vast majority of field-based plague photography focused on identifying and examining habitats of specific hosts.[92] Epidemic photography attempted this by employing the tropes and techniques of survey photography. In so doing, it aimed to answer some long-standing questions about plague but also to convey a sense of control over plague environments. An example of this is evident in the photographic recording of the second leg of the 1911 Sino-Russian plague expedition.

Following the devastating epidemic of pneumonic plague in Manchuria (1910–1911), the Sino-Russian plague expedition tried to establish once and for all whether the natural reservoir of the disease in the region and

the source of human infection was, as Russian scientists had maintained since 1894, the Siberian marmot or so-called tarbagan (*Marmota sibirica*).[93] The photographs in question were taken once the Russian and Chinese parties of the expedition had parted ways in August 1911, and they cover the Chinese leg of the expedition into Mongolia, which was then part of the Qing Empire.[94] I have examined the photographic production of both legs of the Sino-Russian expedition in detail elsewhere.[95] What is important to note here is that one of the central objects of this photographic production were marmot burrows.

Several photographs in the album corresponding to the expedition into Mongolia (six out of sixteen, all 17 × 16 cm, mounted on purple paper with extensive marginalia), all commissioned by the leader of the Chinese party, Wu Liande, depict elaborate, dug-out marmot burrows.[96] The aim of these photographs was to interrogate underground structures as sites of the preservation of plague during the winter when marmots hibernate.[97] The photographs tried to demonstrate the architecture and contents of these complex animal nesting structures. Marking the length of each burrow chamber, the notes on the mounting paper of the album placed emphasis on the locations where marmots slept, and thus grass was accumulated, and where fecal matter was deposited (figure 1.8).[98] The reason for this was that both materials were "believed to potentially be able to sustain plague bacilli or at least fleas carrying them."[99]

This was the first time that these animal structures, which diagrams had tried to represent since 1856, were photographed, revealing the potentially plague-maintaining habits of Siberian marmots. The photographs were reproduced in the publications of the North Manchurian Plague Prevention Service, and they marked an important milestone in epidemiological debates regarding the animal as a host of the disease and the ways in which plague persisted through the seasons in one of its major endemic foci in Asia.[100]

While asserting and problematizing potential relations between suspected drivers of plague maintenance, epidemic photography also recorded and demonstrated the labor of scientific expeditions. In keeping with the broader scope of landscape photography as "a form of imperial prospect," photographs of plague expeditions, such as the one led by Wu, involved explicitly heroic visualizations of scientific labor, providing indispensable details on scientific culture, international collaboration, and epidemiological discovery.[101] In this way, photography was used to "perform [more

Figure 1.8
Dug-out tarbagan burrow with notes indicating deposited fecal matter and other
chamber functions and findings. Courtesy of the University of Hong Kong Libraries.

often than not, imperial] science," and it acted as a visual bolster of scientific selves as products and paragons of performed "objectivity."[102]

PLAGUE AT THE EDGE OF SIGHT

At the same time as fostering scientific knowledge of plague and an image of scientific achievement, photography revealed not simply the hidden or concealed aspects of plague but more importantly the fact that the key mechanisms of plague's endemicity and epidemicity, and the relation between them, laid at the edge of sight. In his famous essay, *Small History of Photography*, Walter Benjamin referred to what he termed the optical unconscious:

> It is through photography that we first discover the existence of the optical unconscious, just as we discover the instinctual unconscious through psychoanalysis. Details of structure, cellular tissue, with which technology and medicine are normally concerned—all this is, in its origins, more native to the camera

than the atmospheric landscape or the soulful portrait. Yet at the same time, photography reveals in this material physiognomic aspects, image worlds, which dwell in the smallest things—meaningful yet covert enough to find a hiding place in waking dreams, but which, enlarged and capable of formulation, make the difference between technology and magic visible as a thoroughly historical variable.[103]

Benjamin's observation derived from a pervasive way of perceiving photography at the turn of the century, which was based, among other things, on Eadweard Muybridge's photography of the running horse.[104] This project, as is well known, was commissioned by the Central Pacific Railroad President and breeder of racehorses, Leland Stanford, so as to solve the question of whether at any moment during its gallop the horse's four legs were all in the air. Developing what historians of photography have called a "'graphic language' of physiology," Muybridge's photography proved this was indeed the case, ushering in a new era in the use and perception of the medium as able to reveal realities hitherto kept hidden to the naked eye.[105]

Whereas Rosalind Krauss dismissed Benjamin's term as psychoanalytically unsustainable, in her book *At the Edge of Sight* Shawn Michelle Smith returned to the notion of the optical unconscious so as to argue that what it implies is not just that photography reveals an unseen world but that it reveals the world as unseen.[106] Photography in this sense draws us to "the edge of sight," involving "a revelation of an unseen world that photography does not fully disclose, but makes us aware of its invisibility."[107] Applying the notion of the "edge of sight" to plague photography is productive, for it allows us to go beyond the usual analysis of photography as a technology that "render[ed] the unfamiliar familiar and the unknown known."[108] However, this application requires a modification to the focus of Smith's analysis insofar as the "edge" in question is not so much cognitive or sensorial as epistemic. In other words, in the case of epidemic photography, the edge of sight is not so much related to the "blind spots of the mind" as to the blind spots of knowing plague—in particular, of an actionable knowledge about the disease.[109]

The application of photography to the third pandemic exposed "a world paradoxically visible in its invisibility" and, at the same time, invisible in its visibility.[110] Revealing plague as a fact of nature lying at the edge of science's sight formed a cornerstone of epidemiological reasoning, for it entailed a deferral of epistemological closure regarding plague's apophantic

ontology. Whereas in post–World War II medical culture, the "dialectics of visibility and invisibility" regarding epidemics, or contagion more generally, have revolved mainly around the human body, at the time of its emergence epidemic photography paid little attention to the latter.[111] By contrast, of particular concern to medical experts and policy-makers was plague's great unknown: "why epidemics or pandemics occur."[112] K. F. Meyer, who spearheaded the study of sylvatic plague in the United States, wrote in 1941: "It would remove a great deal of the fearsome unknown if one could forecast the peregrinations of plague."[113] By the time Meyer wrote his study on plague's knowns and unknowns, the main aim of this "forecasting" was to identify the "insidious" but "rarely . . . obvious" ways in which plague circulated among and between wild and commensal rodents, a question still not fully answered eighty years later.[114] Yet for much of the half century of bacteriologically informed plague research that preceded the ring-fencing of plague's "unknowns" to the field of disease ecology, plague's blind spots involved a much more expansive array of possibilities.

Gendered and colonially inflected metaphors of veiling and unveiling were a perennial part of medicine and epidemiology at the turn of the century.[115] When applied to plague, this metaphor became further invested with the idea that the disease possessed a unique, inherent capability of and indeed agency for confounding human efforts toward knowledge and control. In the opening lines of his influential *Treatise on Plague* (1905), William J. R. Simpson explained: "Plague takes its own time and opportunities for its development, and it is unwise to be lulled into a sense of security by its apparent impotency to spread in a particular country."[116] The legendary elusive agency of plague was often seen as the reason why the application of epidemic-control measures such as disinfection failed. In one of his numerous interventions on the subject of anti-plague maritime quarantine and fumigation, in November 1901 the Istanbulite doctor Pierre Apéry wrote: "We know the enemy, it is true, we also know the means to annihilate it, but it is just as true that we cannot always defeat it, because it hides, Nature perhaps wanting to save the race of the microbial species."[117]

The reason why this elusive agency of plague posed a significant danger to humanity was elaborated further by Simpson in a passage of his *Treatise* that was frequently quoted and commented in medical papers at the time and is worth citing at length here:

There is one noticeable feature belonging to the existing pandemic and which presages danger in the future. It is that notwithstanding its apparent inability to cause in any one place a great epidemic, it exhibits in some places marvellous powers of recrudescence and resistance to all known measures of prevention, and this, even when the cases are few. This tenacious capacity combined with its transportability makes it formidable because its slow progress, few cases, and possibly slight mortality, accustom the people to its presence, and lull the authorities into a frame of mind of looking upon it as a very manageable disease. In the meantime it gradually dots itself over different parts of the country, securing a firm hold in some localities which again form fresh centres for its activity, until, in the course of a few years, it is fairly established in the country at many centres, and only awaits the conditions necessary for its development into an alarming epidemic.[118]

Plague's alleged agency for waiting—eluding science and technology, and striking back at an opportune time—fueled not simply anxiety but rather a *certain epidemiological uncertainty*: the idea that one of the few certain things about plague was that there could be no certainty about how it became epidemic. Medical authors mobilized the metaphor of "lurking" to sound the alarm and urge for scientific research and public health measures, but also to warn against the uncertain results of the latter. In the words of Dr. Stekoulis, the Netherlands' delegate to the Quarantine Council of Istanbul, "the plague virus eludes the best efforts of struggle [against it], it annuls the effects of [our] best efforts and it awaits for the most favorable moment, unknown until now to science, for emerging out of its slumber so as to resume its morbid progress."[119]

Such anxieties became all the more pronounced in cases where recently established "knowns" or certainties about the disease became challenged and destabilized by new data. In an article titled "Is Bubonic Plague Still Lurking in the City of Glasgow?" written seven years after the August 1900 outbreak of plague in the Scottish city, the late physician of the Glasgow Victoria Infirmary Dispensary and of the Glasgow Central Dispensary, Thomas Colvin, wrote, "The origin of the outbreak was never discovered and the rats which infested the area where the disease appeared were on examination found free from plague."[120] Was plague in this case linked to sharing clothes, or was it perhaps carried in human hair? Colvin drew on authorities like Simpson and James Cantlie as well as from his own clinical observations to discuss different possibilities, but he came to no conclusion.

Thus, in a manner typical and productive of outbreak narratives at the time, he perpetuated the certainty of epidemiological uncertainty.

Attributing an agency to the "quiescence of plague" put particular emphasis on the question of the mechanisms through which the disease placed itself at the edge of science's sight. This entangled scientists in long and often fierce debates about the proposed mechanisms of endemicity and epidemicity of plague, and about the validity and priority of different evidentiary methods and criteria regarding the proof or disproof of the latter.[121] In this manner, the configuration of plague as a protean entity productively allowed for a fertile entanglement and exchange between evidential regimes and practices in the examination of the disease's origins, its "breeding grounds," its interepidemic ecology, the relation between plague's endemicity and epidemicity, and, ultimately, the disease's "true nature." At the same time, this certain uncertainty offered itself as a support for devising, combining, and experimenting with public health measures against the disease.

The role of photography in this configuration of plague as an elusive and transformative entity was not to provide certainty or to "visualize the invisible."[122] Rather, it was to foster the idea of certain epidemiological uncertainty—to maintain the certainty that the key traits of plague's endemicity and epidemicity laid at science's edge of sight and thus required extraordinary measures in the struggle to master and subdue the disease. An excellent example of this operation of epidemic photography is Frank Davey's coverage of the operations against the plague epidemic in Honolulu, Hawaii, in January 1900.[123] The outbreak began in December 1899 and ended in March 1900, causing seventy-one deaths, and it was marked by one of the most drastic measures taken against the disease on American soil: the burning down of the city's Chinatown on January 20, 1900.[124] The incineration was well planned, with the city's Board of Health in charge of the operation of evacuating the condemned houses, cordoning off the area, and employing the fire brigade so as to control the fire (see chapter 2). Events, however, did not unfold as planned: after the start of the operation, the fire got out of control and led to a massive conflagration that left 4,000 people homeless and a vast area of the city, including its iconic Kaumakapili Church (established in 1881), a smoking wasteland.[125]

As Engelmann has examined in detail, Davey (1860–1922), best known for his photographs of Hawaiian royalty and surfers, was "commissioned by the Board of Health" to cover the preparations of the incineration of

Honolulu's Chinatown; he worked over a period of two weeks to produce 353 "photographs of empty streets, unoccupied houses, outbuildings, and yards affected or even tinged with the suggestion of plague."[126]

Engelmann draws attention to the similarities between Davey's photographs and those produced under the commission of similar boards of health around the same time in Sydney (1900) and San Francisco (1900) (see chapter 2), stressing that they all "indicate an increased attention to plague's ecology: the structure, shape, and condition of houses, rather than people, that were struck or put 'at risk' by plague."[127] By contrast with these albums, Davey's photographs possessed a unique characteristic that Engelmann has identified as their cartographic capacity. Rather than employing a panoptical "view from above" perspective, as is common to survey mapping (see chapters 2 and 3), Davey's street-level photographic mapping of Honolulu's condemned Chinatown created a forensic archive of the built environment where plague was supposed to lurk.

The medicalization of Honolulu's Chinatown relied on notions of insalubrity and filth predating the bacteriological reconfiguration of plague, and on late-nineteenth-century framings of Chinese ways of life as pathogenic, which formed part of the wider Yellow Peril ideologies in America at the time.[128] But while the commissioning of Davey's photographs was based on turn-of-the-century perceptions of plague as "an infection of locality" or a "spatial pathology" (see chapter 2) and of urban spaces as racialized "breeding grounds" of plague, the photographs themselves did not dwell in representations of disorder, filth, insalubrity, or faulty structures.[129] Instead, in their blunt, uneventful, and serial appearance they created a visual field of plague as something not seen but implied: "where and how plague appeared and thrived remained at the time of the Honolulu outbreak an open-ended question, accommodated best in the equally open-ended faculty of photographic mapping."[130] Here lies Engelmann's most thought-provoking argument: what allowed Davey's photographs to "justify drastic measures deemed necessary to contain epidemic threats" was precisely that they did not produce a certain etiology of the disease but instead what, following Elizabeth Edwards, Engelmann calls "an archive of 'uncertain knowledge'"—a visual record that configured plague as a disease whose most important traits remained at the edge of science's sight.[131]

In epidemic photography, as a consequence, what Edwards calls a "fear of loss of evidence" and an "entropic anxiety" were not a fear or anxiety of not

recording what was known to be there, but a fear and anxiety of not communicating a certain epidemiological uncertainty about plague.[132] This insight builds upon and complicates ideas about photography's role in science insofar as it shows that while epidemic "photography stabilizes vision by showing and rendering to objectivity what was hitherto imperceptible," it "also amplifies the experience of 'imperceptibility' itself, by revealing human interaction with the world as structured around irreducible visual blind spots."[133] As Branwyn Poleykett has argued in her examination of Pasteurian photography in North Africa, the aim of framing diseases and epidemics was not simply to produce knowledge about them but also to "transmit doubt."[134]

It is in this configuration of plague into a universal potentiality whose fundamental traits remained at science's edge of sight that the dialectics of visibility and invisibility of epidemic photography reached their ultimate synthesis. The elusive objectness instituted by epidemic photography did not derealize plague, in Susan Sontag's sense of the term.[135] It did not create an aesthetic abstraction trapped between the bleak certainty of death and the fleeting hope of cure. Rather, by simultaneously stating, "this has been" and "this is invisible," epidemic photography accrued its value and its validity by making epidemiological reality visible and knowable while revealing that reality to be fundamentally and irreducibly unseen and unknown. Epidemic photography "render[ed] the world visible by revealing it to be fundamentally obscure, entropic and opaque."[136]

Yet epidemic photography's dialectic of visibility and invisibility was not in and of itself sufficient for generating, for the first time, the visual field of the pandemic. For this to become possible what was required was not only an assertive ontology of plague, as examined so far, but also an imperative ontology that determined not simply what plague *is* but what it *must be*.

GOTHIFYING PLAGUE

Writings on plague since its first historical recording in Europe in the sixth century CE (the first plague pandemic, also known as the Justinianic plague) form an immense corpus whose complexity continues to invite scholarly attention. Understandings of plague developed over the centuries in response to actual outbreaks and in relation to broader shifts in aesthetic, epistemological, political, and theological frameworks. Pertinent to the present study are the framings of plague that immediately preceded the third plague

pandemic and against which understandings and representations of the out-
breaks in 1894–1959 were developed. What marks this as a distinct period is
the emergence and consolidation of the idea of the Black Death.

The notion of the Black Death is a modern one. People experiencing the
events framed retrospectively by this term (the devastating plague epidemic
of 1347–1351), or more broadly the second plague pandemic (1347–1772),
did not use it, usually relying instead on variations of the "great mortal-
ity."[137] The idea of the Black Death emerged in the first half of the nine-
teenth century and found its systematic form in the writings of the German
physician and prolific medical author Justus Friedrich Karl Hecker (1795–
1850).[138] Hecker's *The Black Death in the Fourteenth Century* (1832) proved to
be a turning point in the historiography of plague, not only because it sys-
tematized the use of a single name for the inaugural epidemic of the second
pandemic but also because it ushered in a framing of plague as a disease that
bore a unique significance on "the image of an age."[139]

The development and diffusion of the Black Death as a concept and as
what Nükhet Varlık has called "a historical and nosological category" trans-
formed understandings of the plague epidemics of 1347–1351 and invested
plague with catastrophic, world-historical consequences.[140] Between the
1720s and 1900, plague remained largely outside the confines of Western
Europe; however, in French, German, and English works in particular,
plague was increasingly invested with the attributes of an ancient enemy.
An enemy that did not properly belong to the modern world but to the
past—or to the "Orient," which was imagined to be the past's contempo-
rary, cultural-geographic equivalent.[141] This mystification and orientaliza-
tion of the Black Death was further fostered by Romantic configurations
of the disease, both in literature and in the visual arts, culminating in what
Faye Marie Getz has described as a "gothic epidemiology."[142]

Getz has noted the relative lack of interest in the plague epidemics of the
fourteenth century from a medical or indeed humanistic perspective at the
height of the Enlightenment, arguing that what triggered Hecker's fascina-
tion with the disease was the early nineteenth century cholera pandemics
and in particular the second cholera pandemic (1826–1837) and its impact
on Europe. Although the claim is not substantiated by direct evidence
(cholera is never mentioned in the book), Hecker's book clearly reflects the
angst surrounding "contagion" at the time.[143] What singled out Hecker's
work was that it attributed world-historical properties to an epidemic. The

idea that epidemics are drivers of historical change is today a staple of our pandemic imaginary. Yet for Hecker the Black Death also revealed the position of humanity vis-à-vis "nature." As Getz has argued, for Hecker "the Black Death was a demonstration of the power and glory of Nature, so overwhelming in its universality and its terror as to defeat the best efforts of mere science to define it."[144]

Gothification contributed to ideas of plague's elusive, stealthy character and rendered the Black Death into a sort of Byronic hero: "the ultimate conqueror, a bacterial Napoleon (or Bismarck), unifying suffering mankind under his terrible yoke."[145] The image of Black Death relied on the ancient trope of *panolethria*, from the Greek *pan* for all or all-encompassing, and *olethros* for disaster. As Rachel Bruzzone has argued, the idea was used in the classics to connote "a nexus of calamities" where all disasters were "presented as acting in tandem" in a way that "involv[ed] simultaneous political, climatological, seismological, and pandemic crises."[146] In Hecker, the Black Death was configured as the culmination of this panolethric nexus, following a catastrophic chain of droughts, floods, and earthquakes in Europe, Asia, and North Africa, and entire mountains collapsing in China.[147] In turn, the "mental shock sustained by all nations" resulting from the Black Death led, in Hecker's historical imagination, to what we could call a chain of social catastrophes.[148] This framing of the plague epidemics of the fourteenth century instituted an image of the Black Death as the culmination of world-enveloping catastrophes that derailed the moral ground of society, leading to an anomic state.

THE THIRD PANDEMIC AS BLACK DEATH

The association of the third plague pandemic with the Black Death was famously made by Alexandre Yersin in the 1894 paper that announced the discovery of the plague bacterium.[149] However, as the *Illustrated London News* inaugural article on the Hong Kong epidemic, titled "The Black Plague in China," demonstrates, the identification actually preceded Yersin's publication.[150] Without any hard evidence to support it at the time, the Black Death trope was repeated regularly by the press: "the bubonic plague . . . is the same old plague that for centuries past has made its appearance at intervals in various countries to claim its tribute of thousands upon thousands of human lives, and which has been known in turn as the Levantine,

Oriental and black plague, and black death."[151] As Robert Peckham has argued, "Part of the panic provoked by the third plague pandemic . . . was plague's residual status as an 'old' disease. For many Western commentators, the plague represented the re-emergence of an obdurate old world into the new."[152]

In the course of the third pandemic, the imperative ontology of plague dictated an identity between contemporary plague outbreaks and the Black Death. The alleged identity relied, first, on the speculation that these were caused by the same bacterium and, second, on the belief that they had the same oriental or "Tartar" origin. This imperative identification fostered the idea that, as "revivals" of the ancient foe, any modern plague outbreaks could develop into an event of mass mortality like the Black Death.[153]

The idea of "revival" here is crucial because it introduced a new historical-epidemiological and indeed historicist framing of epidemics.[154] In Simpson's article for *The Lancet* from April 1900, "Plague Viewed from Several Aspects," where the notion of the pandemic is systematically used, the influential plague expert argued for a need to understand the factors that "periodically" give plague "a fresh impetus" and render it into an "active agen[t]."[155] Simpson reasoned that plague was an organism that witnesses global phases of excitement, "retrocession," cessation, and recrudescence; so the outbreaks of the mid-nineteenth century in Asia Minor or the Volga, although not related directly to the third pandemic, should be seen as part of the same global phenomenon of plague's revival.[156] The potential of individual outbreaks, Simpson reasoned, should not be solely judged in accordance to their severity or to the number of deaths incurred in their course because "even when plague has acquired a firm hold on a locality it is almost impossible to prognosticate its course."[157]

The revival of the Black Death was thus portrayed as the potential of any single outbreak of plague, however small. This association was systematically illustrated in the daily and illustrated press at the time with evocative images of plague's return. On March 2, 1902, for example, the Brisbane daily *Truth* carried a drawing of a rat-drawn scythed chariot tagged "the plague" riding through a stormy sky, with a skeleton marked "death" at the reins and a woman tagged "disease," with disheveled hair and an expression of dread on her face, pointing the way with her finger.[158]

No other outbreak elicited a comparison to and invocation of the Black Death more than the Manchurian plague epidemic of 1910–1911.[159] In

this instance plague assumed a pneumonic clinical form, which rendered it directly transmissible between humans. After plague broke out in the Chinese-Russian border town of Manzhouli in October 1910, it proceeded to devastate Manchuria (as China's northeast provinces were known at the time) until April of the following year. It left behind at least 60,000 dead, with a terrifying case fatality rate of 100 percent.[160]

What made the Manchurian outbreak a particularly good candidate for the rehearsal of pandemic apocalyptic imaginaries was a combination of traits. First, it was an outbreak that occurred in China, which had been depicted as the true origin and home of "oriental plague" ever since Hecker's work.[161] Second, the epidemic took place at China's frontier with Russia, putting this "astonishingly virulent outbreak" in a direct line to Moscow and Europe.[162] Third, this form of plague was also imagined to be nearly instantaneous in its impact—like the Black Death. Jules Courmont, professor of hygiene in the medical faculty of Lyon, France, mused, "The formidable epidemic that ravages Manchuria at the moment revives one of the most tragic plagues of the history of the Middle Ages. This is no longer bubonic plague, in its relatively slow march, with medium mortality and prone to specific treatments; it is the lightning plague [peste foudroyante] of the fourteenth century."[163]

Finally, the plague in Manchuria was also seen as confirming the anomic sociological impact of plague, in particular the idea, fostered since Hecker, that the disease had an ability to bring forth all that is evil (according to normative morals at the time) in humans: "a state of dizziness, madness, cruel egoism, capable of engendering the most implausible superstitions and the most atrocious crimes."[164] Take, for example, the article "The Plague Spreaders" by Dr. Bienvenue, which was published in March 1911 in the French illustrated periodical La Médecine Internationale Illustrée. The article gives a graphic account of the plague epidemic in Manchuria where the image of crowds fleeing infected cities is woven together with that of burial coolies plundering the corpses of the victims of the disease: "Others treat the corpses, pull them by the hair, cut the mats, which they hasten to sell at the hairdressers, plunder the clothes and seize the bags which wrap the bodies, with which they cover themselves to protect from the cold!"[165] In this way, an "oriental plague" fantasy was created that brought together, on the one hand, China as the supposed breeding grounds of plague and anomy and, on the other hand, fears of the return and revival of the Black Death.

Throughout the third pandemic, ever since the first outbreak in Hong Kong, plague was depicted as arising out of the decay of the Chinese Empire. Imagined not simply as a medieval relic but as the active product of stagnation and decline, plague was associated with the accelerating decline of the Qing imperial system.[166] The disease was made to rhyme with what Western observers saw as the social and material decay of Chinese cities, the anomy exemplified in events such as the Boxer Rebellion as well as with the imagined degeneration of the Chinese as a race.[167] More broadly, within the prevalent Yellow Peril paradigm at the time, plague was associated with the perceived decay of Chinese civilization: its supposed inability or resistance to adapt to modernity, its supposed fatalism, and its traditionalism that hampered reform and change.[168] The *Illustrated London News* article on plague by Clement Scott, already discussed previously, provided a panorama of this connection of the fear of epidemics with Sinophobia:

> How, then, should John Chinaman know anything about drainage or sanitation, or care to supply either, when at this period of the nineteenth century he believes that the 'death devil' can be averted by firing off crackers, sacrificing to idols and burning gunpowder! When I was at Canton last year the coolies were dying by the hundred of bitter cold and starvation. This year they are dying by the thousand of the Black Plague.[169]

During the Manchurian epidemic, this anomic image was imaginatively re-created in the large illustrations occupying the front pages of the illustrated press. On the front page of *Le Petit Journal* from February 19, 1911, we see plague as a flying Grim Reaper dressed in a crimson cloak, waving its scythe above what appears to be a stampede of innumerable Chinese women and men fleeing a city in flames while the frozen land of Manchuria becomes gradually covered in corpses of those succumbing to the dreaded disease.[170] A week later, the front page of another Parisian illustrated weekly, *Journal des Voyages*, bore a drawing showing a family huddling together in fright away from a plague corpse, while in the background a man is seen dragging a corpse onto a pyre and a dog or wolf is devouring two cadavers abandoned in the streets of the Chinese hamlet.[171]

What in the eyes of contemporaries made the Manchurian plague a revival of the Black Death—"same havoc, same superstition, same injustice, same dedication"—was more than anything else the way in which the problem of disposing of plague corpses rhymed with the image of the once

and future pandemic.[172] This rhyming was both discursive and visual. On a discursive level, articles on the Manchurian plague would be paired with those of the Black Death or the Plague of London, while catchphrases associated in the English-speaking world with the surplus of corpses during the latter—such as "bring out your dead"—were used in articles on the Manchurian plague.[173] On a visual level, photographs of corpses (piled, stacked, charred, and half-buried) proved catalytic for the gothification of the epidemic in Manchuria.

On March 18, 1911, the French illustrated weekly *L'illustration* provided a grand spectacle of plague corpses and plague pits in Manchuria.[174] Spanning six pages, the illustrated article, "The Nightmare in Manchuria," starts with four images of isolation and distant cremation, only to then confront its viewers with a macabre spectacle of pits filled with corpses. The first image, titled "At the feet of abandoned houses we have dug a tomb for the dead," depicts a plague pit filled with human corpses and firewood (figure 1.9). The second image covers the newspaper's central spread: titled "Vision of Horror," it depicts another pit where among the smoke and flames one can detect a mass of protruding human and animal limbs.[175] Finally, a photograph covering an entire page, titled "On a first stash of burned debris we threw a second load of cadavers," offers a most horrifying view of the epidemic: a close-up of a plague pit containing firewood debris and charred human corpses along with still unburned human corpses, including a baby.[176] What makes this latter image particularly disturbing is not only the mixing of burned and not-burned corpses but the fact that they all appear to have been thrown into the pit in a brutally careless manner. Some corpses lean on the walls of the pit upside-down while others, bearing graphic facial expressions, are stacked head up next to charred human remains.

Corpses had been an important part of the visual record of the third plague pandemic before 1911; for example, in India the cremation of plague victims formed part of broader British visualizations of the colony in the post-1857 era.[177] In the case of Manchuria these images assumed a key role in the representation of the epidemic. This was, on the one hand, because the "epidemic corpse" became the focus of concerns over plague transmission and, on the other hand, because the depiction of human remains rhymed with the dramatization and understanding of the Manchurian plague epidemic as a return of the Black Death.[178]

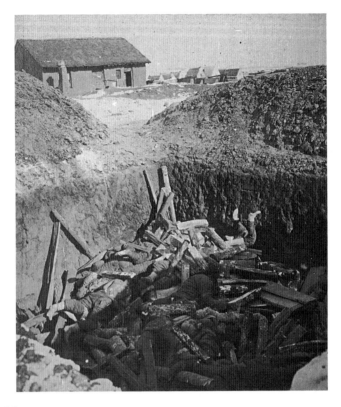

Figure 1.9
"At the feet of abandoned houses we have dug a tomb for the dead." © Institut
Pasteur/Archives Henri Mollaret.

Human corpses in the context of epidemics have attracted medical and
lay attention for centuries.[179] It was, however, only following the develop-
ment of bacteriology that, in addition to being symbolic and ritual fields
of liminality and abjection, corpses were fully rendered into contested
epistemic things within epidemiological approaches of contagion.[180] In the
course of the third pandemic, corpses became suspect for contributing to
the transmission and maintenance of the disease, "function[ing] as a bridge
between diverse sanitary and contagionist schools of disease etiology."[181]
The epistemic investment and problematization of the epidemic corpse was
tied to "its seeming ability to create other kinds of contagion: contagious
panic, contagious social collapse, and contagious terror."[182]

Plague corpse disposal formed a particular problem in Manchuria due
to its subzero temperatures, ice, and snow that made burials practically

impossible.[183] Combined with the initial refusal of Chinese authorities to authorize the cremation of the corpses, this created a major crisis within the epidemic emergency, with thousands of corpses accumulating, themselves frozen and difficult to store and manage across the region.[184] Yet the global circulation of images of plague corpses in Manchuria was detached from the immediate technical and legal problems facing the disposal of corpses in the region. The international coverage of the corpse disposal crisis in the context of the Manchurian epidemic of 1910–1911 used decontextualized corpse photographs to construct an image of the return of the Black Death.[185] These compositions relied on popular imaginaries of the "plague pit" developed in Europe and North America with reference to the Plague of London (1665), as exemplified in engravings contained in editions of Defoe's work, which provided Romantic renditions of these events with a gothic, Black Death–inspired inflection.[186]

The international press thus created a spectacle of the plague pit as an infernal tableau, whose visual force was further fostered by the horror inspired by the plague corpse's postmortem abject materiality and supposed contagiousness. Whereas gothic narratives, borrowing from Lucretius as well as Defoe, usually focused on the decomposing, putrefying, or liquefying pestilential corpse, in the case of Manchuria the spectacle of death involved unprecedented images of dog-eaten, frozen, and carbonized corpses—a spectacle of morbid solidness that often contrasted charred human remains with a landscape covered in snow and ice.[187] This was understood at the time to be not simply a gruesome sight but one that rhymed with apocalyptic images of the end of the world: "on several occasions, survivors have wondered if they were not witnessing the final extinction of mankind."[188] In this manner, the photography of the epidemic corpse and plague pits in Manchuria conjured up the Black Death as the imperative essence of plague, with imminent potential of outbreaks forming part of the third pandemic.

THE CAMERA AS EPIDEMIOLOGIST?

The discussion regarding photography's ability to capture *what plague is* and *what must be* raises the question of the extent to which, to paraphrase Elizabeth Edwards, the examination of the emergence of epidemic photography needs to consider the development of the "camera as epidemiologist."[189] If this is to mean a process contributing to "an archival grid through which the [epidemiological] past may be accessible in an imagined future," then

certainly photography may be said to play this role.[190] As Robert Peckham has argued in his examination of the Shropshire Regiment's photographic depiction of the 1894 epidemic in Hong Kong (see chapter 2), in this way epidemic photography generated "placeholders for a future meaning that will be retrospectively read into the 'view' once science has established the aetiology and transmission pathways of the plague germ."[191] On the one hand, the camera as epidemiologist stabilized an image of significant certainties about plague's transmission and maintenance mechanisms and how to control them. In other words, photography displayed what at any one point or place was known about the disease and the ways of containing or preventing it. On the other hand, the camera as epidemiologist fostered a *certain uncertainty* as regards plague's fundamental traits of endemicity and epidemicity as the mainstay of epidemiological reasoning, pointing at the incompleteness of this knowledge and at science's limited ability to prevent the return of the epidemic in a single location or its reappearance elsewhere. Yet at the same time epidemic photography operated on a symbolic and performative field beyond that described by "the camera as epidemiologist." For, besides asserting *what plague is*, it also configured *what plague must be*, thus contributing to the development and mutual entanglement between plague's apophantic and imperative ontologies, as well as between epidemiological reasoning and epidemic imagination.

DISINFECTING THE CITY

Readers with recent memories of the first months of the COVID-19 pandemic may recall the spectacle of disinfection unfolding on our screens when the disease's epicenter was the Chinese city of Wuhan. It was February 2020 and images of enormous trucks spraying the empty streets of Hubei's capital at night in a perfectly synchronized choreography stimulated awe and bewilderment in global audiences for whom COVID-19 was still a distant phenomenon.[1] The spectacle was similar, if on a much larger scale, to the one provided by images of open-air fumigation against mosquitoes in Brazil during the Zika epidemic four years earlier.[2] Then, as in the case of Wuhan, critics doubted the efficiency of open-air disinfection and decried the operations as costly and pointless. Yet such visual displays of disinfecting the city in the context of an epidemic crisis need to be taken seriously as part of the broader aesthetics and politics of epidemic control and as constitutive of the symbolic and epistemic field of the "pandemic."

This chapter examines the ways in which the visualization of disinfecting the city developed in the course of the third plague pandemic within shifting understandings of infection and disinfection. The question posed by this global photographic corpus, I argue, is not simply how images of anti-plague operations in urban settings visualized or rendered visible disinfection as a necessary and efficient means of epidemic control. It is also about how they configured understandings of infection and its relations to space.

Photographic framings of urban infection and disinfection focused on plague as what Prashant Kidambi has called "an infection of locality."[3] At the same time, they mobilized a global framework of epidemic control as a technologically determined field of mastery over human/nonhuman relations and as a racialized field of "sanitary utopia."[4] In this way, photography synthesized apophantic and imperative ontologies of plague in order to arrive at an enclosure of the city as a pathogenic terrain where the interaction between materialities and corporalities related to class and racial others required constant scrutinization, cleansing, and correction.

LOCATING PLAGUE

Concerns over plague's association with urban space have spanned the centuries and have cut across diverse epistemologies and etiologies of the disease. Such framings of the "pathogenic city" have often led to significant interventions on urban space in different geographical and historical contexts.[5] What Susan Craddock has called "spatial pathologization" applies not only to plague; in the course of the nineteenth century, the configuration of *pestis* as an "urban pathology" was in constant dialogue with similar developments as regards other infectious diseases, in particular cholera and yellow fever.[6] In their review of the relation between plague and the city, Engelmann and colleagues stressed that in the second half of the nineteenth century the "ever closer pathological association between plague and urban forms, structures and lifestyles was dependent on a 'materialisation of infection,' which, as Graham Mooney has recently shown, conceived space as the locus of both public health risk and opportunity."[7]

In this "sanitary-bacteriological synthesis," the idea of "filth"—long associated with plague—continued to play an important role well past the bacteriological discovery of the causative agent of the disease in 1894.[8] Rather than dislodging colonial medical attention from indigenous or working-class spaces, in the "bacteriological city" the discovery of the plague bacillus in 1894 shifted the ontological anchor of this concern from miasma to bacteria, perpetuating the colonial "sanitation syndrome" into the twentieth century.[9] As Mary Sutphen has shown in her comparative study of anti-plague measures in colonial Hong Kong and Calcutta, the persistent focus on "*where* the bacillus lurked" defined scientific research and public health intervention with regards to the disease, fostering synergies and accommodations between bacteriological and sanitarian schools of public health.[10] "Localist ideas," Kidambi has argued, "appeared to supply the missing link in the etiology of the plague by suggesting that the germs that caused the disease were either a product or a constituent element of localized sanitary disorder."[11]

Of key importance to the formation of these ideas, at least in the initial decades of the third pandemic, were understandings of plague as a pathogen whose natural reservoir was the soil, where it could become "invisible" by means of attenuation and where from it could then strike back at humanity through a cycle of natural recrudescence.[12] The idea was originally

developed in 1894 by Alexandre Yersin.[13] Although contested by local medical authorities in Hong Kong, it quickly came to be taken seriously not only in Pasteurian or French imperial contexts but across the globe. In practice, this framing of the soil as a reservoir of plague led colonial authorities to prescribe a series of interventions on local buildings: deroofing houses as a means of desiccating plague in the soil, applying stove-like devices to the earthen floors of houses to "burn" the bacteria supposedly contained therein, or removing the soil from houses and "baking" it in kilns in order for it to be disinfected.[14] Treating the soil as a reservoir of plague was part of much broader processes involving a "metonymy between place and disease" in which the pathogenic relation of materialities and corporalities of racial and class Others was constantly examined and interrogated.[15]

While the soil provided a concrete epistemic basis for the negotiation of this relation within highly structured experimental systems, the "infected house" formed an epidemiological category that connected medical and colonial anxieties about urban pathogenies in immediately actionable ways.[16] A term with a long history and amply used in medical and administrative literature in the context of the third pandemic, the "infected house" formed a potent sanitary-bacteriological bridge. For it encompassed a range of materials (rags, rubbish, the soil, walls) where plague was suspected to "lurk" in and be transmitted through the living conditions (especially crowdedness, degrees and modes of ventilation, and exposure to the sunlight) and dwelling habits (e.g., sleeping on the floor) of colonized, migrant, or working-class subjects targeted as responsible for spreading and maintaining the disease.

This was not simply an evasive vagueness but a productive one insofar as the term "infected house" would come to denote a *certain epidemiological uncertainty* about the actual location of plague, hence the constant need to expand disinfection to an ever greater range of spaces, structures, and materialities. The notion of the "infected house" thus allowed a process of etiological sliding. At the same time, it created a material and operational common ground where different approaches and schools of public health could meet, contend, and arrive at practicable accommodations in spite of their epistemological differences.[17] As Nicholas Evans has argued in his discussion of mapping "infected houses" during the plague outbreak in Bombay in 1897, in this manner the urban terrain appeared to doctors and administrators "to be so ripe with the potential for disease that any simple

explanation of this disease was precluded. The ground, the soil, surface water, the floors of houses, the coating of walls, and the roofs of dwellings were all implicated in the transmission of plague and were all objects of sanitary intervention—being either destroyed or disinfected."[18]

As plague was not seen as a tropical disease, similar sanitary-bacteriological syntheses were also reproduced in noncolonial settings. This is evident in *Eradicating Plague in San Francisco*, a 1909 publication by the Citizens Health Committee of the northern California city.[19] Following the reappearance (after three years of absence) of plague in San Francisco in May 1907, which led to 159 cases and seventy-seven deaths, the committee was appointed (January 28, 1908) by the city's mayor for the express purpose of "secur[ing] the co-operation of the San Francisco public with the sanitary forces of the City, State and Federal governments."[20] The role of the publication was to frame the outbreak as one borne by rats and fostered by the "favorable soil" of post-1906-earthquake urban conditions and to highlight the methods used to rid the city of the disease and its rodent vectors: "The ground-shock had broken the sewers, many of which had never been very good, in hundreds of places. The fire had left the open stump of a soil pipe on nearly every burned-over lot. The rats could go in and out of the branches where they pleased and use the main lines for boulevards."[21]

Composed of twenty-five citizens representing various business and professional sectors, the committee worked in close consultation with the leading plague authority in California at the time, Passed Assistant Surgeon Rupert Blue, as well as with the city's Board of Health and Quarantine Station. It employed 400 inspectors and workers for the purposes of rat-poisoning and rat-trapping. It also mobilized "a large force of volunteer inspectors" and issued $12,375.50 in rat bounties while producing and distributing "700,000 circulars and pieces of literature."[22] The committee's concluding publication carried twenty-six photographs mainly focused on rat-proofing and rat destruction. And yet in spite of the committee's expressed opinion that "bubonic plague is not a filth disease—it is a rat disease," as Joanna Dyl noted in her study of the environmental history of the 1906 San Francisco earthquake, "the Board of Health continued to emphasize poor sanitation as a major factor in susceptibility to plague, referring to 'the amount of filth that had been allowed to accumulate,' the 'disgustingly unsanitary conditions of buildings,' and the residents' 'criminal neglect in matters sanitary.'"[23]

For the image of epidemic risk and hygienic improvement to be symbolically and affectively efficacious, it needed to be framed in relation to the lack of cleanliness, with "clean" and its derivatives appearing 100 times over the 295 pages of *Eradicating Plague in San Francisco*.[24] Hence photographs of rat-related operations were mixed with ones that visualized the general uncleanliness of rat-ridden or rat-prone built environments, reproducing and updating long-standing metonymic associations between "vermin" and the spaces they inhabit.[25] In turn, anti-rat operations were described in terms of "cleaning," a verb that may sound strange to us today when it comes to killing or controlling nonhuman animals. In a photograph captioned "Real Cleaning Up" we see "workmen of the Public Health and Marine Hospital Service destroying a rat focus beneath a boarded backyard," while a photograph captioned "What the Basement Gave Up" depicted "the pile of refuse and garbage" extracted from a basement near one of the city's railway stations in the course of anti-rat operations.[26] Employing tropes of improvement and development through infrastructural change, the contrastive imaging of filth and cleanliness was aimed at eliciting what we may call "sanitary hope" in the book's readership: the idea that controlling plague entailed not simply the limitation of human contact with rats but a wider hygienic utopia—a new life free from filth, infection, and illness.[27]

Toward the end of *Eradicating Plague in San Francisco*, a photograph shows Front Street prepared by the Produce and Commission House District for an outdoors luncheon ("fruit banquet") held on March 21, 1908, celebrating "the destruction of its rats and the scientific sanitation of its quarter of the city" (figure 2.1). As the caption of the photograph suggests, the aim of the banquet, which was attended by the mayor, Dr. Blue, and other dignitaries, was "to show that their particular streets were 'clean enough to eat from.'"[28] The photograph shows a street with laid out tables and cosmetic plants, all arranged in a manner that aestheticizes cleanliness, propriety, and order.[29] Covering the luncheon, the April 1908 issue of the *Merchant's Association Review* featured a similar photograph of "the fruit banquet in Front Street" for its front-page article titled "Commission Men Show The City What Cleaning-Up Really Means."[30] What was "once a rat's paradise" was acclaimed as "now probably the cleanest in the world."[31] Though only barely visible in the photograph, a banner hanging above read in capitals, "We have cleaned up. Go thou and do likewise."[32]

CLEAN ENOUGH TO EAT FROM

The Banquet Set in the Street. How the Produce and Commission House District celebrated the destruc-
tion of its rats and the scientific sanitation of its quarter of the city.

Figure 2.1
"Clean enough to eat from." Courtesy of San Francisco History Center, San Francisco
Public Library.

VISUALIZING PATHOGENIC SPACES

In *Slums on Screens*, Igor Krstić has argued that photographic representa-
tions of slums in the second half of the nineteenth century mobilized the
idea of "filth" to construct links among poverty, disease, and criminality
in ways that followed both sanitary and social reform agendas.[33] At the
same time, Krstić argued, expanding on Stallybrass and White's linking of
sanitary reform and colonial anthropology, the visual representations of
slums contained in works like Jacob Riis's *How the Other Half Lives* (1890)
depended on and fostered "a colonial-anthropological imaginary and scientific
gaze which perceived the slum as a *terra incognita* that had to be explored,

analysed and classified."[34] Whereas not all photographs of plague-infected cities focused on slums or shantytowns, the most extensive and systematic works on the subject relied on these Victorian categories to create panoramas of infected and pathogenic urban spaces. This was achieved through individual photographs such as those depicting houses in India bearing markings on their exterior walls indicating human cases and deaths or the presence of infected rats.[35] It was also achieved through serial representations of urban structures where infection was visually conjured up in the relation between photographs rather than in a single image. Two examples highlight some of the ways in which photography operated on an affective as well as epistemic and political level.

Wu Liande's album *Views of Harbin (Fuchiatien) Taken during the Plague Epidemic (December 1910–March 1911)* is an excellent example of how photography was used to create an image of the pathogenic city in a serial manner.[36] The album was produced by China's leading "plague fighter" (see also chapters 1 and 5) and was shared with international delegates during the First International Plague Conference, held in the old Manchu capital of Mukden (today Shenyang) in April 1911.[37] The stated aim of the conference was to determine the causes of the devastating pneumonic plague epidemic that struck Manchuria between the autumn of 1910 and the spring of 1911. The meeting thus formed a battleground where the three empires in control of Manchuria at the time (China, Russia, and Japan) could prove their respective etiological hypotheses and their scientific superiority in epidemic control.[38] Wu's elegantly bound album consisted in sixty-one carefully curated photographs (20 × 26 cm) arranged in landscape format on glossy paper with captions in English and Chinese. The aim of the album was not to identify the source of the epidemic (marmots, which were not depicted in Wu's album) but to make claims about the cause of its spread and China's ability to control it. Wu identified the cause as migrant coolies and their dwelling spaces as exemplified in the shantytown of Fujiadian (Fuchiatien), which formed part of the great Manchurian city of Harbin at the time.[39] This attribution allowed Wu to counteract Japan's racial epidemic blame narrative, which accused the Qing Empire of being an anachronism unable to employ modern medicine and public health in response to the outbreak; instead, Wu's class-oriented narrative focused on the supposed ignorance, ineptness, and insalubrity of coolies.[40] Wu's stratagem was carefully selected to have both a national and an international appeal. The

depiction of the epidemic as a result of the intrusion of Chinese coolies in the supposed natural haven of the Manchurian-Mongolian borderland rhymed well with centuries of Qing configurations of the region as a place of ethnic and environmental purity.[41] In addition, Chinese coolies had been systematically targeted by colonial medical authorities in East, Southeast, and South Asia as a pestilential "floating population."[42]

In a manner consistent with broader tropes developed in epidemic photography, in visually framing coolies as catalysts of the epidemic Wu did not opt to focus on individuals or groups of this supposedly pathogenic class. Rather, following a pattern consistent with Kidambi's notion of "an infection of locality," his album focused on coolie houses and streets in Fujiadian.[43] The album opens with two bird's-eye vistas of the shantytown taken in a panoptical manner from the local police watchtower (figure 2.2).[44] The third photograph is, by contrast, one taken at body height that shows "the main street of Fuchiatien" and is followed by the fourth photograph of the album, "a crowded alley in Fuchiatien" (figure 2.3).[45] Subsequent photographs focus mainly on epidemic control operations in the city, including disinfection and burning, with an emphasis on wearing anti-plague masks (see chapter 5). It is important to stay here with this inaugural sequence and ask how it configured plague as an urban problem.

The opening sequence of the album produces a feeling of diving down and inside the locus of infection. At first, gazing from above, the squalid mess of the shantytown is identified as what we may call the surface of Harbin's pathology. Then, as the camera descends into Fujiadian, we get a sense of space becoming more and more confined, chaotic, badly lit, and humid, with multiple puddles being visible across the narrow street.[46] A sense of contagious filth and disorder pervades these cramped images, so much so that although the "crowded alley" photograph (a staple of slum photography in general) actually contains not a single human figure the sense of pathogenic crowdedness is unmistakably conveyed both by the narrowness of the alley and by the way in which columns, planks, pipes, and tables seem to be strewn around it in a disorderly manner.

There is indeed something *enargeiac* in this photographic sequence, as if the "manifest presence" of plague is made tangible not simply in the fourth image of the sequence, that chiaroscuro portrait of urban pathogeny, but in the imaginary motion of the camera penetrating the locus of the disease.[47] By borrowing tropes from dissection as well as survey photography, this

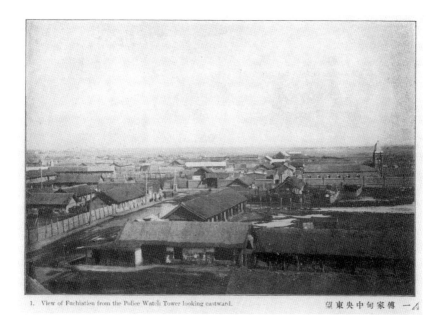

1. View of Fuchiatien from the Police Watch Tower looking eastward. 望東央中旬家傅　一

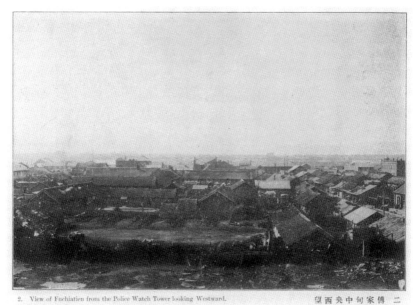

2. View of Fuchiatien from the Police Watch Tower looking Westward. 望西央中旬家傅　二

Figure 2.2
Views of Fujiadian from the police watch tower looking eastward and westward.
Courtesy of the Needham Research Institute.

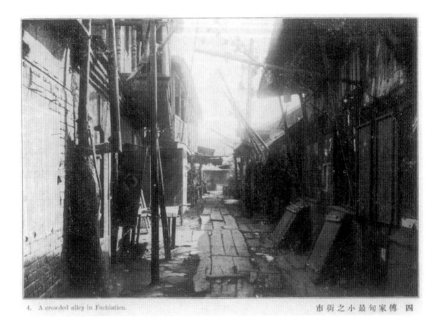

4. A crowded alley in Fuchiatien. 市 街 之 小 最 旬 家 傅　四

Figure 2.3
"A crowded alley in Fuchiatien." Courtesy of the Needham Research Institute.

sequence thus transports us "in motion" into the pathogenic entrails of Harbin's "coolie shantytown" in order to localize the true abode of infection.

A second example of how photography contributed to the pathologization of urban space comes from Kumasi in what was then the British colony of the Gold Coast (today Ghana) and the work titled *Report on the Outbreak of Plague in Kumasi, Ashanti* authored in 1924 by the city's Medical Officer of Health, Percy S. Selwyn-Clarke.[48] The Kumasi plague epidemic broke out in March 1924 and lasted until March 1925, killing 145 individuals.[49] However, the report is limited to the period of June 17 to September 17, 1924, when 140 people became ill and 121 died of the disease.[50] The capital of the Ashanti Protectorate since 1902, Kumasi played a key role in British-Ashanti relations as the stage of British efforts to limit the power of Ashanti chiefs in the region.[51] In his examination of the epidemic and the colonial measures against it, Benjamin Talton has argued that "the successful antiplague campaign in Kumasi was, in many respects, the final undoing of Ashanti political power in Kumasi" and established the Kumasi Public Health Board as the de facto government of the city up until 1943.[52]

The anti-plague campaign led by Selwyn-Clarke focused on quarantine, rat destruction, and the demolition or burning of "infected houses," with the evacuees relocated and demolished areas redeveloped according to hygienic standards current at the time.[53] From the sixty-four photographs included in the report, the majority (thirty-four) focus on illustrating "infected houses" or insanitary infrastructures. This work followed well-established tropes of colonial photography in the region; William Simpson's 1909 *Report on Sanitary Matters in Various West African Colonies and the Outbreak of Plague in the Gold Coast* similarly contained photographs of "insanitary areas," "dilapidated houses," and "plague huts" and possibly was a visual prototype for Selwyn-Clarke.[54] The Kumasi plague report begins with the first page following the report's table of contents carrying two photographs of "types" of "insanitary hovels" where plague cases had been discovered. The report also contains several panoramic images of Kumasi's affected areas, while the close-up focus on "types" of houses ostensibly prone to plague is most prevalent across the report. Captions accompanying photographs draw the attention of the viewer in a quasi-forensic manner to traits that supposedly provided the ideal conditions for the disease.

On one page of the report we see two such photographs (figure 2.4).[55] The first depicts a woman covering her bare breasts with her arm seated on the ground in front of her house. The image's caption draws our attention to "the verandas and annexes which prevented light and air reaching the living rooms."[56] The photograph thus aimed to connect the supposedly "primitive" corporality of the resident with the unhygienic spatiality of the residence in ways that were well established in colonial photography. The second image depicts "another type of Plague infected premises."[57] It shows two Ashanti women seated in front of a house while three sheep, a goat, and a horse are standing nearby. The caption states that "the horse was housed in one of the living room and sheep, goats, chicken, and pigeons shared the others with the human occupants."[58] Whereas the first photograph constructs an image of pathogenicity based on colonial photographic tropes of native nudity, in the second photograph it is the mingling of humans and animals that is operative of the same function.

Such images were part of not only a broader colonial disciplinary frame and racist regime of representation but also a colonial elision of the impact of capitalism on public health and daily life in the city. Talton has examined in detail the way in which the plague outbreak in Kumasi was entangled with the

A. type of Plague infected compound which was later demolished. Note the verandas and annexes which prevented light and air reaching the living rooms.

Another type of Plague infected premises. The horse was housed in one of the living rooms and sheep, goats, chicken, and pigeons shared the others with the human occupants.

Figure 2.4
"Types" of insanitary houses in Kumasi, 1924. Source: The Internet Archive.

production of trade and cocoa capitalism, noting that a great part of the conditions framed by Selwyn-Clarke as pathogenic were not at all "traditional" as portrayed in his photographs: "the living conditions around the Kumasi market and the state of the market itself provide a snapshot of some of the social consequences of rising capitalism in Asante."[59] "Selwyn-Clarke," Talton argues, "placed the responsibility for the plague's presence on Africans living in Kumasi, when, in fact, the epidemic was among the costs of empire and global trade."[60] In framing "insanitary hovels" and creating pathogenic links between native bodies, the photographs in the Kumasi plague report should thus be seen as part of this strategy of relegating epidemic blame away from colonial capitalism and toward native forms of living.

Although in Kumasi and elsewhere "infected houses" and "insanitary slums" were also interrogated as conduits and harboring places for plague-carrying rats (see chapter 4), photographic framings of built structures in terms of "filth" and uncleanliness continued well into the twentieth century and were articulated together with the increasingly rat-centric focus of epidemic control. In the case of Kumasi this was linked to a long-standing association in British colonialism between racial otherness and filth. As Talton has shown, Selwyn-Clarke's framing of plague relied on Simpson's previous work on plague in Accra, where he had transferred his experience of plague research and management in Cape Town, Hong Kong, and Calcutta.[61] It was the Cape Town connection in particular that was most important because there Simpson "had paired poverty and blackness as ailments of their own, and he recommended in Cape Town that it was best to destroy and relocate African communities beyond the city's limits."[62] Moreover, as Jiat-Hwee Chang has argued, in Simpson's 1907 *The Sanitary Conditions of Singapore*, British colonial representations of Chinese shophouses' interiors as pestilential spaces were "augmented" by photographs focused on "dark, gloomy, and squalid" conditions that accentuated miasmatic sensations in a bacteriological context and created an integrated, pathogenic image that encompassed Chinese bodies and built structures in mutually metonymic referents.[63] Although, in general, plague photographs of "infected" or "pathogenic" spaces did not focus on overcrowding, in cases where this was made available, such as Selwyn-Clarke's report, the association between the bodies of racial others and native housing structures was configured in ways that facilitated the "naturalization" of plague and legitimized measures that led to an increase of colonial spatial and political control.[64]

DEMOLITION

One of the most direct and prevalent ways of ridding "infected" or "pathogenic" spaces of plague during the third pandemic was demolition. A practice that was tied to real estate interests, strategic (crowd control and military) planning, and agendas for political control in different colonial and metropolitan contexts, demolition had enjoyed a long history as a sanitary measure by the 1890s. From the anti-miasmatic (and barricade-resistant) properties of wide, radial Parisian boulevards, created through the razing of entire urban blocks under the direction of the self-proclaimed *artiste démolisseur* Baron Haussmann in mid-century France, to destroying Rio de Janeiro's *cortiços* to rid the city of yellow fever in the 1880s, demolition was a sanitarian staple that bridged the miasmatic-bacteriological divide.[65]

Whether involving the destruction of individual houses or wholesale "slum clearance," demolition came to embody the "hygienic zeal" of medicalized urban planning.[66] This zeal was generally accompanied by a utopian vision that formed part and parcel of a project for "hygienic modernity," constituting what, to paraphrase Alice Mah, we can call "demolition for health."[67] Demolition brought together hygienic and urban imaginaries around the notion of modernity and "improvement" in ways that configured the destruction of built structures as cure, regeneration, and progress.

Sanitary demolition took different forms across the globe in the context of the third plague pandemic. It was aimed at a range of goals within distinct epistemological and political contexts of "figuring disease within scientific urbanism."[68] In the case of Kumasi, the demolition of Ashanti neighborhoods like Zongo has been shown to form part of a concrete, specific plan on the part of the British to use plague to challenge the hold of Ashanti chiefs and to "reorde[r] of Kumasi spatially and politically."[69] In Hong Kong, the "resumption" of Taipingshan in response to the Hong Kong plague outbreak of 1894 became the focus of public contestation involving not just Chinese inhabitants but also nongovernmental British agents, who argued against the wholesale demolition of the neighborhood on public health grounds.[70]

As both a local practice adapted to particular epistemes and agendas and as a measure of global appeal and resonance, anti-plague demolition was systematically photographed. Images of urban destruction formed important corpuses in public health records and were a frequent theme in the press.

Across different contexts, photographs of demolition were followed by those of reconstruction, showcasing the capacity of colonial authorities to create and provide "a clear space, a healthy space, a space of unobstructed lines of sight, open to vision and supervision."[71] This juxtaposition of "infected houses" or "insanitary slums," markets, and infrastructures with hygienic built environments replicated what historical studies of medical photography have identified as a "before-and-after" trope.[72] As Eric Stein has shown in relation to medical photography in colonial Java, photographic composites "rel[ying] on temporal sequence to establish validity" included a photograph of a patient with visible signs of a disease next to a photograph of the same patient after being "cured" by colonial doctors.[73] Not applicable to plague pathology but transferrable to the depiction of supposedly pathogenic spaces, the curative spectacle and "moralising tone" of the before-and-after trope of colonial medical photography was used extensively in the course of the third pandemic. It is, for example, clearly reflected in the photographs of urban "improvement" in Selwyn-Clarke's Kumasi report, where modified houses and latrines follow images of their insanitary predecessors.[74]

However, this disciplinary operation of juxtaposing images of plague-infected or plague-prone built structures with those of plague-proof or plague-proofed ones was not present in all photographic representations of anti-plague demolition. In her examination of plague photography during the 1924–1925 outbreak of the disease in Los Angeles, Stephanie Lewthwaite has shown how city officials used racialized framings of the city's "Mexican Quarter," which had previously been utilized for promoting assimilation, to mark a radical shift in policy and push for the "eradic[ation] of Mexican spaces and remov[al of] Mexican tenants."[75]

Plague broke out in Los Angeles in October 1924, taking a pneumonic, contagious form. By the end of the outbreak a month later, over forty individuals had succumbed to the disease. The large photographic collection held at the Bancroft Library in Berkeley affords an extensive view of the way in which officials saw and visualized the last great plague outbreak on US soil in the course of the pandemic.[76] The majority of the epidemic's victims were Mexican, and the disease clustered mainly in the city's Mexican neighborhoods, so the all-White Board of Health focused its investigations and operations on these urban areas with draconian quarantine measures followed by extensive demolition operations.[77] In his study of anti-plague measures in the city, William Deverell noted: "The overall plan, borrowed from

San Francisco's program of plague eradication earlier in the century, was a combination of slash-and-burn destruction and a campaign to lift structures well off the ground with blocks so that cats and dogs, those lucky enough to escape execution as strays, could run under the buildings hunting rats."[78]

Lewthwaite has shown how the framing of the Los Angeles Mexican Quarter depended on preexisting photographic configurations of shanty-towns: the Los Angeles City Health Department "conceded that the city was not 'free from the stain of the slum as witnessed by Jacob Riis in his visit to Los Angeles' almost twenty years earlier."[79] This time, however, the photographic documentation of the infected "slum" aimed at recording condemned spaces and their destruction. Through the absence of humans and a repetitive focus on interiors, the photographic gaze of the Los Angeles Board of Health transformed every structural element and object into "tangible manifestations of social disorganization" and pathogeny.[80] This is what Lewthwaite calls a "slum iconography": a racialized image of Mexican homes no longer as places but as a decayed, abandoned, disorderly, vermin-ridden, irredeemable pathogenic space.[81]

We have already seen that this image formed part of the larger grammar of epidemic photography when it came to capturing pathogenic spaces and "infected houses" in particular. Here photographs were used as an evidentiary base not for reconstruction but for destruction in and of itself. Whereas visual evidence in reports like that of Selwyn-Clarke from Kumasi downplayed the visualization of the actual process of demolition, others like the photographs examined by Lewthwaite or those found in albums covering anti-plague work in Sydney (1900) and San Francisco (1900) focused precisely on this process, with meticulous attention to the labor and force involved.[82]

In the case of Sydney, anti-epidemic work during the plague outbreak of 1900 involved large-scale demolition amounting to "an *ad hoc* slum-reclamation programme."[83] The condemned, plague-infected or plague-harboring inner-city "slums" and their destruction were extensively recorded in the 373 photographs contained in six leather-bound volumes titled *Views Taken during Cleansing Operations, Quarantine Area, Sydney*.[84] Helen Grace has noted the similarity of these photographic records to the work of Jacob Riis, stressing, however, that by contrast with the latter the plague photographs from Sydney do not "present subjects as objects; they are not portraits of slum residents but, rather, portraits of buildings and streets."[85]

This, as we have seen, was a frequent trait of photographs of plague-related demolition. Neither the Los Angeles photographs in 1924 nor the ones commissioned by the president of the San Francisco Board of Health, John Mashall Williamson, in 1900 focused on framing the inhabitants of condemned urban areas.[86] Grace argues that this renders such photographs part of the broader genre of landscape photography, but these images actually seem to resist such certain classification.[87] A great number of plague photographs from Los Angeles (1924), San Francisco (1900 and 1907), and Sydney (1900) appear to employ a survey-like gaze in that they record in great detail the exterior and the interior of condemned houses. When it comes, however, to photographs of actual demolition, a very different affective investment is in place as these focus on dramatizing destructive labor.

The photograph titled "Exeter Place Demolished" (figure 2.5) from the second volume of *Views Taken during Cleansing Operations, Quarantine Area, Sydney, 1900* shows over two dozen men busy destroying a block of houses in Sydney. Shovels and pickaxes fly in the air as a thick layer of dust creates a sort of demolition haze against which we read the figures of the workers, all White men, engaged in bringing down the supposed breeding ground of

Figure 2.5
"Exeter Place Demolished." Courtesy of the Mitchell Library, State Library of New South Wales.

plague. Similarly in Williamson's album, which depicts operations of demol-
ishing San Francisco's Chinatown after the plague epidemic of 1900, several
photographs focus on members of the demolition team as well as city police-
men and Board of Health inspectors posing triumphantly above or among the
debris like conquerors over the defeated corpse of the Yellow Peril (figure 2.6).

Rather than seeing these photographs within prevalent analytical frame-
works of ruination, we should consider them as images of racialized mas-
tery, a process embodied in the depiction of a victorious struggle of White
men against supposed sources of infection. In the cases of Sydney and San
Francisco 1900 albums, this visual performance of mastery was directly
linked to broader contemporary articulations of gender and race but also,
more specifically, with the Sinophobic context of the respective outbreaks
and the epidemic control work accompanying them. In the case of San
Francisco, targeting Chinatown for demolition was a decision and process
directly linked to prevailing ideologies of Yellow Peril and White suprema-
cist framings of Chinese immigrants.[88] In the case of Sydney, whereas the tar-
geted neighborhood was not one primarily inhabited by Chinese migrants,
the perception of the 1900 outbreak was equally Sinophobic, with newspa-
pers from the time going to the extent of illustrating Chinese-faced rats as
the source of the outbreak.[89]

I will return in more detail to the question of Sinophobia later. As far as
the photography of the plague-related demolition in the Sydney and San
Francisco 1900 albums is concerned, understanding the performance of male,
sanitary bravado contained in them requires us to understand that those com-
missioning and taking the photographs as well as those captured in them
in all probability shared an understanding of their actions not simply as a
germicidal war but also as a gendered and racial one. Williamson for one is
quoted by the foremost historian of the plague epidemic in San Francisco,
Guenter Risse, as stating: "If you want more bubonic plague, then let us
have the open door on this side of the Pacific and let the hungry hordes
come in . . . if you want clean cities, undefiled by contagion, then let us
have the re-enactment of the Exclusion Act."[90]

DISINFECTING WITH FIRE

The most intrusive and at the same time destructive method of disinfection
against plague was fire. This was employed on household items, individual

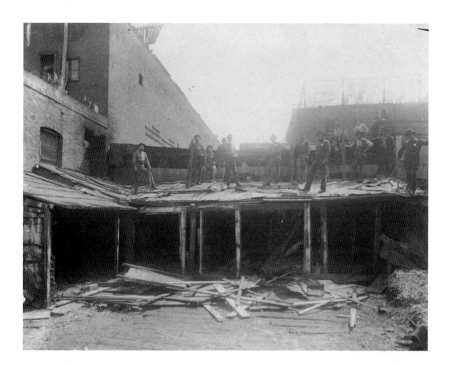

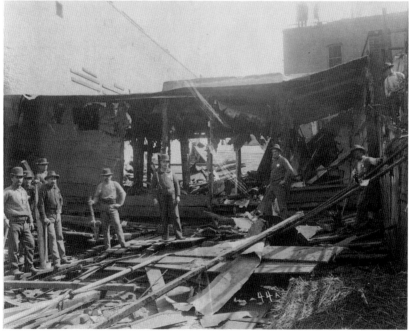

Figure 2.6
Demolition of houses in San Francisco's Chinatown, circa 1900. Courtesy of San Francisco History Center, San Francisco Public Library.

houses, and entire neighborhoods and villages. In the case of objects, fire
was used on items that were seen as either irredeemably infected or of too
little value to warrant other, more costly (for the public health authorities)
methods. In the case of houses and neighborhoods or villages, once again
the rationale behind incineration often relied on ideas of irredeemability as
well as on evaluations of native and working-class houses as being of little
value. In this case, the idea of the soil acting as a natural reservoir of plague,
where the bacillus could become attenuated and carried over a period of
time before regaining its virulence, fostered public health arguments in
favor of the use of fire.[91] But the idea that fire was a drastic and effective
measure against plague was also rooted in the much-deeper and less episte-
mologically nuanced belief that the London Fire of 1666 (a year after the
great plague outbreak) was responsible for the cessation of the epidemic
in the English capital.[92] Though not everyone agreed with this historical
epidemiological narrative, fire was widely seen as a most effective way of
ridding cities, towns, and villages of "infected houses" or neighborhoods.

Although this measure had a recognizable sanitarian aspect to it, it would
be a mistake to think that it was simply a relic from the time before bacteri-
ology or a measure that champions of bacteriological approaches to infec-
tion and disinfection antagonized or belittled. The discoverer of the plague
bacterium himself was not averse to the method, which he enthusiastically
employed on at least three occasions during the 1898–1899 plague epidemic
in Nha Trang, French Indochina.[93] Yersin shared at least one photograph of
this method with Émile Roux, the leading Pasteurian, with a copy finding
its way to the press and showing the burning of a native village near the
Annamite port town.[94] It was neither the first nor the only time when the
use of fire against plague was photographed. Images of fire as a disinfecting
agent formed a large and important corpus of epidemic photography during
the third plague pandemic. These photographs were used to instill an overall
sensation of mastery over plague and to associate the disease with racial and
class narratives and agendas. I will here focus on two themes within this cat-
egory of epidemic photography: burning supposedly infectious objects and
burning "infected houses."

The photographic coverage of the incineration of objects believed to be
carrying or transmitting plague was synchronous with the first use of photo-
graphy to cover an epidemic in history. As Robert Peckham has exam-
ined in detail, during the 1894 plague outbreak in Hong Kong particular

emphasis was placed on Chinese houses, especially in the badly affected neighborhood of Taipingshan.[95] Photographs depicting the supposedly plague-prone conditions of Taipingshan were preferentially represented in the daily and illustrated press, which played a key role in the institution of the "pandemic" as a lay experience. For example, Clement Scott's article "The Black Death in China" (June 30, 1894)—the first coverage of the pandemic in the *Illustrated London News* (see chapter 1)—was accompanied by three photographs contrasting the narrow and "densely populated" streets of the Chinese quarter to the wide and airy ones of the English quarter, a comparison made in several newspapers at the time.[96]

House-to-house visitations played a key role in British anti-plague operations and were often accompanied by the evacuation of Chinese inhabitants from their homes. Also evacuated were household furniture and objects, which were burned in open-air bonfires in the streets of the city. According to Peckham, focused as it was on capturing this process of disinfection by fire, photography contributed to the configuration of an "urban topography of infection" that took as its privileged object "Hong Kong junk": household items from Chinese homes that came under suspicion as vehicles and transmitters of plague.[97] If, according to Peckham's analysis, "epidemic photography was part of the nineteenth-century 'evidentiary crescendo' that brought together and recombined different species of urban photography," it was also a way of visually problematizing "Chinese 'things' as sources of likely contagion."[98]

Peckham focuses in particular on the photographs taken by the professional photographer David Knox Griffith (1841–1897) for the Shropshire Regiment, whose so-called Whitewash Brigade was charged with disinfecting Hong Kong.[99] Griffith's photographs were reprinted at the time in the illustrated press both as photographs and, in some cases, as engravings.[100] Because they rhymed with the wider colonial demand for photographs of China based on tropes and themes of ruination, Peckham argues that Griffith's photographs were also part of a much wider genre of "urban slum photography" that formed part of sanitarian visualization strategies since the 1870s: "Photography thus constituted a regimen of evidence, which was premised on impartiality and closely associated with the empirical aims of science. In this urban photography, the city tended to be pictured as a collection of vacant spaces."[101] In this way, the photographs of what the *Hong Kong Daily Press* described as "a party of Shropshire 'lads' burning

débris from condemned houses on a narrow filthy looking street" formed part of a sanitary-bacteriological synthesis with orientalist characteristics.[102]

In an iconic photograph, encapsulating this form of "imperial debris," that saw wide publication at the time, we see the men of the Whitewash Brigade burning the items of an "infected house" in Taipingshan (figure 2.7).[103] The main figure has his back turned to the viewer, but his all-white uniform, pith-helmet, and baton appear to embody imperial order, cleanliness, and mastery. What lies before the officer—and before us, too, as the viewers of this image who appear to be looking at the streets through the officer's eyes—is a jumble of what Peckham calls "Hong Kong junk": baskets and pots, house beams, and pieces of wood all piled up for burning. A pile of wooden partitions is visibly smoking, with the atmosphere of the street being so clogged with smoke that it creates a characteristically "vitiated" ambiance.

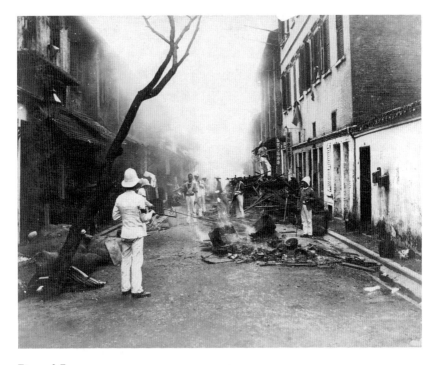

Figure 2.7
Shropshire Regiment's Whitewash Brigade, Hong Kong, 1894. Courtesy of the Soldiers of Shropshire Museum.

Several Shropshire Regiment men are seen standing in the narrow street, some poking the fire, with the figure of a Chinese man defining the end of our field of visibility. Acting as a counterpoint to the crisp figure of the photograph's protagonist, this figure seems to be about to be submerged in the smoke that fills the crammed Taipingshan street. To follow Andrew Jones's analysis of a trope that appears to be repeated in colonial photographs of disaster in China, the human figure and the smoke "emblematize the alterity and ruination of [one] [an]other."[104] All we see of the Chinese man is a large straw hat, with the rest of him being no more than a dark outline cloaked in mystery. The juxtaposition here is very familiar, almost a colonial cliché. As James Ryan has argued, the contrast of darkness and light played a key role in colonial photography, with John Thompson's iconic work on China establishing it as paramount in British representations of the country and its people.[105]

The racial symbolism of these photographs and their "color-coding" was central to the outbreak narrative that they helped institute: "the 'white' volunteers in the composition are pitted against the threat of the 'black death' that seeps from the native homes. This black-and-white iconography of disease echoes news reports from the 1890s that envisioned the battle against pathogens as a bitter frontier-conflict fought between white troops and black bacterial natives."[106]

It is instructive to draw a parallel here between this plague image and a famous photograph of Bronisław Malinowski, the founding father of ethnography, in which he poses with an indigenous wigged sorcerer in the Trobriand Islands (a photograph contained in *The Sexual Life of Savages*, published in 1929): as shown by Michael Taussig, the coloric standoff between the two men, who occupy opposite ends of the frame, does not in fact reveal the body of the "other" but rather, through the employment of shadows, that his being is in fact entirely mysterious. In the Hong Kong photograph, the Chinese man "stands revealed and concealed at the same time," and, we may say, paraphrasing Taussig, "all the more [plague-like] for so being."[107] Similar to the case of Malinowski but also differently, because this is an image of imperial and scientific crisis, the regiment officer is not simply an image of order, health, and cleanliness in the midst of chaos, plague, and filth but—enveloped in the apparatus of his white uniform, pith helmet, and leather boots—a figure that marks the limits of supposed oriental darkness and pathogeny.

Read alongside other critical approaches to colonial photography, Peckham's brilliant analysis of the Shropshire Regiment photographs allows us to see how images of object incineration created a field of vision of infection and disinfection that was at one and the same time sanitary and bacteriological while always remaining imbued by a specifically colonial aesthetic of objectifying and racializing plague's urban pathology. Arguably, the success of this photographic framing of colonial urban space and its transportability to other colonial and noncolonial settings in the course of the third pandemic were fostered by the fact that, through this theme, photography was able to frame plague in an irreducibly imperative manner.

Photographs of burning supposedly plague-infected or infectious objects as well as images of plague-related ruination carried with them and fueled an imperative framing of the disease (see chapter 1). This they did by summoning Black Death and its world-catastrophic potential by way of images that referred back to established, nonphotographic tropes of visualizing plague. Visualizations of burning infectious objects and of ruined cities as a background of plague had formed a staple of etchings and paintings of plague since at least the seventeenth century.[108] In the course of the nineteenth century, following the gothification of plague and the rise of the Black Death as a world-historical category, these images were systematically used in publications discussing the history of the disease.[109] As a result, the oft-repeated photographic theme of burning supposedly infected or infectious objects on the streets of plague-affected cities should be seen not only as a way of framing indigenous and working-class ways of living as pathogenic—and thus contributing to the assertive ontology of the disease—but also as a visual apparatus for instituting the imperative ontology of plague as a disease that, both in essence and in potential, was none other than the Black Death.

If photographs of burning objects on the streets of infected cities thus connected plague's assertive and imperative ontologies in a visually evocative manner, photographs of burning houses, neighborhoods, or villages may be said to have generated one of the most spectacular outputs of epidemic photography; one that moreover was imbued by a markedly racialized representation of infection and disinfection. As we have already seen through the example of Yersin's plague-control methods in French Indochina, burning buildings was not an unusual method in the context of the first decade of the third pandemic.[110] Nor was it reserved exclusively for the colonies: fire was used to destroy "infected houses" during the plague

epidemics in the Portuguese city of Porto (1899) and the American city of Los Angeles (1924).[111] The most widely photographed fire during the pandemic and the one with the greatest public outreach was undoubtedly the one of January 20, 1900, in Honolulu, Hawaii.

Plague was first recorded in Honolulu on December 12, 1899, with the death of You Chong, a Chinese bookkeeper to an English physician; the disease was possibly introduced to the city through ship-borne rats as early as June 1899.[112] The decision of the Board of Health, which by the end of December had assumed the government of the city, to use fire to destroy Honolulu's Chinatown so as to "stamp out" the disease was in line with similar practices adopted by public health authorities across the globe at the time.[113] As Engelmann notes, "Chinatown was perceived to be both the harbour and the target of the epidemic. The social dynamic associated with this district, its built environment, its everyday life, contributed to the already racist projection of the 'Yellow Peril' enjoying an alleged natural affiliation to filth, stench and disease."[114]

According to James Mohr's detailed study of the Honolulu outbreak, the resulting policy of "targeted burning" of Chinese properties where people were discovered to have died of plague was followed from December 31, 1899.[115] We have already seen how photography was employed by Frank Davey in recording Chinatown's condemned houses (chapter 1) in a process "of transforming a building into a health risk, of making non-human, non-sentient elements of the urban environment of Honolulu sources of filth and sickness."[116] The incineration of Chinatown buildings was covered by Davey as well as by commercial photographers.[117] What was initially a photographic production that emphasized the orderly manner in which controlled fires of condemned "infected houses" were managed by Honolulu's celebrated fire department took an unpredictable turn on January 20, 1900, when a sudden change of wind direction led to disaster.[118] The operation originally involved burning down blocks near Kaumakapili Church, a landmark building saved by King Kalakaua himself during the great fire that had destroyed Chinatown in 1886.[119] About an hour after the initial fire was set, the winds changed direction and soon all of Chinatown, including Kaumakapili Church, was consumed by flames: "The conflagration which destroyed Chinatown began in a sanitary fire started in Block #15, east of Kaumakapili Church about 9:30 A.M. the wind increased in strength and the spire of the church caught fire from flying sparks and beyond reach of

water; from there the fire spread to Block #1, burning and destroying all that portion of the city below Kukui street, and between Nuuanu stream [*sic*], Queen street, Maunakea, Smith and Nuuanu streets."[120]

The spread of the fire, the resulting ruination of Chinatown, and the "forced march" of the residents to detention camps were captured in photographs that soon made headlines across the United States.[121] On February 17, 1900, *Harper's Weekly* carried a page-long article on the events of January 20, "The Great Fire in Honolulu."[122] The article featured three photographs arranged in a visual composite meant to relay the sense of a time line (figure 2.8).

The first photograph from the left, captioned "The beginning of the fire," shows the start of the disaster: a desolate street empty of humans with thick smoke rising from various directions, with the outline and one of the spires of the Kaumakapili Church still visible behind a plot of land where the remnants of a condemned house lay smoking.[123] The second photograph, which occupies the center of the composition and is cropped in an oval shape so as to fit between the first and the last image, is captioned "Ruins of the Kaumakapili Church."[124] The third photograph is captioned "Refugees marching under guard" and shows the "forced march" of the residents of the

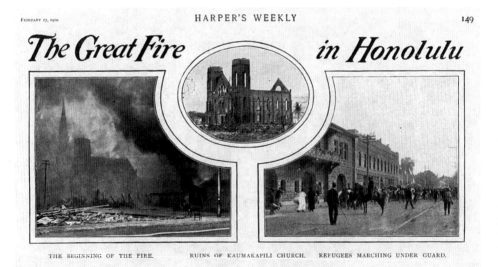

The Great Fire *in Honolulu*

THE BEGINNING OF THE FIRE. RUINS OF KAUMAKAPILI CHURCH. REFUGEES MARCHING UNDER GUARD.

Figure 2.8
"The Great Fire in Honolulu." Courtesy of Chronicling America.

torched Chinatown, under the watchful eyes of the police, National Guard, and armed vigilante groups of White men.[125] This photographic arrangement is rife with the semiotics of the Yellow Peril. It carries over a sense that the real danger facing Honolulu was not the devastating fire, which had "cleaned out the seeds of the plague," but the "terrified mob" of Chinese, Japanese, and native residents who were rendered homeless by it.[126]

The same xenophobic effect is produced by the visual composition of the February 1, 1900, article "Two Million Dollar Blaze Razes Honolulu's Chinatown" for the *San Francisco Call* (figure 2.9). Here the author proclaims the city's Chinatown to be so pestiferous that not even the fire is deemed enough to disinfect it and urges "that the soil of Chinatown is saturated with crude petroleum and burned, then ploughed up and sprinkled with sulphuric acid."[127] The article describes how, faced with a total destruction of their homes and livelihood, "the Chinese and Japanese were seized by a frenzy of rage and terror that almost terminated in a riot," and praises the police, the National Guard, and "citizens . . . armed with ax and pick handles [*sic*]" for cordoning off and "hold[ing] back the frenzied horde": "But for these reinforcements the crazed Asiatics would have overrun Honolulu's plague-free territory like a pestilence."[128]

Photography was used in the *San Francisco Call* article to further foster this racist metonymy between Chinese and Japanese refugees and plague. The composition in this case is vertical. Read from the top of the page, the first image is a copy of a photograph of the Kaumakapili Church ruins taken by F. J. H. Rickon.[129] Cropped in a circle and simply captioned "Kaumakapili Church," the photograph is surrounded by the drawing of two tall palm trees, which contribute to the exoticizing aesthetics of the composition. The image below, cropped in an irregular rectangle, shows "Japanese women being removed to detention camp." The next image, also cropped in an irregular rectangle and adorned with another palm tree drawing, shows "citizens with pick and ax handles [*sic*] going to the scene of fire to hold up quarantine refugees."[130] The final image, cropped in a circle, shows a building burning on Smith Street.[131] Here the main focus of the cascading visual composition is the image of the armed control of the victims of the fire, who are treated not at all as victims or as refugees but as a racial and pestilential peril to the White neighborhoods of the city.

Across the two publications, we see that the events of January 20 were visualized not so much as illustrating the disinfecting power of fire but as

Figure 2.9
"Two Million Dollar Blaze Razes Honolulu's Chinatown." Courtesy of Chronicling America.

framing the control and containment of non-Whites as an indispensable part of mastering plague. No photographs were used to show the devastation wreaked on Chinese, Japanese, or native Hawaiian livelihoods; though the archive holds a large number of such images of suffering, none of them made it to print. Instead what we get—and what defined the field of vision of the outbreak—is an image of racial otherness as the source of disease and disorder. While not surprising within the hegemonic Yellow Peril framework prevalent at the time, this lack of empathic photography—even when suffering is directly caused by epidemic control measures—and its displacement by a visual narrative that deflects blame onto the victims of biopolitical and racial violence needs to be recognized as part of the aesthetic, political, and ethical grammar of epidemic photography.

DISINFECTION AND FUMIGATION

If visualizing disinfection by fire, as exemplified in the case of the destruction of Honolulu's Chinatown, conforms with readings of epidemic photography as a tool of epidemiological as well as biopolitical control, we now need to turn our attention to a visual corpus that unsettles and complicates this disciplinary reading of epidemic photography.

Chemical disinfection, understood as a process of applying a known chemical so as "to have a direct impact on the properties of an infectious agent," is a practice whose history has usually focused on hospitals and antisepsis.[132] However, recent works have come to shift this focus away from the clinic and toward the "infected house," cargo boats, and public spaces. Emerging originally within an anti-quarantine framework but also applicable within quarantinist ones, disinfection has been acclaimed by historians as a paradigmatically flexible practice, which by the end of the nineteenth century formed a key component of sanitary-bacteriological syntheses.[133]

As Graham Mooney has argued, the disinfection of houses and streets rose to prominence in England during the cholera epidemics of the early nineteenth century, with the preferred means being "quicklime, chloride of lime, carbolic acid, sulphate of iron, perchloride of iron, and chloride of manganese."[134] Gradually becoming "a routine municipal practice"—not only applied during epidemic crises but also "a blossoming field of experimental study and theoretical exploration" by the 1860s—disinfection had achieved the status of both an everyday practice and a scientific frontier.[135] Rebecca

Whyte has shown that by the 1890s, as a field of invention and interven-
tion, disinfection became identical to "germicide," sparking long-standing
debates about the appropriate chemical agents and their application.[136]

Expanded to the field of fumigation, which was applied to buildings and
boats, between the 1870s and the 1930s such practices generated hygienic
utopian visions of a world free of pathogens but also liberated from the
time-consuming and trade-impeding practices of quarantine as applied to
merchandise in particular.[137] However, as understandings of the transmis-
sion and maintenance of plague shifted from the human body to animal
hosts and vectors, the definition of "disinfection" was no longer limited to
germicide. Rather, it also involved the destruction of animal carriers of the
disease, in particular rats and their fleas (see chapter 4).[138]

As applied to the "infected house," in the course of the third plague
pandemic disinfection involved a range of "intrusive interventions."[139] By
the mid-1900s, these involved not simply whitewashing with quicklime or
the application of carbolic acid on surfaces but also the employment of an
impressive array of disinfection and fumigation machines, which were at
the time competing in the market and in international sanitary conferences
for supremacy.[140] Involving a variety of chemical agents, the most advanced
of these machines, like the Clayton apparatus, were first developed with the
aim of disinfection and vector destruction in the holds of cargo boats and
were later modified, tested, and adapted for buildings.[141]

The disinfection and fumigation of "infected houses" was a popular theme
in the emerging field of epidemic photography in metropolitan and colo-
nial contexts. An example of this, recently brought into focus by Shivani
Sud, is contained in the *Plague Visitation, Bombay, 1896–1897* photographic
album, commissioned by the India Plague Committee.[142] The photograph
(figure 2.10) shows a street in Bombay, possibly in 1897, where a fire engine
operated by Indian sanitary workers under the supervision of British colonial
officers is spraying a liquid on the façade of an "infected house." The street
teems with bystanders watching the operation while in the background the
team of a second apparatus, which is positioned so as to shut the street off to
traffic, pose on top of the horse-drawn cart of the engine. The machine in
operation is identified in the caption of the photograph as a "Flushing Engine
cleansing infected Houses," with no further information as to the chemical
composition of the liquid being "flushed."[143]

At the time, seawater was used to flush Bombay's sewage system, but
there is no evidence to suggest that seawater was the liquid depicted in this

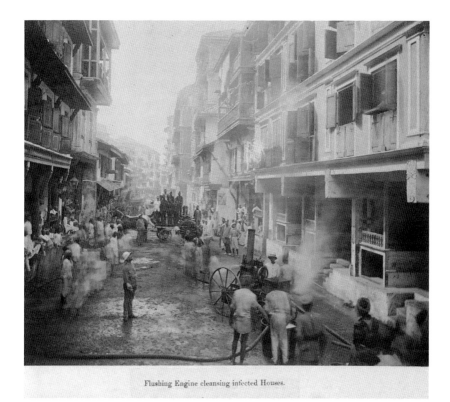

Flushing Engine cleansing infected Houses.

Figure 2.10
"Flushing Engine cleansing infected Houses." Courtesy of Wellcome Collection.

photograph.[144] In fact there is little in the historical record of anti-plague operations in India to suggest the use of water or seawater for disinfection.[145] By contrast, we know that in the course of the first years of the plague epidemic in the city, fire engines were employed to flush corrosive sublimate and that "this treatment was not confined to houses actually known to be infected, but whole streets and quarters in an infected area were washed down, and all bedding and clothing found in the houses were similarly treated."[146]

Commenting on a similar photograph, showing a plague inspector standing before a house and holding an open umbrella above his head, Myron Echenberg has shown that the latter was used "to protect himself on entering some houses from the 'deluge of carbolic acid solution descending from the upper stories.'"[147] Rather than suggesting "a distinct environmentalist conceptualization of disease—one that is attentive to the productive potential of water as a cleansing agent," this photograph needs to be read more

specifically as an image within the framework of sanitary-bacteriological synthesis and the broader debates and experimental systems involving chemical disinfection of "infected houses."[148]

Robert Peckham has noted that "colonial plague photography rarely conveys crisis, but rather focuses on public health measures, accentuating the role of colonial personnel in managing disease" through "largely static and orchestrated scenes [that] convey authority and suggest smooth operations of colonial bureaucracy."[149] If we were to fully adopt this perspective, we would need to read photographs like "Flushing Engine cleansing infected Houses" simply as images showcasing and fostering colonial control and discipline. However, this would be to miss the context of epistemic anxiety within which these photographs were shot and distributed. In his memorandum on plague and house disinfection, the Sanitary Commissioner of Bulsar (now Valsad, in Gujarat), Sergeant-Captain Dyson, wrote, "The prescribed routine of house disinfection consists in a preliminary disinfection, gaseous or liquid, followed by opening up of the house to sunlight and air, digging up and removal of earthen floors, and complete limewashing of the interior. The occupants, meanwhile, are to be accommodated in sheds, and kept there for a period varying from 10 days to a month."[150]

Although this may sound like a typically assertive summary of disinfection measures, it is followed by an admission that these measures were rather based on radical uncertainty about the disease: "An imperfect knowledge of the vitality of the plague bacillus, no doubt prompted such drastic measures."[151] What then if such photographs of disinfection, which appear to us today as what Stein calls "colonial theatres of proof" of technoscientific control, were in fact images that carried with them intense epistemic uncertainty and debate as well as the promise of their resolution?[152] Nowhere else was this tension between certain epidemiological uncertainty and mastery more pronounced than in the advertising material produced by the various companies holding patents over disinfection and fumigation machines.

The Clayton Company, which had chapters in a number of countries and agents across the British, Portuguese, and French colonies, was diligent in producing an appealing visual image of its apparatus, which combined fire-extinguishing, disinfecting, and rat-destruction properties by means of its unique sulfuric gas.[153] Published in a number of languages, the advertising pamphlets of the Clayton Company contained not just images and diagrams of the machines in their various maritime and land-based forms but also images of the machine in action, which underlined the adaptability

of the apparatus in different environments and to different purposes.[154] The glimpse of the commercial side of epidemic photography afforded to us by these corporate publications is all the more important because the manner of visually staging fumigation and disinfection machines for commercial promotion was quickly reflected in medical and epidemiological publications debating their efficacy in the struggle against plague.

In works like Simpson's *Treatise on Plague*, in popular science articles, and in colonial reports like Selwyn-Clarke's report on plague in Kumasi, images of fumigation and disinfection machines came to contribute to the phantasmagoria of epidemic control. At the same time, these photographs fostered the visual field of the "pandemic" as a process that did not simply encompass the globe in bacteriological terms but also necessitated and brought about technoscientific globalization through the international debate, comparison, and adoption of anti-plague machines—the latest word of science and technology at the time.[155] Nations, cities, and ports able to afford and operate a Clayton or other competing apparatuses were keen to advertise this financial and operational capacity. They were also keen to showcase themselves as optimally equipped against plague and free from the time-consuming and trade-hampering quarantine rules of rival ports or cities that lacked similar disinfecting technologies.

As Engelmann has argued in relation to the electrified sulfur-based fumigator known as the Marot machine and its application in Argentina, such machines were seen as guarantors of "general prophylaxis," even if local authorities did not always agree about which machine was superior in delivering this hygienic utopia.[156] And yet fumigation remained a constantly doubted and challenged process of plague control, with machines like the Clayton being at the center of endless controversies that unfolded on the stage of international sanitary conferences and in the corridors of colonial offices, chambers of commerce, port authorities, and public health bureaus.[157] Although it is tempting to interpret photographs of anti-plague fumigation within a disciplinary analytical framework, it is much more fruitful to see these as visual nodes of tension between sanitary mastery and epistemic uncertainty.

From this perspective, photographs of fumigation and disinfection operated as visual integrators of the pandemic as a threat to global health and a catalyst of new technological and scientific breakthroughs whose adoption and application promised a disease-free future of complete mastery over human/nonhuman relations. Yet at the same time these images operated as

visual registers of epistemic uncertainty and anxiety regarding both the unknowns of plague and the unknowns of plague control that continued to trouble scientists, engineers, and government officials.

MASTERY WITHOUT CONTROL

Photographs of disinfecting the city may be said to encompass interlinked projects for mastery at the turn of the nineteenth century. The first, which will be explored in more detail in chapter 4, was a project for mastery not so much over "nature" as over humanity's relation with the nonhuman, which in this case took the form of the plague pathogen and its animal hosts and vectors. In this manner, the emergence of epidemic photography coincided and was in dialogue with a much broader transformation in human/nonhuman relations, which found some of its most violent expressions in epidemic control.[158] The second, which reflects the broader colonial aspects of epidemic photography, involved a project of mastery on the bases of class and race, which framed indigenous, working-class, and non-White modes of living as inherently pathogenic. By bringing together these aspects of the broader project of mastery characterizing bourgeois, White, imperialist societies, photographs of disinfection fostered an image of infection as a menace that could only be effectively controlled once the terrain of corporal and spatial otherness was brought under technoscientific management.

And yet as the examination of photographs of chemical disinfection shows, visualizations of disinfecting the city in the course of the third pandemic cannot be reduced to an iconography of sanitary, epidemiological, or colonial control. The project for mastery reflected in and fostered by epidemic photography was underlined by a *certain epidemiological uncertainty* regarding the true nature of plague and the means of containing it. Never reduced to merely the exercise of control, the project for mastery thus "worked" only to the extent that it constantly came apart, broke down, and got jammed by conflicting political outlooks, financial interests, and epistemic investments and aporias.[159] Far from simply being a mirror or stage of power and knowledge, the photography of disinfecting the city contributed to the agonistic composition of the two and their interrelation on the applied field of urban space, where definitions of infection and disinfection remained in flux throughout the third plague pandemic.

QUARANTINE FRAMES

Quarantine is perhaps the most persistent measure of epidemic control in modern history. Since its Venetian invention in Ragusa (today's Dubrovnik) in 1377, it has been used, debated, and contested in diverse historical, geographical, and epidemiological contexts across the globe.[1] In the course of the nineteenth century, the question of quarantine offered opportunities for political, commercial, and medical debates under shifting epistemological frameworks (miasmatic theory, contingent contagionism, germ theory).[2] More recently, in the guise of lockdowns and travel restrictions impacting the majority of countries in the course of the COVID-19 pandemic, quarantine has become once again a global experience.

In general, discussions of quarantine by historians have focused on maritime quarantine, a practice that involved the holding of passenger boats and cargo boats off the shore of ports or in designated quarantine stations in their vicinity for a duration of time to ascertain whether the crew, passengers, or cargo were infected.[3] However, by the end of the nineteenth century a more complex picture of the practice emerged with the adaptation of quarantine to bacteriological understandings of infection and its combination with practices and principles of isolation.[4] Although the term "quarantine" continued to be mainly used in relation to maritime trade and human movement, technologies and policies of epidemiological detention also proliferated on terra firma where they combined practices of sanitary cordons, evacuation of infected areas, and the isolation of infected individuals, "contacts," and people who happened to live in infected areas in makeshift detention structures or camps.[5]

In this chapter, I examine the visualization of quarantine by the photographic lens, focusing on two forms of quarantine applied during the third plague pandemic: lazarettos and quarantine stations where human travelers were detained and plague camps set up for evacuees of plague-stricken

villages, towns, and cities.[6] Rather than providing a survey of themes or tropes developed around the visualization of quarantine, I highlight three operations of epidemic photography as they were applied to the subject: first, the contribution of photography to the development of a technoscientific framing of quarantine; second, the contribution of photography to framing quarantine through questions of individual freedom; and third, the racialization of quarantine as fostered by photography.

The chapter will examine how these three aspects relate to different epistemic and political processes and produced aesthetically diverse photographic corpuses. But I also maintain that we need to examine the point of convergence of these three aspects of epidemic photography in generating a pandemic vision of the world. On the one hand, each visual corpus examined in this chapter—first from the Ottoman Empire, second from France, and third from British India—was entangled within discreet political agendas and epistemic as well as aesthetic affordances. On the other hand, taken together, photographs of quarantine conjured up and problematized the pandemic as a global challenge that could be met only through scientific modernization and its corresponding political and social hierarchies.

REPORTING LAZARETTOS

In the course of the third plague pandemic, the implementation of maritime quarantine was used across the globe as a method of preventing the infection of unaffected harbors—the nodal points of imperial and national financial, political, and military power.[7] Regulations for plague-related quarantine within bacteriological frameworks first became internationally debated and agreed during the 1897 International Sanitary Convention in Venice, and they underwent regular renegotiation and debate in subsequent conventions as well as in smaller international sanitary conferences.[8] The initial regulations mainly concerned crew members, passengers, and cargo, but the 1903 International Sanitary Convention in Paris formalized a shift of attention toward rats as the generally accepted host of plague, reflecting actual practices across international harbors.[9] The examination of the development of relevant legislation and practices across the globe has shown that "quarantine formed a sort of imperial counterspace, where besides suspicious objects that occasionally needed to be destroyed, what was sacrificed was a key component of capitalist production: quantifiable time."[10]

By 1900 maritime cargo quarantine was seen within the "empire of free trade" as a technology of epidemic control and prevention that for the moment required technoscientific modernization, but which would eventually be replaced by fumigation and disinfection as science-led approaches to the problem of plague importation (see chapter 2).[11] At the same time, maritime quarantine, and in some cases land-based quarantine, also targeted migrant laborers, immigrants, pilgrims, and "coolies."[12] This system of inspection and quarantine has been studied extensively by historians, and has been identified as one based on and fostering colonial racial hierarchies and the pathologization of ethnic, religious, and class Others—with a particularly strong focus on the annual pilgrimage to Mecca (Hajj).[13]

Contrary to what we would perhaps expect, given the historiographical attention to this issue and to the surveillance of human bodies more generally, epidemic photography produced by colonial agents in the course of the third plague pandemic did not extensively or systematically cover the inspection of travelers in general or the quarantining of Muslim pilgrims in particular.[14] Where the photographic coverage of the subject proves more systematic is in Ottoman reports on the public health management of the Hajj and, more specifically, on the inspection, retrofitting, and construction of quarantine stations aimed at preventing the spread of diseases through pilgrimage.[15]

During the first decade of the third plague pandemic, quarantine stations and lazarettos across the globe became sites for updating a tradition inaugurated in fourteenth-century Ragusa based on novel bacteriological and chemical framings of infection and disinfection, which integrated and adapted international regulations to local needs and agendas. In the case of the Ottoman Empire, this construction and reconstruction was fostered by international pressure regarding the sanitary regulation of the Hajj as a conduit of cholera and plague.[16] While cholera had provided the nosological framework of medical concerns over the Hajj for most of the nineteenth century, by 1897 the third plague pandemic had reached Jeddah, where the imposition of quarantine led to severe riots.[17] Moreover, by 1899 studies had come to show that plague was endemic in the Hejaz region, with the region featuring in nosological maps as a natural focus of the disease.[18] Plague was far from new to the Ottoman Empire, but this was the first time that it presented itself as a problem within the epidemiological and geopolitical context of the third plague pandemic.[19]

International pressure to monitor and regulate the Hajj so as to prevent it becoming a source of the spread of the pandemic within and, most importantly, outside the Empire made it urgent for Ottoman officials to conduct surveys of existing quarantine structures. This effort was led by the Commission for the Inspection of Lazarettos (*Commission d'Inspection des Lazarets*), which was established by Istanbul's internationally composed Conseil Supérieur de Santé in 1905.[20] The commission consisted of the British delegate Frank Clemow, the Greek delegate Balilis, and a Turkish member of the Council, Ahmed Raghib.[21] Its output consisted of reports on the Empire's key quarantine stations.[22] A number of these reports were accompanied by rich visual evidence in support of the inspectors' surveys and recommendations: photographs, maps, and diagrams of the lazarettos under examination.

An example that highlights the importance of this visual apparatus in the context of late Ottoman public health is the 1906 report on the lazaretto of Beirut.[23] Composed by the Ottoman Commission for the Inspection of Lazarettos and presented to the Conseil Supérieur de Santé on October 9, 1906, the report contains fifteen photographs of the sanitary infrastructure with the aim of assessing the Empire's oldest lazaretto (established in 1835), which formed a key part of the infrastructure of the Hajj by new techno-scientific standards, and of ascertaining its need for improvement.[24] The inspectors considered four criteria in relation to the evaluation of the old structure:

> 1) The exact position of all buildings in the vicinity of the lazaretto, and the distance of their walls from it; 2) the possibility of constructing new buildings near the lazaretto; 3) the possibility of finding another location for the lazaretto in case it is decided to definitely move it; and 4) the possibility of assuring the isolation of the lazaretto, if not in a mathematically perfect manner, at least in a manner so that the danger of the diffusion of infectious diseases through its walls would be reduced to a practically negligible point.[25]

The fifteen photographs provided in the report were thus meant to be viewed in dialogue with textual evidence as well as with three maps and four diagrammatic plots of the lazaretto, which included a chart describing the proposed flow of pilgrims and other passengers for disinfection purposes through the structure.[26]

The photographs (figure 3.1) provided internal and external survey-like views of Beirut's lazaretto, focusing on its walls, its disinfection pavilion,

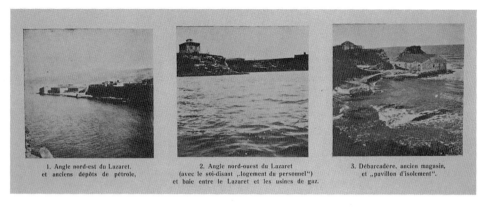

1. Angle nord-est du Lazaret. 2. Angle nord-ouest du Lazaret 3. Débarcadère, ancien magasin,
et anciens dépôts de pétrole, (avec le soi-disant „logement du personnel") et „pavillon d'isolement".
 et baie entre le Lazaret et les usines de gaz.

Figure 3.1
External views of the Beirut lazaretto. Courtesy of Wellcome Collection.

and its hospital. These images were not, however, to be viewed simply as an annex to the report. Rather, the composition of the report unfolded in a manner that systematically referred the readers (the members of the Conseil Supérieur de Santé) back to the relevant visual evidence in an "inter-visual" manner.[27] Reading the report required constant cross-matching between textual information and photographs and maps or diagrams:

> (1) The position of the buildings in the vicinity of the lazaretto is indicated in the annexed sketch (see map No. 1). On the east coast, or rather the northeast, of the lazaretto are found the old petrol depots; they are situated in a terrain slightly elevated above the sea-level, forming a promontory space, which is separated from the terrain of the lazaretto by cliffs (see Photograph No. 1).[28]

The commission's reports as well as the visual evidence provided in them were well received internationally. *The Lancet* noted that any previous information about these structures had been "of a fragmentary character" and that most of the previous reports provided by the council had "either no detailed plans or plans of a very elementary (and, it must be added of some, inexact) character, while in the case of none of them had photography been systematically employed to bring home to those responsible for their management the nature and actual condition of the institutions they had to deal with."[29] We may safely assume that *The Lancet* editorial reflected the opinions of Clemow, the influential British delegate to Istanbul's Conseil Supérieur de Santé, who was also a member of the Commission for the Inspection of Lazarettos and the rapporteur of the Beirut report.

The editorial claimed that the photographs included in the commission's reports to date (1907) had been taken by Clemow. Although the British delegate did lay claim to the photographs included in the July 1906 report on the Kamaran lazaretto, he made no similar claim to those found in the October 1906 report on the Beirut lazaretto.[30] Moreover, although the Kamaran photographs were extensively reproduced in a thirteen-installment article "Some Turkish Lazarets and Other Sanitary Institutions in the Near East," published by Clemow in *The Lancet* between April and August 1907, the Beirut lazaretto was not covered visually or textually in the article series.[31]

Whatever the case may be, all fifteen photographs from Beirut and the majority of the forty photographs contained in Clemow's *Lancet* series employed a survey-like photographic framing of lazarettos; only a couple of the photographs taken in Kamaran resembled ethnographic or orientalist portraits of pilgrims and pilgrimage.[32] This evidentiary use of epidemic photography rhymes with uses of survey photography in Western Europe and the United States that were prevalent at the time.[33] As Robin Kelsey has shown in his landmark study of the practice in the United States, survey-style photography relied on "persuasive realism, reliability, and sense of presence to promote a survey activity that in fact lay largely outside its scope. The brilliance of this strategy resided in its rhetoric of immediacy."[34] Historians have shown that survey photography was also widely used in the late Ottoman Empire by the end of the nineteenth century and that the tropes and methods of this photographic genre were being adapted to local needs and aesthetics.[35] At the same time, as Zeynep Devrim Gürsel has shown in her examination of medical photography under the Ottoman Sultan Abdülhamid II, photography played a key role not only in bolstering Ottoman state power but also in advancing medical and hygienic reform.[36]

The Beirut photographs thus form part of the wider "technopolitics of pilgrimage" in the late Ottoman Empire as well as in the Empire's "centralization through sanitation reform" in the region.[37] Markedly less ethnographic or orientalist than the photographs of the Kamaran lazaretto and more strictly focused on producing survey-style evidence of the station, the aim of the Beirut photographs appears to have been to bolster the technopolitical centralization of hygiene and epidemic control in the Ottoman Empire. We thus need to recognize the Beirut lazaretto photographs as part of a broader process of de-orientalizing the image of the Empire while

also enhancing "control [over its] lands and populations."[38] This they did by innovatively applying a visual, survey-like gaze in a way that allowed the recording and evaluation of existing sanitary infrastructures but also the demonstration of a capacity for sanitary reform. A report composed three years later confirms that this use of epidemic photography became an important evidentiary practice in the development of modernized public health in the final years of the Ottoman Empire.[39]

Addressed to the Conseil Supérieur de Santé, the report was not composed by the commission but by the director of the Tabuk lazaretto, Dr. Rifaat. Its aim was to showcase the successful construction of a modern, science-led lazaretto on the Damascus-Medina railway line (the Hejaz railway, established in 1908), which in the period of three months since its construction had successfully held and inspected 14,126 pilgrims returning from Mecca.[40] The lazaretto of Tabuk was constructed in 1909 on the basis of an older Ottoman hospital (established in 1907) partly in order to halt the spread of plague.[41] The location of this inland lazaretto was 160 meters west of the village's train station and 250–300 meters south of the town's hospital.[42] The lazaretto was divided in ten divisions, each with a maximum capacity for 400 pilgrims, hosted "hospital tents" for five individuals, and had a disinfection pavilion that was attached to a railway platform and was divided into three compartments for undressing, disinfection, and redressing.[43] Also included in the premises were a pharmacy, a bacteriological laboratory, a personnel pavilion, and mobile latrines.[44]

The report included fifteen photographs aimed at illustrating the structure and function of the different components of the Tabuk lazaretto. These, like the photographs in the Beirut report, corresponded systematically to a diagram of the lazaretto.[45] In the photographs, individuals are but distant figures in a landscape that is captured in a way that underlines the technological and scientific principles applied to the design of this new inland lazaretto (figure 3.2).

The photographic coverage of the lazaretto was not aimed at framing pilgrimage as a pathogenic process or pilgrims as dangerous individuals or "racial/cultural types." Instead its aim was to provide visual evidence of the technological and scientific proficiency of Ottomans to contain plague within its endemic foci and to protect not just the rest of their empire but, in Dr. Rifaat's words, Europe too from infection.[46] An excellent example of this

Figure 3.2
Disinfection pavilion in the Tabuk lazaretto. © bpk / Staatsbibliothek zu Berlin.

technoscientific focus are two photographs of the mobile latrines that provide inside and outside views of these emblems of hygienic modernity (figure 3.3).

The importance of the particular photographs as evidence of sanitary reform in response to pandemic threat needs to be understood within the context of the Tabuk lazaretto in broader international debates about the Hejaz Railway project and quarantining pilgrims. On the one hand, the Hejaz railway was part of Abdülhamid II's pan-Islamist policy aimed at "freeing pilgrims from their dependency on European transport."[47] On the other hand, Birsen Bulmuş has argued that "the Hijaz Railway greatly concerned the British after 1908, since it allowed pilgrims from the Empire and beyond to bypass the British sanitary controls at the Suez Canal."[48]

If the construction of the Tabuk railway lazaretto is a good example of the colonization of the Hejaz by way of sanitary reform, its photography comes to complicate the picture of imperial antagonism.[49] For it shows, similarly to what Elizabeth Edwards has argued, that photographs were not simply tools of colonial power but became "entangled with the practices of governance through complex and sometimes ambiguous demands made of them to 'perform' information in ways that inflect larger governmental practices"—and, we may add, geopolitical and interimperial antagonisms.[50]

Jennifer Tucker has argued that the relation between photography and science during the first century of the medium was experienced in a double

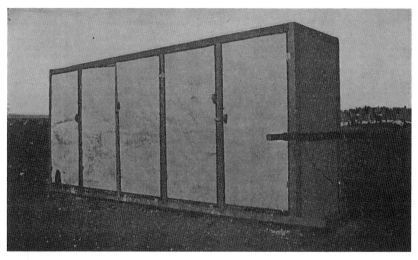

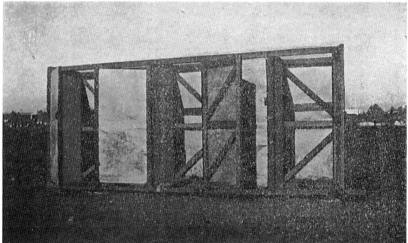

Figure 3.3
Mobile latrines in the Tabuk lazaretto. © bpk / Staatsbibliothek zu Berlin.

way.[51] On the one hand, photography was seen as the result of scientific innovation and progress. On the other hand, "the importance of photography to society was also reckoned in terms of *contribution* (not merely its indebtedness) to science."[52] As Daston and Galison have shown, this involved not simply a contribution to the development of scientific research but also the formation of scientific selves, which depended on the ability to render facts visible in a supposedly objective manner.[53] Photographs contained in the

Beirut and Tabuk reports were more than simply a demonstration of the new railway lazaretto or of Ottoman power in the region. They were part of an evidentiary practice that set out to demonstrate before the international forum that was the Conseil Supérieur de Santé, first, the architectural and technical particularities of any given quarantine structure and, second, an ability to assess and construct such structures in a scientific manner.

Contributing to the wider development of a technoscientific framing of quarantine at the time, Ottoman lazaretto photography is a forgotten but important part of the emergence of epidemic photography. Mindful of processes relating to the corrective and creative adaptation and appropriation of Western tropes on the part of Ottoman officials, we may approach the application of photography to creating evidence about lazarettos as carrying an assertion of scientific objectivity, which in turn fostered forms and experiences of the scientific self.[54] As noted in Wendy Shaw's broader analysis of Ottoman photography, being "chosen as agents of modernization [that] represented the empire literally," lazaretto photographs may be said to have rendered Ottoman epidemic control measures into indexes of new, modern, and scientific selves equal to those acclaimed by rival empires at the time.[55]

AN INTIMATE QUARANTINE

If epidemic photography was used to bolster the Ottoman's state's scientific image and self-consciousness as well as the technoscientific framing of quarantine, not all photographs of quarantine stations or lazarettos produced in the context of the third plague pandemic had similar aims or impact. Quarantine had long been framed in European and North American settings as a draconian practice that restricted and violated individual freedom.[56] No such colonial visual representations emerged in relation to quarantining or isolating Muslim pilgrims or racial others; however, when it came to applying the same measures to Europe, photography proved to be an ideal medium for illustrating the supposed absurdity or cruelty of quarantine and the way in which it remained a technology of epidemic control fundamentally opposed to individual freedom.[57] The most extensive photographic corpus on this subject covered the 1901 quarantine in the lazaretto of Frioul off the coast of Marseille of the passengers of a celebrated "scientific cruise."

The incident involved the S.S. Sénégal, which had previously carried celebrities to the first Olympic Games in Athens in 1896. On September 14, 1901,

the *Sénégal* sailed for a cruise organized by the French scientific journal *Revue générale des sciences pures et appliquées*, which carried 174 passengers, including seventeen doctors, the father of French cinema Léon Gaumont, and the future prime minister and president of France, Raymond Poincaré.[58] The boat was supposed to visit Rhodes, Cyprus, Syria, and Palestine, and on its return stop at Egypt and Malta. However, two days later, just before reaching Lipari, it had to turn back because one of its crew members, forty-seven-year-old Marius Fabre, exhibited symptoms of plague.[59] The *Sénégal* was not allowed to sail into Marseille; instead, on September 17 it was directed to the port of Frioul on the isle of Ratonneau, where a lazaretto had been established in 1850.[60] At this point, a second member of the crew had also begun to show symptoms of the disease.

After the immediate removal of the two sick crewmen, on September 20 the passengers were ordered to disembark, and they were installed in the lazaretto's dormitories.[61] On September 22, Yersin's plague serum was offered to the quarantined passengers, and only "nine or ten" refused to take it.[62] Due to political pressure exercised by Poincaré, the passengers (referred to as "tourists" in contemporary reports and documents) were released on September 27, three days earlier than what regulations dictated.[63] On their final night in the lazaretto, they threw a party with a concert and readings of poetry composed on site for the event, including a "ballad to eighty dead rats."[64]

Yet not everyone was content with the procedures followed during the incident or the conditions of detention. The director of the *Revue générale des sciences pures et appliquées*, Louis Olivier, warned the press to not misrepresent the "large empty barracks" of the lazaretto as "hotels" or even less as a "hospital." In a comic turn of phrase, the organizer of the cruise described to the reporter of the Parisian weekly *La Vie Illustrée* the Spartan conditions in Frioul:

> Persuaded that it is only dirty people who wash themselves, [the pavilion guard] takes pity on tourists who ask for water, shrugs his shoulders without indulgence when seeing the sybarites of the cruise seeking uselessly under their beds for utensils that Diogenes had no knowledge of and that our National Manufacture of Sèvres has deigned to produce [i.e., chamber pots].[65]

In more bitter spirit, the doctor Jean Bertot decried the state of the lazaretto's lavatories in his memoir of the quarantine, which was soon to be published as a book richly illustrated with photographs by various

detainees, including Gaumont: "It is great to know how, in full progress of scientific ideas, in full development of the respect that man owes to man, in the height of brilliant and touching theories of public hygiene, one can mock the most basic salubrity, one can treat free citizens."[66]

With a much larger audience, and the ears of the press at his disposal, given he had by then already been a cabinet minister three times, Poincaré decried the delay of disinfection and serotherapy: "It was a totally ridiculous comedy."[67] Coming from the man who a decade later would condemn millions to slow and pointless death and mutilation in the trenches of World War I, the irony of this statement should not be lost on the reader. The future French President's indignation over his and his friends' detention was typical of the European attitude at the time, which demanded maximum application of epidemic control measures to colonial Others but protested at the slightest application of the same measures to oneself:

> We made every effort to release us before a period of ten days, when our health was excellent and there was obviously no risk to run either for us or for anyone. The Minister of the Interior, by order of the prefect, released us after seven days, but there are certainly good people in Health who considered this decision as a small coup d'état.[68]

This was not simply an occasion for reproducing what we would today call a culture of complaint but rather one for performing class—in this case, bourgeois entitlement and moral superiority. Following Poincaré's interview with *Le Matin* on September 29, 1901, what he described as the impudent violation of the "elementary rules of hygiene" in the lazaretto was met by the high morale of the passengers: "No one expressed the slightest concern, the traveling companions made amusing ditties about our situation; we laughed, we sang, we played the piano; and this general gaiety was certainly the best preservative against contagion."[69]

The press coverage of the events systematically supported this image of class superiority in the face of the supposed fiasco of public health measures.[70] On October 13, 1901, the illustrated weekly *Armée et Marine* carried three pages on the incident where the conditions suffered by the quarantine passengers were decried: "Not enjoying any freedom, parked like sheep, there was no communication with their friends outside, whom they could only see in a bars-covered parlor and at a distance of at least 2 meters, the *pestiférés* were also forced to undergo inoculation."[71] The article was

accompanied by six photographs plus a page-long photographic composition of seven photographs titled "In Frioul—Tribulations of the *Sénégal* Passengers." The photographs showed the disembarkation of the passengers in the Frioul port, disinfection machines, the doctor of the lazaretto and various non-medical staff, a detained passenger (Dr. Jacques), a caged parlor, a dormitory, and exterior views of the lazaretto and the cruise boat.

The living conditions under quarantine were highlighted in a photograph by Gaumont showing detainees in one of the dorms (figure 3.4): "Intimate scene in one of the lazaretto's dormitories." The photograph shows seven men, mostly in pajamas, seated on and standing around their beds. Like similar photographs of the detainees published in other illustrated weeklies, like *L'Instantané* (October 19, 1901) or *L'Actualité* (October 20, 1901), hardship was here staged through a focus on simplicity and bareness.

As is evident in the October 11, 1901, cover of *La Vie Illustrée*, where we see a number of the passengers "behind the bars of the lazaretto" (figure 3.5), the simplicity of the dorm, like the "barren" nature of the island and the oft-repeated images of bars and fences, was meant to communicate the deprivation of comfort and freedom endured by these bourgeois tourists

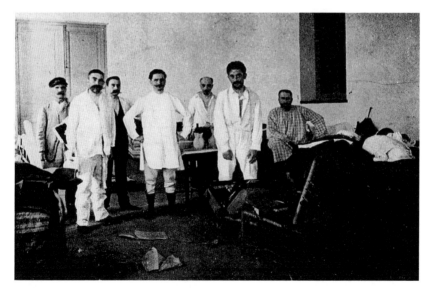

Figure 3.4
"Intimate scene in one of the lazaretto's dormitories," photograph by Gaumont.
Courtesy of Gallica/Bibliothèque nationale de France.

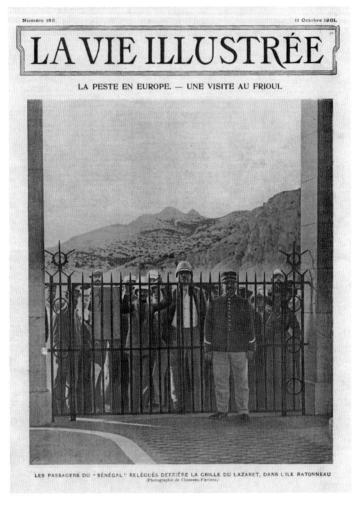

Figure 3.5
Passengers behind the bars of the Frioul lazaretto. Author's collection.

over the seven-day period of quarantine as well as their class-derived resil-
ience in the face of insult and adversity.[72]

And yet, carefully orchestrated as this staging was, the photographic lens
also offered meanings that surpassed the dominant framework of represen-
tation within which epidemic photography was articulated. As a journalist
of the Bordeaux newspaper *La Petite Gironde* commented, "it is a curious
sight to see everyone carrying their luggage and settling as best they can in
rooms and dormitories, and I know such an indiscreet photographer who

seizes on the flight the former Minister Poincaré succumbing under the weight of a suitcase that had nothing diplomatic about it."[73]

This subversive reading of the photographic dramatization of the plague quarantine in Frioul echoes Ariella Azoulay's challenge to approaches focused solely on the intended or "sovereign" meaning of photographs: "The camera generates events other than the photographs anticipated as coming into being through its mediation, and the latter are not necessarily subject to the full control of the agent who holds the camera."[74] Incorporating this analytical vantage point in their anthropological examination of medical photography, Prince and Lynteris have argued that "at the same time as medical photography interpellates subjects, it also creates a field of interpretive indeterminacy about conditions of health, illness, disease, cure and recovery."[75] Here instead we have an example of political and social indeterminacy not so much about illness or health as about social status, privilege, and class.

The photographic record of the quarantine of the *S.S. Sénégal* passengers in Frioul in September 1901 allows us to see how, even at the peak of the third plague pandemic, visualizing quarantine was not necessarily tied exclusively to a depiction of danger, risk, or otherness or to a demonstration of technoscientific development and hope. The Frioul case affords a view of how, for European contexts, quarantine remained primarily a practice to be understood within a discussion of the balance between freedom and safety but also within frameworks that dramatized and negotiated class position and privilege.

PLAGUE CAMPS

By contrast with the European and Ottoman focus on lazarettos, in colonial contexts quarantine and isolation photographs during the third plague pandemic principally focused on depicting, first, cordoning off areas and epidemic control within quarantine zones, and, second, "plague camps" where patients and contacts were forcefully detained for varying lengths of time under the most dismal conditions. Nowhere else were camps so extensively used as in British India, where plague was considered "the greatest and most important event India has had to face since the Mutiny."[76] Since the Subaltern Studies turn in the 1980s, historians have systematically studied the development of colonial medicine and the application of public health measures against plague in India under British rule.[77] After becoming formalized under the Epidemic Diseases Act of 1897, epidemic control

in British India came to revolve around a number of measures, including "compulsory hospitalization and segregation of plague 'suspects'; disinfection and, if necessary, destruction of homes and buildings labelled 'Unfit for Human Habitation' or UHH; compulsory medical examination; forced entry into homes; projects of sanitation and conservancy."[78]

As Aidan Forth has argued in his detailed examination of British colonial camps, "plague camps" in India "operated under the dual auspices of segregating the 'dangerous classes'—deemed most likely to carry disease—and accommodating homeless 'refugees' evicted from unsanitary areas."[79] Whereas "detention" or "segregation" camps were reserved for "suspect cases," "evacuation camps" "accommodated less dangerous categories evicted from inner-city slums and relocated to supposedly hygienic living environments."[80] These camps, Forth argues, "detained not only those infected with plague but broad categories of humanity considered dangerous for a variety of social and cultural reasons."[81]

In several cases, local communities resisted being moved into camps or even, as in the case of Sankharta or Kanpur, attacked and destroyed these structures.[82] However, in most cases the evacuation and segregation of communities was conclusive: in Bombay between June 1, 1899, and May 31, 1900, alone 110,000 individuals passed though the municipality's camps.[83] Plague camps feature regularly in the photographic record of plague in India between 1896 and 1899, and are represented in three albums produced at the time: the Karachi Plague Committee album (1897), the *Plague Visitation, Bombay, 1896–1897* album, and the *Poona Plague Pictures* album (1897–1908).[84]

A common trope or register of photographs of camps included in these works is the "view from above."[85] Although no flying technology was used in their production, the bird's-eye or "elevated viewpoints" of the plague camps reproduced what Louis Marin has identified as a totalizing "utopic" point of view, in the sense that it involved "a point of space where no man can see: a no-place not outside of space but nowhere, utopic."[86] "The bird's-eye view," Marina Warner has argued, "gives a vantage point of great power; from this height and synoptic angle, hitherto unknown experiences and information can be unified and displayed."[87] James Ryan has in turn examined how such catoptic views formed a cornerstone of the visualization of military expedition camps in the British Empire.[88] Examining the photography of the 1868 Abyssinian Campaign in particular, Ryan has shown how bird's-eye views were created by the Royal Engineers through collating

two or more still segments into "photographic panoramas of the landing site and principal camps of the expedition."[89] Involving complex techniques of exposure and plate preparation, "such panoramas provide grand, sweeping views of a landscape disciplines by British engineering and military might."[90]

Similar to the photographs of camps taken during the Abyssinian Campaign, the photographs of plague camps in India taken twenty years later provide what, following Jean-Marc Besse, we may call staged topographic views of mastery.[91] As "a form of regulated"—but also regulating—"technology," bird's-eye views of plague camps were intended not so much to create an actually functioning Panopticon or decipher invisible information on a visible surface as they were to generate a sense of order and control over the disease, the population, and the land affected by it.[92] In a photograph contained in the Karachi Plague Committee album (figure 3.6), for example, the camera frames the shacks of the Runchore Segregation Camp in a way that

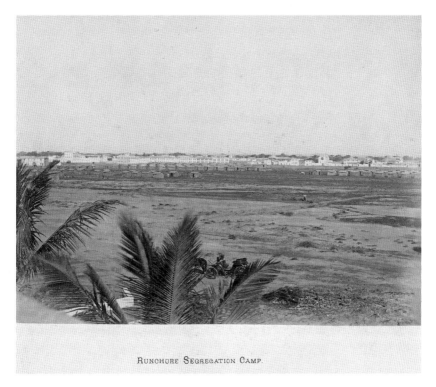

RUNCHORE SEGREGATION CAMP.

Figure 3.6
Runchore Segregation Camp, Karachi. Courtesy of Wellcome Collection.

presents them as an orderly infrastructure built at a safe distance from the city of Karachi itself and before a foreground of palm trees that accentuates a sense of oriental otherness.[93]

Embedded in what Mark Harrison has identified as the mutual metaphorical function between war and medicine in the context of Empire (militarized medicine, medicalized war), the main focus of plague camp photographs was on disinfecting native subjects.[94] As we saw in the previous chapter, disinfection played a key role as an epidemic control technology at the time, and its photographic framing was of key importance for the configuration of the pandemic. Here I will focus on the synergy between quarantine and disinfection as applied to humans inside plague camps through further examination of the Karachi Plague Committee's 1897 album.[95]

One of the most striking and perhaps best known images of the Karachi Plague Committee album (figure 3.7), captioned "In the Disinfecting Tub,"

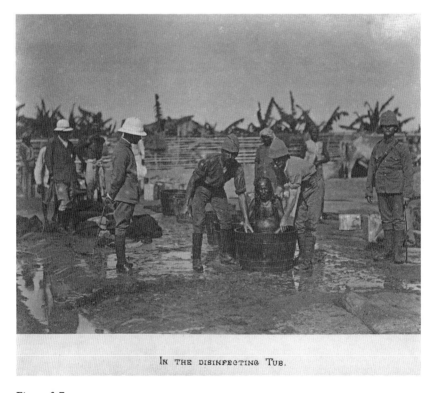

IN THE DISINFECTING TUB.

Figure 3.7
"In the Disinfecting Tub," photograph from a Karachi plague camp. Courtesy of Wellcome Collection.

depicts a scene in an unidentified plague camp around Karachi between January and June 1897. Two British soldiers are holding an elderly Indian man in a wooden tub; a colonial officer, cane in hand, supervises the disinfection process while another officer stands guard. Behind these central figures of the image, we see a line of other washing tubs as well as a fourth colonial officer and several Indian men, one of whom seems to be getting ready to undergo disinfection. The entire scene takes place in the open, and we can see the clothes of previously disinfected individuals thrown to the ground, which has been turned into thick mud by the liquid contained in the tubs and carried in tin boxes lying nearby. The man undergoing disinfection is clothed from the waist down and is looking at the camera as are the soldiers who are holding him by the arms inside the tub while trying to maintain their balance on the slippery, muddy ground.

This is a very disturbing image, and from among the photographs of the Karachi album the one that portrays colonial power and "racially coded visual tropes of medical resuscitation and salvation" in the most direct and forceful manner.[96] Things became only worse with the reproduction of this image in the illustrated press. In particular, in *The Graphic* it was published on August 21, 1897, with the title "'The pool of Siloam: In a plague segregation camp at Karachi." This was accompanied by a horrific text, an epitome of colonial racism:

> The snapshot shows the kind of work that Tommy Atkins [slang for British soldiers] has to do in the plague segregation camps in India. Here is a Barria being disinfected before being allowed to return to his home in Karachi. Two stalwart gunners assist him in his toilet, and the doctor in attendance to see that he is fit to be discharged. The man's bodily condition is evidence of the good living he has enjoyed while in segregation. Probably this is the first bath he has had for many years, as men of his caste are very dirty.[97]

The overt racism of this republication was part and parcel of British framings of plague at the time as not simply an epidemiological but also a racial problem. As Branwyn Poleykett has argued for colonial medical photography more broadly, "the spectacular racist aesthetics of degradation and vulnerability abstracts bodily experiences from their contexts, allowing suffering bodies to stand in for the 'sick' culture in need of 'rescue' and colonial modernisation."[98] Jacob Steere-Williams's work on "dipping" has moreover underlined how such photographs are "a powerful example of a discourse on disinfection, colonial power, and public health in an epistemic

moment of the late nineteenth century" and of the "racialized technologies of colonial disinfection practices in British India."[99]

But the colonial and biopolitical affordances of photography as applied to plague camps should not be seen as limited to such overt forms of racialization. To understand the way in which photography of plague-related detention in India contributed to colonial visions of the disease and its control—but was also situated within what Christopher Pinney calls "the fragility and instability of the relationship between images and their context"—we need to immerse ourselves in the immediate epistemic and political context of the depicted crisis.[100] In light of this, we need to situate the reading of the particular photograph within the epidemic events in Karachi of 1897 and within the visual culture of the Karachi Plague Committee album, where plague camps form one of the main themes of the composition, with twenty-three out of a total of eighty-one photographs (all taken by R. Jalbhoy, sheet 22 × 28.5 cm) focusing on the subject.

Plague struck Karachi, a city with a population of approximately 130,000 at the time, for the first time in December 1896; the disease was believed to have been imported from Bombay around the ninth of the month.[101] The first population evacuation took place more than a month later on January 24, 1897, when Nassarpuris living in the Old Town and Market quarters, numbering between 2,500 and 3,000 individuals, voluntarily moved into a plague camp of 400 huts that the municipality had built for them across the Lyari River, where they would stay until July 1897.[102] The camp, Acting Commissioner Wingate reported, was "well laid out with water-pipes and bathing platforms; in fact the Municipality had spared no expense to make the camp attractive and convince the people that the desire was to save, not to kill."[103] But the evacuation did little to halt the spread of the outbreak, leading to an officially endorsed exodus of 25,000 individuals, mainly from the worse-affected quarters of Karachi where in the course of January 743 people perished of the disease.[104]

As plague climaxed in February, a second camp was constructed at Gulamshah composed of closely huddled huts made of mats and reeds.[105] The camp hosted 561 individuals and "was riddled with plague and smallpox at the same time," leading colonial authorities to evacuate the detainees into yet another camp and to burn Gulamshah camp down.[106] It was not before the middle of February that colonial authorities decided to "move the healthy members of an infected house, that is the contacts, to regular

segregation camps," gradually adopting a system of disinfection of individuals and any objects they could carry in the process of evacuation.[107]

In his interview by the Indian Plague Commission's chairman, T. R. Fraser, on January 23, 1899, Robert Giles, who was the Collector of Karachi during the outbreak, explained that to deal with the spiraling epidemic a Plague Committee was appointed by the end of March.[108] This committee soon laid claim to the containment of the disease; in reality, by the time of the committee's first meeting, on March 22, 1897, the daily cases had already begun to decrease. The committee imposed what Fraser called "measures of rigid segregation" under the provision of the Epidemic Diseases Act of 1897. These consisted in the systematic disinfection and complete isolation of all inhabitants for the duration of ten days and the placement of military guards to maintain the quarantine.[109] The example Giles gives of this new process is that of the Gharibabad camp, which had received the 913-strong population of the homonymous village at the beginning of May 1897. According to Giles, the effect of disinfection and quarantine was immediate in spite of the fact that there had been several pneumonic plague cases in the village. Similarly successful was the evacuation and quarantine of "a village of Mekranis" numbering 170 people; according to Giles, they were disinfected and moved into a camp, after which not a single plague was reported in the hitherto badly affected population.[110]

The lessons learned through the initially disastrous epidemic response and the subsequent success in evacuation, disinfection, and quarantine were applied in the outbreak of the disease that erupted in July 1898 and lasted until June 1899.[111] For Giles the lesson was simple: "If you could remove all Karachi right away into clean ground, I believe plague would die out."[112] Though this was not actually done, the fantasy underlying the extensive use of evacuations into plague camps rhymed with the broader visions of sanitary utopias in India at the time, like that attributed to Bombay Health Officer, J. A. Turner, which revolved around the creation of a temporary "floating city of 300,000 people in the Back Bay of Bombay" where people would be kept healthy and under constant medical surveillance.[113]

In spite of the initial problems faced by the colonial authorities, the experience of plague camps in Karachi over the course of the first outbreak of plague in the city was thus evaluated as positive. In a telegram from the Secretary of the Government of India to the Secretary of the Government of Bombay dated February 21, 1897, we read: "experience in Karachi seems

to show that it can be so introduced as not to offend the prejudices of the people and is effectual in holding disease in check."[114] Not only were there no riots or any serious form of resistance, but the setting up of "voluntary camps" such as the Nassarpuri camp was hailed as an exemplar for the rest of British India and became the blueprint for no less than forty-four "voluntary camps" in the course of the 1898–1899 epidemic of plague in Karachi.

We need to stay a little longer with this notion. If the Karachi plague camps were recognized as an important part of the colonial experience of plague in India, this was because of the emergence and trial of this new type of camp. The definition of a "voluntary camp" was one where people were allowed to settle after evacuating their homes and neighborhoods for the duration of an outbreak.[115] Some such camps, according to Giles, actually formed their own plague committees: "The Committee inspected the houses night and morning. They had their sick sheds at a very short distance from the camps, but apparently at quite a sufficient distance. The results in almost every case were excellent."[116]

Yet in reality these camps were always kept under close British supervision.[117] Asked by the Plague Commission to explain of "what the voluntariness of a voluntary camp consists," Dr. W. L. Seymour, who had been in charge of 12,319 individuals in "voluntary camps" during the second epidemic of plague in Karachi, explained,

> It consists in allowing the people to settle within a definite area, where they like to arrange their houses. At first they were allowed to arrange them as they liked. Subsequently we took care to insist upon the streets being broader, and there being more ventilation. Thirdly, we made them arrange for the sanitation of the streets, and of their own accord isolate the sick in their own huts, and segregate the relatives. There was to be no interference with them if those conditions were fulfilled.[118]

How do plague camps then feature in the Karachi album, which was produced in 1897 to showcase the work of the Karachi Plague Committee presumably to other colonial officers? As already mentioned, the album contains panoramic as well as ground-level images of several plague camps at the time. What is immediately striking is that the framings of the Nassarpuri, Gulamshah, Gharibabad, and Mekrani camps bear little or no indication of their part in the story of the development and containment of the outbreak. We know, for example, that the Nassarpuri camp was seen

as the first "voluntary camp"; though it did not halt the first epidemic of plague in Karachi, it was appreciated as an example to be emulated in future epidemics. By contrast the Gulamshah camp was a disaster and had to be evacuated and burned down. In turn, the Gharibabad and Mekrani camps were seen as positive examples of enclosures incorporating the regulations imposed from March 1897. Yet nothing distinguishes these camps in their representation in the album. Here we have a smoothed visual narrative, which does not dramatize the initial mistakes of epidemic control or the eventual resolution of the crisis. Time lies flat in the album. Though the depiction of camps does roughly follow a chronological order, this is only perceptible to someone who already knows the time line of the construction of each detention structure.

As already argued, what connects the Karachi albums with similar photographic productions from the same time in British India is the depiction of plague camps as sites for the disinfection of individuals. We need to remember here that the disinfection of individuals before entering camps and then again before being released from them is something that was seen by the British as essential to halting the first Karachi outbreak—the one depicted in the album. Although broader anthropological readings of "liminality" cannot be excluded, here we need to consider this sanitary attention as resulting not so much from some symbolic unconscious as from pragmatic and scientifically informed concerns about camps developing into hotbeds of infection.[119] In this respect, humans and their clothes posed a key problem.

At the time of the first Karachi outbreak, the predominant view on the transmissibility of plague accepted that humans and their clothes could import the pathogen across distanced locations. Clothes were also seen as the source of infection for rats, which then proceeded to spread the disease locally.[120] Moreover it was proving very difficult to ascertain the infectivity of humans and clothes in a way that did not confound the two.[121] However, in the midst of this colonial angst and epistemic uncertainty, the case of Karachi seems to have made a mark as regards the combination of quarantine and disinfection. Disinfecting individuals and their clothes upon entering the camps appeared to keep the latter plague free, whereas disinfecting humans and clothes before the release of inmates was believed to mitigate the risk of transmitting plague still "lurking" in the camps back into the city.

Upon being questioned by the Indian Plague Commission (February 24, 1899) regarding the role of clothing in plague transmission, W. L. Reade stated that the best example of this was Karachi's plague camps during the first epidemic in the city.[122] Reade argued that what halted the epidemic was the disinfection of clothing upon entering the camps. Reade's statement was based on hearsay, as he had not worked in Karachi, but is indicative of the reputation of Karachi's plague camps and their association with the benefits of disinfection.

As regards personal disinfection, the method preferred in Karachi was "bathing persons in tubs with a mixture of Jaye's [sic] fluid in the water."[123] Jeyes Fluid was a carbolic acid disinfectant patented in 1877 that had proved popular against plague in various British colonies at the time.[124] Another photograph from the same album shows the disinfection of individuals in the "voluntary" Trans-Lyari camp (figure 3.8).

By contrast to figure 3.7, the sense of force and humiliation is relatively absent in figure 3.8. There are no British officials present in the image, where two Indian men are seen squatting inside disinfection tubs while being hosed with a handheld pump by sepoys. Unlike figure 3.7, this photograph also bears a sense of conviviality. The men in the tubs are fully clothed and surrounded by fellow detainees, including several children, a mother and her child seated on a mat, and several men. They are not exactly jovial, but the crowd appears relaxed: one man is smoking, and another seems to be smirking. Only the sepoys look serious and a bit out of place. It is possible that, like in figure 3.7, disinfection here was the last act before the people depicted in the photograph were allowed to leave the camp after a long detainment and return home, in which case this would mark not simply the end of the plague but a resumption of social life. In this sense, figures 3.7 and 3.8 could be said to represent the end of the epidemic (for the moment at least), the successful operation of the camps, and the added precaution taken by colonial authorities to disinfect detainees before allowing them to return home.

Plague camp photographs appear, as a result, to have more historical affordances than those allowed by a narrow reading of figure 3.7 in its incarnation in *The Graphic*. Seen in the context of the Karachi album and the plague epidemic in that city, plague camps take a particular meaning that incorporates and relays sanitary hope: the promise of an ability to face future outbreaks in ways that are both scientific, as embodied by disinfection, and nonconflictual, as embodied by the "voluntary camps" and the general lack

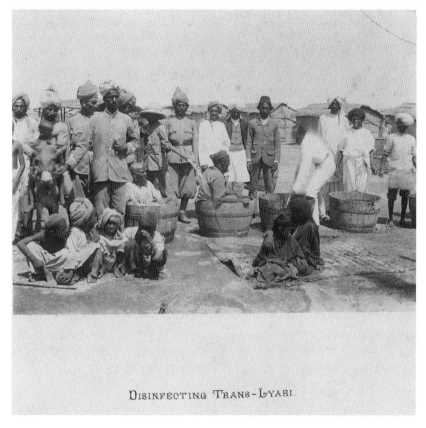

DISINFECTING TRANS-LYARI.

Figure 3.8
"Disinfecting Trans-Lyari," photograph from a Karachi plague camp. Courtesy of
Wellcome Collection.

of conflict as regards evacuation and detention in the first Karachi outbreak.
In this sense, for their principal intended audience (colonial officers), these
quarantine photographs have a strong apophantic function: they assert the
correct way of controlling plague from an epistemic and a political point of
view; they set an example from the angle of a case that almost went disas-
trously wrong but was saved in the nick of time.

And yet we cannot ignore the other function that such photographs of
quarantine in plague camps acquired once they had left their immediate
context and were reprinted in the global press, such as in the case of *The
Graphic*. There, the photographs were stripped of most or all contextual
references; once they are divested of their apophantic function, they can be

invested with an imperative one. Detached from the context of the Karachi Plague Committee's album, figure 3.7 no longer aims to identify which measures were successful in Karachi, nor does it instruct future sanitary and medical authorities on the correct way to handle quarantine and disinfection. Rather, it states what plague itself *must be* in order for it to be true "oriental" plague. Plague, the photograph declaims, must be a disease of racial Others, and it must be a disease of filth. Taken together, these two imperative statements make up a third one, where the racist determination of plague's imperative ontology becomes clear: plague must be a disease of filthy races and, at the same time, a disease of racial filth.

We have already followed this epistemic and political compound that lies at the heart of plague science and plague photography as a colonial science and a colonial photography (chapter 2). And we have seen how visualizing disinfection generated phantasmagorias that would define the meaning and the experience of the pandemic. With these analytical insights in mind, we need to return to the question of quarantine and ask how the photographs of plague camps worked in relation to colonial framings of race.

Photographs of plague camps are first and foremostly images of and for colonial control. They are images depicting the control of a disease of Others by their colonial masters, and they are images fostering the reproduction of this double mastery (of one's relation to disease and to Others) as one that is irreducibly connected to scientific technology and political technique. On the one hand, the ultimate success of colonial science was portrayed as the application of quarantine and disinfection in such manner and in such combination so that, first, there were as few new cases of plague inside the camps as possible and, second, the epidemic in the affected area quickly subsided, if possible for good. On the other hand, the ultimate success of the plague camp policy, the Karachi records tell us, came when colonial subjects took it upon themselves to leave their homes and self-quarantine in camps of their own making. The "voluntary camps" were, of course, voluntary only to the extent that the people in them self-organized according to colonial rules, and they ceased to be voluntary once those rules were neglected, challenged, or broken.

In the Karachi album, the plague camp thus emerges not only or primarily as a space of displacement, danger, loss, or suffering but also as a veritable colonial medical heterotopia. In other words, it is a place where, from the point of view of colonial officials, the impossible happens, if only for a little

while: racial Others are kept clean and healthy, and they are also politically transformed through voluntarism (always under colonial supervision) into something akin to modern citizens.[125] In embodying and relaying this colonial heterotopic vision, plague photography must thus be seen as a mirror of a biopolitical process that goes much deeper than simply othering plague or pathologizing the native body. From the colonial point of view, this is the image of a future in the waiting: a hygienic modern utopia that (hardly surprising, given the colonial mindset) assumes the shape of a detention camp.

GLOBAL QUARANTINES

In the photographic records I have examined in this chapter, quarantine is shown to be less an infrastructure or node in the "geo-body" of nations than a technology constituting complex social, political, and epistemic spaces. These records comprise an apparatus that, in the context of the third plague pandemic, fostered visions of sanitary protection while being always already entangled in questions and debates about freedom, self-discipline, imperial antagonism, and colonial governmentality.[126] If different photographic corpuses of quarantine and isolation in the course of the third pandemic bore and advanced particular, situated agendas and debates, the international circulation of images of quarantine contributed to the experience of the pandemic as a global emergency. If we are then to take quarantine stations such as the Tabuk, Beirut, or Frioul lazarettos seriously as "portals of globalisation," we also need to consider how the globalized lazaretto was instituted as part of a pandemic imaginary fostered through epidemic photography.[127]

In his examination of colonial Colombo and "the visual politics of new imperialism," Sujit Sivasundaram warned that "while photographs . . . bear the marks of colonial ideology, they cannot be taken simply as indicators of governmentality, or as an effect or a cause of colonial politics."[128] Colonial photographs need to be also seen, analyzed, and critiqued for their role in "envisioning the globe."[129] The globalization of lazarettos in the Old World had already been instituted through the narrative and visual apparatus of John Howard's *Account of the Principle Lazarettos in Europe* (1798).[130] Yet the third plague pandemic fostered a much more complex and dynamic image of quarantine than that entailed by the brick and mortar tradition of the practice.

As we have seen in this chapter, on the one hand, lazarettos functioned as stages for imperial antagonism and sanitary reform as well as for articulations of individual freedom and class superiority. On the other hand, plague camps became a key technology of quarantine and isolation in the colonial world. Through its circulation in the daily and illustrated press, photography connected the old and new forms and practices of quarantine across the globe in an image that was not necessarily integrated and yet it conferred a sense of a shared emergency and shared methods and technologies for its mitigation.

THE GLOBAL WAR AGAINST THE RAT

It is almost impossible to find a plague-related news item today that is not accompanied by an image of a rat. The best-known carriers of zoonotic diseases, rats are so closely identified with plague that research articles about the role of other mammals in the spread or maintenance of the disease are met with enthusiasm in the media—and in some cases mistakenly hailed as exonerating rats from the spread of plague.[1] This tautology between rat and plague is articulated in a context of framing an expanding range of nonhuman animals as hosts or vectors of infectious diseases such as influenza, Ebola, severe acute respiratory syndrome (SARS), and COVID-19.[2]

Identified for the first time in the 1870s and known as zoonoses (from the Greek *zoon*, for animal, and *nosos*, for disease), diseases that spread from animals to humans have formed a particular source of human anxiety since the rise of the emerging infectious diseases framework in the early 1990s.[3] This has come to understand viral spillovers (i.e., interspecies jumps between nonhuman animals to humans) as potential sources of a future global catastrophic pandemic among what would presumably be a "virgin," nonimmune human population. Historians and anthropologists have dedicated much effort to elucidate and deconstruct the philosophical, epistemological, and biopolitical premises behind this pandemic imaginary, which has transformed animal-human contact into a perilous zone of interaction that could even lead to human extinction.[4] In this imaginary, the rat plays a backstage role as an ancient foe that, while posing no direct existential risk to humanity, reminds us of the devastation brought about when zoonotic hosts are not scientifically understood and controlled.

The current status of rats should not, however, obscure their historical importance in the emergence of the image of nonhuman animals as epidemic villains and in the rise and dissemination of the notion of the pandemic. Contrary to popular perceptions, before the end of the nineteenth century rats were not believed to be carriers or spreaders of plague or any

other infectious disease.[5] If rats had long been considered to be "vermin" damaging to property and consuming or spoiling food resources, their only redeeming characteristic was widely believed to be their supposed disease-free nature.[6] Hence while mid-seventeenth-century plague treatises noted the rat's destructive impact on clothing and food, no mention of its connection with the disease was made.[7]

Two hundred years later, when in the 1840s British colonial officers in India observed that at the first sight of rat epizootics Garhwali villagers fled to the Himalayan foothills in fear of the "Mahamari" disease, they first dismissed this behavior as superstitious and then deduced that rats, like humans in the region, succumbed to excessively "vitiated" air.[8] Indeed, the rat was considered to be uniquely able "to 'clean' and preserve itself from contamination by the filth and miasma of the sewer."[9] Neil Pemberton notes that, "rather than being correlated with plague, the sewer rat's appetite for putrefying matter saved human inhabitants from 'periodical plagues,' which [James] Rodwell insisted were the 'result of deadly gases arising out of the putrefaction of animal and vegetable matter.'"[10] Until the final decade of the nineteenth century, in Euro-American and colonial contexts the rat problem was seen not as a source of infection but as an issue of food destruction and of boundaries and their transgression, including the unwarranted nocturnal wonderings of the rat into private and familial spaces and its "invasive," transnational character.

Scientists only began to study the rat's ability to carry and spread diseases after the inaugural outbreak of the third plague pandemic in Hong Kong (1894).[11] Tacitly mentioned by the discoverer of the plague bacillus, Alexandre Yersin, the potential role of the rat first acquired a central place in epidemiological frameworks of plague in British India.[12] This marked the start of a biopolitical and epistemological transformation of the rat from "vermin" to "host/vector" and, at the same time, from a nuisance to modern history's paradigmatic epidemic villain. Rather than being a sudden revelation, the transformation of the rat into Public Enemy No. 1 was mediated by intense scientific debate and was facilitated by the rat presenting itself as a quantifiable and universally recognizable object of hygienic intervention.[13]

Over the first half of the twentieth century, an extraordinary effort to study and control rats and their contact with humans was undertaken on a global scale—what the English rat-expert Boetler called "a world's war

against the rat."[14] This was a goal that was conceivable only within a pandemic framework and in turn further fostered the idea of the pandemic as a scientifically knowable and actionable threat to humanity. Combining techniques and technologies of epidemic control derived from a number of medical and sanitary traditions and backed by relevant laws and decrees, the global war against the rat focused on its eradication and isolation from humans.[15]

This was an effort not confined to cities or ports but also employed in the trenches of World War I and in rural areas where rats spread disease not only to humans but, as epidemiologists were terrified to discover, also to wild rodents, which were in turn transformed into long-term endemic disease reservoirs.[16] Responding to this public-health menace and to the economic losses caused by rats as a result of food destruction (marking a damage of $200 million in 1917 for the United States alone) as well as by halting trade as a result of quarantines, anti-rat operations rapidly spread across the globe.[17]

Often assuming the form of public health "campaigns," the global war against the rat involved rat-proofing buildings and infrastructures, rat destruction by means of predators, poisons, viruses, and chemical gases, and the deployment of professional and civic bodies of rat-catchers.[18] These operations assumed different guises in different colonial and metropolitan contexts, becoming entangled with class and racial narratives as well as with imperial, national, and local political and economic agendas.[19]

Central to scientific studies of rats and public health measures against them were questions regarding the way in which rats harbor and transmit diseases. Most important were questions about the link between disease epidemics among rats (epizootics) and human illness, including the extent to which rats functioned as disease reservoirs and how the migratory or "invasive" behavior of different rat species (especially *Rattus rattus* and *Rattus norvegicus*) impacted the spread of diseases. These questions were developed and debated in hundreds of scientific publications and numerous conferences, including the International Sanitary Conventions between 1903 and 1938, two international conferences on the rat (1928 and 1931), and through on-the-ground experience in the course of practical processes of rat control.[20] Investing on long-standing understandings of the interaction between rats and humans but also unsettling these through new medical and epidemiological frameworks of infection, these questions fostered extensive international exchange on the scientific and public health aspects of what the leading Pasteurian Albert Calmette called the "global scourge" of the rat.[21]

Collaboration and antagonism on the subject were developed within and across nations, empires, and scientific schools.[22]

The photographic lens was extensively employed in capturing the scientific study of the rat as a zoonotic host and its control as part of the global struggle against the third plague pandemic. These photographs had various purposes: to document the study of the animal, to demonstrate plague-related rat pathology, to identify and record the habitus and nesting environment of different rat species, including structures that allowed and encouraged rat harborage or functioned as entry points for rats into human space, and to record, glorify, encourage, and instruct rat-catching, rat-proofing, and other rat-control practices.

In this chapter I argue that rather than simply *recording* the rat as a disease vector, photography helped institute the particular animal as a global pandemic infrastructure: a species that, spanning the entire globe and connecting remote points on it via maritime travel and trade, both spread and maintained plague not just as an infectious disease but also *as a pandemic*.[23] Rendering the rat not simply into a host or vector of plague but into the culprit of plague pandemics—past, present, and future—gave the particular animal a unique world-historical agency, unprecedented by any other nonhuman animal. While photography did not of course do all this single-handedly, the way in which it visualized rats and the global war against them created a visual field that was indispensable for transforming the rat into a pandemic villain and an epistemic thing that continued to unsettle understandings of how plague was spread and maintained throughout the course of the third pandemic.

The photography of rats during the third plague pandemic revolved around two main subjects: the scientific study of the rat and the control of the animal. Underlying these was a new sanitary hope and confidence that, following scientific principles and methods, diseases transmissible from animals to humans (zoonoses) could be halted by separating one from the other and by mediating the contact between them.[24] This hygienic-utopian vision saw the liberation of humanity from zoonotic diseases as based on a universal breaking of the so-called chains of infection; a separation and at the same time unshackling of humans from animals through the application of the

fumigation gases, dichlorodiphenyltrichloroethane (DDT), rat-proofing, and other technologies or techniques. These were methods that were believed to be able to isolate pathogens in their natural reservoirs, which were collectively defined as the animal realm: "As an epidemic disease in man plague is almost a direct expression of man's inability to dissociate himself from his lowly neighbors."[25]

THE RAT IN THE LAB

The identification by Paul-Louis Simond of the rat and its flea as the source of human plague in 1898 is today hailed as an important breakthrough in the epidemiology of infectious diseases.[26] And yet the acceptance of the importance of this discovery was much slower and more reluctant than the usual story of the "bacteriological revolution" may suggest.[27] The first images relating rats to plague come from late-nineteenth-century British India, but rather than being laboratory photographs these are images of rat-catchers employed by various plague committees.[28] In turn, by 1905 images of rat examination in laboratories had become a recurrent motif of plague photography across the globe. Photographs of the scientific study of rats as plague hosts visually integrated the rat with symptoms of the disease among humans or with images of the bacterium and of the flea, creating composite panoramas of plague for lectures, publications, and education purposes.[29]

Part of this medical presentation of plague was the visual image of the dissected rat, a common theme across scientific literature in the context of the third plague pandemic.[30] In some cases, rat-dissection photographs served as a method for visual comparison between plague-infected and non-plague-infected rats. Two photographs would be printed next to each other in a trope common to pathological visualization.[31] The goal of this visual comparison was to demonstrate plague pathology in the animal and help laboratory researchers in identifying plague-infected rats. Figure 4.1 is an example of this, a colorized photograph published by the Indian Plague Research Commission in 1907 that shows a dissected healthy rat next to a dissected plague-infected rat with a caption noting the differences resulting from plague pathology.[32]

Other photographs also focused more directly on the plague pathology of rat organs.[33] In some cases, the portrayal of externally visible buboes, the iconic plague symptom, on captured or killed rats (in fact a rarely visually

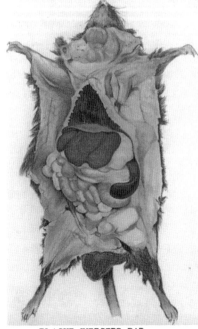

HEALTHY RAT. PLAGUE INFECTED RAT.

Figure 4.1
Healthy Rat—Plague Infected Rat, illustration by Edwin Wilson. Courtesy of Cambridge University Press.

perceptible symptom on the animal) was also used to underline the continuity with the human disease.[34]

Rat dissections took mass proportions in British India, necessitating intensive and "tedious" labor in and outside laboratories—something recorded in detail not only in India but in other locations affected by the disease including the United States.[35] In this strictly scientific context, rat photography worked as a visual technology in combination with other visual means of determining the relation between plague in rats and plague in humans. These included two principal means of visualization: diagrams and maps.

Diagrams were used, first, to visualize the rat-to-human chain of infection and, second, to show that human epidemics followed rat epizootics. In the first case, diagrams involved the depiction of the spread of the bacillus from rats to humans via fleas, initially in a linear and progressively in more complex ways that also involved other species as hosts and vectors

of the disease. The simpler, earlier diagrams positioned drawings or photographs of the three protagonists (rat, flea, human), sometimes also including microphotographic images of the bacillus, in left-to-right or bottom-to-top sequence, which aimed to show the progression of the bacillus along the transmission pathway.[36] As more elaborate models of disease ecology developed, by the 1940s these diagrams were gradually replaced by ones utilizing what I have identified elsewhere as "zoonotic cycles": diagrams showing the enzootic and epizootic phases of plague transmission and maintenance and their connecting infection "bridges" leading from wild rodents to humans via rats.[37] In linear and cyclical diagrams alike, arrows were frequently used to portray transmission and to indicate the interruptability of the latter were one to use the appropriate, scientific means of rat control.

In the second case, a diagrammatic form used widely at the time employed both linear and cyclical graphs to visualize the correlation between rat epizootics and human epidemics of plague. These showed how plague-derived mortality in humans followed, usually with a short interval, an almost identical curve of rat cases.[38] What differentiated these diagrams from the ones discussed previously was that they were supposed to constitute actual proof of rat-to-human infection and of rat epizootics as reliable predictors of human epidemics, something highly contested at the time.

In turn, maps were used as investigative and apodictic tools for epizootic-epidemic correlation. Maps charted human and rat cases on the map of a plague-stricken city like Hong Kong or Bombay, with the use of dots replicating the visual proof method that is today popularly associated with John Snow's famous cholera map of Soho, London: correlation by proximity.[39] Maps were also used to chart the movement of rats in urban space. Using techniques of catching, marking, releasing, and recapturing rats, scientists were able to demonstrate the animal's living range—a much-contested scientific datum of great importance as it also indicated the range of infectivity by a single plague-carrying rat in a given urban structure.[40]

Like photographs, such maps were not simply statements of "what has been" but part of complex experimental systems regarding the interrelation between plague and the urban environment based on the configuration of the rat as an epistemic thing. They depicted a zone of what, following Hans-Jörg Rheinberger, we may call "unspecified ignorance" where *not precisely knowing what one does not know* about the particular animal and its relation to plague formed the bases of its "operational potential."[41] Rather than necessarily

(re)producing some sort of epistemic or operational stability, rat cartographies were dynamic systems that challenged, destabilized, and provoked new conceptualizations of the relation between rats, plague, and the city.[42]

Yet not all visual representations of the scientific study of the rat were meant to carry an epistemic value or to demonstrate the zoonotic mode of transmission of plague. A large number of laboratory rat photographs from Argentina to New Orleans and from Kumasi to Honolulu were instead aimed at depicting scientific labor and scientific modernity, thus instituting the promise of a disease-free future. Take for example the photograph in Figure 4.2, included in the San Francisco Citizens' Health Committee publication already examined in chapter 2, which depicts research on rats in the laboratory of Rupert Blue, the Passed Assistant Surgeon responsible for stamping out plague from the Californian city in 1907.[43]

Captioned "The Only Good Rat Is a Dead Rat," the photograph shows six men working on rat examination around a laboratory bench. The rats have been tacked on a wooden plank known as a shingle, a technique adopted across the globe, with a label explaining when and where they were captured so that any infected rats could be mapped accordingly. The photograph's caption maintained that over 150,000 rats had been examined in the particular laboratory and that the laboratory workers had become so skilled that they processed up to 500 rats per day per person. The image was part of a large set of photographs included in the publication, which portrayed integrated efforts to rid San Francisco of plague: rat-catching, rat-poisoning, rat-proofing but also disinfection, demolition, and limewashing (see chapter 2).

The opening photograph of this publication is a long landscape bird's-eye view of the city that highlighted its postearthquake skyscrapers and bore the following long caption: "The new San Francisco. One of the healthiest cities of the world. The mortality from contagious diseases for the year 1908 was less than two per thousand of population."[44] Seen as a prelude to and condition for this sanitary utopia, the photograph of the laboratory where rats were examined by Blue's team partakes in a narrative about a historical rupture that supposedly transformed San Francisco from a city riddled by infectious diseases and, at the same time, from a city suspicious of and hostile to bacteriology into a model of epidemic control and hygiene.[45]

Long gone, the photographs seem to declaim, were the days when San Francisco was the entry point of diseases from the East into the American

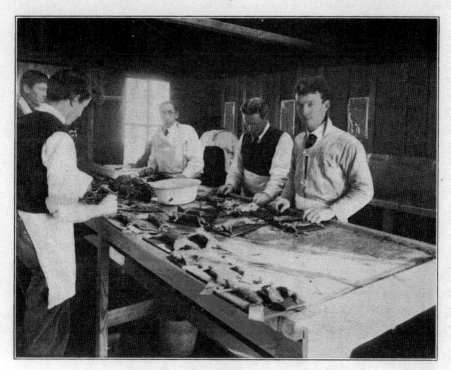

THE ONLY GOOD RAT IS A DEAD RAT

Interior Ratatorium. Passed Assistant Surgeon Rupert Blue's headquarters. Here the captured rodents were tacked to shingles, the label showing when, where and by whom caught recorded, the shingle given a number, and then dipped in the antiseptic solution in the white pan. The rats were then opened and prepared for examination by the bacteriologist and pathologist. On the plain, lead-topped tables shown over 150,000 rats have been examined. The men employed in this work reached such a state of skill that it was no uncommon thing for them to prepare for examination 500 rats a day each. Note the sticky fly paper on the wall to capture flies which might be the means of transferring the infection.

Figure 4.2
"The Only Good Rat Is a Dead Rat." Courtesy of San Francisco History Center, San Francisco Public Library.

Pacific states. Also gone, it declared, were the days of scientific ignorance, when prominent sectors of the city had united to ridicule, scapegoat, and expel the harbinger of a bacteriological explanation and solution to its plague problem, Dr. J. J. Kinyoun.[46] In this context, the photograph of Blue's rat-examination laboratory signaled an epistemological as well as political triumph over the city's insalubrious status and its inhabitants' alleged antiscience bias.

At the same time, because the third plague pandemic was a theater not only for scientific discovery and reform but also of colonial, national, and imperial competition for an image of scientific competence, rat-examination photographs could be put to use in more agonistic ways. Photographs could be deployed so as to criticize the scientific status of rival players or to self-criticize the anti-plague operations of one's own country and demand reform. In such cases, photographs of the laboratory examination of rats could be extracted from their original context and be recombined in such a way so as to provide a narrative of scientific modernization or the need for it.

In October 1908, the *Illustrated London News* published a short article accompanied by two pages of photographs praising the "Arrest of Plague in Japan."[47] Japan had been visited by plague since 1899 when Kobe was struck by the disease which then spread to Osaka and other cities. Several outbreaks followed in 1902, 1903, and 1905–1906, among other places in Tokyo and Yokohama. Japan enjoyed a unique advantage as regards the fight against the disease because it was the home of Dr. Kitasato Shibasaburō, who in 1894 had been the first to identify the plague bacillus in Hong Kong. Whereas this identification was subsequently challenged by Yersin, Kitasato continued to be recognized by many as the true discoverer of the bacillus; in Japan itself, he held a position of unsurpassed authority regarding plague-related matters.[48] In spite of having faced intense antagonism from Yersin in Hong Kong, Kitasato was an avid supporter of the rat-flea model, which by 1908 had been dissociated from the strict confines of Pasteurianism through the work of British doctors in India, Australia, and Hong Kong.[49]

The *Illustrated London News* article presented plague-control in Kobe as a paragon of efficiency led by scientific principles and liberal economic incentives. Not only did people delivering the carcass of a rat receive 5 sen per dead animal, but they also entered a lottery with a prize of 600 yen.[50] The article underlined the need to combine anti-rat methods (poisoning, catching, and proofing) with the claim that between 1900 and 1906 4,820,000 rats had been killed in Tokyo alone. The key message of the text and the photographs accompanying it was the industry and professionalism of the Japanese plague-control force: "the thoroughness and care with which the inspection is carried on is evinced by the fact that over a hundred thousand rats may be dissected without finding a trace of infection, yet vigilance is never relaxed.

Never for one instant do the surgeons forget that the very next one may contain microbes enough to depopulate the largest city."[51]

With a heading aimed at castigating the lack of similarly scientifically led procedures in British India, the article showcased the "remarkable precautions taken against the plague in Japan": "An Example to India: Exterminating the Microbe-Carrying Rat."[52] The page carried five photographs (figure 4.3) positioned so that a large photograph in the middle was placed between four smaller ones (two at the top and two at the bottom of the page), with the composition being surrounded by what was probably aimed to be an oriental-looking strip. The main photograph bore the caption "the tables on which the dead bodies of the rats are dissected" and showed in high resolution nine laboratory workers at the Bacteriological Laboratory of the Tokyo Metropolitan Police Board. All of them, with the exception of one, wore personal protection uniforms and headgear that could fold back to cover their mouths and noses while engaged in rat dissection, thus providing a compelling spectacle of medical modernity.

The men were positioned around a large table where we can see, row after row, a large number of dissected rats. They are pictured in the process of dissection, while one is seen working on a microscope. The two images above the central photograph are also of the laboratory, with the right image depicting the "sorting and labelling of rats brought in from different districts in Tokio [sic]," and the left image depicting the examination of the rats under the microscope. Two laboratory workers, one in white personal protective equipment and the other wearing a white uniform and jockey hat, are captured looking into microscopes, while a third man is seen preparing petri dishes. The two photographs on the lower end of the page are, by contrast, images of rat-proofing, placing emphasis on the use of zinc fences for surrounding houses undergoing deratization, a term used for rat extermination at the time.

By combining the image of the laboratory and the street, the composition achieved something unintended in the original photographs, which had been taken by Gertrude M. Williams and published in the *Philippine Journal of Science* as illustrations of Kitasato's paper "Combating Plague in Japan" two years earlier.[53] There, the laboratory and the rat-proofing photographs formed part of a larger plates sequence (in total nineteen photographs) that aimed to capture the full visual field of the outbreak: house and warehouse

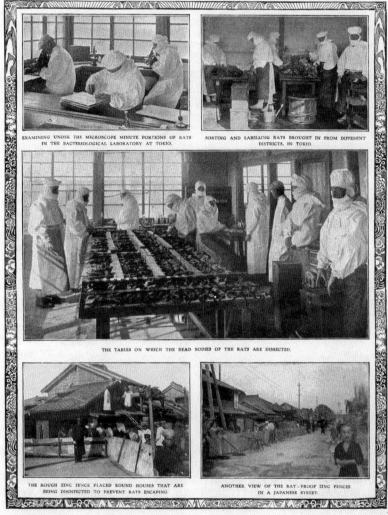

THE ILLUSTRATED LONDON NEWS, OCT. 3, 1908.—478

AN EXAMPLE TO INDIA : EXTERMINATING THE MICROBE - CARRYING RAT.

REMARKABLE PRECAUTIONS TAKEN AGAINST THE PLAGUE IN JAPAN.

Figure 4.3
"An Example to India: Exterminating the Microbe-Carrying Rat." © Illustrated
London News Ltd/Mary Evans.

fumigation, contact isolation, rat-proofing, laboratory examination, and four clinical photographs of buboes in victims of the disease. By selecting and recomposing the five previously discussed photographs on a single page, the *Illustrated London News* article accentuated the affinities between the laboratory and the street as a continuity of scientifically led anti-plague work focused on the rat as the true host and spreader of the disease.[54]

Rhyming with later photographs of laboratory research with rats that we are all so familiar with, these rat-research photographs created a narrative about scientific superiority. In this case, the supposed superiority was that of Japan, which since its victorious war against Russia in Manchuria (1905) had been portrayed in the British press as an exception in the accepted world order: an Asian country able to compete with and surpass European ones and thus accepted as an "honorary civilized nation."[55] In the *Illustrated London News* article, Japan, unlike British India, was shown as capable and eager to incorporate scientific principles and methods in plague control, setting it as an international example.

Achieved by way of praising what in colonial terms "should have been" a scientifically inferior country, the visual shaming of Britain's scientific standards in anti-plague work in India in the nation's most popular illustrated weekly is indicative of the polemic potential of epidemic photography. It shows us how photography was used to establish comparisons in public health efficiency, to illustrate best practice, and to declaim the need for science-led approaches to epidemic control. At the same time, this example shows how photography was used to foster the idea of the pandemic not simply as an event of global infection but also as a field of international competition, where the combination of scientific plague research on rats and scientifically led rat control were raised to a global golden standard that imperatively connected all countries and empires.

RAT-CATCHING

Outside the laboratory, in the first two decades of the twentieth century rat-catching became a prolific field of epidemic photography. Rat-catching was not a phenomenon initially connected with epidemic control. In fact, it was a practice with deep historical roots which in the course of the nineteenth century had come to involve ferrets, dogs, and cats as well as skilled rat-catchers in what Neil Pemberton has called a "multi-species labour of

rat-catching."[56] In England, which forms the focus of most histories of this practice, rat-catching involved public spectacles of "ratting": a blood sport involving specially constructed "rat-pits" that "dramatized the hunting zone at the moment of flushing, but also adapted the spectacle to the temporal order and rhythms of industrial time and production: bets were placed on the ability of different dogs to kill the largest numbers of rats in the quickest time."[57] At the same time, rat-catching involved the development of ideas about rat intelligence and intentionality as is famously evident in Henry Mayhew's 1850s account of the practice.[58] As Pemberton has noted, "these cultural practices invested rats with a menacing and formidable persona: a species co-existing and co-emerging with civilization, devouring it from within."[59]

The visual culture fomented through and at the same time fostering these practices and ideas mostly consisted of images of ratting in rat pits (as, for example, illustrated in Mayhew's account).[60] These differed significantly from the earlier sixteenth-to-seventeenth-century theme of the rat-catcher, visible, for example, in Christian Wilhelm Ernst Dietrich's etching *The Mountebank* (1740), Jan Joris van der Vliet's etching *The Rat-Catcher* (circa 1610), or most famously Rembrandt's 1632 *The Rat Catcher* (also known as *The Rat Killer or The Rat-Poison Peddler*).[61] For whereas early modern artworks focused on the person or "character" of the rat-catcher, by the midnineteenth century etchings had shifted their attention to the *practice* of rat-catching. Already in 1814 we see, for example, in Abraham Cooper's etching *The Rat Trap* a boy kneeling in front of a rat trap and holding open its door as two dogs await to snatch the rat trapped in it.[62] This novel emphasis on action is perhaps best exemplified in Ernest Henry Griset's 1871 engraving *The Terrier and the Rat* (figure 4.4).[63] This work by the quintessential animal artist of Victorian England was used to illustrate an article debating the necessity or cruelty of ratting. It shows a close-up of a terrier attacking a rat, presumably in a rat pit. The tension in the image is palpable, as the rat twists around to face the dog who, hackles raised, is about to bite.

If generally less dramatic than Griset's engraving, the vast majority of photographs of rat-catching related to plague control in the course of the third plague pandemic replicated the action-focused emphasis established in Victorian etchings of ratting. These photographs focused on depicting the work of rat-catchers in diverse contexts across the globe. In Victorian times and earlier on, at least in Europe and the Americas, rat-catching was

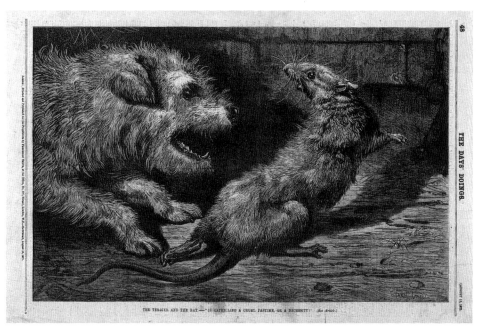

Figure 4.4
Ernest Henry Griset's 1871 engraving *The Terrier and the Rat*. Courtesy of Wellcome
Collection.

mainly a solitary vocation. By contrast, the urgency of the third pandemic
necessitated completely new forms of labor. Schematically we may say that
rat-catching took three principal forms.

First, rat-catching was achieved through mass mobilization, as exempli-
fied in the war declared against rats by the Danish king in March 1907. After
an aggressive campaign by the president of the Society for the Destruction
of Rats, Emil Zuschlag, this involved the participation of all Danish sub-
jects in a massive effort of eradication, resulting between July 1907 and
January 1909 in 1,557,656 dead rats, not including those destroyed directly
by the government.[64] Less totalizing but also on a mass scale, in the British
and French colonies rat bounties led to the mobilization of colonial sub-
jects in rat-catching.[65] Second, rat-catching was undertaken by voluntary
organizations, such as the Women's Municipal League of Boston, which
organized Rat Days and Rat Weeks aimed at eliminating the animal.[66]
Third, rat-catching was led by professional groups of salaried laborers
whose job was rat eradication or the procurement of rats for laboratory

tests and examination (figure 4.5). Most forms of rat-catching, including those employing traps, cats, ferrets, or dogs, required the development of a practical knowledge of rats, their habitats, and their sentient behavior but also the exchange and adoption of anti-rat methods circulating internationally across different fields of application (such as shipping or farming).[67]

With the exception of British India, where photographs of the scientific study of rats included some of rat-catching by so-called Indian "coolies" for laboratory use, the vast majority of rat-catching photographs during the pandemic focused on all-male, all-White groups engaged in the practice.[68] This is in spite of the fact that across the globe colonial subalterns were mobilized in rat-catching, often with disastrous results.[69] By contrast to these campaigns, which remained mainly outside the photographic gaze, the coverage of White, settler-colonial, male rat-catching stretched from Australia to California and from New Orleans to Argentina and focused on the employment of ratter dogs in the war against rats.

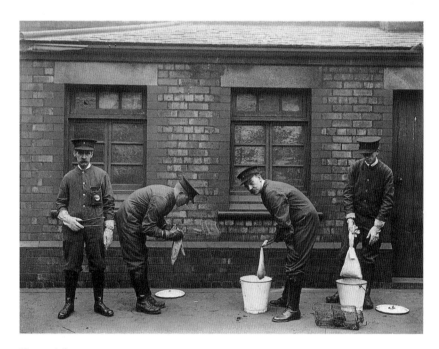

Figure 4.5
Liverpool Port Sanitary Authority rat-catchers dipping rats in buckets of petrol to kill fleas for plague control. Courtesy of Wellcome Collection.

Argentina witnessed the introduction of plague in 1899–1900 with the disease developing into both an urban and rural problem over the following decades.[70] This led to extensive scientific research on plague and its animal hosts and vectors in the country, which lasted for over three decades. At the same time, by 1906 anti-rat campaigns were in full swing across Argentina and in particular in Buenos Aires where they became entangled with broader sanitary visions of transforming the Argentine capital into "a model hygienic city."[71] As demonstrated by Lukas Engelmann, this involved a shift of "the government's epidemiological focus from the entry of plague from foreign countries, to the conditions under which this and other diseases might nest within the fabrics of the urban infrastructure."[72] Under the auspices of José Penna, a "vision of the total 'deratisation' of Buenos Aires" was mainly driven by novel technological application of fumigation through the Marot apparatus (see chapter 2).[73] At the same time less technologically driven solutions to the rat problem persisted, with rat-catching being particularly well represented and endorsed in the popular press.

Over the first two decades of the twentieth century, the popular Argentinean illustrated periodical *Caras y Caretas* hosted numerous articles about plague and its control. In the issue of September 9, 1912, the article "La Bubónica y las Ratas" featured a well-designed header with the caption reading "killing rats in the port of Buenos Aires."[74] The header consisted of a photograph cropped into a circle showing four rat-catchers and their dogs in the process of rat eradication (figure 4.6). Surrounding the photograph, on a grey background, four rats were drawn so as to give the impression that they were running to hide behind the photograph or to escape from the operations depicted in it. One of the three rats bore a decisively dead aspect, completing the image of extermination while the "R" in the article's title "Ratas," which was written across the photograph, was connected with the final "s" of the word, creating a playful semblance of a rat's tail that visually rhymed with the tail of a rat scurrying to hide behind the image and its shadow.

The war on rats by means of rat-catching dogs was depicted more extensively in the April 21, 1923 issue of the same illustrated magazine, which hosted a total of fifteen photographs over two pages in its article "Man's Friend: The Dog. The Struggle against Rats in the Port" (figure 4.7), signed by its author with the pseudonym Argus, referring to Ulysses's faithful dog in the *Odyssey*.[75] The illustration consisted of eleven images of digging out and catching rats, with additional large photographs of three rats and a dog

Matando ratas en el puerto de Buenos Aires.

Figure 4.6
"Killing rats in the port of Buenos Aires." Courtesy of Biblioteca Nacional de España.

cropped and pasted on the page in such a way so as to appear as if the ani-
mals are walking on the sheet. This visual effect, which formed a popular
trope in the periodical, created a pop-out effect that brought the rival ani-
mals to life.

Such images of rat-catching in the course of the third plague pandemic
played the role of a visual switch between the past of ratting as a blood
sport and the present of rat-catching as a method of epidemic control. They
depicted rat-catching in a manner that established civic participation in epi-
demic control as a modern, science-led, civic duty and glorified White male
fraternities as the spearhead of these efforts. Drawing on values and prac-
tices of settler societies and giving them scientific legitimacy, the particular
framing of rat-catching allowed the practice to acquire the status of a task
aimed at protecting one's city or nation against infection while dissociating

it from similar, supposedly degrading, native-led activities in the colonies such as bounty rat-catching.[76]

RAT-PROOFING

As the pandemic progressed, what became more and more obvious was that the actual eradication of rats was an unreachable dream. Developing in parallel on land and in the field of maritime sanitation, where fumigation had been the preferred vector-control method since the 1890s (see chapter 2), by the 1910s a new method started emerging as the golden standard: rat-proofing. This was a term adopted across the globe to refer to the architectural and engineering methods aimed at the exclusion of the rat from human settlements.[77] The implementation of rat-proofing took different forms in different parts of the world, carrying with it "infrastructural promise" for an infection-free future.[78]

Increasingly coming to replace rat-catching and other methods of extermination, rat-proofing reached its global apex in the decades after World War I. It involved an array of interventions that combined the destruction or retrofitting of old "faulty" structures and the construction of entirely new rat-proof buildings. While borrowing elements from anti-mosquito campaigns (which were being developed in parallel), rat-proofing quickly developed into an autonomous field of engineering and architectural practice that went beyond the simple application of barriers.[79] The practice involved a systematic diagnosis of the built environment in terms of its material and engineering properties. Materials and the modes of building came to be problematized in two principal ways. First, they were scrutinized for creating the opportunity for "rat harborage," or places where rats could nest and hide. Second, they were surveyed as rat passageways, which allowed rats to enter buildings or to pass from one building into another and thus also offered escape routes for animals under attack.

As regards rat harborage and its prevention, rat-proofing depended on an advanced knowledge of nesting and burrowing habits and capacities of different rat species. Intervention on this level involved the development of an understanding of where rats build their nests, where they seek refuge when under threat, and where they go to die when they become ill. As regards the entry points and passageways of rats, rat-proofing focused on structural thresholds but also on rats' climbing, burrowing, tightrope-walking, and

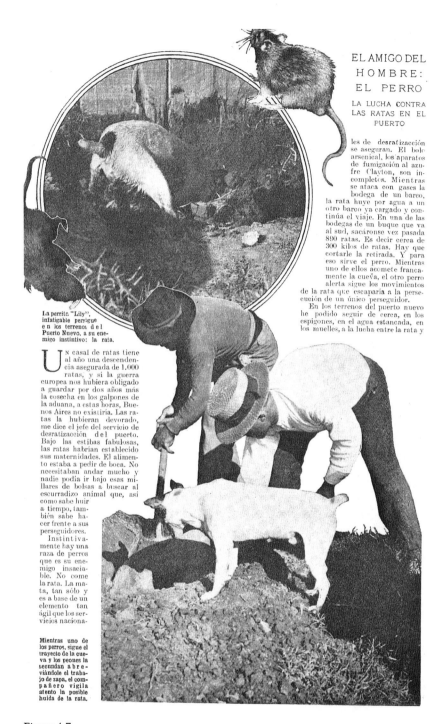

EL AMIGO DEL
HOMBRE:
EL PERRO

LA LUCHA CONTRA
LAS RATAS EN EL
PUERTO

les de desratización
se aseguran. El bolo
arsenical, los aparatos
de fumigación al azu-
fre Clayton, son in-
completos. Mientras
se ataca con gases la
bodega de un barco,
la rata huye por agua a un
otro barco ya cargado y con-
tinúa el viaje. En una de las
bodegas de un buque que va
al sud, sacáronse vez pasada
890 ratas. Es decir cerca de
300 kilos de ratas. Hay que
cortarle la retirada. Y para
eso sirve el perro. Mientras
uno de ellos acomete franca-
mente la cueva, el otro perro
alerta sigue los movimientos
de la rata que escaparía a la perse-
cución de un único perseguidor.

En los terrenos del puerto nuevo
he podido seguir de cerca, en los
espigones, en el agua estancada, en
los muelles, a la lucha entre la rata y

La perrita "Lily",
infatigable persigue
en los terrenos del
Puerto Nuevo, a su ene-
migo instintivo: la rata.

Un casal de ratas tiene
al año una descenden-
cia asegurada de 1.000
ratas, y si la guerra
europea nos hubiera obligado
a guardar por dos años más
la cosecha en los galpones de
la aduana, a estas horas, Bue-
nos Aires no existiría. Las ra-
tas la hubieran devorado,
me dice el jefe del servicio de
desratización del puerto.
Bajo las estibas fabulosas,
las ratas habrían establecido
sus maternidades. El alimen-
to estaba a pedir de boca. No
necesitaban andar mucho y
nadie podía ir bajo esas mi-
llares de bolsas a buscar al
escurridizo animal que, así
como sabe huir
a tiempo, tam-
bién sabe ha-
cer frente a sus
perseguidores.

Instintiva-
mente hay una
raza de perros
que es su ene-
migo insacia-
ble. No come
la rata. La ma-
ta, tan sólo y
es a base de un
elemento tan
ágil que los ser-
vicios naciona-

Mientras uno de
los perros, sigue el
trayecto de la cue-
va y los peones la
secundan abre-
viándole el traba-
jo de zapa, el com-
pañero vigila
atento la posible
huida de la rata.

Figure 4.7
"Man's Friend: the Dog. The Struggle against Rats in the Harbor." Courtesy of
Biblioteca Nacional de España.

El decano de los perros ratoneros, viejo e inválido.

Las piedras del espigón son las terribles mu rallas que las ratas oponen a los perros.

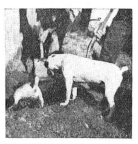

La febrilidad de los perros indica que la rata no está lejos.

el perro. Es un espectáculo de circo romano. El combate es impresionante y "el amigo del hombre" adquiere verdaderos titulos a nuestro agradecimiento.

Parecerá tal vez paradojal esta pregunta frente a esa plaga que lleva desde la India a todos los vientos la peste bubónica. ¿Conviene extirpar las ratas? En el Congreso de Higiene de París, el delegado por el Egipto aseguró que después de haber concluido con las ratas, en el Cairo una epidemia de cucarachas se extendió por los mismos lugares con caracteres fatales. La cucaracha era peor que la rata y vive de los mismos desperdicios.

Los servicios de desratizacción del puerto cuentan con ocho cuadrillas y cuarenta perros. Al fin del día — el trabajo es cruento, pues la rata tiene un campo excelente donde atrincherarse — se cazan unos doscientos ejemplares. Al mes, oscilan entre cinco y ocho mil, las que se toman, fuera de otras muchas que mueren en las cuevas por la acción del arsénico y del azufre. No hay descanso en esta persecución. La avería de la rata puede calcularse anualmente por millones de pesos, fuera de los perjuicios que causan las estibas al caerse en los galpones, minadas sus bases por las ratas. A bordo, la rata concluye, en viajes largos, con gran parte de la mercadería. ¡890 ratas en una bodega sola, royendo quince horas seguidas, lo que consiguen!

Como un comensal correcto, la rata no come todo, pero destruye lo que toca.

A R G U S

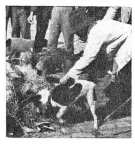

Así se enseña a los perros la pesquisa de la rata.

De vuelta a casa, después de una larga jornada bajo la tierra detrás de la presa.

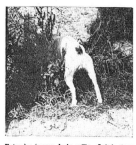

Entre los juncos de la orilla, «Lebel» sigue un rastro.

«Mustafá» vuelve con la rata que perseguía, y «Lebel» decide reservarse para otra oportunidad.

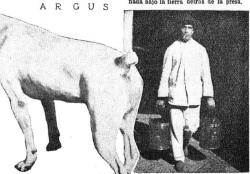

El producto de la caza, las ratas, infectadas de peste o no, son conducidas al Instituto Bacteriológico.

FOTOS DE ARROYO.

Figure 4.7
(continued)

jumping abilities. At the same time as behavioral scientists were required to "think like a rat," "building the rat out of existence" required and led to an unprecedented understanding of rat's spatial behavior while also contributing to the image of the animal, in the words of a Hawaii Chamber of Commerce anti-rat pamphlet from 1943, as a "super-saboteur" (figure 4.8).[80]

Contributing to a unified vision of pathogenic urbanity (see chapter 2), this diagnostic scrutinization of the built environment in light of the problem of the rat was a process with strong class and racial aspects. In her examination of "building out the rat" in South Africa, Branwyn Poleykett has shown how "anti-rat campaigns were powerful instruments for allying the health of the nation with whiteness and proposing white settlement as a prophylaxis against epidemic disease."[81] At the same time, rat-proofing involved governmental intervention in spaces where the state had hitherto limited access. By the 1920s, we see a global trend developing: the issuing of standardized guidelines for retrofitting private and public buildings. These practices were systematically visualized in rat-proofing pamphlets and manuals by means of comprehensive diagrams and photographs, and they formed the subject of colonial exhibitions on infectious disease control and hygiene.[82] The application of this rat-proofing imperative often led to the mass reconstruction of working class, immigrant, and indigenous living spaces or even to their wholesale destruction in the name of national defense against plague.

A most striking example of this comes from Java, where Dutch colonial doctors and public health officers targeted Javanese houses as playing a key role in the transmission of plague, which first struck the island in 1911.[83] Dutch colonial doctors and administrators saw these native structures as harbors of rats, focusing in particular on a perennial material of indigenous architecture: bamboo (figure 4.9). Maurits Meerwijk has examined the ways in which this building was medicalized as a passageway, a nesting environment, and a postmortem receptacle of rats, showing how this problematization fostered in turn what, following Graham Mooney, we can call "intrusive interventions" into Javanese social and domestic space.[84]

Terence Hull, in his study of plague in the region, has highlighted the destruction and dependence resulting from Dutch colonial rat-proofing and more broadly anti-rat policies.[85] This was, however, not simply a material but also a visual operation. Meerwijk explains that colonial officers employed photography to record these interventions (involving, according to Hull, 1.5 million houses up until the 1930s) and to provide

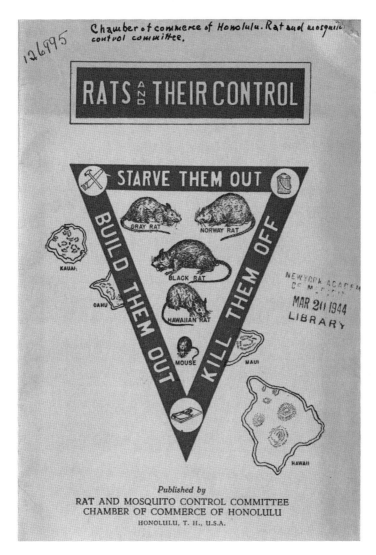

Figure 4.8
Cover page of Hawaii rat control manual. Courtesy of the New York Academy of Medicine Library.

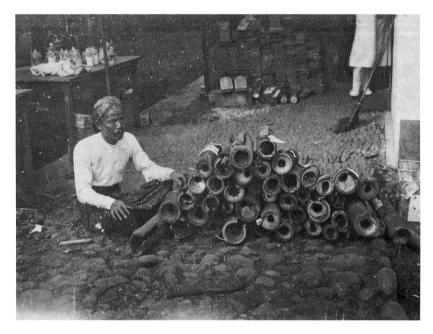

Figure 4.9
"By the plague brigade collected hollow bamboo containing rat nests, obtained from Javanese houses." Courtesy of the Stichting Nationaal Museum van Wereldculturen.

scientific evidence of the way in which bamboo—and more broadly indigenous ways of home-making and habitation—was implicated in the spread and maintenance of plague in Java. This involved what Meerwijk calls a "quasi-anatomic" or "post-mortem" gaze, which included "peeling away" and "dissecting" built structures.[86] This visual method photographically pathologized the materiality and design of bamboo house and interpellated the native population to a hygienic modernity mediated by architectural and engineering "improvement."[87]

Photographing the rat in the context of the third plague pandemic contributed to a colonial "fashion[ing of] human moral responsibility."[88] For rather than simply blaming the rat as an epidemic villain, photography also distributed this blame to human actors and in particular to groups seen as prone to allowing and fostering rat infestation and rat-human contact.[89] Combining sovereign and disciplinary technologies of power, building out the rat was an essential part of projects for hygienic modernity across the globe. In the United States, for example, the method was widely endorsed

and applied, with photography playing an important role in the process. An excellent example of this is *Rat-Borne Disease Prevention and Control*, published in February 1949 by the US Public Health Service's Communicable Disease Center, the forerunner of the US Centers for Disease Control and Prevention (CDC).[90]

Three hundred and six pages long, the manual was divided in eight parts and made extensive use of a wide range of visual media: photographs, maps, diagrams, graphs, microphotographs, and comics, numbering a total of 139 figures, not including the cartoons (an average of nearly one figure per two pages). Of these, thirty images focused on rat-proofing, and fifteen more, often composed of several photographs, showed evidence of rat burrowing and climbing, typical "rat-runs," and the damage done by rats to building materials such as the "example of rat gnawing of a service pipe."[91] From among these figures, photographs focused not so much on the methods of achieving rat-proofing (this was mainly done through architectural and engineering diagrams) as on the "breaking and entering" agency of rats. The manual stressed: "Behavior is CONSTRUCTIVE and GOAL-ORIENTED. Behavior reflects CHOICES influenced by CONSEQUENCES. Behavior shows VARIABILITY and RESOURCEFULNESS in a problem situation."[92]

As a consequence of "rat habits" not being "static," the manual warned that "any control effort which has any appreciable effect on the rat population will change the consequences of given acts and thus change the choices."[93] Of particular interest was the rat's "agility": "The physical prowess of the rat in terms of reaching and jumping is frequently underestimated. In designing ratproof structures, or in planning the rat-proofing of existing structures, it is imperative that the rat's potential attack be understood . . . and that the necessary protection against such attach be provided."[94]

To demonstrate how one should "NEVER UNDERESTIMATE THE RAT'S ABILITY!," the manual accompanied its analysis of the animal's climbing, jumping, and acrobatic abilities with two large photographic composites.[95] Captioned "series of photographs illustrating agility of roof rats in wire walking and vertical wall climbing," the manual's figure 16, included six sequential panels over one and a half page, with vertical and horizontal gutters between them, organized in two tiers.[96] Figure 19 (figure 4.10), in turn, included sixteen sequential panels over three pages, with vertical and horizontal gutters between them, organized in two tiers covering the full length of three pages. An introductory box explained that

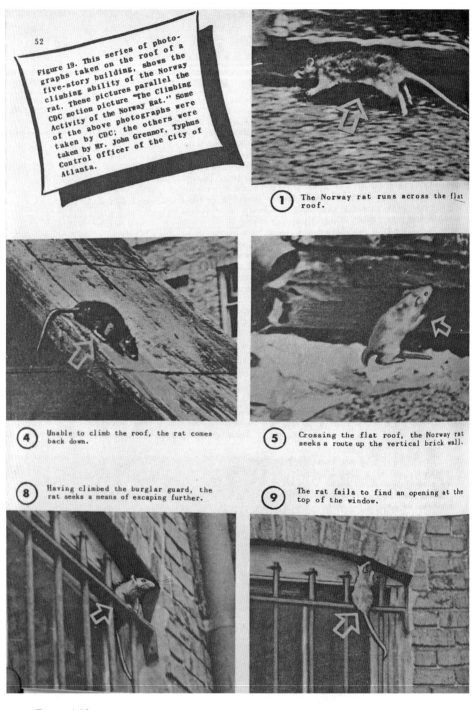

Figure 4.10
Figure 19 of the Communicable Disease Center's *Rat-Borne Disease Prevention and Control*, first of two pages. Courtesy of the New York Academy of Medicine Library.

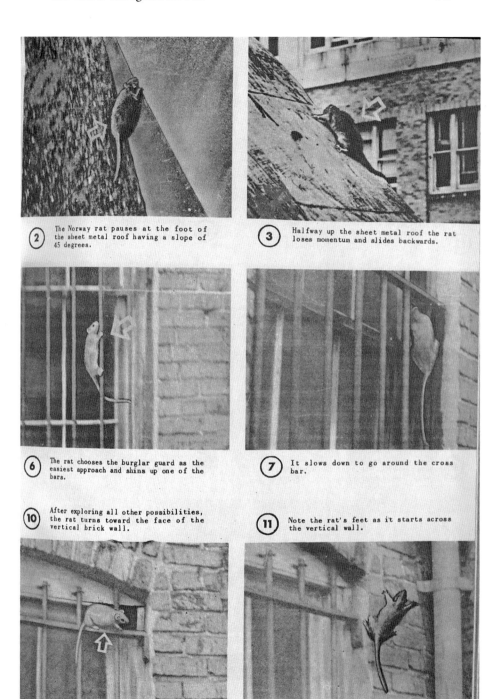

(2) The Norway rat pauses at the foot of the sheet metal roof having a slope of 45 degrees.

(3) Halfway up the sheet metal roof the rat loses momentum and slides backwards.

(6) The rat chooses the burglar guard as the easiest approach and shins up one of the bars.

(7) It slows down to go around the cross bar.

(10) After exploring all other possibilities, the rat turns toward the face of the vertical brick wall.

(11) Note the rat's feet as it starts across the vertical wall.

Figure 4.10
(continued)

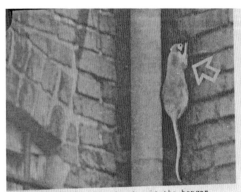

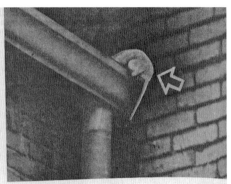

(12) Crossing the drain pipe at the hanger strap, the rat starts toward the top of the wall. Note that the rat is not bracing against the gutter drain pipe as it climbs.

(13) Observe the use of the rat's hind feet as it scrambles over the outside edge of the gutter.

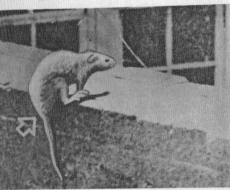

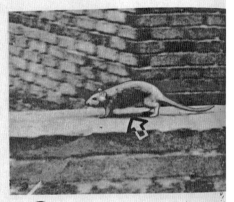

(14) The rat crosses another flat roof and jumps to the top of a parapet wall. Notice how it pulls itself over the edge.

(15) Still seeking escape, the rat runs along the parapet wall.

(16) The Norway rat gains safe harborage by going down a former chimney now used as an air shaft.

Figure 4.10
(continued)

"this series of photographs taken on the roof of a five-story building, shows the climbing ability of the Norway rat."[97] In both cases, a comic-strip-like visual structure was employed to show the way in which rats move in built space, in particular from public into private space in the city.[98]

The dramatic effect was further fostered by the numbering of the individual photographs per set and by accompanying captions. This is particularly pronounced in the work's figure 19 (figure 4.10) where suspense was created by the adoption of a sequential narrative with thick arrows used to point at the rat's position. Here, the rat was portrayed as an individual whose action one could observe on the printed page as if in a motion picture: it runs, it hesitates, it pauses, it loses momentum, and it slides back down the roof; so it seeks another way into the house, tries to cross the iron bars, fails again, and then takes to walking on a vertical wall climbing onto the roof where it finds a way in through a defunct chimney.[99] The configuration of the rat as an antagonist of sanitary reform and hygienic modernity was thus fostered through the visual dramatization of the animal's ability and prowess to overcome obstacles and rat-proofing improvements.

<center>HUMAN/NONHUMAN MASTERY</center>

In the course of the third plague pandemic, rats and their interaction with the built environment were photographed from various perspectives and angles, all aimed at generating knowledge about the animal's habitats and at controlling human-rat interaction and the space where this takes place. However, as understandings of plague came to involve more and more data about the disease's zoonotic nature, and as the sylvatic and domestic cycles of infection became less and less clearly defined, the rat became not simply the elusive carrier of an elusive disease but also a species whose ubiquity meant that the control of plague and zoonotic diseases more broadly was far from a once-and-for-all achievement of hygienic modernity.

What the examination of the rat's visualization in the course of the third plague pandemic allows us to see is that epidemic control involved a vision of modernity that, as Walter Benjamin has stressed, entailed not human mastery over the nonhuman but instead human mastery over humanity's relation with the nonhuman.[100] The distinction may sound philological but is in fact crucial: Benjamin's perspective allows us to move beyond the usual critique of mastery as domination or control and to assume a more

relational perspective without losing the crucial focus on power as so many contemporary multispecies approaches risk doing.[101]

Benjamin's critique of modern societies as fueled by a project for mastery that centrally involved their relation with the nonhuman world allows us to appreciate how this was an always already deferred process, where humanity's ability to set itself apart from nonhuman animals as sources of illness became constantly unsettled by new epistemological and biopolitical framings of infection.[102] We thus need to understand the role of epidemic photography in the formation of this pandemic imaginary, where the goal of a disease-free future, while being constantly approached by means of the technoscientific management of human/nonhuman relations, also constantly receded into the future.

The photographic framing of rats as plague hosts fostered a vision of urban multispecies existence that took disease as properly speaking belonging to the nonhuman animal realm and only occasionally or temporarily to the human realm. Partaking in a vision of a future free of zoonotic infection, epidemic photography configured this future as resulting not so much from the total eradication of rats or their diseases but from commitment to a relentless struggle against the animal and to engineering and maintaining sufficient separation between it and humans. This was then not a teleological but an agonistic process involving the regulation of human-rat interaction or the continuous pushing back of zoonotic infection.

Photography was mobilized in rendering rats into humanity's antagonists in four ways. First, it updated old tropes and affects around rats as damaging vermin with new scientific frameworks of them as a disease host. Second, it elaborated on the agency of rats and rendered them scientifically intelligible and actionable through their translation and enclosure in terms of human subjectivity and intent. Third, it visually pathologized social and cultural practices—usually those of colonial subjects, racial others, or the working classes—that supposedly fostered zoonotic infection through animal-human contact; a framing that focused particularly on the spatial aspects of that interspecies relations. And finally, it created an intense, mutual, and fluid metonymy between plague and the rat, where one reflected and amplified the supposed elusive and treacherous nature and agency of the other in a manner that dispelled any distinction between prototype and copy or signifier and signified.

In order for this agonistic relation of mastery to be possible, the rat had to remain a challenge and threat in ways that necessitated renewed effort and ingenuity on the part of its human rivals. Hence, in spite of the enclosure of the rat within an epidemiological and often anthropomorphic framework, it was important for something to always remain at the edge of science's sight and out of reach for technologically mediated mastery. Whether this involved the way the rat moved between buildings, its relation with the soil, its "migratory" patterns, or the relation between plague in rats and in sylvatic rodents, the rat persisted in its role as a pandemic infrastructure precisely because of the "unspecified ignorance" surrounding it.[103]

Genese Marie Sodikoff has identified the interaction between burial practices and rats in the context of Pasteurian epidemiologies of plague in Madagascar as a "multispecies infrastructure of zoonosis."[104] Sodikoff has argued that if "we approach 'infrastructure' through a multispecies ethnographic lens, we see how obstructions to desirable resource flows can stem from non-human bodies and energy expenditures, as much as from unequal (human) social relations of power and privilege."[105] Similarly, Maan Barua has recently suggested that animals usually considered to be "vermin" within colonial and capitalist framings of nonhuman life may be better approached as "infrastructures in a 'minor' key" that "operat[e] against and along the grain of majoritarian imperatives of the state, capital and planning."[106] Here I would like to suggest that, in the broader context of the third plague pandemic, the rat was elevated to the status of a pandemic infrastructure not simply because it became stabilized as plague's *sine qua non* but because its precise role in plague transmission and maintenance retained something irreducibly unknown and elusive.

By 1910 no plague outbreak could become scientifically intelligible and actionable other than through a focus on rodents; at the same time, the rat, as the par excellence plague rodent, eluded epistemic closure. In this way, rats deferred and propelled the project for mastery to develop ever-newer methods, technologies, and techniques in the quest of a zoonosis-free future. Photography contributed to this double configuration of the rat as pandemic infrastructure and epistemic thing: a source of public health anxiety persisting well beyond the development of efficient poisons, traps, gases, or doorstops aimed at its extermination or isolation from humans and their spaces.

Photography did this, on the one hand, by framing the rat as plague's protagonist and anti-rat measures as indispensable methods of epidemic control; and, on the other hand, by placing emphasis on the field of relations between the rat and other components of disease transmissibility and maintenance as an unknown terrain of zoonotic potential. Photogenic and yet elusive, observable but always hiding, something lurking at the edge of sight, the rat may then be said to have embodied the dialectic of visibility and invisibility of epidemic photography but also of epidemiological reasoning, in ever-unsettling and productive ways.

PLAGUE MASKS

Assuming the form of a diagonal band spanning the interior of a white circle, a cotton facemask appears to be "stamped" on the cover of the Sunday magazine of Hong Kong's leading journal, the *South China Morning Post*.[1] On the murky blood-red background, behind this striking visual device we can read, in alternating order like a genetic sequence of doom, the ominous acronyms of three emerging infectious diseases: avian flu (H7N9), severe acute respiratory syndrome (SARS), and Middle East respiratory syndrome (MERS). This peculiar image functions as an epidemiologically inflected stop sign. Printed in smaller letters under it, the cover title of the *Post Magazine*'s December 1, 2013, issue explains, "Stress and Strains: Hong Kong's Never-ending Fight against Viruses."

The *Post Magazine* cover story, which like similar feature articles in that same year paid homage to Hong Kong's SARS epidemic decennial, contains striking images. The majority portray individuals in different settings donning a range of face-worn personal protective equipment (PPE): "a member of staff at the Beijing Centre for Disease Control put[ting] on a decontamination suit"; "a haj pilgrim near Mecca, in Saudi Arabia wear[ing] a mask to avoid catching Mers [*sic*]"; five hooded, white overalls and goggle-wearing "health workers carry[ing] away bags containing dead chickens during a culling operation near Kathmandu."[2] In relation to these images, the facemask sign on the front page functions as an accumulative second-order signifier. Assembling and entangling emerging pathogens as an existential risk, it provides an essentially apotropaic promise of scientific control vis-à-vis the "next pandemic."[3]

In terms of remembering SARS and preparing Hong Kong's population for what Laurie Garrett has coined the "coming plague," the facemask in this publication appears to carry certain talismanic properties, allowing humanity to persist on the edge of a pandemic "end of the world."[4] Nearly twenty years since the 2003 SARS pandemic, the use and efficacy of PPE in

epidemic control have become the subject of intense scientific debate. Up until 2020 this was mainly in the context of the 2014–2016 Ebola epidemic in West Africa, where the prophylactic efficacy and the transmission risk posed by PPE use came under scrutiny.[5]

Equally prevalent in that period were behavioral and social scientific studies of public perception and the social impact of anti-epidemic masks—or, more generally, masks employed to limit human-to-human transmission in the context of epidemics.[6] The COVID-19 pandemic has marked the true globalization of the anti-epidemic mask as a first-line apparatus of personal protection from infection.[7] At the same time, the pandemic has seen the transformation of masks into politically and socially contested objects, their globalization as fashion items, and their involvement in debates about solidarity and altruism as behavioral and moral frameworks of epidemic response.

This chapter will examine the emergence of this personal protection device in the context of the third plague pandemic and in particular in the Manchurian plague epidemic of 1910–1911. Rather than focusing on simply drawing the history of how the anti-epidemic mask was developed or how it was used on the ground, I will show how anti-epidemic masks emerged as fundamentally visual objects and the role played by photography in their institution into what we today recognize as a key defense against epidemics and pandemics.

However, to understand the visual institution of the anti-epidemic mask, a key anthropological question needs to be tackled: to what extent were these devices, at the historical moment of their emergence, actually instituted as *masks*? Should anti-epidemic apparatuses covering one's face or facial orifices be treated as masks, or should we pass over this denomination as simply conventional? In approaching the development and use of such face-worn technologies in epidemic contexts, should we engage at all with the corpus of historical and anthropological literature on masking, or is it better to turn our back to it and seek tools for understanding this modern biomedical phenomenon from other ethnographic, historical, or theoretical spheres?

As objects of material culture and as components of bodily techniques, masks have played a crucial role in a wide range of societies across space and time. From Franz Boas and Marcel Mauss to Claude Lévi-Strauss and Alfred Gell, key anthropologists have dedicated their attention to analyzing masks in their particular ethnographic contexts and masking comparatively as a practice spanning human societies and cultures. In spite of their often

stark differences, these approaches, as well as key historical works on masking, may be said to converge on a basic understanding of masks as objects and technologies that relate to identity, or more broadly to personhood, and its transformation.[8]

Whether the focus has been on how masks operate ritually in relation to intergenerational dynamics or how they mediate between the living and ancestors or animal spirits, studies of masks and masking converge on the centrality of the semiotics and performativity of "categorical change."[9] A transformative potential that, as Elizabeth Tonkin has observed, is the result of an inversion, contradiction, or paradox introduced by the mask—conceived as a "mask-in-action"—and in particular by its principal physical operation: covering the human face.[10] Already identified by Mauss, the faculty of revealing by hiding is central to what Tonkin coined the mask event, insofar as it "provide[s] a medium for exploring formal boundaries and a means of investigating the problems that appearances pose in the experience of change."[11]

Adopting this anthropological baseline as a comparative touchstone for discussing whether anti-epidemic face-worn PPE should be taken seriously as masks, I will show that this invention involved not only adopting facecoverings aimed at halting infection as a bacteriologically understood process but also the transformation of these devices from mere cloths and fabrics around one's mouth and nose to media of a categorical transformation of their wearers into "reasoned" subjects of "hygienic modernity."[12] I will thus argue that the emergence of PPE is entangled with the transformation of masks and their symbolic and performative faculties in the age of biomedicine. An irreducibly visual process that sets in place, if not necessarily the ritualization of epidemic control operations, a design-driven potential of subjectivation at the heart of modern technologies against contagion.

THE EMERGENCE OF THE PLAGUE MASK

As already examined in previous chapters, the first Manchurian plague epidemic broke out in the autumn of 1910 in the Chinese-Russian frontier town of Manzhouli and spread quickly south along the railroads to Harbin and other Manchurian cities, killing around 60,000 people by April 1911, with a case fatality rate of 100 percent. Manifested clinically in pneumonic form and spread between humans in an airborne manner, the epidemic further

fueled the intense antagonism between the Chinese, Japanese, and Russian Empires, which controlled different areas of Manchuria at the time.[13] In the midst of this crisis, which involved not only the three empires but also Foreign Legation doctors, missionaries, and an American medical delegation from the Philippines led by R. P. Strong, the Chinese imperial court appointed as the head of its anti-plague efforts the Penang-born, ethnically Chinese, and Cambridge-educated Wu Liande. Entangled in a struggle that involved the disease itself, local interests, imperial conflict, and wider aspects of social conflict, Wu adopted the bold theory that the spread of the disease did not require nonhuman vectors (rats or their fleas), as rival Japanese scientists insisted, but was transmitted directly between humans in an airborne manner and was therefore contagious.[14]

Though clinical observations of pneumonic cases of the disease had been in place since the first outbreaks of the third plague pandemic in Hong Kong and India, the idea that plague could be airborne bore a destabilizing effect on the recently accepted theory that the disease spread mainly, if not uniquely, by rats and their fleas. Accompanying this explanation of the epidemic was the development and proliferation of an anti-epidemic technology that Wu actively propagated as his own personal invention: the anti-plague mask (figure 5.1).[15] This mask resembled the recently established surgical face-worn protective devices (usually dated back to 1897) and other facecoverings previously used in the course of the third pandemic, but it involved more protective layers and a complex tying process, which was designed to keep the mask in place while the wearer operated in the adverse open-air conditions of wintertime Manchuria:[16]

> This consists of two layers of gauze enclosing a flat oblong piece of absorbent cotton 6 inches by 4 inches. It can be easily made by cutting the usual surgical gauze (9 inches wide), as supplied from the shops, into strips, each measuring 3 feet in length. Each strip is then doubled lengthwise so as to contain in the middle a flat piece of cotton wool measuring 4 inches by 6 inches. At either end of the gauze two cuts, each measuring 15 inches, are made. Thus turning the pad into a three-tail gauze bandage, with the central piece of wool for covering the respiratory entrance. The upper tail of one side should be passed round the side of the head above the ear and tied to the other corresponding tail. The lowermost tail should in a similar manner be passed under the ear and tied to the one on the other side, while the middle tail should be passed over the crown of the head, so as to fix the pad and prevent it from slipping down the neck.[17]

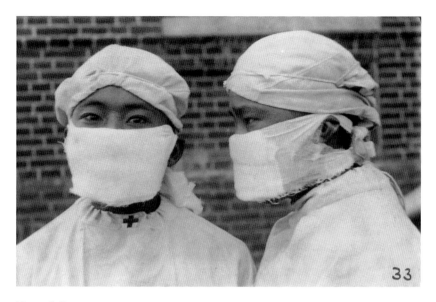

Figure 5.1
Wu Liande, "wearing anti-plague masks, front and side views." Courtesy of the
University of Hong Kong Libraries.

The aim was for this device to be worn by doctors and other medical or
paramedical staff who were operating in diverse contexts such as in plague
hospitals, during open-air cremations of plague corpses, and in the work
of removing, guarding, and examining plague contacts. It was also meant
to be worn by patients, contacts, and, to the extent that this was possible,
by the entire affected population. Although earlier attempts at producing
anti-epidemic masks have been recorded, this was the first time that such an
epidemic containment measure was attempted on this scale, matched only
by similar efforts across the globe during the 1918 influenza pandemic.[18]
Wu's transmission theory did not remain uncontested. In his later, hero-
ically inflected autobiography, he provided a villainous icon of medical
resistance to his airborne transmission theory and the anti-plague mask in
the form of Dr. Gérald Mesny, a French physician with previous work-
ing experience with plague. Writing in the third person, Wu narrated their
confrontation: "Dr. Wu was seated in a large padded armchair, trying to
smile away their differences. The Frenchman was excited, and kept on
walking to and fro in the heated room. Suddenly, unable to contain himself
any longer, he faced Dr. Wu, raised both his arms in a threatening manner,

and with bulging eyes cried out 'You, you Chinaman, how dare you laugh at me and contradict your superior?'"[19]

According to this dramatization of the encounter, Mesny went off to operate in plague hospitals without wearing Wu's mask. As a result, he contracted the disease and died a few days later, on January 2, 1911, thus leading to a universal adoption of Wu's theory and its accompanying prophylactic apparatus: "almost everyone in the streets was seen to wear one form of mask or another."[20]

We should be careful here to treat this story not as historical evidence but as part of the constitutive mythology of the particular anti-epidemic personal protection device as a mask. For Wu, the latter played a crucial role in epidemic control but perhaps even more importantly in checking the medico-juridical ambitions of his rivals. As we have already seen in chapter 2, during the April 1911 International Plague Conference in Mukden, where conflicting theories about the nature of the disease and the manner of halting the epidemic were to be discussed—effectively deciding which empire was "modern enough" to rule Manchuria—Wu presented international delegates with a carefully crafted photographic album titled *Views of Harbin (Fuchiatien) Taken during the Plague Epidemic, December 1910—March 1911.*[21]

VIEWS OF HARBIN

Containing sixty-one images, each occupying a single page with captions in English and Chinese, Wu's album rivaled similar photographic productions by the Russians and the Japanese. We have already seen how Wu's album assumed an impressive visual technique beginning with a series of bird's-eye views of Harbin (chapter 2). The album then proceeded by depicting anti-plague efforts under Wu: cremation, isolation, laboratory work, statistical calculations, house-to-house inspections, quarantining contacts, disinfection, ambulatory assistance, aid to the poor, and burning down the supposed breeding grounds of plague.

Throughout the album, such is the prominence of masks that we may claim it is these, rather than any single event, measure, social group, or person, that are set center stage in Wu's photographic narrative. From a total of sixty-one photographs, out of which forty-seven depict humans, thirty-two are photographs of masked men (all these figures are male). More than 230 individuals wearing anti-epidemic masks can be seen in total, invariably

posing before the camera, often in large, closely clustered groups. Rather than being hidden by their masks, this legion of "plague-fighters" stands revealed by them.[22] For in the sepia photographic reproduction of the album, the white color of the masks creates a striking ground-figure effect; individuals not wearing masks (mostly contacts in or heading for quarantine) tend to fuse with the surrounding urban landscape. The white contour of the mask creates a strong contrast that renders Wu's anti-epidemic army all the more visible. From burial coolies to distinguished doctors, nearly all counter-epidemic staff under Wu appear to be wearing the mask, creating a visual contrast that accentuates the sense of a united front against the disease.

This spectacle of masked unity is realized in individual photographs and across them in the album. For example, photograph 23, "Staff of Section III," depicts two rows of mask-wearing anti-plague fighters: the front row is doctors and their assistants (wearing lab coats), and the back row includes "coolies" and cart drivers (the former in overalls) (figure 5.2). Similarly, photograph 27, "Staff of Section IV," depicts three rows of mask-clad

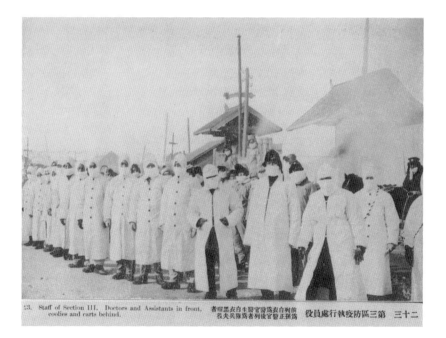

:3. Staff of Section III. Doctors and Assistants in front, coolies and carts behind.　前列白衣官醫爲正醫官後列白衣官醫爲生自黑衣帽者　　第三區防疫行處員役　　三十二

Figure 5.2
"Staff of Section III. Doctors and Assistants in front, coolies and carts behind."
Courtesy of the Needham Research Institute.

men: a front row of mask and lab-coat wearing doctors and assistants, a second row of mask and uniform wearing policemen, and a third row of mask and overalls wearing coolies, some of whom are standing on a burial cart or ambulance.

The spectacle of white-masked unity obscured the deeply entrenched mistrust between the different classes and professions who are depicted in these photographs and its practical manifestation in the course of undertaking epidemic control. At the same time, it underlined the contrast between Wu's hygienic model army and the social "background" on which its image was drawn: the supposed backwardness of victims and contacts metonymically exemplified in the depiction of squalor in the streets of Fujiadian. This visual pattern rhymed with Wu's overall strategy of blaming migrant "coolies" (especially from Shandong Province) for the transmission of plague from its original reservoir (the Siberian marmot) to humans and for the subsequent spread of the disease between humans in a threefold manner: first inside the sunless, underground coolie "hovels" of marmot-hunting hubs like Manzhouli, then in crammed third-class railway wagons headed south, and finally (as discussed in chapter 2) in equally dark and crowded coolie slums like Fujiadian.[23] Rather than simply being illustrative, Wu's epidemic photography accomplished a visual architecture of class-derived pathogeny, which in turn bolstered Chinese sovereignty in Manchuria. It absolved China's ruling classes from responsibility regarding the epidemic disaster while putting the blame onto an anthropological type already held by international players in the Manchurian theater to be responsible for the generation and spread of disease: coolies.

In visually delivering this epidemic blame, Wu mobilized tropes that had already been developed in the photographic configuration of plague across the globe since the eruption of the initial outbreak of the third pandemic in Hong Kong (1894). Most importantly, these involved the visual contrast between white-masked plague fighters and dark shantytowns, which rhymed emphatically with photographs taken by David Knox Griffith of the Shropshire Regiment's "Whitewash Brigade" evacuating Chinese working-class homes and "cleansing" Hong Kong's Taipingshan neighborhood by burning supposedly infectious material out in the streets (see chapter 2). Hong Kong photographs visualized epidemic control as a civilizational and racial war against the supposedly irreducible link between germs and Chinese backwardness. Seventeen years later, Wu borrowed this British colonial

visual trope during his anti-plague operations in Manchuria and redirected it toward a class-oriented outbreak narrative. Thus, he attempted to demonstrate how the Chinese were now able to fight effectively against this link themselves insofar as it was a link pertaining not to race, as colonial forces had maintained, but to class.

We must then conclude that in this album Wu did not simply use masks as a visual prop to draw a portrait of the epidemic after the latter's causes and mode of control had already been decided. Instead, Wu rendered anti-epidemic masks into an organizing principle of his field of vision, as a vision of state-organized medical reason and hygienic modernity.

REASONED TRANSFORMATION

While Wu was a vocal proponent of the airborne theory and of the mask designed to halt this form of contagion, he was far from alone in making these claims or in developing such technologies. As with other emerging sanitary and biomedical technologies at the turn of the twentieth century such as disinfection machines (see chapter 2), the anti-plague mask arose within a tangled contest of competing design practices, epidemiological theories, and utopian projects of hygienic modernity.

In the course of the First International Plague Conference in Mukden, Dr. Fang Chin displayed "over ten varieties of masks from different sources" used in Fujiadian during the epidemic.[24] At the same time, outside the main conference room, "mannequins bearing the costumes and the masks employed during the epidemic by Russian, Japanese and Chinese doctors" were on display in the corridors, which were transformed into "a kind of museum of plague."[25] Similarly, in the session of the French Academy of Medicine of May 30, 1911, the pioneer of tropical medicine and 1907 Nobel Prize recipient Alphonse Laveran presented three anti-plague mask models collected by Jean-Jacques Matignon during the Manchurian epidemic.[26]

A record of different face-worn devices in use during the epidemic may be assembled from various Chinese, Russian, Japanese, American, and French textual and visual sources.[27] These included the "Mukden mask," which was used widely in the Japanese-controlled areas in South Manchuria and "consisted of a pad of absorbent cotton about 16 by 12 centimetres and about 1.5 centimetres thick; this was wrapped in gauze, the ends of which were tied at the back of the head . . . A many-tailed bandage . . . composed of three

layers was tied around the entire head and served to press the mask firmly against the face and keep it snugly in place for hours at a time."[28] Another Japanese model, often described as resembling a bird's nest, was reportedly used by Japanese doctors and health workers as well as "officials and soldiers on the South Manchuria Railway," attracting the curiosity and admiration of European observers: "it is a sort of bird's nest whose wire frame is held against the respiratory openings by means of cords tied behind the head and behind the ears: each can vary the shape of this carcass at will and get different models."[29]

Another mask was developed by the Breton doctor Charles Broquet, a Pasteurian with considerable experience with plague in the south of China who would represent France at the Mukden conference in 1911.[30] Broquet initially designed a device comprising in a simple hood but found it to be impracticable: "As in the past, we had recourse to the simple hood pierced with holes in the eyes; this is an awkward mask which hinders breathing and sight without, however, protecting the conjunctivae, and under which any operation is almost impossible. The hood could be adequate for the impassive monks of the Inquisition, [but] it is not for the doctor of the twentieth century, who is no longer satisfied with looking at his patients from afar with a telescope, but must approach them to treat them or operate them."[31]

Broquet thus constructed a "simpler and more comfortable" mask composed of "a cotton layer held in contact with the face by a compress tied behind the head, serving as a protective filter for the respiratory tract and allowing freedom of breathing and air."[32] He also tried to fit a full hood and a semihood to this device, but these were ultimately abandoned as impracticable.[33] Broquet suggested that in the case of both his mask and the bird's-nest Japanese model adding goggles could increase protection from plague bacteria, although this also increased the risk of the actual mask being displaced.[34] Broquet experimented with different combinations, including a model that he claimed was inspired by a quarantine doctor costume from 1819 (see the costume discussed later by Clot-Bey), only to conclude that the most practicable and protective device was one combining "compress+glasses+hood" (figure 5.3):

> I had the wall of my first model modified by replacing the airways, the canvas with a net in which is placed a layer of cotton; thus breathing can be performed without danger through this filter. It is also necessary, so as to avoid misting

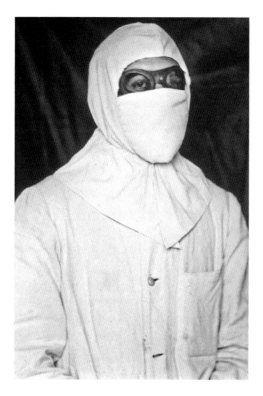

Figure 5.3
Charles Broquet wearing protective clothing against the plague. © Institut Pasteur/
Musée Pasteur.

and condensation on the mica plate, to coat the internal surface of this plate
with glycerin soap. Under these conditions, the mask can be worn for an hour,
allowing the wearer's sight free to examine or operate on the patient, The mica
plate is interchangeable and the mask can be easily sterilized in an autoclave, in
boiling water or in an antiseptic solution. Its weight is 113g.[35]

Broquet was questioned about his experience with masks during the
Mukden conference, and the delegates, physicians Strong and Aspland, were
particularly skeptical about these devices. W. H. Graham Aspland explained
that Broquet's mask was good only for indoor, hospital-based operations
"where the temperature was moderately warm."[36] Aspland asked Broquet
whether he had tried wearing his mask "for three or four hours at a time at
a temperature of about 20°C below zero"—a common winter temperature

in the region—commenting that from his extensive experience in Fujiadian goggles should be avoided as they severely hampered one's ability to operate: "the moisture from the heat of the face condensed on the glass and it then became impossible to see. One's eyelashes and eyebrows rapidly became covered with small icicles."[37]

It is hard to estimate the extent to which any of these face-worn devices were adopted by medical staff or the general population although news items from the time indicate that instructions to use these were widely circulated.[38] The discussion of the Mukden conference resolution to provide masks to isolated contacts in case of a new outbreak is revealing of the practical limitations involved. Aspland noted that, from the point of view of those who had been involved in quarantine work, supplying 1,500 or 2,000 contacts "with a fresh mask every day" was not only a logistically complicated task, but also one that ignored the reality on the ground: "You would not get the contacts to wear them except around their necks. They spend the whole time smoking in the cars [i.e., immobilized train wagons used for isolating contacts]."[39]

An equivocal attitude toward masks was also recorded in an anecdote related by Dr. J. Chabaneix, a colonial medical doctor, professor at the Peiyang Medical School, and attaché of the sanitary service of Tianjin, who was in charge of anti-plague operations in the port of Shanhaiguan and later deputy to Broquet at the Mukden conference. Chabaneix wrote that, on March 10, 1911, a medical student visited a Chinese-run hospital in Changchun wearing his "protective attire" only to find the Chinese doctors were not wearing any.[40] The student advised the doctors to wear a mask and goggles only to receive the following response: "You call this disease the rat plague, and you think it is transmitted by the rat. Our clothes are lined with fox [fur], which scares rats away. In this way plague does not reach us."[41] The student reportedly tried to convince them otherwise but failed; within seven days from the opening of the hospital, the head doctor, two physicians, and seven nurses were dead.[42] The narrative in Chabaneix's pamphlet is dotted with Sinophobic remarks and should not be taken at face value. Yet from the little evidence we have, it appears that the adoption of masks sometimes involved unconventional processes, such as the one reportedly employed in Chefoo (as the name of German-controlled Zhifu, today known as Yantai in China's Shandong Province, was commonly romanized) where masks were reportedly stamped with temple seals that effectively rendered them into amulets.[43]

According to Barber and Teague, elaborate experiments conducted on the Mukden masks with *Serratia marcescens* (at the time known as *Bacillus prodigiosus*) in the bacteriological laboratory of the Bureau of Science in Manila proved not only that the three-tailed gauze and cotton-wool pad mask often did not properly fit the wearer's face, but that it also allowed bacteria to penetrate: "It appears that, while the gauze and cotton comprising the mask may intercept the bacteria in droplets of sputum emitted—for example, by the cough of pneumonic-plague patients—if the bacilli are suspended in a fine vapor, they penetrate in some way, either around the edges or through the mask."[44] Barber and Teague concluded, "Their use in the recent epidemic of pneumonic plague in Manchuria lent a false sense of security which may have led to the taking of unnecessary risks."[45]

Still, perhaps the Mesny anecdote and Wu's photographic spectacle tells us more about the symbolic efficacy of these devices than the true history of their emergence insofar as they are able to offer us a glimpse of their unintentional truth.[46] To understand the emergence of the facemask as an anti-epidemic technology and its continuing impact today, we need to take its imagined origins seriously, in the same way in which, for example, we consider the Kwakiutl myth of the creation of their masks as a result of "the original ancestors shed[ing] their skins and emerg[ing] as human beings," with the skins "bec[oming] the masks later associated with the name of the ancestors."[47] Only then can we begin to see how, while being a practical and in some cases effective prophylactic technology, its material application was always already tied to a symbolic function, which we should more precisely classify as mythic. This function, I would argue, rendered these devices into masks in the proper sense of the term, but only insofar as it maintained their ontology as irreducibly both material and visual objects.

In examining this anti-epidemic apparatus from an anthropological perspective, it becomes immediately obvious that a representational focus is inadequate for grasping what the anti-plague mask does in the social, rather than simply bodily, milieu in which it operates. By contrast to the vast majority of masks studied by anthropologists, these devices are not anthropomorphic, zoomorphic, or theriomorphic. In other words, anti-plague masks do not assume, mimic, or configure the physical features of an entity other than their wearer, the alternate-identity or properties of whom the latter—be that individual or in some cases collective—is meant to assume, mimic, tame, or master. Yet even if anti-epidemic face covers are nonrepresentational, they

are still implicated, like the masks studied by anthropologists, in the invocation, embodiment, and manipulation of a force: in this case, reason.

I suggest here that we need to approach the emergent anti-epidemic mask of the Manchurian plague epidemic as a dialectical image—in other words, as something which, in Walter Benjamin's sense, operates as a "switch" insofar as it "arrests fleeting phenomena" and "sets reified objects in motion."[48] It may be worth remembering here the critical-theoretical premise of reversibility, according to which the production of rationalism is "instrumental in generating the supposed irrationalism that it encounter[s] and often f[ights] to control."[49] In other words, what I propose is that, in approaching this anti-epidemic prophylactic device in its historical and ethnographic moment of emergence as an icon of an agonistic medical rationalism, we may be able to decipher how "in its very modernity and mundaneness, [it] conjured up . . . the mythic."[50] This was an apparatus that did not simply protect its wearers from infection but also immersed them and their immediate social environment into a performance of medical reason and hygienic modernity.[51]

MYTHIC ORIGINS

It is common today to see images of contemporary face masks and PPE such as those used in the context of the COVID-19 pandemic flanked by images of the early modern "plague doctor" in his characteristic costume and beaked mask (often misrepresented as "Black Death" or medieval medical devices).[52] This prolific popular-science visual trope invokes the "beak mask" as the progenitor of modern PPE. What the anachronistic nature of the particular visual idiom may lead us to overlook is that this pedigree of anti-epidemic PPE was already part of its emergence in the course of the third plague pandemic. This pervasive mythohistory was linked to the idea held by a number of physicians at the time that plague in general was discernible by the triptych of axillary, inguinal, and cervical buboes but that the Black Death (1346–1353), as the prototypical "pandemic," was pneumonic in character. The notion relied on an interpretive emphasis on historical tracts mentioning pneumonic symptoms as well as on the interpretation of retrospective Renaissance plague-related paintings bearing the motif of people approaching victims while holding a presumably scented handkerchief on their mouth and nose.[53] Discussing the Manchurian plague of 1910–1911, Laveran noted that there "pneumonic plague was the rule, and,

consequently, it was human-to-human contagion which was the ordinary mode of propagation, as had occurred during the famous black plague epidemic of 1348: 'We carried with us death, writes G. de Mussis, one of the historians of this epidemic, and we spread it by our breath.'"[54]

In his account of the "history of the mask" written as part of his authoritative monograph on pneumonic plague for the League of Nations in 1926, Wu Liande attempted to frame his invention as the final stage of a painstakingly slow progress of personal plague prophylaxis, which included Charles de l'Orme's seventeenth-century invention: the *medico della peste* mask and costume—the famous beaked plague doctor. According to the memoirs of Michel de Saint-Martin, de l'Orme was a physician at Louis XIII's court who constructed the costume in the course of the 1619 plague outbreak in Paris out of saffian (sheepskin or goatskin); the ears and nose of the bespectacled mask (also made of saffian) contained garlic and rue so that the "bad air" would find it difficult to penetrate and inflict the practicing doctor with plague.[55] If Wu was quick to jump from this iconic figure to late-nineteenth-century devices, other authors such as Broquet would discern the "continuation" of the plague mask via a number visual sources such as de Troy's "La Peste dans la ville de Marseilles en 1720" or Micco Spadaro's scene of the Piazza Mercatello in Naples during the plague of 1656, where four masked men were said to be among the pestiferous multitude.[56]

This narrative traced the slow but supposedly unstoppable march of medical reason from recognition to recognition and from illumination to illumination; even though the etiological framework involved in such practices was recognized as fundamentally false, the practice itself was seen as containing the seeds of reason as an unalienable trait of humanity. According to this iconographically reliant time line, similar applications of anti-plague masks could be seen through the nineteenth century in such instances as the gravure depicting the costume of a physician at the Marseille lazaretto in 1819 contained in the treatise on plague in Egypt by Antoine Barthélemy Clot aka Clot-Bey (1840)—Broquet's self-confessed original inspiration for his own mask experiments.

We should pause here to consider this example in greater detail because of the striking discrepancy between Clot-Bey's reception of the particular costume and the early-twentieth-century citations of it as a progenitor of the Manchurian plague mask.[57] Clot-Bey was a French doctor who, after a brilliant but tumultuous career at the medical school of Marseille, left for

Egypt in 1825 where he became one of the most important agents of the country's medical and public health modernization.[58] Clot-Bey would rise to international repute and act as Muhammad Ali Pasha's principal medical advisor at the time of the 1834–1837 plague outbreak in Egypt.[59] The initial and best-recorded phase of the epidemic (1834–1835) killed "more than a third of Alexandria's civilian population," and "a third of [Cairo's] 250,000 inhabitants."[60]

In his history of public health in nineteenth-century Egypt, LaVerne Kuhnke showed that Clot-Bey was opposed to the prevalent theories at the time that saw Egypt as an endemic heartland of plague resulting from the decomposition of corpses (most famously formulated in Étienne Pariset's "cadaveric virus theory").[61] Clot-Bey maintained that "meteorological circumstances peculiar to the country endowed [plague] with a 'pestilential constitution.'"[62] He moreover disagreed with Muhammad Ali and French doctors in Egypt in that he refuted the communicability of plague.[63]

In 1840, Clot-Bey published a treatise on plague under the title *De la peste observée en Egypte*. In this text, the French doctor painted a bleak picture of the costume in view (figure 5.4). The apparatus of clogs, oilcloth gloves, and waxed linen garments—which the doctor noted had changed little from the "grotesque and frightening costume" of the beaked plague doctor—even included a stick for approaching the sick.[64] In the eyes of Clot-Bey, this was not simply ridiculous but potentially harmful: "Think of the effect to be produced on a sick mind, a fainthearted brain, by the appearance of a ghost-like figure—when, in this very costume, the unfortunate sees the surgeon who is about to operate, what can he see in the man who should comfort him, other than a subject of horror and terror?"[65]

We need to read this passage not simply as a poetic evocation of the force of fear but epistemologically as well—that is, in relation to the pervasive understanding at the time in European contexts of the imagination as a cause of plague.[66] As shown by art historian Sheila Barker, this idea was established during the Renaissance.[67] In the words of Geronimo Gastaldi, the pesthouses' general commissioner during Rome's 1656 plague, "the imagination merely frightened by the plague is enough to bring on the disease."[68] Such concerns about the pathogenic, fear-inducing imagination of plague and about human types susceptible to it were endorsed over the course of the seventeenth century by authorities like Athanasius Kircher and were

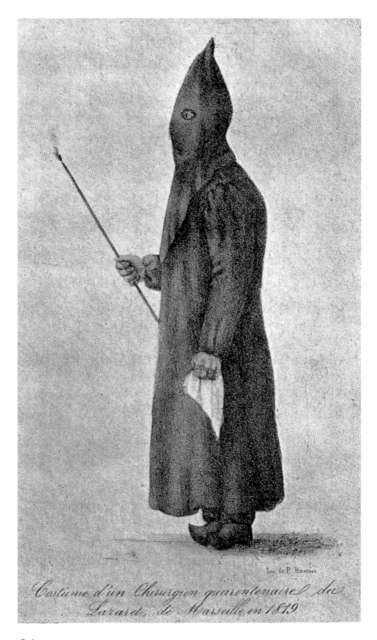

Figure 5.4
Plague doctor's costume: "Costume d'un chirurgien quarantenaire du Lazaret de
Marseille, en 1819," which originally appeared in Clot-Bey (1840). Source: Europeana.

intricately linked to humoral and Paracelsian understandings of the human body.[69]

A good example of this theory can be found in Pierre-Jean Fabre's 1642 *Remèdes Curatifs et Préservatifs de la Peste* where a short chapter by the influential doctor-alchemist is titled "That the Fear and Terror of Men Can Attract the Pestilent Vapor, and Make It More Contagious Than It Is of Itself."[70] In the text, which was reprinted in 1720, the year of the great plague epidemic in Marseille, Fabre explained, "We must not therefore be afraid or fear the plague in times of contagion: for the prime antidote to plague is courage; by this means we resist and overcome the poison [*venin*] of plague."[71] As shown by Barker, such ideas played a key role in the development of a visual culture of plague at the time, with paintings such as Poussin's *Plague of Ashdod* (1630–1631) operating not merely as representations of the disease but as prophylactic devices that, through a process of mimetic purging, redirected "feelings of fear and pity onto a work of art structured according to the poetics of tragedy, so that ensuing tragic catharsis can provide an artificial—and harmless—outlet for these emotions."[72]

This framework was still in operation at the dawn of the nineteenth century and in Napoleonic medicine in particular, as is attested in Grisby's analysis of Antoine-Jean Gros's vast, monumental painting *Bonaparte Visitant les Pestiférés de Jaffa* (1804) depicting Napoleon meeting French soldiers, victims of bubonic plague, in a mosque in Jaffa that had been converted into a hospital (figure 5.5).[73] Rather than the painting embodying a Blochean moment of a *roi thaumaturge* and his healing touch, Grigsby argues, Napoleon's gesture of touching the axillary bubo of one of his infected soldiers was meant to prove that the disease was not contagious and to cast away fear as the cause of plague.[74] Emmanuel Comte de Las Cases's recounting of Napoleon's discussion of the event is illuminating: "The principal seat of the plague was in the imagination. During the Egyptian Campaign all those whose imagination was struck by fear died of it. The surest protection, the most efficacious remedy, was moral courage."[75] In Gros's painting, we see a man standing behind Napoleon holding his handkerchief against his nose, in the trope established in the seventeenth century by Nicolas Poussin. This was Marshal Jean-Baptiste Bessières. Rather than connoting here a rational way of protection against plague, the gesture and the accompanying expression of terror in the Marshal's face was intended by Gros as a personal, pictorial revenge against his old friend turned enemy: Bessières

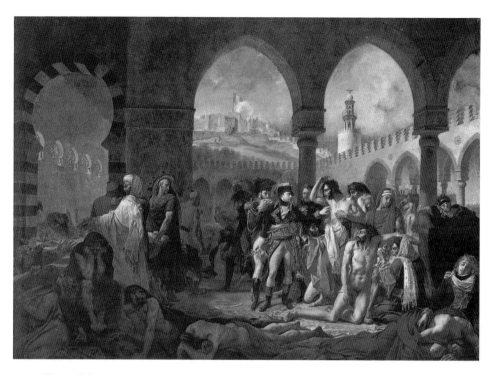

Figure 5.5
Bonaparte Visitant les Pestiférés de Jaffa by Antoine-Jean Gros, 1804. Source: Wikipedia Commons.

was hence represented as a coward and a danger to the health of the Grande Armée as a result of his fear-disturbed constitution.[76]

We need to read Clot-Bey's visual quote of the 1819 plague doctor costume as part of this transformation of covering one's mouth and nose from a prophylactic gesture to one that exposed one as a coward and (as a result) as susceptible to plague.[77] If in the Manchurian context the costume accompanying Clot-Bey's volume functioned as a model for or progenitor of contemporary anti-plague masks, within its original reference framework (Clot-Bey's book) that very costume was seen as at best useless and at worse as being a cause of the disease, not its prophylaxis.

My purpose here is not to debunk the genealogy of the anti-contagion mask as developed in the course of its emergence in 1910–1911. Instead, I wish to underline that the configuration of this apparatus as a mask of reason was predicated upon the redefinition of what pertains to reason and

what does not. If Wu's mask could defend doctors and the general population from plague, this was only because it supposedly both stopped germs from entering the human body and transformed the public from a superstitious and ignorant mass into an enlightened hygienic-minded population—a population that accepted the contagious nature of the disease and corresponding, often brutal, quarantine and isolation measures.

Designed to bring about a transformation—not simply in the individuals wearing it but also in the society embracing it and its principles as a whole—the facecovering would then be properly speaking a mask. For it did not only block germs but also catalyzed a passage from one mode of being into another: from unreason to reason.

Hence, the profanation effect reportedly experienced in Chefoo, where coolies transformed masks into amulets by stamping them with a temple seal.[78] This practice, like other instances such as using carbolic acid disinfectant in ritual exorcisms against plague demons, was seen as a mockery of medical science's tools of reason.[79] By canceling out the transformative effect of the apparatus—its mask effect—such acts reduced it to a simple cloth around one's mouth and nose.[80] This was, in fact, far less than the cloth held against one's nostrils by Poussin's plague-stricken denizens of Ashdod or wrapped around the face of burial workers in Michel Serre's 1720 painting *Scène de la Peste de 1720 à La Tourette*. For while reason was latent in these early-modern practices, in the coolies' abominable if alleged ritualization, wearing facecoverings profaned reason.[81]

Reaching out to ongoing anthropological debates on medical and sanitary devices, I suggest that in its emergence this prophylactic technology contained the practical promises of safeguarding health.[82] Yet at the same time it also contained much broader, utopian promises of an anthropological transformation: a transformation that rendered the relation between practical promise and utopian hope both generative and hierarchical. Whether or not we want to consider these devices as sanitary/biomedical "gadgets" (or as part of the prehistory of the latter), their portable anti-epidemic technology embodied a simple, easily reproducible, and malleable design that operated on three interlinked levels as (1) a supposedly foolproof way of halting airborne plague-related contagion; (2) an indisputable, photogenic proof of Chinese scientific sovereignty; and (3) a visual and material mediator-transformer of the Chinese people into a population in the biopolitical sense of the term. While each of the three aspects was fundamental to the emergence of this

technology of epidemic control, only the economy between them instituted it as a mask. Subtracting one of these aspects, as supposedly happened in the case of Chefoo, threatened to reduce it to merely a protective device, devoid of its political, mythic, and broader performative capacities.

GLOBALIZING THE PLAGUE MASK

Not just a prophylactic device but also a catalyst of biopolitical transformation, the anti-epidemic mask emerged in the context of the 1910–1911 Manchurian plague epidemic as an image of reason but also, to paraphrase Alfred Gell, as an elaboration of humanity as being-for-reason.[83] In China, with Wu's assumption of the chairmanship of the newly founded North Manchurian Plague Prevention Service after the 1911 Revolution, the mask would become a fixture of anti-epidemic work.[84] It therefore featured in both plague and nonplague epidemic contexts, including the second Manchurian plague epidemic of 1920–1921, in the course of which Wu Liande would oversee the production and distribution of 60,000 masks to the general population.[85]

At the same time, the mask would be adopted against pneumonic plague outbreaks in other contexts of the third pandemic where it became entangled with various technologies of epidemic control and their visualization. For example, in the context of outbreaks of pneumonic plague in Madagascar in the 1920s and 1930s and their management under the director of the colony's Institut Pasteur, Georges Girard, the photographic theme of the mask would merge with those of disinfection and hygienic burial in producing a spectacle of science overcoming supposed indigenous superstition, as identified by Pasteurian doctors with the Malagasy tradition of reburial known as *famadihana*.[86] An iconic photograph of this process, later reproduced in Roger Pollitzer's definitive book on plague issued by the World Health Organization, shows a team of barefoot native burial workers in masks and goggles carrying a plague corpse into a coffin destined for hygienic burial.[87] Behind them we see another barefoot man with a nozzle disinfector, while three colonial officers, also in masks and goggles, inspect the operation as two Malagasy women, possibly relatives of the victim, are observing the operation (figure 5.6).[88]

Both a material and a visual object, the anti-plague mask would become quickly globalized, reaching its apogee during the 1918–1919 influenza

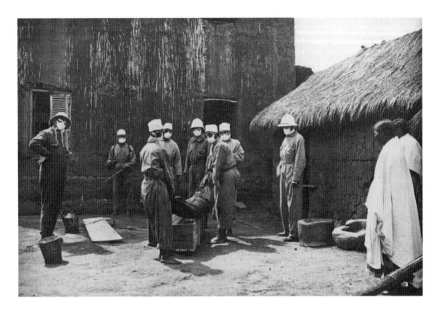

Figure 5.6
"Casketing of a dead body by a plague hygiene team in Madagascar c.1935." © Institut
Pasteur/Musée Pasteur.

pandemic. In the United States, where the old plague-fighter Rupert Blue
had become the Surgeon General of the Public Health Service, anti-influenza
masks were made to rhyme with plague through discursive and visuals com-
positions like that accompanying Dr. Gordon Henry Hirshberg's article
"Medical Science's Newest Discoveries about the 'Spanish influenza.'" The
article, originally printed in the *Washington Times*, was then syndicated to
a number of other newspapers in the first two weeks of October 1918.[89]
Taking up a large part of the page, the article's visual apparatus combined a
map of the spread of the disease with a diagram of the anatomy of the "nasal
and the laryngeal passages which are the seat of infection," a diagram of the
anatomy of sneezing, a copy of John Maler Collier's famous Pre-Raphaelite
painting *The Plague* (1902), and a cropped photograph of a World War I sol-
dier wearing a gauze mask.[90] The photograph was captioned, "Masks such
as this are being worn by sufferers in the camps and by all those who come
in contact with them, thus entirely doing away with the danger of commu-
nicating the infection."[91]

It is likely that the international fame and media exposure enjoyed by
Manchurian masks as a protection against pneumonic plague in 1910–1911

contributed to their adoption, adaptation, and acceptance seven years later across the globe. In the United States, the mask in its various guises and forms was a key visual feature of articles covering the 1910–1911 epidemic. Some presented the mask and accompanying protective equipment as an essential but also experientially tantalizing medical novelty. An American reporter in Harbin, for example, wrote of his adventure in one of the city's plague hospitals: "Meanwhile a mask, a pad of gauze with string attached, was being tied over the lower part of my face by one of the nurses. . . . Next I am fastened into a heavy white canvas union suit, and the trousers are tied tightly around my ankles and the sleeves around my wrists. Over this comes a white coat: a hat ties down over the ears and a hood goes over the hat. My feet are put into heavy high rubber shoes: then the anti-plague outfit is complete."[92]

What, however, fostered the global symbolic efficacy of this visual-material device was its entanglement with the imperative ontology of plague. A visually evocative "short story" in the *Richmond Palladium*, titled "How Science Masks Itself against the Black Plague," declaimed "what plague must be" in the strongest terms by identifying the Manchurian outbreak with the Black Death.[93] "There is every indication," the article opened, "that the pneumonic plague now raging China will prove to be the most disastrous in history. In the Black Death of the Middle Ages, the worst pest hitherto recorded, seventy-five millions perished. The death list in the present plague may be over two hundred million!"[94] Explaining that, like the Black Death, plague in Manchuria was pneumonic and "communicated through the medium of the air," the article argued that the only protection against the dreaded disease were masks: "A full working kit consists of the pad of lint, soaked in carbolic acid; a linen mask and goggles, which make it impossible for the bacilli to reach the face; gloves and a linen gown, which can be boiled and disinfected easily, and covers the wearer to the shoes."[95]

The visual composition accompanying the article, and taking more than half of its allocated space on the page, juxtaposed images of Black Death–like horror with those of scientific control (figure 5.7). The former consisted of a photograph of stacked coffins covered with oil (in reality paraffin) and set aflame on the snow-covered steppe and another photograph, which had previously featured in the British and French illustrated press, showing a patient staggering in the streets of Harbin.[96] These images of desolation and desperation were contrasted with an image of two doctors wearing PPE,

Figure 5.7
"How Science Masks Itself against the Black Plague." Courtesy of Chronicling America.

including masks, and a photograph of a "doctor fully guarded from conta-gion inspecting a trainload of passengers."[97] The latter was in fact a photo-graph of a Russian doctor inspecting Chinese contacts, who were kept in isolation in train wagons immobilized and transformed into isolation cabins in the midst of the steppe.[98] What is remarkable in this image is not so much the location's misinterpretation, as the photograph being visibly retouched so that it was cropped into the shape of a coffin. In this manner, the mask appears to be warding off certain death, even as the doctor has figuratively entered the realm of Black Death itself.

These examples of the American coverage of the Manchurian plague mask indicate that outside the context of China this device operated as a visual object in relative autonomy to its history and social life on the epi-demic ground. Through this decontextualization, while the plague mask

retained its potential of a visual proof of China moving beyond its hith-
erto perceived resistance to modern medicine and into the role of a medical
innovator, it also acquired another symbolic layer, which it lacked on the
operational ground: an apotropaic device against the return of the Black
Death as a world-catastrophic event.[99]

The globalized image of the mask relied on a fundamental paradox. It
was portrayed as an innovative device—which at least some publications
recognized as a Chinese invention—but it was also acclaimed as the only
thing that could protect the West from Black Death as a world-historical
catastrophe emanating from the supposed backwardness and decay of
China. Assertive as well as imperative, the visual ontology of plague was
characteristic of the broader tensions and affordances of epidemic photo-
graphy at the time of its emergence during the third plague pandemic.

CONCLUSION

The examination of visualizing plague in the context of the third pandemic has shown that at the time of its emergence epidemic photography was not a means of creating "ontological certainty" about a given disease.[1] Nor was it used to simply illustrate the outbreaks whose image it captured or to support and bolster epidemic response policies in different parts of the world. Rather, epidemic photography forged complex interrelations between epidemiological certainty and uncertainty through tropes and stagings of plague's visibility and invisibility. In this way, photography contributed to the establishment and development of modern epidemiological reasoning, which continues to inform scientific research and understandings of infectious diseases. At the same time, epidemic photography forged for the first time a coherent and efficacious image of the "pandemic" as an event of immediate relevance and indeed simultaneous urgency for humans across the globe.

By capturing local outbreaks in their situated specificity and as part of a global event, epidemic photography emerged as a scientific practice and at the same time as a symbolic form, which has come to define the way we see, visualize, and imagine infectious disease epidemics as threats to human existence. In the process of its emergence, epidemic photography added an important layer to understandings and experiences of the "global" by creating a visual field of pathogenic interconnectedness and exchange: a vision of how the global is constituted through the spread of infectious diseases and how, in turn, the spread of diseases is fostered by the intensification of global connectedness.

By creating a new visual field for "contagion," "infection," and other categories of disease transmissibility and maintenance as forces of global integration and risk, photography advanced an experience of the world as a unified terrain under the bane of existing epidemics or pandemics. But it also created an image of the world as facing a fatal threat: the return of a pandemic of world-catastrophic proportions. Through its assertive and imperative

faculties, epidemic photography became central to the emergence of a new understanding and experience of the world and of new scientific and symbolic ways of acting in it as a place where connectedness is irreducibly the source of power and wealth as well as death and destruction.

More than sixty years have passed since the declaration of the end of the third plague pandemic by the World Health Organization in 1959 and more than a century since the peak of the pandemic. In recent decades, a series of important works from across the medical humanities have examined the visual culture of contagion since World War II and the visual culture reflecting and fostering the transformation of epidemiological thinking brought about by the emerging infectious diseases framework and the anticipation of the "next pandemic" since the early 1990s.[2] Under these frameworks, a projected pandemic of a new pathogen has been portrayed as threatening humankind with extinction. This pandemic imaginary, as anthropologists in particular have argued, relies on complex viral ontologies and supports the biosecurity apparatus stemming from pandemic preparedness.[3] In this context, photography has been shown to play an important role, especially as regards the framing of human/nonhuman relations in ways "meant to transform every element in them . . . into a sign of spillover and ultimately of human extinction as a never-completed but always in-the-process, inevitable event."[4]

It is not the aim of this book to examine the development of epidemic photography through these epistemic, social, and epidemiological transformations. My hope is that this work provides tools to readers who are examining the latter in their engagement with the role of photography in these developments. However, in concluding this book, and in light of the context of the immediate experience of its readers, it is worth noting that the current COVID-19 pandemic has come to show that a number of the tropes, functions, and themes of epidemic photography as they emerged in the course of the third plague pandemic continue to play a significant role in the framing and experience the pandemic today. Still, new tropes and perspectives are also at play, including critical uses of photography and other visual media that have made a significant contribution to negotiating the experience and meanings of the pandemic from nonhegemonic perspectives.[5]

Visualizations of anti-epidemic masks in the course of the COVID-19 pandemic have presented a tantalizing challenge to dichotomies of continuity/

discontinuity.[6] To a significant extent, mask images have been in constant dialogue with works and commentaries about the historical genealogy of personal protective equipment (PPE) as material and visual devices, but they have also generated innovative ethnographic, artistic, and theoretical approaches.[7] At the same time, the photographic coverage of India's devastating second wave of COVID-19 in the spring of 2021 relied on depictions of public cremations, which offered themselves for both an orientalization and distancing of the pandemic from the West (which in that period was experiencing a pandemic ebb) and national as well as international criticism of the disastrous way in which Prime Minister Modi's government has managed the pandemic.[8] By contrast, the visualization of China and its wet markets as the probable source of the pandemic presents a less complicated image insofar as it follows closely similar Sinophobic configurations developed during the severe acute respiratory syndrome (SARS) 2003 pandemic. In fact, several media outlets covering wet markets as the supposed source of COVID-19 (which at the point of this writing in December 2021 has yet to be scientifically proven) have used images from the SARS 2003 outbreak to illustrate their point.[9]

On the other hand, an entirely new photographic angle to the coverage and configuration of pandemic-related quarantine has emerged in the context of the imposition of lockdowns across the globe in 2020–2021. This involves photographs focusing on the depiction of "emptiness." The trope has taken several forms so far during the pandemic, involving photographs and videos of wild animals reoccupying locked-down urban spaces, portraits of hitherto iconically "busy" cityscapes turned into apocalyptically "empty" cities, and the cartographic depiction of skies over China "empty" of pollution in the early months of the epidemic.[10] As journalist Sophie Haigney has noted, the systematic coverage of lockdowns through the trope of the "empty" or "deserted" city during the "first wave" of the pandemic (and of lockdowns) in the spring of 2020 was "part of an exercise in mythmaking," which portrayed the world as united under the bane of the epidemic and in the struggle against it.[11] "In fact," Haigney explained, "the world never really stopped or emptied out. In fact, we were never all in this together. In fact, the virus was not the great equalizer that put everything on pause. Many people continued to commute to their jobs, either because they were suddenly deemed 'essential' or simply because they had to."[12]

The history of the emergence of epidemic photography in the course of the third plague pandemic urges us to understand how visual media (photographs, films, videos, diagrams, graphs, and maps), the apparatus through which the lives of millions have come to be mediated and changed over 2020–2021, are not just ways of illustrating or providing evidence about COVID-19 but also means of configuring the disease, supporting and challenging pandemic response, and, most importantly, transforming epidemiological reasoning and our pandemic imaginary.

INTRODUCTION

1. Roger Cooter and Claudia Stein, "Visual imagery and epidemics in the twentieth century," in *Imagining Illness: Public Health and Visual Culture*, ed. David Harley Serlin, 169–192 (Minneapolis, MN: University of Minnesota Press, 2010).

2. Christos Lynteris, "The prophetic faculty of epidemic photography: Chinese wet markets and the imagination of the next pandemic," *Visual Anthropology* 29, no. 2 (February 2016): 118–132.

3. Heide Fehrenbach and Davide Rodogno, eds., *Humanitarian Photography. A History* (Cambridge, UK: Cambridge University Press, 2015); Adia Benton, "Risky business: Race, nonequivalence and the humanitarian politics of life," *Visual Anthropology* 29, no. 2 (February 2016): 187–203; Christina Twomey, "Framing atrocity: Photography and humanitarianism," *History of Photography* 36, no. 3 (2012): 255–264.

4. Christos Lynteris, "Plague masks: The visual emergence of anti-epidemic personal protection equipment," *Medical Anthropology* 36, no. 6 (2018): 442–457.

5. David Harley Serlin, "Introduction. Towards a visual culture of public health," in *Imagining Illness: Public Health and Visual Culture*, ed. David Harley Serlin, xi–xxxvii (Minneapolis, MN: University of Minnesota Press, 2010). For a study of this operation in relation to HIV/AIDS, see Lukas Engelmann, *Mapping Aids, Visual Histories of an Enduring Epidemic* (Cambridge, UK: Cambridge University Press, 2018).

6. World Health Organization chronology is followed here for the third plague pandemic's time span, although, as recent outbreaks in Madagascar, Bolivia, and Peru demonstrate, in biological terms the pandemic is ongoing.

7. Carlo Caduff, "Sick weather ahead: On data-mining, crowd-sourcing, and white noise," *Cambridge Journal of Anthropology* 32, no. 1 (June 2014): 32–46; Nicholas B. King, "The scale politics of emerging diseases," *Osiris* 19 (2004): 62–76, 65; Frédéric Keck, "Une sentinelle sanitaire aux frontières du vivant: Les experts de la grippe aviaire à Hong Kong," *Terrain* 54 (2010): 26–41; Andrew Lakoff, *Unprepared: Global Health in a Time of Emergency* (Berkeley, CA: University of California Press, 2017); Limor Samimian Darash, "Governing future potential biothreats: Toward an anthropology of uncertainty," *Current Anthropology* 54, no. 1 (2013): 1–22.

8. Carlo Caduff, *The Pandemic Perhaps: Dramatic Events in a Public Culture of Danger* (Berkeley, CA: University of California Press, 2015); Christos Lynteris, *Human Extinction and the Pandemic Imaginary* (London, UK: Routledge, 2019); Dahlia Schweitzer, *Going Viral: Zombies, Viruses, and the End of the World* (New Brunswick, NJ: Rutgers University Press, 2018).

9. For examinations of how different analytical frameworks of epidemics (as drama, narrative, etc.) may help us understand the social life of the COVID-19 pandemic, or have indeed become challenged by it, see the Winter 2020 special issue of the *Bulletin of the History of Medicine* on "Reimagining Epidemics," edited by Mary E. Fissell, Jeremy A. Greene, Randall M. Packard, and James A. Schafer Jr.

10. On the analytical limitations of the illustration/evidence dichotomy as regards photographs, see Nicolas Peterson, "Early 20th century photography of Australian Aboriginal families: Illustration or evidence?" *Visual Anthropology Review* 21, no. 1–2 (2006): 11–26.

11. Robert Peckham, "Panic encabled: Epidemics and the telegraphic world," in *Empires of Panic: Epidemics and Colonial Anxieties*, ed. Robert Peckham, 131–154 (Hong Kong: Hong Kong University Press, 2015).

12. Charles Rosenberg, "Disease in history: Frames and framers," *Milbank Quarterly* 67, Supplement 1, Framing Disease: The Creation and Negotiation of Explanatory Schemes (1989), 1.

13. Indicatively, Carol A. Benedict, *Bubonic Plague in Nineteenth-Century China* (Redwood City, CA: Stanford University Press, 1996); Marilyn Chase, *The Barbary Plague: The Black Death in Victorian San Francisco* (London, UK: Random House, 2004); Myron J. Echenberg, *Plague Ports: The Global Urban Impact of Bubonic Plague, 1894–1901* (New York, NY: New York University Press, 2007); Myron J. Echenberg, *Black Death, White Medicine: Bubonic Plague and the Politics of Public Health in Colonial Senegal, 1914–1945* (Oxford, UK: James Curry, 2002); Christos Lynteris, *Ethnographic Plague: Configuring Disease on the Chinese-Russian Frontier* (London, UK: Palgrave Macmillan 2016); James C. Mohr, *Plague and Fire: Battling Black Death and the 1900 Burning of Honolulu's Chinatown* (Oxford, UK: Oxford University Press, 2004); Carl F. Nathan, *Plague Prevention and Politics in Manchuria 1910–1931* (Cambridge, MA: Harvard East Asian Monographs, 1967); Gunther B. Risse, *Plague, Fear, and Politics in San Francisco's Chinatown* (Baltimore, MD: Johns Hopkins University Press, 2012); William C. Summers, *The Great Manchurian Plague of 1910–1911: The Geopolitics of an Epidemic Disease* (New Haven, CT: Yale University Press, 2012).

14. For a critical study of the periodization and serialization of the three pandemics, see Merle Eisenberg and Lee Mordechai, "The Justinianic plague and global pandemics: The making of the plague concept," *Historical American Review* 125, no. 5 (December 2020): 1632–1667.

15. Benedict, *Bubonic Plague*.

16. Echenberg, *Plague Ports*.

17. Florence Bretelle-Establet, "Les épidémies en Chine à la croisée des savoirs et des imaginaires: Le Grand Sud aux xviiie et xixe siècles," *Extrême-orient extrême-occident* 34 (2014): 21–60; Robert Peckham, "Matshed laboratory: Colonies, cultures, and bacteriology," in *Imperial Contagions: Medicine, Hygiene, and Cultures of Planning in Asia*, ed. Robert Peckham and David M. Pomfret, 123–147 (Hong Kong: Hong Kong University Press, 2013).

18. Echenberg, *Plague Ports*.

19. Monika Pietrzak-Franger, *Syphilis in Victorian Literature and Culture: Medicine, Knowledge and the Spectacle of Victorian Invisibility* (London, UK: Palgrave Macmillan, 2017). On how yellow fever epidemics up to the 1890s were visually represented through illustrations but not photography, see Ingrid Gessner, "Epidemic iconographies: Toward a disease aesthetics of the destructive sublime," in "Iconographies of the Calamitous in American Visual Culture," ed. Ingrid Gessner and Susanne Leikam, special issue, *Amerikastudien/American Studies* 58, no. 4 (2013): 559–582.

20. Erin O'Connor, "Pictures of health: Medical photography and the emergence of anorexia nervosa," *Journal of the History of Sexuality* 5 (1995), 546.

21. Kirsten Ostherr, *Medical Visions: Producing the Patient through Film, Television, and Imaging Technologies* (Oxford, UK: Oxford University Press, 2013), 14.

22. Pietrzak-Franger, *Syphilis in Victorian Literature*.

23. Pietrzak-Franger, *Syphilis in Victorian Literature*.

24. Philippe Calain, "Ethics and images of suffering bodies in humanitarian medicine," *Social Science and Medicine* 98 (December 2013): 278–285.

25. Indicatively, 178 of the 2,281 photographs (that is, about 8 percent) contained in the Visual Representations of the Third Plague Pandemic Photographic Database show patients or their symptoms. Though this database is not a complete record of plague photography, the project's unpublished research database, containing over 11,000 photographs of the pandemic, presents a similar picture.

26. Erin O'Connor, "Camera medica: Towards a morbid history of photography," *History of Photography* 23, no. 3 (1999), 234.

27. Deborah Poole, *Vision, Race, and Modernity: A Visual Economy of the Andean Image World* (Princeton, NJ: Princeton University Press, 1997).

28. Nathan, *Plague Prevention and Politics*; Summers, *Great Manchurian Plague*; Mark Gamsa, "The epidemic of pneumonic plague in Manchuria 1910–1911," *Past and Present* 90 (2006): 147–184; Cheng Hu, "Quarantine sovereignty during the pneumonic plague in Northeast China (November 1910-April 1911)," *Frontier History of China* 5, no. 2 (2010): 294–295.

29. Temporary Epidemic Prevention Department of the Governor's Office of Kwantung, *An Account of the Plague in South Manchuria 1910–11 Illustrated with Photographs Taken on the Spot* (Kwantung Metropolitan Government, 1912); NYAML, RBS74, Anon., *Chuma v Manchzhurii, v. 1910–11 g.g* (1911); NRI, 808.24za WLD:1 (RBR), Wu Lien-teh, *Views of Harbin, Fuchiatien, Taken during the Plague Epidemic, December 1910–March 1911* (Shanghai, China: Commercial Press, [1911]).

30. For instance, Roger Baron Budberg, *Bilder aus der Zeit der Lungenpest-Epidemien in der Mandschurei 1910/1911 und 1921* (Hamburg, Germany: C. Behre, 1923); for Richard P. Strong's lantern show slides, see the Countway Library, University of Harvard, Strong, Richard P. (Richard Pearson), 1872–1948, Papers, 1911–2004. For a collection of missionary sources, see the Dugald Christie and Arthur Jackson holdings of the Centre for the Study of World Christianity archives, University of Edinburgh.

31. Robert Peckham, "Plague views: Epidemics, photography and the ruined city," in *Plague and the City*, ed. Lukas Engelmann, John Henderson, and Christos Lynteris, 91–115 (London, UK: Routledge, 2018), 93.

32. Christine M. Boeckl, *Images of Plague and Pestilence: Iconography and Iconology* (University Park, PA: Pennsylvania State University Press, 2001); Franco Mormando and Thomas Worcester, eds., *Piety and Plague from Byzantium to the Baroque* (Kirksville, MO: Truman State University Press, 2007); Gauvin Alexander Bailey, *Hope and Healing: Painting in Italy in a Time of Plague, 1500–1800* (Chicago, IL: University of Chicago Press, 2005).

33. I. F. C. Hecker, *The Black Death in the Fourteenth Century*, trans. B. G. Babington (London, UK: A. Schloss, 1833 [1832]), ix.

34. Faye Marie Getz, "Black Death and the silver lining: Meaning, continuity, and revolutionary change in histories of medieval plague," *Journal of the History of Biology* 24, no. 2 (1991): 265–289.

35. See especially Monica H. Green, "Taking 'pandemic' seriously: Making the Black Death global," *Medieval Globe* 1, no. 1 (2014): 4, https://scholarworks .wmich.edu/tmg/vol1/iss1/4.

36. Kenneth L. Gage and Michael Y. Kosoy, "Natural history of plague: Perspectives from more than a century of research," *Annual Review of Entomology* 50 (2005): 505–528; S. Ayyadurai, L. Houhamdi, H. Lepidi, C. Nappez, D. Raoult, and M. Drancourt, "Long-term persistence of virulent *Yersinia pestis* in soil," *Microbiology* 154 (2008): 2865–2871.

37. Michael Y. Kosoy, "Deepening the conception of functional information in the description of zoonotic infectious diseases," *Entropy* 15 (2013): 1929–1962.

38. Priscilla Wald, *Contagious: Cultures, Carriers, and the Outbreak Narrative* (Durham, NC: Duke University Press, 2008).

39. Poole, *Vision, Race, and Modernity*.

40. Lukas Engelmann, "Picturing the unusual: Uncertainty in the historiography of medical photography," *Social History of Medicine* 34, no. 2 (2021): 375–398.

41. Paradoxically Mark Honigsbaum has claimed in relation to the "Russian influenza" that "whereas prior to 1890 *The Times* had used the term 'pandemic' just twice (and more or less as a synonym for an epidemic), after 1890 it became increasingly linked to the increasing speed of global communications and other tropes of modernity." In fact, a search for the word in *The Times* reveals three appearances before 1890 (in 1877, 1879, and 1883) and just two in relation to the Russian influenza of 1889–1890; Mark Honigsbaum, "Defining pandemics: The coronavirus conundrum," *Hurst*, February 10, 2020, https://www.hurstpublishers.com /defining-pandemics-the-coronavirus-conundrum/.

42. Elizabeth Edwards, "Photographic uncertainties: Between evidence and reassurance," *History and Anthropology* 25, no. 2 (2014), 172.

43. Mark Harrison, "Pandemic," in *The Routledge History of Disease*, ed. Mark Jackson, 129–146 (London, UK: Routledge, 2017), 133.

44. Lynteris, "Plague masks."

45. Christos Lynteris, "Photography, zoonosis and epistemic suspension after the end of epidemics," in *The Anthropology of Epidemics*, ed. Ann H. Kelly, Frédéric Keck and Christos Lynteris, 84–101 (London, UK: Routledge, 2019); Maurits Bastiaan Meerwijk, "Bamboo dwellers: Plague, photography, and the house in colonial Java," in *Plague Image and Imagination from Medieval to Modern Times*, ed. Christos Lynteris, 205–234 (London, UK: Palgrave Macmillan, 2021); David Arnold, "Picturing plague: Photography, pestilence, and cremation in late nineteenth- and early twentieth-century India," in *Plague Image and Imagination from Medieval to Modern Times*, ed. Christos Lynteris, 111–139 (London, UK: Palgrave Macmillan, 2021).

46. University of Cambridge Repository—Apollo, Visual Representations of the Third Plague Pandemic Photographic Database (Apollo/VR3PP), https://www .repository.cam.ac.uk/handle/1810/280684.

47. For a reflexive look at the construction of the database, see Branwyn Poleykett, Nicholas H. A. Evans, and Lukas Engelmann, "Fragments of plague," in "The Total Archive," ed. Boris Jardine and Christopher M. Kelty, special issue, *Limn* 6 (2016), https://limn.it/articles/fragments-of-plague/.

48. Daniel R. Headrick, *The Tools of Empire: Technology and European Imperialism in the Nineteenth Century* (Oxford, UK: Oxford University Press, 1981).

49. See especially Ostherr, *Medical Visions*, and the collection of essays in Serlin, *Imagining Illness*.

50. BL, Captain Moss, photographer, *Plague Visitation, Bombay, 1896–97* (Photo 311/1: 1896–1897); Wu, *Views of Harbin*.

CHAPTER 1

1. Beatriz Pichel, "From facial expressions to bodily gesture: Passions, photography and movement in French 19th-century sciences," *History of the Human Sciences* 29, no. 1 (1016), 30.

2. Shawn Michelle Smith, *At the Edge of Sight: Photography and the Unseen* (Durham, NC: Duke University Press, 2013).

3. Smith, *Edge of Sight*, 4.

4. Monika Pietrzak-Franger, *Syphilis in Victorian Literature and Culture: Medicine, Knowledge and the Spectacle of Victorian Invisibility* (London, UK: Palgrave Macmillan, 2017).

5. David Serlin, "Introduction: Towards a visual culture of public health," in *Imagining Illness: Public Health and Visual Culture*, ed. David Harley Serlin, xi–xxxvii (Minneapolis, MN: University of Minnesota Press, 2010), xxxiii; Carlos Mondragón, "Concealment, revelation and cosmological dualism: Visibility, materiality and the spiritscape of the Torres Islands, Vanuatu," in "Montrer/Occulter," ed. Jacques Galinier, special issue, *Cahiers d'anthropologie sociale* 11 (2015): 38–50.

6. Sander L. Gilman, *Disease and Representation: Images of Illness from Madness to AIDS* (Ithaca, NY: Cornell University Press, 1988), 4, 7.

7. Sander L. Gilman, *Picturing Health and Illness: Images of Identity and Difference* (Baltimore, MD: Johns Hopkins University Press, 1995), 34.

8. I am borrowing here from Giorgio Agamben, who has pointed to the existence of two distinct but interlinked ontologies in classical thinking—what he calls "the ontology of apophantic assertion" (or "the ontology of *esti,*" from the Greek "to be") and "the ontology of command" (or "the ontology of *esto,*" from the Greek "must be"). If, Agamben argues, the originary statement of apophantic ontology is to be found in Parmenides's single surviving work, the poem "Peri Phuseōs" (On Being), in the form "*esti gar einai*: 'there is actually being,'" the equivalent imperative ontological form is "*esto gar einai,* 'let there actually be being'"; Giorgio Agamben, *Creation and Anarchy: The Work of Art and the Religion of Capitalism*, trans. Adam Kotsko (Redwood City, CA: Stanford University Press, 2019), 59.

9. The truism approach is adopted in Merle Eisenberg and Lee Mordechai, "The Justinianic plague and global pandemics: The making of the plague concept," *Historical American Review* 125, no. 5 (December 2020): 1632–1667. I would like to thank Merle Eisenberg for a frank discussion on this point of disagreement.

10. Erin O'Connor, "Pictures of health: Medical photography and the emergence of anorexia nervosa," *Journal of the History of Sexuality* 5 (1995), 546. These semiotics were augmented by the fact that turn-of-the century photographers' discourse had internalized medical tropes, as shown in Tanya Sheehan, *Doctored: The Medicine of Photography in Nineteenth-Century America* (University Park, PA: Pennsylvania State University Press, 2011).

11. See the Introduction for a discussion of the Database.

12. Jeffrey Mifflin, "Visual archives in perspective: Enlarging on historical medical photographs," *American Archivist* 70 (Spring/Summer 2007), 56.

13. Christine M. Boeckl, *Images of Plague and Pestilence: Iconography and Iconology* (University Park, PA: Pennsylvania State University Press, 2001).

14. Boeckl, *Images of Plague*. On continuities in the clinical description of plague between the Middle Ages and modern times, see Lars Walløe, "Medieval and modern bubonic plague: Some clinical continuities," supplement, *Medical History* 27 (2008): 59–73.

15. D. G. Grigsby, "Rumour, contagion and colonization in Gros's plague-stricken of Jaffa (1804)," *Representations* 51 (1995): 1–46.

16. Chris Amirault, "Posing the subject of early medical photography," in "Expanded Photography," special issue, *Discourse* 16, no. 2 (Winter 1993–1994), 73. On the photography of fibromas and tumors in colonial contexts, see Larissa N. Heinrich, "The pathological empire: Early medical photography in China," *History of Photography* 30, no. 1 (2006): 25–38; Gilman, *Disease and Representation*, chapter 9; Nancy Leys Stepan, *Picturing Tropical Nature* (London, UK: Reaktion Books, 2001); Annick Opinel, "Corps sommeilleux, déformés, interrompus: Les tableaux cliniques des maladies parasitaires (début XXᵉ siècle)," *Corps* 2, no. 5 (2008): 49–56; Kirsten Ostherr, "Empathy and objectivity: Health education through corporate publicity films," in *Imagining Illness: Public Health and Visual Culture*, ed. David Harley Serlin, 62–82 (Minneapolis, MN: University of Minnesota Press, 2010). For examples of such posing for photographing buboes, see E. Tardif, *La peste á Quang-Tchéou-Wan* (Paris, France: Ballière et fils, 1902); L. N. Malinovsky, D. K. Zabolotny, and P. N. Bulatov, *Chuma v Odesse v 1910 g. Epidemiologiya, patologiya, klinika, bakteriologiya i meropriyatiya* (Saint Petersburg, Russia: Tip. A. S. Suvorna "novoye vremya," 1912); Alejandro del Río, Ramon Zegers, Ricardo D. Boza, and Louis Montero, *Informe sobre la epidemia de peste bubónica en Iquique en 1903: Presentado al Supremo Gobierno por la comisión encargada de reconocer la naturaleza de la enfermedad (Santiago, Chile: Impr. Cervantes, 1904)*; Heinrich Albrecht, Hermann Franz Müller, and Anton Ghon, Kaiserlichen Akademie der Wissenschaften in Wien, *Über die Beulenpest in Bombay, im Jahre 1897*, vol. 1–3 (Vienna, Austria: K. K. Hof- und Staatsdruckerei, in Commission bei Carl Gerold 1898–1900). Poleykett has also argued that, in Pasteurian North African contexts, "Subjects of [medical] photographs contort their bodies uncomfortably to 'present' and 'frame' one part of their body to the camera while still making their whole body visible"; Branwyn Poleykett, "Pasteurian tropical medicine and colonial scientific vision," *Subjectivity* 10 (2017), 199–200.

17. Wellcome Collection's holding notes that the photograph was "originally collected by British anthropologist Edwin Nichol Fallaize (1877–1957). Purchased by Capt. L.W.G. Malcolm in 1934, on behalf of Sir Henry Solomon Wellcome, for the

price of £25. From a letter in the Wellcome archives dated 16th December 1934," https://search.wellcomelibrary.org/iii/encore/record/C__Rb1539279?lang=eng.

18. Albrecht et al., *Über die Beulenpest*. The image was consequently reproduced in several works on plague across the globe, including W. G. Savage and D. A. Fitzgerald, "A case of the plague from a clinical and pathological point of view," *British Medical Journal* 2, no. 2078 (1900): 1232–1236; IEM, 11836, Vasily Pavlovich Kashkadamov, *Al'bom snimkov c chumnuikh bol'nuikh* (Saint Petersburg, Russia: Severnaya Fototipiya, 1902).

19. Lukas Engelmann, "Making a model plague: Paper technologies and epidemiological casuistry in the early twentieth century," in *Plague Image and Imagination from Medieval to Modern Times*, ed. Christos Lynteris, 235–266 (London, UK: Palgrave Macmillan, 2021). For a discussion of the significance of buboes and their location, see William Hunter, "Buboes and their significance in plague," *The Lancet* 168, no. 4324 (July 14, 1906): 83–86. In a small number of publications, photographs of infected organs were also reproduced, with this being more prevalent and systematic in the case of pneumonic plague. See, for example, Wu Lien-teh, *Treatise on Pneumonic Plague* (Geneva, Switzerland: League of Nations, 1926).

20. Erin O'Connor, "Camera medica: Towards a morbid history of photography," *History of Photography* 23, no. 3 (1999), 234. See also Adria L. Imada, "Promiscuous signification: Leprosy suspects in a photographic archive of skin," *Representations* 138, no. 1 (Spring 2017): 1–36; Katherine Ott, "Contagion, public health and visual culture of nineteenth-century skin," in *Imagining Illness: Public Health and Visual Culture*, ed. David Harley Serlin, 85–107 (Minneapolis, MN: University of Minnesota Press, 2010). On the dramaturgical aspect of diseases and epidemics, see Charles E. Rosenberg, "What is an epidemic? AIDS in historical perspective," in "Living with AIDS," special issue, *Daedalus* 118, no. 2 (Spring 1989): 1–17.

21. I am here borrowing on the double function of sense and sense-making of photographs from Zahid R. Chaudhary, *Afterimage of Empire: Photography in Nineteenth-Century India* (Minneapolis, MN: University of Minnesota Press, 2012). There is an extensive corpus of historical, anthropological, and visual studies works and collections on colonial photography and the production of "racial types" and exotic pathology; for example, see James R. Ryan, *Picturing Empire: Photography and the Visualization of the British Empire* (London, UK: Reaktion Books, 1997); Chaudhary, *Afterimage of Empire*; Eleanor M. Hight, and Gary D. Sampson, eds., *Colonialist Photography: Imag(in)ing Race and Place* (London, UK: Routledge, 2002); Elizabeth Edwards, ed., *Anthropology and Photography, 1860–1920* (New Haven, CT: Yale University Press, 1992); Paul S. Landau, "Empires of the visual: Photography and colonial administration in Africa," in *Images and Empires: Visuality in Colonial and Postcolonial Africa*, ed. Paul S. Landau and Deborah D. Kaspin, 141–171 (Berkeley, CA: University of California Press, 2002); Poleykett, "Pasteurian tropical medicine."

22. Ryan, *Picturing Empire*, 145. Ryan borrowed the term from Mary Louise Pratt, *Imperial Eyes: Travel Writing and Transculturation* (London, UK: Routledge, 1992).

23. On the production of regularity in colonial photography, see Chaudhary, *Afterimage of Empire*, 8. For a photograph of a European patient, from Porto, regularly used to this effect, see PIP, MP31294, Malade de la peste à Porto en 1899.

24. Ryan, *Picturing Empire*, 165.

25. Abhijit Sarkar, "Reflexive gaze and the construction of meanings: Photographing plague hospitals in colonial Bombay," in *Plague Image and Imagination from Medieval to Modern Times*, ed. Christos Lynteris, 141–189 (London, UK: Palgrave 2021); Christopher Pinney, "The prosthetic eye: Photography as cure and poison," in "The Objects of Evidence: Anthropological Approaches to the Production of Knowledge," special issue, *Journal of the Royal Anthropological Institute* 14, no. 1 (2008): 33–46. On the gendered aspect of missionary clinical photographs of plague in British India, see also Malavika Karlekar, "Postcards from Home," in *Visual Histories: Photography in the Popular Imagination* (New Delhi, India: Oxford University Press, 2013).

26. Sarkar, "Reflexive Gaze."

27. Paul Gilroy, *Against Race: Imagining Political Culture beyond the Colour Line* (Cambridge, MA: Belknap Press of Harvard University Press, 2000).

28. On the epidemiological reality of colonial plague hospitals and on indigenous perceptions of these institutions, see Carol A. Benedict, *Bubonic Plague in Nineteenth-Century China* (Redwood City, CA: Stanford University Press, 1996); Samuel K. Cohn Jr, *Epidemics: Hate and Compassion from the Plague of Athens to AIDS* (Oxford, UK: Oxford University Press, 2018).

29. Apollo/VR3PP, PhotoID_4032, https://www.repository.cam.ac.uk/handle /1810/282692. The photograph in the Database is from WL, .b32162698, Karachi Plague Committee in 1897, where Simond is misidentified as "Dr Simmonds."

30. On the imagery of languid patients, see Jean-Jacques Lefrère and Bruno Danic, "Pictorial representation of transfusion over the years," *Transfusion* 49, no. 5 (2009): 1007–1017. What is not, however, present in vaccination or serotherapy images is the transgressive element present in images of transfusion. The gesture we see here seems to be rhyming with Pasteurian photographs of quinine delivery from North Africa at the time; Claire Fredj, "Le laboratoire et le bled: L'Institut Pasteur d'Alger et les médecins de colonisation dans la lutte contre le paludisme (1904–1939)," *Dynamis* 36, no. 2 (2016): 293–316. On gesture in colonial photography, see also Karlekar, *Visual Histories*, chapter 2.

31. For a discussion of medical photography's contribution to this dichotomy and the way in which it more broadly fits within John Tagg's reading of photography and power, see Mifflin, "Visual archives in perspective."

32. Ann Perez Hattori, "Re-membering the past: Photography, leprosy and the Chamorros of Guam, 1898–1924," *Journal of Pacific History* 46, no. 3 (December 2011), 310.

33. Matheus Alves Duarte da Silva, "Quand la peste connectait le monde: Production et circulation de savoirs microbiologiques entre Brésil, Inde et France (1894–1922)." PhD diss., École des Hautes Études en Sciences Sociales, 2020.

34. Pratik Chakrabarti, *Bacteriology in British India: Laboratory Medicine and the Tropics* (Rochester, NY: University of Rochester Press, 2012), 49. For a discussion of plague postcards in India, including the one of inoculation, see Zinnia Ray Chaudhury, "How the British used postcards as a propaganda tool during the Bombay plague of 1896," *Scroll.in*, September 22, 2018, https://scroll.in /magazine/891745/how-the-british-used-postcards-as-a-propaganda-tool-during -the-bombay-plague-of-1896. For a discussion of the colonial politics and aesthetics of selecting photographs for postcards, see Richard Vokes, "Reflections on a complex (and cosmopolitan) archive: Postcards and photography in early colonial Uganda, c.1904–1928," *History and Anthropology* 21, no. 4 (2010): 375–409. For a discussion of postcards of leprosaria in Guam, see Hattori, "Re-membering the Past," 293–318.

35. Silva, "Quand la peste connectait le monde."

36. Figure 1.3 was, for example, included in Anon., "Plague pandemic," *British Medical Journal* 2, no. 2078 (1900): 1255; William Burney Bannerman, *Plague in India, Past and Present* (London, UK: Research Defence Society, 1910); Anon., "A microbe manufactory," *Hickman Courier* 50, no. 34 (February 4, 1909): 1. For examples of photographs of Pasteurian serum production, see Apollo/VR3PP, PhotoID_9803, https://www .repository.cam.ac.uk/handle/1810/284823, and PhotoID_9805, https://www .repository.cam.ac.uk/handle/1810/284825. For examples another photograph of producing Haffikine's plague vaccine, see Apollo/VR3PP, PhotoID_9806, https:// www.repository.cam.ac.uk/handle/1810/284826.

37. For a critique of this idea of photography as "merely a 'screen onto which more powerful primary ideologies are projected,'" see Christopher Pinney, "Civil contract of photography in India," *Comparative Studies of South Asia, Africa and the Middle East* 35, no. 1 (2015): 21–34, 29.

38. Walløe, "Medieval and modern bubonic plague."

39. AIP, SIM.5, Lieu: A3/81–84. I would like to thank Matheus Alves Duarte da Silva for bringing these letters to my attention and sharing transcripts of them. The exchange seems to have been elicited by Simond, although the letter asking Choksy for photographs is missing from the archives.

40. Here, as in the majority of clinical photographs of plague, what Ingrid Gessner has identified in the case of 1890s yellow fever photography in the United States as a reluctance to show "heavily distorted victims" is not present; Ingrid Gessner,

"Epidemic iconographies: Toward a disease aesthetics of the destructive sublime," in "Iconographies of the Calamitous in American Visual Culture," ed. Ingrid Gessner and Susanne Leikam, special issue, *Amerikastudien/American Studies* 58, no. 4 (2013), 579.

41. AIP, SIM.5, Lieu: A3/81–84, Choksy to Simond, January 11, 1908.

42. IEM, 11836, Kashkadamov, *Al'bom snimkov c chumnuikh bol'nuikh*. For a summary of Kashkadamov's itinerary in India, see L. I. Mirchanov et al., *Fort "Imperator Aleksandr I"* (Ostrov, Russia, 2008). That Choksy's work was well known to Russian plague researchers is evident in frequent references (sometimes spelled Choksey or Choxey, in Roman characters) found in Kashkadamov's letters from India, as well as in Russian publications on plague in India; IEM, 10561, Vasily Pavlovich Kashkadamov, Pis'ma iz Indii (1898), especially the letter dated Bombay, February 7/19, 1898; IEM, 11043, N. N. Vestenrik, *Chuma v Bombeye* (Saint Petersburg, Russia: Tipografiya Morskogo Ministerstva, 1900).

43. IEM, 11836, Kashkadamov, *Al'bom snimkov c chumnuikh bol'nuikh*, 1. Three of the photographs in this album, of which two also appearing in Choksy's letter to Simond, had previously appeared a year earlier in another publication by Kashkadamov: IEM, 14065, Vasily Pavlovich Kashkadamov, *O chume soglasno noveyshim dannuim* (Saint Petersburg, Russia: Tipografiya M. M. Stasyulevicha, 1901).

44. As already noted, figure 1.1 is also included in Kashkadamov's album. Of the nine photographs coinciding between those in Choksy's letter and the Kashkadamov album, five appear in more complete form in Choksy and four in Kashkadamov; in both cases, copies were cropped so as to focus more directly on the symptoms to the exclusion of the larger body of the patient.

45. AIP, SIM.5, Lieu: A3/81–84, Simond to Choksy, December 6, 1910.

46. Paul-Louis Simond, "Peste," in *Traité de pathologie exotique, clinique et thérapeutique. 6, Maladies parasitaires, peste*, ed. Lecompte et al., 455–648 (Paris, France: J.-B. Baillière et fils, 1913). By contrast Choksy was later recognized as the author of these photographs in German works by Reinhold Friedrich Ruge: Reinhold Friedrich Ruge and Max Zur Verth, *Tropenkrankheiten und Tropenhygiene* (Leipzig, Germany: Klinkhardt, 1912); Reinhold Friedrich Ruge, *Krankheiten und Hygiene der warmen Länder: Ein Lehrbuch für die Praxis*, 4th ed. (Leipzig, Germany: Georg Thieme, 1938).

47. Previously, in his 1898 work demonstrating fleas as plague vectors, Simond had associated necrosis with fleabites; Paul-Louis Simond, "La propagation de la peste," *Annales de l'Institut Pasteur* 12 (1898): 625–687.

48. N. H. Choksy, "An unrecognized type of plague," in *Transactions of the Seventh Congress Held in British India, December 1927, Far Eastern Association of Tropical Medicine*, ed. J. Cunningham, 40–43 (Calcutta, India: Thacker's Press & Directories, 1927), 40.

49. Choksy, "Unrecognized type of plague," facing 42, 43.

50. David J. Bibel and T. E. Chen, "Diagnosis of plague: An analysis of the Yersin-Kitasato controversy," *Bacteriological Reviews* 40, no. 3 (September 1976): 633–651.

51. AIP, YER.6, Lieu: A1/13. For a discussion of the matshed and its history, see Robert Peckham, "Matshed laboratory: Colonies, cultures, and bacteriology," in *Imperial Contagions: Medicine, Hygiene, and Cultures of Planning in Asia*, ed. Robert Peckham and David M. Pomfret, 123–147 (Hong Kong: Hong Kong University Press, 2013).

52. The most commonly used portrait at the time was: PIP, MP24789, Portrait d'Alexandre Yersin (1863–1943) à l'âge de 30 ans en 1893, Photo Pierre Petit. On masculinity and colonial Pasteurianism, see Aro Velmet, *Pasteur's Empire: Bacteriology and Politics in France, Its Colonies, and the World* (Oxford, UK: Oxford University Press, 2020).

53. Matheus Alves Duarte da Silva, "From Bombay to Rio de Janeiro: The circulation of knowledge and the establishment of the Manguinhos Laboratory, 1894–1902," *História, Ciências, Saúde—Manguinhos, Rio de Janeiro* 25, no. 3 (July-September 2018), https://www.scielo.br/pdf/hcsm/v25n3/en_0104-5970-hcsm-25-03-0639.pdf. The Institut Pasteur was very conscious of its image in the press and sought to control it, often systematically; Velmet, *Pasteur's Empire*.

54. In India alone, during the first years of the pandemic, in addition to the British research teams and commissions, at least four foreign commissions (Austrian, German, Italian, and Russian), as well as a group of the Institut Pasteur from French Indochina, competed for data and "discoveries."

55. On Alexandre Yersin's famous photograph of his matshed laboratory in 1894 Hong Kong, see Peckham, "Matshed laboratory."

56. See, for example, the plague laboratory accident in Vienna, 1898: Anon., "The plague at Vienna; Dr. Mueller, who attended Barisch, succumbs to the disease—his devotion to science," *New York Times*, October 24, 1898, https://www.nytimes.com/1898/10/24/archives/the-plague-at-vienna-dr-mueller-who-attended-barisch-succumbs-to.html.

57. Christos Lynteris, "Vagabond microbes, leaky laboratories and epidemic mapping: Alexandre Yersin and the 1898 plague epidemic in Nha Trang," *Social History of Medicine* 34, no 1 (2021): 190–213.

58. Some examples include: WL, b29146318, *The Plague Expedition to Anzob in Russian Turkestan*. Photograph album by A. M. Levin, 1899, https://wellcomelibrary.org/item/b29146318; IEM, 11836, Kashkadamov, *Al'bom snimkov c chumnuikh bol'nuikh*. For an examination of photographs of the Anzob plague expedition, see Gian Pietro Basello and Paolo Ognibene, "A black dog from Marzic: Legends and facts about Anzob plague," in *Yaghnobi Studies I: Papers from the Italian Missions in Tajikistan*, ed. Antonio Panaino, Andrea Gariboldi, and Paolo Ognibene, 87–115 (Milan, Italy: Mimesis, 2013).

59. Mirchanov et al., *Fort "Imperator Aleksandr I."*

60. I. M. Eyzen, "Bor'ba chumoy," *Niva* 48 (1900): 952–959, 974–975, my translation.

61. Apollo/VR3PP, PhotoID_8588, https://ww.w.repository.cam.ac.uk/handle /1810/281378.

62. Jennifer Mary Keating, "Space, Image and Display in Russian Central Asia, 1881–1914," PhD diss. (University College London, 2016), 67.

63. For the image discussed by Keating, see V&A Museum, NAL pressmark PP.400.R, N. N. Karazin, "Zakaspiiskaia zheleznaia doroga," *Vsemirnaia illiustrat- siia* 1888 (II), p. 181.

64. Valeria Sobol, *Haunted Empire: Gothic and the Russian Imperial Uncanny* (Ithaca, NY: Cornell University Press, 2020). For a discussion of plague in the South- East Russian frontier and Russian Central Asia, see Christos Lynteris, *Ethnographic Plague: Configuring Disease on the Chinese-Russian Frontier* (London, UK: Palgrave Macmillan, 2019); Dmitry Mikhel, "Chuma i epidemiologicheskaya revolyutsiya v Rossii, 1897–1914," *Vestnik Evrazii* 3 (2008): 142–164; Anna E. Afanasyeva, "Explaining and Managing Epidemics in Imperial Contexts: Russian Responses to Plague in the Kazakh Steppe in the Late 19th and Early 20th Centuries," Higher School of Economics Research Paper No. WP BRP 145/HUM/2017 (2017), http://dx.doi.org/10.2139/ssrn.2949792.

65. Martyrology was prevalent in Russian narratives of plague research. Schreiber was not the first doctor to perish in Plague Fort; before him, in 1904 the labo- ratory's director Vladislav Ivanovich Turchinovich-Vuizhnikevich (1865–1904) had died after becoming infected with the disease. Schreiber's death led to Danilo Kirilovich Zabolotny, a doctor with extensive experience on plague research, being appointed as the director of Plague Fort; Russian Academy of Sciences/ North-West Branch of RAMS, *Institute of Experimental Medicine* (Saint Petersburg, Russia: Khromis, 2005). Martyrological images are also contained in NYAML, RBS74, Anon., *Chuma v Manchzhurii, v. 1910–11 g.g* (n.p., 1911).

66. Moscow Economic and Law Institute, "Geroi dolga. Na Forte 'Imperator Aleksandr I.' (ocherk I. M. Eyzena, 1907 god)," *Problemui mectonogo samoypravleniya*, n.d., http://www.samoupravlenie.infobox.ru/38-11.php. See also the facsimile of the *Niva* article at http://www.samoupravlenie.ru/18-03.htm.

67. Moscow Economic and Law Institute, "Geroi dolga."

68. Moscow Economic and Law Institute, "Geroi dolga."

69. Moscow Economic and Law Institute, "Geroi dolga."

70. Figure 1.6 source: https://commons.wikimedia.org/wiki/File:Шрейбер_М ._Ф._—_жертва_чумной_пневмонии_(1907).png

71. The original image of the bottle containing the ashes can be accessed at Apollo/ VR3PP, PhotoID_8592, https://www.repository.cam.ac.uk/handle/1810/281382.

The portrait of the dead doctor is a cropped image from Apollo/VR3PP, Photo-ID_8645 https://www.repository.cam.ac.uk/handle/1810/281440.

72. Moscow Economic and Law Institute, "Geroi dolga"; Apollo/VR3PP, Photo-ID_8593, https://www.repository.cam.ac.uk/handle/1810/281384.

73. Apollo/VR3PP, PhotoID_8685, https://www.repository.cam.ac.uk/handle /1810/281482.

74. Jennifer Tucker, "The historian, the picture, and the archive," *Isis* 97, no. 1 (March 2006): 111–120, 118; Vokes, "Reflections on a complex (and cosmopolitan) archive," 397.

75. Vokes, "Reflections on a complex (and cosmopolitan) archive," 405. I am borrowing the term "elided past" from Joshua A. Bell, "Out of the mouths of crocodiles: Eliciting histories in photographs and string-figures," *History and Anthropology* 21, no. 4 (December 2010), 351.

76. Jennifer Tucker, *Nature Exposed: Photography as Eyewitness in Victorian Science* (Baltimore, MD: Johns Hopkins University Press, 2013), 182.

77. For an excellent example of radical uncertainty on the identity of the causative agent, see Anon., "The plague panic in Calcutta and government," *Calcutta Journal of Medicine* 17, no. 4 (April 1898): 134–141. On Hankin's doubts, see HCPP, Cd. 140, Indian Plague Commission, 1898–99. Minutes of Evidence Taken by the Indian Plague Commission with Appendices. Vol. II. Evidence taken from 11th January 1899 to 8th February 1899; Session: 1900, CH Microfiche number: 106.269–274.

78. Bruno Latour, *The Pasteurization of France* (Cambridge, MA: Harvard University Press, 1988); Andrew Cunningham, "Transforming plague, the laboratory and the identity of infectious disease," in *The Laboratory Revolution in Medicine*, ed. Andrew Cunningham and Perry Williams, 209–244 (Cambridge, UK: Cambridge University Press, 1992); Sean Hsiang-lin Lei, "Sovereignty and the microscope: Constituting notifiable infectious disease and containing the Manchurian plague (1910–11)," in *Health and Hygiene in Chinese East Asia: Policies and Publics in the Long Twentieth Century*, ed. Angela Ki Che Leung and Charlotte Furth, 73–106 (Durham, NC: Duke University Press, 2011); Lynteris, *Ethnographic Plague.*

79. Myron J. Echenberg, *Plague Ports: The Global Urban Impact of Bubonic Plague, 1894–1901* (New York, NY: New York University Press, 2007). At the same time, the absence of the microorganism could not be accepted as proof of the absence of the disease. In the words of the first Indian Plague Commission, "the non-discovery of such bacteria will not in any way rebut a diagnosis of plague based on clinical symptoms"; HCCP, Cd. 810, Indian Plague Commission, 1898–99. Report of the Indian Plague Commission with Appendices and Summary. Vol. V; Session: 1902, CH Microfiche number: 108.637, p. 61. On how this fostered many years of epidemiological debate over the category of pestis minor, see Christos

Lynteris, "*Pestis minor*: The history of a contested plague pathology," *Bulletin of the History of Medicine* 93, no. 1 (Spring 2019): 55–58.

80. Tucker, *Nature Exposed*, 187.

81. Lukas Engelmann, *Mapping AIDS: Visual Histories of an Enduring Epidemic* (Cambridge, UK: Cambridge University Press, 2017), 177. See also Thomas Schlich, "Linking cause and disease in the laboratory: Robert Koch's method of superimposing visual and 'functional' representations of bacteria," *History and Philosophy of the Life Sciences* 22, no. 1 (2000): 43–58. On the use of diagrams in configuring plague, see Christos Lynteris, "Zoonotic diagrams: Mastering and unsettling human-animal relations," *Journal of the Royal Anthropological Institute* 23, no. 3 (2017): 463–485; Lukas Engelmann, "Configurations of plague: Spatial diagrams in early epidemiology," in "Working with Diagrams," ed. Lukas Engelmann, Caroline Humphrey, and Christos Lynteris, special issue, *Social Analysis* 63, no. 4 (2019): 89–109; Lukas Engelmann, Caroline Humphrey, and Christos Lynteris, "Introduction: Diagrams beyond mere tools," in "Working with Diagrams," ed. Lukas Engelmann, Caroline Humphrey, and Christos Lynteris, special issue, *Social Analysis* 63, no. 4 (2019): 1–19. For an interesting use of a plague diagram in public health communication in French West Africa, see Pauline Kusiak, "Instrumentalizing rationality, cross-cultural mediators, and civil epistemologies of late colonialism," *Social Studies of Science* 40, no. 6 (2010): 871–902, p. 885, figure 4.

82. William J. R. Simpson, "The Croonian lectures on plague. Delivered before the Royal College of Physicians of London on June 18th, 20th, 25th, and 27th, 1907. Lecture 1," *The Lancet* 169, no. 4374 (June 29, 1907), 1757.

83. Nicholas H. Evans, "Blaming the rat? Accounting for plague in colonial Indian medicine," *Medicine, Anthropology, Theory* 5, no. 3 (2018): 15–42.

84. Mark Honigsbaum, "'Tipping the balance': Karl Friedrich Meyer, latent infections, and the birth of modern ideas of disease ecology," *Journal of the History of Biology* 49 (2016): 261–309.

85. "Pestigenic" was a term used during the pandemic. See, for example, Sir Philip H. Manson-Bahr, *Manson's Tropical Diseases: A Manual of the Diseases of Warm Climates* (London, UK: Cassell & Company, 1898); Ricardo Jorge, *La peste africaine: Rapport présenté au Comité permanent de l'Office International d'Hygiène Publique dans sa session d'avril–mai 1935* (Paris, France: Office International d'Hygiène Publique, 1935); Karl F. Meyer, "The sylvatic plague committee," *American Journal of Public Health and the Nation's Health* 26, no. 10 (October 1936): 961–969. For the notion of pathogenic/pestigenic interrelations my work is indebted to conversations with Lukas Engelmann, who has developed this notion from his own analytical angle in Lukas Engelmann, "Picturing the unusual: Uncertainty in the historiography of medical photography," *Social History of Medicine* 34, no. 2 (November 2019): 375–398, https://doi.org/10.1093/shm/hkz108.

86. These expeditions predated the formation of the notion of natural ecology or disease ecology by several decades, with the transition from reservoir-focus to ecology-focus approaches taking place in the 1930s and 1940s; for a discussion of the epistemological turn in the context of the United States, see Honigsbaum, "Tipping the balance."

87. William J. R. Simpson *A Treatise on Plague: Dealing with the Historical, Epidemiological, Clinical, Therapeutic and Preventive Aspects of the Disease* (Cambridge, UK: Cambridge University Press, 1905); Simond, "Peste." *The Conquest of Plague*, published at the proclaimed conclusion of the pandemic, makes only passing references to tropical medicine; L. Fabian Hirst, *The Conquest of Plague: A Study of the Evolution of Epidemiology* (New York, NY: Oxford University Press, 1953).

88. Pratik Chakrabarti has recently unsettled historical analytical frameworks of tropical medicine "as an invented tradition"; Chakrabarti, *Bacteriology in British India*, 7.

89. Ryan, *Picturing Empire*, 40; Pratik Chakrabarti, *Medicine and Empire 1600–1960* (London, UK: Palgrave Macmillan, 2014), 146.

90. David Arnold, *The Problem of Nature: Environment, Culture and European Expansion* (Oxford, UK: Blackwell, 1997). It is tempting here to think of plague as being part of diseases discussed by historians of Pasteurian medicine in North Africa as associated with a lag in time; see Poleykett, "Pasteurian tropical medicine"; and Anne-Marie Moulin, "Tropical without tropics: The turning point of Pastorian medicine in North Africa," in *Warm Climates and Western Medicine: The Emergence of Tropical Medicine*, ed. David Arnold (Amsterdam, Netherlands: Rodopi, 1996). I would like to thank Matheus Alves Duarte da Silva for his advice on the tropicality of plague. At the conference "Reframing Disease Reservoirs: Histories and Ethnographies of Pathogens and Pestilence" (St Andrews, May 26–28, 2021), Matheus Alves Duarte da Silva argued that the notion of sylvatic plague emerged in relation to plague as a disease of desertic or arid natural environments.

91. Ryan, *Picturing Empire*; Stepan, *Picturing Tropical Nature*; Opinel, "Corps sommeilleux"; Annick Opinel, "La photographie et la Clinique des maladies parasitaires sans le premier tier du XXᵉ siècle," in "Actes du Congrès d'histoire des sciences et techniques organisé à Poitiers du 20 au 22 mai 2004 par la Société française d'histoire des sciences et techniques," ed. Anne Bonnefoy and Bernard Joly, *Cahiers d'histoire et de philosophie des sciences*, hors-série, 2006: 166–167; Sílvio Marcus de Souza Correa, "O 'combate' às doenças tropicais na imprensa colonial alemã," *História, Ciências, Saúde—Manguinhos* 20, no. 1 (2013): 69–91.

92. Chakrabarti, *Bacteriology in British India*, 13.

93. Lynteris, *Ethnographic Plague.*

94. HKUL, U 614.49518 W9, Views of Chinese plague epidemic expedition in west Manchuria, 1911/ headed by W.L.T.

95. Christos Lynteris, "Photography, zoonosis and epistemic suspension after the end of epidemics," in *The Anthropology of Epidemics*, ed. Ann H. Kelly, Frédéric Keck, and Christos Lynteris, 84–101 (London, UK: Routledge, 2019); Christos Lynteris, "Tarbagan's winter lair: Framing drivers of plague persistence in Inner Asia," in *Framing Animals as Epidemic Villains: Histories of Non-Human Disease Vectors*, ed. Christos Lynteris, 65–90 (London, UK: Palgrave Macmillan, 2019).

96. It is not known when these were excavated, but it is probable that this had taken place soon after the thaw (around April) rather than in the course of the expedition.

97. Lynteris, "Tarbagan's winter lair."

98. Figure 1.8 is contained in HKUL, U 614.49518 W9.

99. Lynteris, "Photography, zoonosis and epistemic suspension," 95.

100. For an example see Wu Lien-teh (G. L. Tuck) and The Hulun Taotai, "First report of the North Manchurian Plague Prevention Service," *Journal of Hygiene* 13, no. 3 (October 1913): 237–290.

101. Ryan, *Picturing Empire*, 67. In the case of the Sino-Russian expedition, the photographs taken and published by the Chinese side of the expedition lionized the efficiency and rigor of the Chinese side of the expedition by comparison to what they portrayed as the dated if respectable science of the Russians; Lynteris, "Photography, zoonosis and epistemic suspension."

102. Elizabeth Edwards, "Performing science: Still photography and the Torren Strait expedition," in *Cambridge and the Torres Strait: Centenary Essays on the 1898 Anthropological Expedition*, ed. Anita Herle and Sandra Rouse, 106–135 (Cambridge, UK: Cambridge University Press, 1998), 106. See also Morris Low, "The Japanese eye: Science, exploration and empire," in *Photography's Other Histories*, ed. Christopher Pinney, Nicolas Peterson, and Nicholas Thomas, 100–188 (Durham, NC: Duke University Press, 2003); Lorraine Daston and Peter Galison, *Objectivity* (New York, NY: Zone Books, 2007).

103. Walter Benjamin, "Little history of photography," in *Selected Writings*, vol. 2: *1927–1934*, 507–530 (Cambridge, MA: Belknap Press of Harvard University Press, 1991), 511–512.

104. Eadweard J. Muybridge, *The Attitudes of Animals in Motion: A Series of Photographs Illustrating the Consecutive Positions Assumed by Animals in Performing Various Movements; Executed at Palo Alto, California, in 1878 and 1879* ([San Francisco, CA], 1881), https://exhibits.stanford.edu/muybridge/catalog/qd999gm5772.

105. Lisa Cartwright, "'Experiments of destruction': Cinematic inscriptions of physiology," in "Seeing Science," special issue, *Representations* 40 (Autumn 1992): 129–152, 131; Phillip Prodger, *Time Stands Still: Muybridge and the Instantaneous Photography Movement with an Essay by Tom Gunning* (Oxford, UK: Oxford University Press, 2003); Jimena Canales, *A Tenth of a Second: A History* (Chicago, IL: University of Chicago Press, 2009).

106. Rosalind E. Krauss, *The Optical Unconscious* (Cambridge, MA: MIT Press, 1993); Smith, *Edge of Sight*. It should be noted that Zahid Chaudhary has integrated Benjamin's "optical unconscious" in his approach to British colonial photography in India from a perspective that maintains its psychoanalytical value; unfortunately, this effort overlooks Krauss's critique, which shows Benjamin's term as wanting in coherence within the rubric of psychoanalysis; Chaudhary, *Afterimage of Empire*, see pp. 9–10.

107. Smith, *Edge of Sight*, 6.

108. Ryan, *Picturing Empire*, 36.

109. Smith, *Edge of Sight*, 6.

110. Smith, *Edge of Sight*, 8.

111. Kirsten Ostherr, *Cinematic Prophylaxis: Globalization and Contagion in the Discourse of World Health* (Durham, NC: Duke University Press, 2005).

112. Karl Friedrich Meyer, "The known and unknown in plague," *American Journal of Tropical Medicine and Hygiene* 1–22, no. 1 (January 1, 1942), 9.

113. Meyer, "Known and unknown," 9.

114. Meyer, "Known and unknown," 9.

115. Malek Alloula, *The Colonial Harem* (Minneapolis, MN: University of Minnesota Press, 1988). See also: George R. Trumbull IV, *An Empire of Facts: Colonial Power, Cultural Knowledge, and Islam in Algeria, 1870–1914* (Cambridge, UK: Cambridge University Press, 2009).

116. Simpson, *Treatise on Plague*, vii.

117. Pierre Apéry, "Bulletin épidémiologique. L'utilité des quarantaines," *Revue médico-pharmaceutique* 14, no. 21 (November 1, 1901): 241–242, 241, my translation. Apéry was the founder and editor of the *Revue médico-pharmaceutique* and the *Gazette médicale d'orient*, the Ottoman Empire's most influential medical journals at the time; Michele Nicolas, "Pierre Apéry et ses publications scientifiques," *Revue d'histoire de la pharmacie* 94, no. 350 (2006): 237–247.

118. Simpson, *Treatise on Plague*, 144–145.

119. D. Stekoulis, "Bulletin épidémiologique," *Gazette médicale d'orient* 43, no. 24 (February 15, 1899), 353, my translation.

120. Thomas Colvin, "Is bubonic plague still lurking in the city of Glasgow?" *The Lancet* 170, no. 4396 (November 30, 1907), 1522. On the absence of plague-infected rats in the city, see Corporation of Glasgow, *Report on Certain Cases of Plague Occurring in Glasgow in 1900 by the Medical Officer of Health* (Glasgow, UK: Robert Anderson, 1900). For a recent study where the question of this absence appears to still trouble epidemiological reasoning about the disease, see Katharine R. Dean, Fabienne Krauer, and Boris V. Schmid, "Epidemiology of a bubonic plague outbreak

in Glasgow, Scotland in 1900," *Royal Society Open Science* 6, no. 1 (2019):6181695, https://doi.org/10.1098/rsos.181695.

121. Simpson, "Croonian lectures on plague," 1759. Elsewhere I have discussed two of these mechanisms, as understood and problematized at the time, in detail. The first concerned the idea, first defended by Alexandre Yersin, that plague's true locus of attenuation and recrudescence was the soil; the second concerned the idea of "pestis minor" or ambulatory plague—a form of the disease that could supposedly escape clinical and bacteriological observation inside the human body; Lynteris, *"Pestis Minor"*; Christos Lynteris, "A 'suitable soil': Plague's urban breeding grounds at the dawn of the third pandemic," *Medical History* 61, no. 3 (2017): 343–357.

122. Emily Eastgate Brink, "Ordering the invisible," *Antennae: The Journal of Nature in Visual Culture* 49 (2019), 145.

123. These can be accessed via the photographic collection of the Hawaii State Archives, http://gallery.hawaii.gov/gallery2/main.php.

124. James C. Mohr, *Plague and Fire: Battling Black Death and the 1900 Burning of Honolulu's Chinatown* (Oxford, UK: Oxford University Press, 2004).

125. Mohr, *Plague and Fire.*

126. Lukas Engelmann, "'A source of sickness'. Photographic mapping of the plague in Honolulu in 1900," in *Plague and the City*, ed. Lukas Engelmann, John Henderson, and Christos Lynteris, 139–158 (London, UK: Routledge, 2018), 140. By contrast, at the same time significant attention by the Board of Health was placed on creating a photographic "medico-juridical archive" of "leprosy suspects" and their symptoms in Hawaii; Imada, "Promiscuous signification," 5.

127. Engelmann, "Source of sickness," 140.

128. On plague, the urban environment, and filth, see chapters in Lukas Engelmann, John Henderson, and Christos Lynteris, eds., *Plague and the City* (London, UK: Routledge, 2019). On the Yellow Peril and plague, see Marilyn Chase, *The Barbary Plague: The Black Death in Victorian San Francisco* (London, UK: Random House, 2004); Susan Craddock, *City of Plagues: Disease, Poverty, and Deviance in San Francisco* (Minneapolis, MN: University of Minnesota Press, 2000); Christos Lynteris, "Yellow Peril epidemics: The political ontology of degeneration and emergence," in *Yellow Perils: China Narratives in the Contemporary World*, ed. Frank Billé and Sören Urbansky, 35–59 (Honolulu, HI: Hawaii University Press, 2018); Guenter B. Risse, *Plague, Fear, and Politics in San Francisco's Chinatown* (Baltimore, MD: Johns Hopkins University Press, 2012); Nayan Shah, *Contagious Divides: Epidemics and Race in San Francisco's Chinatown* (Berkeley, CA: University of California Press, 2001).

129. Prashant Kidambi, "'An infection of locality': Plague, pythogenesis and the poor in Bombay, c. 1896–1905," *Urban History* 31, no. 2 (August 2004): 249–267; Craddock, *City of Plagues*, 10.

130. Engelmann, "Source of sickness," 149.

131. Engelmann, "Source of sickness," 153; Engelmann, "Picturing the unusual," 16; Elizabeth Edwards, "Photographic uncertainties: Between evidence and reassurance," *History and Anthropology* 25, no. 2 (2014): 171–188, 174.

132. Elizabeth Edwards, *The Camera as Historian: Amateur Photographers and Historical Imagination, 1885–1918* (Durham, NC: Duke University Press, 2012), 81–82.

133. Daston and Galison, *Objectivity*; Tucker, *Nature Exposed*; Christos Lynteris and Rupert Stasch, "Photography and the unseen," *Visual Anthropology Review* 35, no. 1 (2019): 5–9, 6.

134. Poleykett, "Pasteurian tropical medicine," 192.

135. Susan Sontag, *On Photography* (1977; repr., New York, NY: Picador, 2001).

136. Christos Lynteris and Ruth J. Prince, "Introduction: medical photography," *Visual Anthropology* 29, no. 2 (2016): 101–117, 107.

137. Nükhet Varlık, "Why is Black Death *black*? European gothic imaginaries of 'Oriental' plague," in *Plague Image and Imagination from Medieval to Modern Times*, ed. Christos Lynteris, 11–35 (London, UK: Palgrave Macmillan, 2021).

138. For a discussion of earlier uses of the term in the works of August Ludwig von Schlözer and Kurt Polycarp Joachim Sprengel, as well as in the historical work of Mrs. Markham (pseudonym of Elizabeth Penrose), see Varlık, "Why is Black Death *black*?"

139. I. F. C. Hecker, *The Black Death in the Fourteenth Century*, trans. B. G. Babington (London, UK: A. Schloss, 1833 [1832]), ix. On variants of "Black Death" in different languages, and on why "black" is of importance, see Varlık, "Why is Black Death *black*?"

140. Varlık, "Why is Black Death *black*?," 20

141. Varlık, "Why is Black Death *black*?"

142. Varlık, "Why is Black Death *black*?"; Faye Marie Getz, "Black Death and the silver lining: Meaning, continuity, and revolutionary change in histories of medieval plague," *Journal of the History of Biology* 24, no. 2 (1991): 265–289. For a study of the German ideological roots of the connections between Romanticism, death, and contagion, see David Farrell Krell, *Contagion: Sexuality, Disease, and Death in German Idealism and Romanticism* (Bloomington, IN: Indiana University Press, 1998).

143. On contagion and the first half of the nineteenth century, see Andrew Robert Aisenberg, *Disease, Government, and the "Social Question" in Nineteenth-Century France* (Redwood City, CA: Stanford University Press, 1999); Peter Baldwin, *Contagion and the State in Europe, 1830–1930* (Cambridge, UK: Cambridge University Press, 1994); Allan Conrad Christensen, *Nineteenth-Century Narratives of Contagion: "Our Feverish Contact"* (London, UK: Routledge, 2005); Mark Harrison, *Contagion: How Commerce Has Spread Disease* (New Haven, CT: Yale University Press,

2012); Melvin Santer, *Confronting Contagion: Our Evolving Understanding of Disease* (Oxford, UK: Oxford University Press, 2015), chapter 12. An indication of the connection between the interest in Hecker's book and the cholera pandemics is, however, evident in Adrien Philippe's introduction to his 1853 book on the "black plague," which incorporated translated sections of Hecker's book; Adrien Philippe, *Histoire de la peste noire (1346–1350) d'après des documents inédits* (Paris, France: À la Direction de Publicité Médicale, 1853).

144. Getz, "Black Death and the silver lining," 276.

145. Getz, "Black Death and the silver lining," 281.

146. Rachel Bruzzone, "*Polemos, pathemata*, and plague: Thucydides' narrative and the tradition of upheaval," *Greek, Roman, and Byzantine Studies* 57 (2017): 882–909, 889, 894.

147. However, for Hecker this was not a synchronous disaster but a chain reaction, which proceeded from China to Europe and which, depending on different scenarios developed in the book, eventually led to the pollution of the atmosphere with "foreign, and sensibly perceptible, admixtures"—a "poison" that inflamed the lungs and lymphatic glands, resulting in what we would today classify as the pneumonic and bubonic symptoms of the disease, respectively (Hecker, *Black Death*, 36, 37). The apocalyptic affinities of this narrative are made clear once they are compared with the place of plague in end of the world narratives of the Middle Ages; Laura A. Smoller, "Of earthquakes, hail, frogs, and geography: Plague and the investigation of the apocalypse in the later Middle Ages," in *Last Things: Death and the Apocalypse in the Middle Ages*, ed. Caroline Walker Bynum and Paul Freedman, 156–186 (Philadelphia, PA: University of Pennsylvania Press, 2000).

148. Hecker, *Black Death*, 82.

149. Alexandre Yersin, "La peste bubonique à Hong Kong," *Annales de l'Institut Pasteur* 8 (1894): 662–667, 662–663, my translation.

150. Clement Scott, "The Black Death in China," *The Illustrated London News* 2880, no. 104 (June 30, 1894): 823, 823. The fact that "Black Death" was used as early as May 1894 to talk about the outbreak in Hong Kong is attested in various news clips attached to National Archives, United Kingdom, CO 129/263, 10928 Bubonic Plague; James Lowson, Government Civil Hospital Hong Kong, 16th May 1894, enclosed in William Robinson to the Marquess of Ripon, May 17, 1895, 48–69, 51.

151. Anon., "The scourge of the century," *Lincoln County Leader* 8, no. 10 (May 11, 1900): 2.

152. Robert Peckham, *Epidemics in Modern Asia* (Cambridge, UK: Cambridge University Press, 2016), 127.

153. On the common "Tartar" origin, see, for example, Anon., "The plague at Hong Kong," *The Lancet* 143, no. 3695 (June 23, 1894): 1581–1582. "Revival" was a common trope to talk about the pandemic at the time; see, for example, Anon.,

"The present pandemic of plague," *The Lancet* 172, no. 4440 (October 3, 1908): 1024–1025.

154. See, for example, Anon., "Pandemic plague," *British Medical Journal* 2, no. 2078 (October 27, 1900): 1247–1258.

155. William J. R. Simpson, "Plague viewed from several aspects," *The Lancet* 155, no. 3998 (April 14, 1900), 1063.

156. Simpson, "Plague viewed."

157. Simpson, "Plague viewed," 1065.

158. Anon., "The plague," *Truth* (Brisbane) 604 (March 2, 1902): 7.

159. Burton J. Hendrick, "Fighting the 'Black Death' in Manchuria," *The World's Work* 27 (1914): 210–222.

160. Mark Gamsa, "The epidemic of pneumonic plague in Manchuria 1910–1911," *Past and Present* 90 (2006): 147–184.

161. See, for example, the preface to the second edition of Francis Aidan Gasquet's popular book on the Black Death: Francis Aidan Gasquet, *The Black Death of 1348 and 1349*, 2nd ed. (London, UK: George Bell and Sons, 1908), vii.

162. Anon., "A real Yellow Peril: The astonishingly virulent outbreak of pneumonic plague in the Far East," supplement, *The Sphere* (February 18, 1911): i–iii.

163. Jules Courmont, "La peste," *Le monde medical, revue international de médecine et de thérapeutique* 21, no. 408 (February 25, 1911): 161–175, 161, my translation. See also Hendrick, "Fighting the 'Black Death.'" The notion of *peste foudroyante* was employed by Yersin during the Hong Kong 1894 outbreak to refer to cases reportedly resulting in death within less than twelve hours of the initial symptoms; AIP, IND.A1, Lieu: 4/151–153. Readers may be familiar with the term from Arthur Conan Doyle's 1913 story "The Poison Belt": "All night delirious excitement throughout Provence. Tumult of vine growers at Nimes. Socialistic upheaval at Toulon. Sudden illness attended by coma attacked the population this morning. *Peste foudroyante.* Great number of dead in the streets. Paralysis of business and universal chaos"; Arthur Conan Doyle, *The Poison Belt* (New York, NY: Hodder and Stoughton, 1913), Project Gutenberg, http://www.gutenberg.org/ebooks/126.

164. Courmont, "La peste," 161. The origin of the third pandemic itself had been woven together with an image of anarchy as its spread was attributed to the Panthay Rebellion (1856–1873) in Yunnan. See, for example, William J. R. Simpson, "The Croonian lectures on plague—Lecture II," *The Lancet* 170, no. 4376 (July 13, 1907): 73–78.

165. Bienvenue, "Les semeurs de peste," *La médecine internationale illustrée* 19, no. 2 (March 1911): 75–81, 75, my translation.

166. For a detailed examination of this, see Christos Lynteris, "Yellow Peril epidemics."

167. Lynteris, "Yellow Peril epidemics."

168. Lynteris, "Yellow Peril epidemics."

169. Scott, "Black Death in China," 823.

170. Anon., "La peste en Mandchourie," in "Supplément du Dimanche," *Le petit journal* 22, no. 1057 (February 19, 1911): 1, 1.

171. Anon., "La peste en Mandchourie," *Journal des voyages et des aventures de terre et de mer* 747 (March 26, 1911): 1. The first work to briefly examine the illustration of corpses as regards the Manchurian plague was Dominique Chevé and Michel Signoli, "Corps dans la tournmente epidemique de peste en Madchourie," *Corps* 1, no. 2 (2007): 75–92.

172. Courmont, "La peste," 164.

173. For example, in 1910–1911, the *Illustrated London News* used the caption "bring out your dead" for a three-photo full-page composite on plague in Manchuria (March 1911) and for a page carrying an illustration of the Black Death by Caton Woodville (November 1910); Anon., "In the plague-ridden country: Pest scenes in Manchuria," *Illustrated London News* 3750 (March 4, 1911): 310; Anon., "When first the plague came to our land: The Black Death," *Illustrated London News* 3733 (November 5, 1910): 710.

174. Anon., "Le cauchemar de Mandchourie," supplement, *L'illustration* 3551 (March 18, 1911): 190–195.

175. Apollo/VR3PP, PhotoID_10060, https://www.repository.cam.ac.uk/handle /1810/284839.

176. A cropped version of this photograph is contained in: NYAML, RBS74, Anon., *Chuma v Manchzhurii*; Apollo/VR3PP, PhotoID_1219, https://www.repository .cam.ac.uk/handle/1810/281908. Full as well as cropped versions of the photograph appeared in several publications across the globe; see, for example, Antonino Marcó del Pont, *Historia de la peste bubónica* (Buenos Aires, Argentina: Antonino Flaiban, 1917); Dr. A. de M., "La peste de la Mandchuria," *España médica* 1, no. 9 (April 20, 1911), 7.

177. David Arnold, "Picturing plague: Photography, pestilence, and cremation in late nineteenth- and early twentieth-century India," in *Plague Image and Imagination from Medieval to Modern Times*, ed. Christos Lynteris, 111–139 (London, UK: Palgrave Macmillan, 2021).

178. Christos Lynteris and Nicholas H. Evans, "Introduction: The challenge of the epidemic corpse," In *Histories of Post-Mortem Contagion: Infectious Corpses and Contested Burials*, ed. Christos Lynteris and Nicholas H. Evans, 1–25 (London, UK: Palgrave Macmillan, 2018).

179. See chapters in Christos Lynteris and Nicholas H. Evans, eds., *Histories of Post-Mortem Contagion: Infectious Corpses and Contested Burials* (London, UK: Palgrave Macmillan, 2018); Scott J. Juengel, "Writing decomposition: Defoe and the corpse," *Journal of Narrative Technique* 25, no. 2 (Spring 1995): 139–153; M. Signoli,

"Reflections on crisis burials related to past plague epidemics," *Clinical Microbiology and Infection* 18, no. 3 (2012): 218–223.

180. On the emergence of the human corpse in modern medical evidential contexts, see Zoe Crossland, "Of clues and signs: The dead body and its evidential traces," *American Anthropologist* 111, no. 1 (2009), 71. On corpses in prebacteriological contexts of epidemics and abjection, see Juengel, "Writing decomposition."

181. Lynteris and Evans, "Challenge of the epidemic corpse," 16.

182. Lynteris and Evans, "Challenge of the epidemic corpse," 3. For other examples from the third plague pandemic, particularly from Madagascar, see Branwyn Poleykett, "Ethnohistory and the dead: Cultures of colonial epidemiology," *Medical Anthropology* 37, no. 6 (2018): 472–485; Genese Marie Sodikoff, "The multispecies infrastructure of zoonosis," in *Anthropology and Epidemics*, ed. Ann H. Kelly, Frédéric Keck, and Christos Lynteris, 102–120 (London, UK: Routledge, 2019).

183. Anon., "The plague," *North-China Herald* 2269 (February 3, 1911): 245–248.

184. Anon., "Conditions in Harbin," *North-China Herald* 2271 (February 17, 1911): 357–358.

185. The international press relied on several sources, such as NYAML, RBS74, Anon., *Chuma v Manchzhurii*.

186. See in particular the illustrations by S. Davenport in 1835 or by Frederic James Shields in the 1860s; Getty Images, "Illustration from History of the Plague Defoe 18," https://www.gettyimages.co.uk/detail/news-photo/illustration-from-history-of-the -plague-frederic-james-news-photo/924230888; Wikimedia Commons, "Illustration of D Defoe by Frederic Shields 'The Plague Cart,'" https://commons.wikimedia .org/wiki/File:Shields_the_Plague_Cart.jpg. For Davenport's illustration of Defoe's plague pit, see Wellcome Collection, "Men burying the bodies of plague victims in a pit. Engraving by S. Davenport, 1835, after G. Cruikshank," 6921i, https:// wellcomecollection.org/works/bw8peyrr.

187. Yael Shapira, *Inventing the Gothic Corpse: The Thrill of Human Remains in the Eighteenth-Century Novel* (London, UK: Palgrave Macmillan, 2018); Hunter H. Gardner, *Pestilence and the Body in Latin Literature* (Oxford, UK: Oxford University Press, 2019).

188. Courmont, "La peste," 161.

189. Edwards, *Camera as Historian*.

190. Edwards, *Camera as Historian*, 7.

191. Robert Peckham, "Plague views: Epidemics, photography, and the ruined city," in *Plague and the City*, ed. Lukas Engelmann, John Henderson, and Christos Lynteris, 91–105 (London, UK: Routledge, 2018), 101.

CHAPTER 2

1. See, for example, New China TV, "Coronavirus fight: Hundreds of trucks spray disinfectants in Luoyang," *YouTube*, February 11, 2020, https://www.youtube.com/watch?v=3-RqckJAulM.

2. See, for example, Reed Johnson and Rogerio Jelmayer, "Brazil to allow aircraft to spray for mosquitoes to combat Zika," *Wall Street Journal*, July 1, 2016, https://www.wsj.com/articles/brazil-to-allow-aircraft-to-spray-for-mosquitoes-to-combat-zika-1467382925.

3. Prashant Kidambi, "'An infection of locality': Plague, pythogenesis and the poor in Bombay, c. 1896–1905," *Urban History* 31 (2004): 249–267.

4. Mark Harrison, "Towards a sanitary utopia? Professional visions and public health in India, 1880–1914," *South Asia Research* 10 (1990): 19–41.

5. For a discussion of this from a diachronic perspective, see Lukas Engelmann, John Henderson, and Christos Lynteris, "Introduction: The plague and the city in history," in *Plague and the City*, ed. Lukas Engelmann, John Henderson, and Christos Lynteris, 1–17 (London, UK: Routledge, 2018). Also see the collection of essays in the same volume. On the notion of the "pathogenic city," see Lenore Manderson, *Sickness and the State: Health and Illness in Colonial Malaya, 1870–1940* (Cambridge, UK: Cambridge University Press, 1996).

6. Susan Craddock, *City of Plagues: Disease, Poverty, and Deviance in San Francisco* (Minneapolis, MN: University of Minnesota Press, 2004); Engelmann et al., "Introduction: The Plague," 2.

7. Engelmann et al., "Introduction: The Plague," 6; Graham Mooney, *Intrusive Interventions: Public Health, Domestic Space, and Infectious Disease Surveillance in England, 1840–1914* (Rochester, NY: University of Rochester Press, 2015).

8. David S. Barnes, *The Great Stink of Paris and the Nineteenth-Century Struggle against Filth and Germs* (Baltimore, MD: Johns Hopkins University Press, 2006). On plague and "filth" before the nineteenth century, see Carole Rawcliffe, "'Great stenches, horrible sights, and deadly abominations': Butchery and the battle against plague in late medieval English towns," in *Plague and the City*, ed. Lukas Engelmann, John Henderson, and Christos Lynteris, 18–39 (London, UK: Routledge, 2018); John Henderson, "'Filth is the mother of corruption': Plague, the poor, and the environment in early modern Florence," in *Plague and the City*, ed. Lukas Engelmann, John Henderson, and Christos Lynteris, 69–90 (London, UK: Routledge, 2018); Martha Bayless, *Sin and Filth in Medieval Culture* (London, UK: Routledge, 2012); David Gentilcore, "Purging filth: Plague and responses to it in Rome, 1656–1657," in *Rome, Pollution and Propriety: Dirt, Disease and Hygiene in the Eternal City from Antiquity to Modernity*, ed. Mark Bradley and Kenneth Stow, 153–168 (Cambridge, UK: Cambridge University Press, 2012).

9. Maynard W. Swanson, "The sanitation syndrome: Bubonic plague and urban native policy in the Cape Colony, 1900–1909," *Journal of African History* 18, no. 3 (1977): 387–410.

10. Mary Sutphen, "Not what, but where: Bubonic plague and the reception of germ theories in Hong Kong and Calcutta, 1894–1897," *Journal of History of Medicine and Allied Sciences* 52, no. 1 (January 1997), 84.

11. Kidambi, "Infection of locality," 254.

12. Christos Lynteris, "A 'suitable soil': Plague's breeding grounds at the dawn of the third pandemic," *Medical History* 61, no. 3 (June 2017): 343–357.

13. For discussion, see Lynteris, "A 'suitable soil.'"

14. Lynteris, "A 'suitable soil.'" For sources on these practices, see HCPP, Cd. 139, Session 1900, "Indian Plague Commission, 1898–99. Minutes of evidence taken by the Indian Plague Commission with appendices., vol. I. Evidence taken from 29th November 1898 to 5th January 1899, 57"; BL, IOR/V/27856/58, *Punjab Plague Handbook, 1905* (Lahore, Pakistan: Punjab Government Press, 1905); Anon., "The plague in Hyderabad State: A report by Lieutenant-Colonel Lawrie I.M.S.," *The Lancet* 1, no. 3935 (January 28, 1899): 249–350. For an example of the photography of deroofing in India, see Apollo/VR3PP, PhotoID_3644, https://www .repository.cam.ac.uk/handle/1810/282472.

15. Susan Craddock, "Sewers and scapegoats: Spatial metaphors of smallpox in nineteenth century San Francisco," *Social Science and Medicine* 41, no. 7 (1995), 961.

16. I am borrowing here Hans-Jörg Rheinberger's theory of experimental systems; Hans-Jörg Rheinberger, *Toward a History of Epistemic Things: Synthesizing Proteins in the Test Tube* (Redwood City, CA: Stanford University Press, 1997).

17. Supthen, "Not what, but where."

18. Nicholas Evans, "The disease map and the city: Desire and imitation in the Bombay plague, 1896–1914," in *Plague and the City*, ed. Lukas Engelmann, John Henderson and Christos Lynteris, 116–138 (London, UK: Routledge, 2018), 127.

19. Frank Morton Todd, *Eradicating Plague from San Francisco: Report of the Citizens' Health Committee and an Account of Its Work* (San Francisco, CA: Press of C. A. Murdock & Co., 1909).

20. Rupert Blue, "Anti-plague measures in San Francisco, California, U.S.A," *Journal of Hygiene* 9, no. 1 (April 1909): 1–8; Todd, *Eradicating Plague*, 7.

21. Todd, *Eradicating Plague*, 35. These conditions were, according to the Committee, further compounded by the makeshift nature of "wooden tents" and other shelters for the homeless, as well as of the equally rat-prone bunk houses of thousands of workers brought into the city for reconstruction. Several works discuss the photographic coverage of the 1906 earthquake and fire: Mark Klett and Michael Lundgren, *After the Ruins, 1906 and 2006: Rephotographing the San Francisco*

Earthquake and Fire (Berkeley, CA: University of California Press, 2006); Alan E. Leviton, Michele L. Aldrich, and Karren Elsbernd, "The California Academy of Sciences, Grove Karl Gilbert, and photographs of the 1906 earthquake, mostly from the archives of the Academy," *Proceedings of the California Academy of Sciences* 57, no. 1 (2006): 1–34.

22. Todd, *Eradicating Plague*, 50, 51. The Committee paid 10 cents per rat, the same price as established in September 1907 by the Board of Health, leading to the capture of 1,237,550 rats; San Francisco Public Library, San Francisco History Center, San Francisco Department of Public Health Records (SFH 63), September 12, 1907, 321; Lavern Mau Dicker, "The San Francisco earthquake and fire: Photographs and manuscripts from the California Historical Society Library," *California History* 59, no. 1 (1980): 33–65.

23. Joanna L. Dyl, *Seismic City: An Environmental History of San Francisco's 1906 Earthquake* (Seattle, WA: University of Washington Press, 2017), 208.

24. Todd, *Eradicating Plague*, 12.

25. On the question of vectors being seen as "vermin," see Christos Lynteris, "Introduction: Infectious animals and epidemic blame," in *Framing Animals as Epidemic Villains: Histories of Non-Human Disease Vectors*, ed. Christos Lynteris, 1–25 (London, UK: Palgrave Macmillan, 2019); Karen Sayer, "Vermin landscapes: Suffolk, England, shaped by plague, rat and flea (1906–1920)," in *Framing Animals as Epidemic Villains: Histories of Non-Human Disease Vectors*, ed. Christos Lynteris, 27–64 (London, UK: Palgrave Macmillan, 2019).

26. Todd, *Eradicating Plague*, 95, 135.

27. On infrastructure as key to hygienic "improvement" ideologies and practices in colonial and post-colonial contexts, see Martin Beattie, "Colonial space: Health and modernity in Barabazaar, Kolkata," *Traditional Dwellings and Settlements Review* 14, no. 2 (Spring 2003): 7–19; Aditya Ramesh and Vidhya Raveendranathan, "Infrastructure and public works in colonial India: Towards a conceptual history," *History Compass* 13 (2020): e12614; Macarena Ibarra, "Hygiene and public health in Santiago de Chile's urban agenda, 1892–1927," *Planning Perspectives* 31, no. 2 (2016): 181–203.

28. Todd, *Eradicating Plague*, 146.

29. Todd, *Eradicating Plague*, 157

30. Anon., "Commission men show the city what cleaning-up really means," *Merchant's Association Review* 12, no. 140 (April 1908): 1.

31. Anon., "Commission men," 1.

32. Anon., "Commission men," 1.

33. Igor Krstić, *Slums on Screen: World Cinema and the Planet of Slums* (Edinburgh, UK: Edinburgh University Press, 2016).

34. Krstić, *Slums on Screen*, 44; Peter Stallybrass and Allon White, *The Politics and Poetics of Transgression* (London, UK: Methuen, 1986).

35. For examples of marked houses in India, see Apollo/VR3PP, PhotoID_246, https://www.repository.cam.ac.uk/handle/1810/282423; Apollo/VR3PP, Photo-ID_3695, https://www.repository.cam.ac.uk/handle/1810/282525. For a discussion of this practice, see Jacob Steere-Williams, "'Coolie' control: State surveillance and the labour of disinfection across the late Victorian British Empire," in *Making Surveillance States: Transnational Histories*, ed. Robert Heynen and Emily van der Meulen, 35–57 (Toronto, Ontario: University of Toronto Press, 2019).

36. NRI, 808.24za WLD:1 (RBR), Wu Lien-teh, *Views of Harbin (Fuchiatien) Taken during the Plague Epidemic (December 1910–March 1911)* (Shanghai, China: Commercial Press, [1911]).

37. Richard Pearson Strong, G. F. Petrie, and Arthur Stanley, eds., *Report of the International Plague Conference (Held at Mukden in April 1911)* (Manila, Philippines: Bureau of Printing, 1912).

38. Mark Gamsa, "The epidemic of pneumonic plague in Manchuria 1910–1911," *Past Present* 190 (2006): 147–184. The conference's minutes are available in Strong et al., *International Plague Conference.*

39. On the implication of migrant coolies in epidemic blame during the Manchurian plague epidemic of 1910–1911, see Christos Lynteris, *Ethnographic Plague: Configuring Disease on the Chinese-Russian Frontier* (London, UK: Palgrave Macmillan, 2016).

40. Lynteris, *Ethnographic Plague.*

41. Jonathan Schlesinger, *A World Trimmed with Fur: Wild Things, Pristine Places, and the Natural Fringes of Qing Rule* (Redwood City, CA: Stanford University Press, 2017).

42. Lynteris, *Ethnographic Plague*; Sujit Sivasundaram, "Towards a critical history of connection: The port of Colombo, the geographical 'circuit,' and the visual politics of new imperialism, ca. 1880–1914," *Comparative Studies in Society and History* 59, no. 2 (2017): 346–384; Robert Peckham, *Epidemics in Modern Asia* (Cambridge, UK: Cambridge University Press, 2016).

43. Kidambi, "Infection of locality"; Timothy Barnard, *Imperial Creatures: Humans and Other Animals in Colonial Singapore, 1819–1942* (Singapore: National University of Singapore Press, 2019).

44. Apollo/VR3PP, PhotoID_2, https://www.repository.cam.ac.uk/handle/1810/280770; Apollo/VR3PP, PhotoID_3, https://www.repository.cam.ac.uk/handle/1810/281866.

45. Apollo/VR3PP, PhotoID_4, https://www.repository.cam.ac.uk/handle/1810/281977; Apollo/VR3PP, PhotoID_5, https://www.repository.cam.ac.uk/handle

/1810/282089. For a discussion of bird's-eye views in epidemic photography, see chapters 2 and 3.

46. As Megan Vaughan has shown, this motion of the camera diving in so as reveal the breeding grounds of plague was also used later in a public health education film on plague in colonial Nigeria (*Anti-Plague Operations in Lagos*); the film "begins . . . with an aerial view of a Lagos shantytown before 'zooming in' on a rat scurrying amongst rubbish"; Megan Vaughan, *Curing Their Ills: Colonial Power and African Illness* (Cambridge, UK: Polity Press, 1991), 188.

47. I rely here on Carlo Ginzburg's reading of *enargeia* as developed by Polybius in relation to Homer and of *graphike enargeia* as developed by Plutarch in relation to Thucydides; Carlo Ginzburg, *Threads and Traces: True False Fictive*, trans. Anne C. Tedeschi and John Tedeschi (Berkeley, CA: University of California Press, 2012), 9, see also pp. 8–12.

48. P. S. Selwyn-Clarke, *Report on the Outbreak of Plague in Kumasi, Ashanti* (Accra, Gold Coast [Ghana]: Government Printing Department, 1925).

49. Benjamin Talton, "'Kill rats and stop plague': Race, space and public health in postconquest Kumasi," *Ghana Studies* 22 (2019): 95–113.

50. Selwyn-Clarke, *Outbreak of Plague in Kumasi*, 3.

51. Liora Bigon, "Bubonic plague, colonial ideologies, and urban planning policies: Dakar, Lagos, and Kumasi," *Planning Perspectives* 31, no. 2 (2016): 205–226.

52. Talton, "Kill rats and stop plague," 96.

53. Talton, "Kill rats and stop plague"; Bigon, "Bubonic plague."

54. WL, +M289, *Report by Professor W. J. Simpson on Sanitary Matters in Various West African Colonies and the Outbreak of Plague in the Gold Coast* (London, UK: Darling & Son: His Majesty's Stationery Office 1909). The report is on the plague outbreak in Accra in 1908. See also William J. R. Simpson, *Report on Plague in the Gold Coast in 1908* (London, UK: J. & A. Churchill, 1909). For a discussion of this outbreak, see Ryan Johnson, "Mantsemei, interpreters, and the successful eradication of plague: The 1908 plague epidemic in colonial Accra," in *Public Health in the British Empire: Intermediaries, Subordinates, and the Practice of Public Health, 1850–1960*, ed. Ryan Johnson and Amna Khalid, 135–153 (London, UK: Routledge, 2011); Akwasi Kwarteng Amoako-Gyampah, "Sanitation and Public Hygiene in the Gold Coast (Ghana) from the Late 19th Century to 1950," PhD diss. (University of Johannesburg, 2019). For a discussion on the challenges of researching the plague outbreaks in the Gold Coast, see Daniel Gilfoyle, "Researching Colonial Office correspondence: Plague in Gold Coast," *National Archives Blog*, March 26, 2018, https://blog.nationalarchives.gov.uk /researching-colonial-office-correspondence-plague-in-gold-coast/.

55. Selwyn-Clarke, *Outbreak of Plague in Kumasi*, unnumbered plate between pages 14 and 15.

56. Selwyn-Clarke, *Outbreak of Plague in Kumasi.*

57. Selwyn-Clarke, *Outbreak of Plague in Kumasi.*

58. Selwyn-Clarke, *Outbreak of Plague in Kumasi.*

59. Talton, "Kill rats and stop plague," 103. Peckham makes a similar point as regards technology as a driver of the pandemic, in the form of steamboats and railways; Peckham, *Epidemics in Modern Asia.*

60. Talton, "Kill rats and stop plague," 103.

61. Talton, "Kill rats and stop plague," 103.

62. Talton, "Kill rats and stop plague," 104. On plague, racism, and sanitary reform in Cape Town, see Swanson, "Sanitation syndrome."

63. Jiat-Hwee Chang, *A Genealogy of Tropical Architecture: Colonial Networks, Nature and Technoscience* (London, UK: Routledge, 2016), 132. See also Brenda S. A. Yeoh, *Contesting Space in Colonial Singapore: Power Relations and the Urban Built Environment* (Singapore: Singapore University Press, 2003), chapter 3.

64. On photographs of overcrowding and their sanitarian as well as orientalist inflections, see Krstić, *Slums on Screen*; Daniel Czitrom and Bonnie Yochelson, *Rediscovering Jacob Riis: Exposure Journalism and Photography in Turn-of-the-Century New York* (New York, NY: New Press, 2007).

65. Ann-Louise Shapiro, *Housing the Poor of Paris, 1850–1902* (Madison, WI: University of Wisconsin Press, 1985); Sidney Chalhoub, "The politics of disease control: Yellow fever and race in nineteenth century Rio de Janeiro," *Journal of Latin American Studies* 25, no. 3 (October 1993): 441–463. Within medical materialist readings of the Bible at the time, demolition further enjoyed divine sanction, as it was seen as a practice whose roots laid with Moses himself; Edward T. Williams, "Moses as a sanitarian," *Boston Medical and Surgical Journal* 106 (1882): 6–8.

66. Giovanna Borasi and Mirko Zardini, "Demedicalize architecture," in *Imperfect Health: The Medicalization of Architecture*, ed. Giovanna Borasi and Mirko Zardini, 15–37 (Montreal, Quebec: Canadian Centre for Architecture/Lars Müller, 2012), 19.

67. In her work introducing the notion of hygienic modernity, Ruth Rogaski discusses the demolition of the ancient walls of Tianjin and the "shacks" reclining on them as part of the treaty port's colonial plan for urban hygiene; Ruth Rogaski, *Hygienic Modernity: Meanings of Health and Disease in Treaty-Port China* (Berkeley, CA: University of California Press, 2004); Alice Mah, "Demolition for development: A critical analysis of official urban imaginaries in past and present UK cities," *Journal of Historical Sociology* 25, no. 1 (March 2012): 151–176.

68. Branwyn Poleykett, "Public culture and the spectacle of epidemic disease in Rabat and Casablanca," in *Plague and the City*, ed. Lukas Engelmann, John Henderson and Christos Lynteris, 159–171 (London, UK: Routledge, 2018).

69. Talton, "Kill rats and stop plague," 102.

70. Cecilia Chu, "Combatting nuisance: Sanitation, regulation and politics of property in colonial Hong Kong," in *Imperial Contagions: Medicine, Hygiene, and Cultures of Planning in Asia*, ed. Robert Peckham and David Pomfret, 17–36 (Hong Kong: Hong Kong University Press, 2013).

71. John Tagg, *The Burden of Representation: Essays on Photographies and Histories* (London, UK: Macmillan, 1988), 151.

72. Larissa Heinrich, *The Afterlife of Images: Translating the Pathological Body between China and the West* (Durham, NC: Duke University Press, 2008); Eric A. Stein, "Colonial theatres of proof: Representation and laughter in 1930s Rockefeller Foundation hygiene cinema in Java," in "Health, Medicine and the Media," special issue, *Health and History* 8, no. 2 (2006): 14–44.

73. Stein, "Colonial theatres," 21, 24.

74. Stein, "Colonial theatres," 26; Selwyn-Clarke, *Outbreak of Plague in Kumasi*.

75. Stephanie Lewthwaite, *Race, Place, and Reform in Mexican Los Angeles: A Transnational Perspective, 1890–1940* (Tucson, AZ: University of Arizona Press, 2009), 120.

76. BANC PIC 1988.052—PIC, Photographic Documentation of Pneumonic Plague Outbreak Sites and Rats in Los Angeles, 1924.

77. William F. Deverell, *Whitewashed Adobe: The Rise of Los Angeles and the Remaking of Its Mexican Past* (Berkeley, CA: University of California Press, 2004); A. J. Viseltear, "The pneumonic plague epidemic of 1924 in Los Angeles," *Yale Journal of Biological Medicine* 47, no. 1 (1974): 40–54.

78. Deverell, *Whitewashed Adobe*, 187.

79. Lewthwaite, *Race, Place, and Reform*, 124.

80. Lewthwaite, *Race, Place, and Reform*, 124.

81. Lewthwaite, *Race, Place, and Reform*, 124–125. The destruction of Mexican houses involved no compensation and no rehousing of those rendered homeless as a result of anti-plague demolition; Deverell, *Whitewashed Adobe*, 188.

82. Selwyn-Clarke, *Outbreak of Plague in Kumasi*; Lewthwaite, *Race, Place, and Reform*.

83. Helen Grace, "A new journal of the plague year," *Cultural Studies* 1, no. 1 (1987): 75–91, 77.

84. State Library of New South Wales, PXE 90–1001, "Views taken during Cleansing Operations, Quarantine Area, Sydney, 1900, Vol. I to XI, under the supervision of Mr George McCredie, F.I.A., N.S.W."

85. Grace, "New journal of the plague year," 76.

86. San Francisco Public Library, leather-bound album titled "J. M. Williamson M.D. Board of Health" (uncataloged, no call number). Williamson's album contains

some, clearly orientalist, frames of Chinese men in their condemned houses; for example, see Apollo/VR3PP, PhotoID_7188, https://www.repository.cam.ac.uk/handle/1810/281176.

87. Grace also speculates that the photographs of the plague-ridden slum may have been "intended to be used as evidence *in case litigation arose*"; Grace, "New journal of the plague year," 77. This form of photographic "legal realism" has been shown by Tagg to be the case in the case of photographs of in Quarry Hill, Leeds, England, aimed at supporting the case of slum clearance before Parliament after a series of typhus outbreaks in the neighborhood; Tagg, *Burden of Representation*, 144.

88. Guenter B. Risse, *Plague, Fear, and Politics in San Francisco's Chinatown* (Baltimore, MD: Johns Hopkins University Press, 2012); Nayan Shah, *Contagious Divides: Epidemics and Race in San Francisco's Chinatown* (Berkeley, CA: University of California Press, 2001); Marilyn Chase, *The Barbary Plague: The Black Death in Victorian San Francisco* (London, UK: Random House, 2003); Craddock, *City of Plagues*.

89. Anon., "The bubonic plague and the remedy," *The Worker* 11, no. 464 (March 24, 1900): 1. For a discussion on plague and Sinophobia in Australia, see Peter Curson and Kevin McCracken, *Plague in Sydney: The Anatomy of an Epidemic* (Kensington, Australia: New South Wales University Press, 1989). The Sydney albums contain only four photographs directly identified as "Chinese sleeping apartments," for example, Apollo/VR3PP, PhotoID_2653, https://www.repository.cam.ac.uk/handle/1810/282185.

90. Williamson in Risse, *Plague, Fear, and Politics*, 192.

91. Lynteris, "A 'suitable soil.'"

92. For a discussion of this idea at the time, see Hong Kong Government, "Report, Scheme for the Improvement of the Resumed Area in Taipingshan (incorporating Correspondence No. 132 by Francis A. Cooper, Director of Public Works, 22 March 1895), (March 30, 1895)," *Hong Kong Government Gazette*, GA 1895, no. 117, p. 264.

93. AIP, YER.Cor1, Lieu: A1/13, Alexandre Yersin to Fanny Yersin, 29 September 1898; AIP, YER.Cor1, Lieu: A1/13, Alexandre Yersin to Fanny Yersin, 16 March 1899. For discussion, see Christos Lynteris, "Vagabond microbes, leaky laboratories and epidemic mapping: Alexandre Yersin and the 1898 plague epidemic in Nha Trang," *Social History of Medicine* 34, no. 1 (2021): 190–213.

94. AIP, BPT.Doc.81, Lieu: A7/244–267; Apollo/VR3PP, PhotoID_6877, https://www.repository.cam.ac.uk/handle/1810/284802. The caption in the published photograph misdates the outbreak as having taken place in 1897. On Yersin sharing these photographs with Roux, see AIP, IND.A2, Lieu: A4/151–153, Yersin to Roux, 12 August 1898.

95. Robert Peckham, "Plague views: Epidemics, photography, and the ruined city," in *Plague and the City*, ed. Lukas Engelmann, John Henderson, and Christos Lynteris, 91–115 (London, UK: Routledge, 2018).

96. Clement Scott, "The black death in China," *Illustrated London News* 2880, no. 104 (June 30, 1894): 823.

97. Peckham, "Plague views," 94; Robert Peckham, "Hong Kong junk: Plague and the economy of Chinese things," *Bulletin of the History of Medicine* 90, no. 1 (2016): 32–60.

98. Peckham, "Plague views," 94; Peckham, "Hong Kong junk," 32.

99. Peckham, "Plague views"; see also Jerome J. Platt, Maurice E. Jones, and Arleen Kay Platt, *The Whitewash Brigade: The Hong Kong Plague, 1894* (London, UK: Dix Noonan Webb, 1998).

100. See, for example, Anon., "Hong Kong during the plague," *Australian Town and Country Journal* (Sydney) 49, no. 1285 (September 22, 1894): 30; Anon., "The Plague at Hong Kong: British troops destroying the refuse from infected houses at Tai-ping-shan," *The Graphic* (London) 1288 (August 4, 1894): 120; Anon., "The Plague at Hong Kong," *Illustrated London News* 2884 (July 28, 1894): 100.

101. Peckham, "Plague views," 100. Peckham clarifies that "the 'ruin' as a subcategory of building photography, [was] a genre popularized in a Chinese context by photographers such as Felice Beato, Thomas Child, and John Thomson" (53). On the photography of ruination in China, see Andrew F. Jones, "Portable monuments: Architectural photography and the 'forms' of empire in modern China," *Positions* 18, no. 3 (2010): 599–631.

102. Anon., "The Plague," *Hongkong Daily Press*, July 6, 1894, 2; quoted in Peckham, "Plague views," 101.

103. Shropshire Regiment "Whitewash Brigade" emptying items from Chinese homes in Taipingshan, Hong Kong, and burning them on the street as an epidemic control measure during the 1894 plague outbreak; Apollo/VR3PP, PhotoID_73, https://www.repository.cam.ac.uk/handle/1810/282067. Originals of the photograph are held by the Wellcome Library (L0022367) and the National Archives (United Kingdom): 6005/SHYKS/10/0256, Album of Photographs. On imperial debris, see Ann Laura Stoler, *Duress: Imperial Durabilities in Our Times* (Durham, NC: Duke University Press, 2016).

104. Jones, "Portable Monuments," 620.

105. James R. Ryan, *Picturing Empire: Photography and the Visualization of the British Empire* (London, UK: Reaktion Books, 1997).

106. Peckham, "Plague views," 102.

107. Michael Taussig, *What Color Is the Sacred?* (Chicago, IL: University of Chicago Press, 2009), 82.

108. As shown by Carole Rawcliffe, bonfires were used since the Middle Ages not simply to dispel stench but also to burn "corrupt foodstuffs" and other pestilential objects; Rawcliffe, "Great stenches, horrible sights," 18. On plague, fire, and

ruination in visual culture, see Christine M. Boeckl, *Images of Plague and Pestilence: Iconography and Iconology* (University Park, PA: Pennsylvania State University Press, 2001); Sheila Barker, "Poussin, plague, and early modern medicine," *Art Bulletin* 86, no. 4 (2004): 659–689.

109. Faye Marie Getz, "Black Death and the silver lining: Meaning, continuity, and revolutionary change in histories of medieval plague," *Journal of the History of Biology* 24, no. 2 (1991): 265–289.

110. Mohr may be correct in suggesting that the example best known to Honolulu's Board of Health was the burning of rubble during the Taipingshan resumption in Hong Kong, which took place in 1898; James C. Mohr, *Plague and Fire: Battling Black Death and the 1900 Burning of Honolulu's Chinatown* (Oxford, UK: Oxford University Press, 2004), 91.

111. BANC PIC 1988.052. Centro Português de Fotografia holds fifty-nine photographs of the 1899 plague epidemic in Porto (Oporto), a number of which involve disinfection and the destruction of "infected houses."

112. Mohr, *Plague and Fire*.

113. "Stamping out," as Mohr notes, was the trope used by army medical authorities in Honolulu at the time; Mohr, *Plague and Fire*, 90.

114. Engelmann, "'A source of sickness': Photographic mapping of the plague in Honolulu in 1900," in *Plague and the City*, ed. Lukas Engelmann, John Henderson and Christos Lynteris, 139–158 (London, UK: Routledge, 2018), 143.

115. Mohr, *Plague and Fire*.

116. Engelmann, "Source of sickness," 146.

117. Mohr, *Plague and Fire*. For press coverage and visualization of these "sanitary fires," see Anon., "Fighting bubonic plague in the Chinese and native quarters, Honolulu, H.I.," *Harper's Weekly*, February 3, 1900, 112; Anon., "Plague fought by fire," *New-York Tribune Illustrated Supplement*, January 28, 1900, 13; The Hawaii State Archives hold several prints and albums by photographers covering "sanitary fires" and the events of January 20, 1900.

118. On the reputation and professionalism of Honolulu's fire department, see Mohr, *Plague and Fire*, 118–119. For examples of the press exonerating the fire department from blame over the January 20 catastrophe, see Charles H. Thurston, "The Honolulu fire department," *Pacific Commercial Advertiser* (Honolulu) 35, no. 6054 (January 1, 1902): 47; Frank Godfrey, "The Kaumakapili church fire," *Austin's Hawaiian Weekly* 2, no. 20 (February 3, 1900): 7.

119. Mohr, *Plague and Fire*; Richard A. Greer, "'Sweet and clean': The Chinatown fire of 1886," *Hawaiian Journal of History* 10 (1976): 33–51. For photographs of the 1886 fire, see Hawaii Historical Society Library, Photographic Collection, Nos. 699, 700, 701, 702, 4543, 4544.

120. Hawaii State Archives, 501 v.2, Records of the Special Vector Eradication Campaign, Oahu and Maui Plague Records, 1899–1900, The Attack of Plague, December 12th 1899, 33.

121. On the "forced march," see Mohr, *Plague and Fire*, 138–139.

122. Anon., "The great fire in Honolulu," *Harper's Weekly*, February 17, 1900, 149.

123. Hawaii Historical Society Library, Photographic Collection, No. 693.

124. This is possibly: Hawaii State Archive, Photograph Collection, Epidemics, Bubonic Plague, 1900, PP-19-1-007, http://gallery.hawaii.gov/gallery2/main.php ?g2_itemId=15043.

125. I have not been able to locate the archival repository or source of this photograph.

126. Anon., "Great fire in Honolulu," 149.

127. Anon., "Two million dollar blaze razes Honolulu's Chinatown," *San Francisco Call*, February 1, 1900, 4.

128. Anon., "Two million dollar blaze," 4.

129. Hawaii State Archives, Photograph Collection: Albums, PA 4b, Photo Album Hawaiian Islands, 1898–1900, F.J. H. Rockon, Vol. 3 (untitled, no page number).

130. Hawaii Historical Society Library, Photographic Collection, No. 691; The "Citizens with pick and ax handles" photograph was taken by Taylor Coll, and is only slightly cropped in this publication: Hawaii State Archive, Photograph Collection, Epidemics, Bubonic Plague, 1900, PP-19-1-042, http://gallery.hawaii .gov/gallery2/main.php?g2_itemId=15148.

131. This was taken by Davey and was severely cropped for its published version; Hawaii State Archives, Photograph Collection, Epidemics, Bubonic Plague, 1900, PP-18-9-027.

132. Lukas Engelmann and Christos Lynteris, *Sulphuric Utopias: A History of Maritime Fumigation* (Cambridge, MA: MIT Press, 2020), 49; Lindsey Fitzharris, *The Butchering Art: Joseph Lister's Quest to Transform the Grisly World of Victorian Medicine* (London, UK: Penguin, 2017).

133. Peter Baldwin, *Contagion and the State in Europe, 1830–1930* (Cambridge, UK: Cambridge University Press, 2005); David S. Barnes, "Cargo, 'infection,' and the logic of quarantine in the nineteenth century," *Bulletin of the History of Medicine* 88, no. 1 (2014): 75–101; William Coleman, *Yellow Fever in the North: The Methods of Early Epidemiology* (Madison, WI: University of Wisconsin Press, 1987); Engelmann and Lynteris, *Sulphuric Utopias*; Mooney, *Intrusive Interventions*; Michael Worboys, *Spreading Germs: Disease Theories and Medical Practice in Britain, 1865–1900* (Cambridge, UK: Cambridge University Press, 2000).

134. Mooney, *Intrusive Interventions*, 126.

135. Mooney, *Intrusive Interventions*, 127; Engelmann and Lynteris, *Sulphuric Utopias*, 51.

136. Rebecca Whyte, "Disinfection in the laboratory: Theory and practice in disinfection policy in late C19th and Early C20th England," *Endeavour* 39, no. 1 (March 2015): 35–43.

137. Engelmann and Lynteris, *Sulphuric Utopias*.

138. See Engelmann and Lynteris, *Sulphuric Utopias*, for discussion. For example, in a publication on disinfecting experiments in India from *The Lancet*, we read "the most successful disinfectant will be the one which is capable of destroying both rats and their fleas"; Anon., "Recent experiments on plague disinfectants in India," *The Lancet*, September 26, 1908, 960.

139. Mooney, *Intrusive Interventions*.

140. Engelmann and Lynteris, *Sulphuric Utopias*.

141. Lukas Engelmann has, for example, examined the development and application of the Marot apparatus for land-based use in Argentina; Lukas Engelmann, "Fumigating the hygienic model city: Bubonic Plague and the sulfurozador in early-twentieth-century Buenos Aires," *Medical History* 62, no. 3 (2018): 360–382.

142. BL, *Plague Visitation, Bombay, 1896–97*. Photographer(s): Cpt. Moss, Photo 311/1: 1896–1897; WL, no. 24258i, *The Bombay Plague Epidemic of 1896–1897: Work of the Bombay Plague Committee*. Photographs attributed to Capt. C. Moss, 1897. See Shivani Sud, "Bombay plague visitation, 1896–97," *Asian and African Studies Blog* (British Library), July 22, 2020, https://blogs.bl.uk/asian-and-african/index.html; Shivani Sud, "Water, air, light: The materialities of plague photography in colonial Bombay, 1896–97," *Getty Research Journal* 12 (2020): 219–230. As David Arnold explains, "Of the 142 images in the album the majority are attributed to Captain C. Moss of the Gloucestershire Regiment with a smaller number, eight in all, attributed to a professional 'photo artist', F. B. Stewart of Poona, who is also credited with having complied [sic] the volume"; David Arnold, "Picturing plague: Photography, pestilence, and cremation in late nineteenth- and early twentieth-century India," in *Plague Image and Imagination from Medieval to Modern Times*, ed. Christos Lynteris, 111–139 (London, UK: Palgrave Macmillan, 2021). On the album and its production, see Abhijit Sarkar, "Reflexive gaze and constructed meanings: Photographs of plague hospitals in colonial Bombay," in *Plague Image and Imagination from Medieval to Modern Times*, ed. Christos Lynteris, 141–189 (London, UK: Palgrave Macmillan, 2021).

143. The Getty photograph was also reproduced in Anon., "The plague in India: Fighting the epidemic in Bombay," *The Graphic* (London) 1451 (September 18, 1897): 394.

144. The use of water is suggested in Sud, "Water, Air, Light," 219.

145. Following Simpson, in a disinfection experiment that Hankin carried out, water was used to spray the walls and ceilings of an infected room before burning sulfur in it; the experiment resulted in failed germicide; William J. R. Simpson, *A Treatise on Plague: Dealing with the Historical, Epidemiological, Clinical, Therapeutic and Preventive Aspects of the Disease* (Cambridge, UK: Cambridge University Press, 1905), 390. The only supporting evidence, to my knowledge, of water being used in the operations depicted in this photograph comes from the text accompanying the photograph in a rough rendition of it included in a French popular science article in 1900; AIP, BPT.Doc.81, Lieu: A7/244–267, Unknown. "La fin d'un cauchemar," "Lectures pour tous: mars 1900," 492. I would like to thank Shivani Sud for her feedback on this matter.

146. Surgn.-Capt. T. E. Dyson, "Memorandum. Plague and house disinfection," *Indian Medical Gazette* 32, no. 8 (August 1897): 298. For an extensive review of disinfectants used, with no mention of water other than as a diluter for "Perchloride of Mercury" ($HgCl_2$), see also chapter 4 in NLS, 77505435, *Report of the Municipal Commissioner of the Plague in Bombay for the Year Ending 31st May 1899, Part I. General Administration* (Bombay, India: Times of India, 1899).

147. Myron J. Echenberg, *Plague Ports: The Global Urban Impact of Bubonic Plague, 1894–1901* (New York, NY: New York University Press, 2007), 57–58.

148. Sud, "Water, air, light," 225. The Getty Research Institute album (138 photographs) holds a slightly different photograph of the same scene to the British Library (142 photograph) and the Wellcome Library (125 photographs) copies which share figure 4.5. Apollo/VR3PP contains the combined British Library and Wellcome Library prints of the albums. In the Getty version of the photograph, there is less commotion on the streets, resulting in less ghostly looking figures from the long exposure. At the same time, in the Getty copy the liquid has hit the surface of the wall resulting in a visible cascade on the surface of the building while in the British Library version a studio artist has added what looks like a badly drawn cloud of particles at the end of the jet; Getty Research Institute, 1384–039/96.R.81, Plague visitation, Bombay, 1896–1897.

149. Peckham, *Epidemics in Modern Asia*, 88.

150. Dyson, "Memorandum," 298.

151. Dyson, "Memorandum," 298.

152. Stein, "Colonial theatres."

153. On the Clayton Company and the Clayton machine, see Engelmann and Lynteris, *Sulphuric Utopias.*

154. An example of these pamphlets can be found in National Archives (United Kingdom), MH 19/274, "Plague Destruction of Rats on Ship; Plague Precautions. Destruction of Rats on Ships, 24 May 1900," enclosed pamphlet "The Clayton

Fire Extinguishing and Ventilating Company, Limited"; ANOM, INDO GGI 4416, Appareil Clayton; AIP, CAL.D16, Lieu: 5/174–179, brochure "Gaz Clayton Appareil Clayton" (Paris, May 1903).

155. Selwyn-Clarke, *Outbreak of Plague in Kumasi*. Following the demise of large fumigators circa 1945, photographs of DDT disinfection against plague would fulfill a similar role. For photographs of these in Senegal, see Myron Echenberg, *Black Death, White Medicine: Bubonic Plague and the Politics of Public Health in Colonial Senegal, 1914–1945* (Oxford, UK: James Currey, 2002).

156. Engelmann, "Fumigating the hygienic model city."

157. Engelmann and Lynteris, *Sulphuric Utopias*.

158. For recent works, outside plague, on how epidemic control violently transformed these relations to nonhuman animals, see Rohan Deb Roy, *Malarial Subjects: Empire, Medicine and Nonhumans in British India, 1820–1909* (Cambridge, UK: Cambridge University Press, 2017); Barnard, *Imperial Creatures*; Deborah Nadal, *Rabies in the Streets: Interspecies Camaraderie in Urban India* (University Park, PA: Pennsylvania State University Press, 2020).

159. I am drawing here from the broader theory of capitalism in: Gilles Deleuze and Felix Guattari, *Capitalism and Schizophrenia I: Anti-Oedipus*, trans. Robert Hurley (1972; repr., London, UK: Penguin, 2009).

CHAPTER 3

1. Alison Bashford, "Maritime quarantine: Linking Old World and New World histories," in *Quarantine: Local and Global Histories*, ed. Alison Bashford, 1–12 (London, UK: Palgrave Macmillan, 2016); Jane Stevens Crawshaw, "The Renaissance invention of quarantine," in *The Fifteenth Century XII: Society in an Age of Plague*, ed. Linda Clark and Carole Rawcliffe, 161–174 (Cambridge, UK: Cambridge University Press, 2013).

2. Erwin H. Ackerknecht, "Anticontagionism between 1821 and 1867," *Bulletin of the History of Medicine* 22 (1948): 562–593; Peter Baldwin, *Contagion and the State in Europe, 1830–1930* (Cambridge, UK: Cambridge University Press, 2005); Mark Harrison, *Contagion: How Commerce Has Spread Disease* (New Haven, CT: Yale University Press, 2013).

3. David S. Barnes, "Cargo, 'infection,' and the logic of quarantine in the nineteenth century," *Bulletin of the History of Medicine* 88, no. 1 (2014): 75–101; Lukas Engelmann and Christos Lynteris, *Sulphuric Utopias: A History of Maritime Fumigation* (Cambridge, MA: MIT Press, 2020).

4. On the merging of quarantine and isolation, see Robert Peckham, "Spaces of quarantine in colonial Hong Kong," in *Quarantine: Local and Global Histories*, ed. Alison Bashford, 66–84 (London, UK: Palgrave Macmillan, 2016).

5. Inland lazarettos had been used for centuries. For discussion, see Ann G. Carmichael, "Pesthouse Imaginaries," in *Plague Image and Imagination*, ed. Christos Lynteris (London, UK: Palgrave Macmillan, 2021).

6. In the case of Manchuria, contacts were also isolated in immobilized train wagons. For relevant photographs, see NRI, 808.24za WLD:1 (RBR), Wu Lien-teh, *Views of Harbin (Fuchiatien) Taken during the Plague Epidemic, December 1910–March 1911* (Shanghai, China: Commercial Press, 1911); NYAML, RBS74, Anon., *Chuma v Manchzhurii, v. 1910–11 g.g* (n.p., 1911).

7. On the importance of ports as loci for problematizing and intervening on plague, see Myron J. Echenberg, *Plague Ports: The Global Urban Impact of Bubonic Plague, 1894–1901* (New York, NY: New York University Press, 2007); Engelmann and Lynteris, *Sulphuric Utopias*; Harrison, *Contagion*, chapter 4.

8. Adrien Proust, *La défense de l'Europe contre la peste et la conférence de Venise de 1897* (Paris, France: Masson, 1897). For a historical reviews of the International Sanitary Conferences, their relation to quarantine and their colonial vestiges, see W. F. Bynum, "Policing hearts of darkness: Aspects of the international sanitary conferences," *History and Philosophy of the Life Sciences* 15, no. 3 (1993): 421–434; Harrison, *Contagion*. On the negotiation of plague-related quarantine in smaller sanitary conferences, see Engelmann and Lynteris, *Sulphuric Utopias*. For a general history of lazarettos, see Sofiane Bouhdiba, *Pavillon jaune: Histoire de la quarantaine, de la Peste à Ebola* (Paris, France: L'Harmattan, 2016).

9. Ministère des Affaires Étrangère, *Conférence sanitaire internationale de Paris: 10 octobre–3 décembre 1903, procès-verbaux* (Paris, France: Imprimerie Nationale, 1904).

10. Engelmann and Lynteris, *Sulphuric Utopias*, 14.

11. Engelmann and Lynteris, *Sulphuric Utopias*; Harrison, *Contagion*.

12. Alison Bashford, *Imperial Hygiene: A Critical History of Colonialism, Nationalism and Public Health* (Basingstoke, UK: Palgrave Macmillan, 2004); Krista Maglen, *The English System: Quarantine, Immigration and the Making of a Port Sanitary Zone* (Manchester, UK: Manchester University Press, 2014); Howard Markel, *Quarantine!: East European Jewish Immigrants and the New York City Epidemics of 1892* (Baltimore, MD: Johns Hopkins University Press, 1999); Sujit Sivasundaram, "Towards a critical history of connection: The port of Colombo, the geographical 'circuit,' and the visual politics of new imperialism ca.1880–1914," *Comparative Studies in Society and History* 59, no. 2 (2017): 346–384, especially 378–379.

13. Birsen Bulmuş, *Plague, Quarantines and Geopolitics in the Ottoman Empire* (Edinburgh, UK: Edinburgh University Press, 2012); Sylvia Chiffoleau, *Le voyage à La Mecque: Un pèlerinage mondial en terre d'Islam* (Paris, France: Belin, 2015); John Chircop, "Quarantine, sanitization, colonialism and the construction of the 'contagious Arab' in the Mediterranean, 1830s-1900," in *Mediterranean Quarantines, 1750–1914: Space, Identity and Power*, ed. John Chircop and Francisco Javier

Martinez, 199–231 (Manchester, UK: Manchester University Press, 2018); Mark Harrison, "Quarantine, pilgrimage, and colonial trade," *Indian Economic and Social History Review* 29 (1992): 117–144; Francisco Javier Martínez, "Mending 'Moors' in Mogador: *Hajj*, cholera and Spanish-Moroccan regeneration, 1890–99," in *Mediterranean Quarantines, 1750–1914: Space, Identity and Power*, ed. John Chircop and Francisco Javier Martínez, 66–106 (Manchester, UK: Manchester University Press, 2018); Saurab Mishra, *Pilgrimage, Politics, and Pestilence: The Haj from the Indian Subcontinent* (Oxford, UK: Oxford University Press, 2011); Christian Promitzer, "Prevention and stigma: The sanitary control of Muslim pilgrims from the Balkans, 1830–1914," in *Mediterranean Quarantines, 1750–1914: Space, Identity and Power*, ed. John Chircop and Francisco Javier Martínez, 145–169 (Manchester, UK: Manchester University Press, 2018).

14. Examples of such photographs in the British India plague photographic corpus are contained in BL, *Plague Visitation, Bombay, 1896–97*. Photographer(s): Moss, C. Photo 311/1: 1896–1897; WL, 24258i, *The Bombay Plague Epidemic of 1896–1897: Work of the Bombay Plague Committee*, photographs attributed to Capt. C. Moss, 1897; Getty Research Institute, 1384–039/96.R.81, *Plague visitation, Bombay, 1896–1897*; for instance, respectively, Apollo/VR3PP, PhotoID_3689, https://www.repository.cam.ac.uk/handle/1810/282518; Apollo/VR3PP, PhotoID_4019, https://www.repository.cam.ac.uk/handle/1810/282679.

15. For an excellent collection of primary sources on the subject, see Laurent Escande, ed., *Avec les pèlerins de La Mecque: Dossiers numériques* (Aix-en-Provence, France: Presses Universitaires de Provence, Maison Méditerranéenne des Sciences de l'Homme, 2013). The Ottoman Empire's establishment of a sanitary service in Hejaz dates back to 1866; Chiffoleau, *Le voyage à La Mecque*, 194.

16. Sylvia Chiffoleau, *Genèse de la santé publique internationale: De la peste d'Orient à l'OMS* (Rennes, France: Presses Universitaires de Rennes 2012).

17. Michael Christopher Low, "Empire and the Hajj: Pilgrims, plagues, and pan-Islam under British surveillance, 1865–1908," *International Journal of Middle East Studies* 40, no. 2 (May 2008): 269–290.

18. Cozzonis Effendi, *Rapport sur la manifestation pestilentielle à Djeddah, en 1898 suivi d'une esquisse sur les conditions générales de la dite ville* (Constantinople, Turkey: Impemerie Osmanié, 1898).

19. On plague in the Ottoman Empire before the third pandemic, see Nükhet Varlık, *Plague and Empire in the Early Modern Mediterranean World: The Ottoman Experience, 1347–1600* (Cambridge, UK: Cambridge University Press, 2015).

20. Anon., "The Turkish lazarets," *The Lancet* 169, no. 4365 (April 27, 1907): 1173. The Commission was preceded by the Commission of Lazarettos (*Commission des Lazarets*, established in 1891), as well as two earlier commissions (1867 and 1870); Administration Sanitaire de l'Empire Ottoman, *Projets pour la réorganisation*

des lazarets de l'empire Ottoman: Actes du conseil supérieur de santé 1889–1894 (Constantinople, Turkey: Typographie et Lithographie Osmanié, 1894). The nine lazarettos in the Ottoman Empire contemporary to the 1905 commission (Sinop and Kavak, in the Bosporus, Clazomenes, Beirut and Tripoli, in the Mediterranean, Abu-Saad and Kamaran (also spelled Camaran) in the Red Sea, Basra, and Khanaqin on the Turkish-Persian border) were under the control of the Council; The British Delegate on the Constantinople Board of Health, "Some Turkish lazarets and other sanitary institutions in the Near East, I," *The Lancet* 169, no. 4365 (April 27, 1907): 1188–1189. Also known as the Quarantine Council, the Constantinople Board of Health, the Council (*Meclis-i Tahaffuz* in Turkish) was established in 1839, composed of Ottoman as well as international members, and was "tasked with enforcing quarantine regulations in the Mediterranean region"; A. Arslan and H. A. Polat, "Travel from Europe to Istanbul in the 19th century and the quarantine of Çanakkale," *Journal of Transport and Health* 4 (2017): 10–17, 16. On the history of the Council, see Nuran Yıldırım, *A History of Healthcare in Istanbul: Health Organizations—Epidemics, Infections and Disease Control Preventive Health Institutions—Hospitals—Medical Education* (Istanbul, Turkey: Ajansfa, 2010).

21. Combining Clemow and Balilis in the Commission was a risky choice as the two men were known to hold diametrically opposed positions on quarantine and to have engaged in heated exchanges in the past; Engelmann and Lynteris, *Sulphuric Utopias*.

22. Other than those examined here, reports also covered the lazarettos of Abou-Saad, Wasta, and Abou-Ali (1906), Kamaran (1906), and Sinop (1908), while the disinfecting stations in Jaffa and Rhodes were also inspected; see Anon., "Turkish lazarets." Kamaran lazaretto is the Ottoman quarantine station that has attracted the most historical attention to date: Sylvia Chiffoleau, "Les pèlerins de La Mecque, les germes et la communauté international," *Médecine/Sciences* (Paris) 27, no. 12 (December 2011): 1121–1126; Harrison, "Quarantine, pilgrimage, and colonial trade"; Saurab Mishra, "Incarceration and resistance in a Red Sea lazaretto, 1880–1930," in *Quarantine: Local and Global Histories*, ed. Alison Bashford, 54–65 (London, UK: Palgrave Macmillan, 2016); G. Sariyildiz and O. D. Macar, "Cholera, pilgrimage, and international politics of sanitation: The quarantine station on the island of Kamaran," in *Plague and Contagion in the Islamic Mediterranean*, ed. Nukhet Varlık, 243–274 (Croydon, UK: ARC Humanities Press, 2017).

23. For a history of sanitation in Lebanon, see Houssam Yehya, "La protection sanitaire et sociale au Liban (1860–1963)," PhD diss. (Université Nice Sophia Antipolis, 2015).

24. Administration Sanitaire de l'Empire Ottoman, *Rapport de la commission d'inspection des lazarets sur le lazaret de Beyrouth, presenté au Conseil supérieur de santé le 9 octobre, 1906* (Constantinople, Turkey: Imprimerie F. Loeffler, Lithographie de S.M.I le Sultan, 1906). On the construction of the lazaretto by request of Ibrahim Pasha

(the son of Muhammad Ali of Egypt) and the early nineteenth-century history of quarantine in Ottoman Beirut, see Toufoul Abou-Hodeib, "Quarantine and trade: The case of Beirut, 1831–1840," *International Journal of Maritime History* 19, no. 2 (2007): 223–224. On the history of the lazaretto, see also Jens Hanssen, *Fin de Siècle Beirut: The Making of an Ottoman Provincial Capital* (Oxford, UK: Oxford University Press, 2005).

25. Administration Sanitaire de l'Empire Ottoman, *Le lazaret de Beyrouth*, 3–4, my translation.

26. The use of diagrams had been an integral part of discussions of lazarettos since Howard's authoritative monograph on the subject; John Howard, *An Account of the Principal Lazarettos in Europe with Various Papers Relative to Plague* (Warrington, UK: William Eyres, 1789). For a discussion of diagrams in lazaretto treatises before the third pandemic, see also Manlio Brusatin, *Il muro della peste: Spazio della pieta e governo del lazaretto* (Venice, Italy: Cluva Libraria Editrice, 1981); Pierre-Louis Laget, "Les lazarets et l'émergence de nouvelles maladies pestilentielles au XIXe et au début du XXe siècle," *In Situ: Revue des Patrimoines* 2 (2002), https://dx.doi.org/10.4000/insitu.1225.

27. On intervisuality and photography, see Nicholas Mirzoeff, "The multiple viewpoint: Diasporic visual cultures," in *Diaspora and Visual Culture: Representing Africans and Jews*, ed. Nicholas Mirzoeff, 1–18 (London, UK: Routledge, 2000).

28. Administration Sanitaire de l'Empire Ottoman, *Le lazaret de Beyrouth*, 4, my translation.

29. Anon., "Turkish lazarets," 1173.

30. Administration Sanitaire de l'Empire Ottoman, *Rapport de la commission d'inspection ses lazarets sur le lazaret de Camaran, présenté au Conseil supérieur de santé le 31 juillet 1906* (Constantinople, Turkey: Imprimerie Française E. Souma & cie 1906); Clemow was *rapporteur* to both reports.

31. British Delegate on the Constantinople Board of Health, "Some Turkish lazarets and other sanitary institutions in the Near East," *The Lancet* 169, no. 4365 (April 27, 1907): 1188–1189, the beginning of an article series that ran between April and August 1907.

32. British Delegate on the Constantinople Board of Health, "Some Turkish lazarets and other sanitary institutions in the Near East, V. The Camaran lazaret," *The Lancet* 169, no. 4370 (June 1, 1907): 1518–1521.

33. Elizabeth Edwards, *The Camera as Historian: Photographers and Historical Imagination, 1885–1918* (Durham, NC: Duke University Press, 2012); Robin Kelsey, *Archive Style: Photographs and Illustrations for U.S. Surveys, 1850–1890* (Berkeley, CA: University of California Press, 2007).

34. Kelsey, *Archive Style*, 97.

35. Michael Christopher Low, "Ottoman infrastructures of the Saudi hydro-state: The technopolitics of pilgrimage and potable water in the Hijaz," *Comparative Studies in Society and History* 57, no. 4 (2015): 942–974. On survey photography in the late Ottoman Empire, see Ahmet A. Erso, "Ottomans and the Kodak galaxy: Archiving everyday life and historical space in Ottoman illustrated journals," *History of Photography* 40, no. 3 (2016): 330–357.

36. Zeynep Devrim Gürsel, "A picture of health: The search for a genre to visualize care in late Ottoman Istanbul," *Grey Room* 72 (Summer 2018): 36–67; Zeynep Devrim Gürsel, "Thinking with X-rays: Investigating the politics of visibility through the Ottoman Sultan Abdülhamid's photography collection," *Visual Anthropology* 29, no. 3 (2016): 229–242.

37. Low, "Ottoman infrastructures"; Bulmuş, *Plague, Quarantines*, 5.

38. Esra Ekcan, "Off the frame: The panoramic city albums of Istanbul," in *Photography's Orientalism: New Essays on Colonial Representation*, ed. Ali Behdad and Luke Gartland (Los Angeles, CA: Getty Research Institute, 2013), 95.

39. Administration Sanitaire de l'Empire Ottoman, *Rapport générale sur la campagne du pèlerinage de 1909 au lazaret de Tébuk* (Constantinople, Turkey: Gérard Frères, 1909).

40. Administration Sanitaire de l'Empire Ottoman, *Rapport générale sur la campagne du pèlerinage de 1909 au lazaret de Tébuk*. The railway route via Tabuk operated between 1909 and 1913, with large parts of it and the entirety of the lazaretto destroyed during World War I; League of Nations, Health Organisation, *Report of Commission to Enquire into International Arrangements in Connection with Epidemic Disease Prevention in Certain Areas of the Near East (Basin of Eastern Mediterranean and Black Sea, etc.) and in Connection with the Mecca Pilgrimage*, February 20th to March 27th 1922, C 342. M 193. 122 II.

41. Frank-Gerard Clemow, "Étude sur la défense sanitaire du chemin de fer du Hedjaz," *Revue d'hygiène et de police sanitaire* 32 (1910): 213–244, 342–361. Clemow's article contains four more photographs of the Tabuk lazaretto. The hospital had been built in 1907 for soldiers and workers engaged in the construction of the Hejaz railway line; Chiffoleau, *Le voyage à La Mecque*, 190.

42. Administration Sanitaire de l'Empire Ottoman, *Rapport générale sur la campagne du pèlerinage de 1909 au lazaret de Tébuk* .

43. A pavilion hospital replaced these tents in 1910; Chiffoleau, *Genèse de la santé*. See also Gabriel Delamare, *La défense sanitaire de la ligne Médine-Damas* (Constantinople, Turkey: Imprimerie L. Mourkidès, 1912).

44. Administration Sanitaire de l'Empire Ottoman, *Rapport générale sur la campagne du pèlerinage de 1909 au lazaret de Tébuk*.

45. On the importance of diagrams in the reconfiguration of lazarettos in the course of the nineteenth century, see Laget, "Les lazarets."

46. Administration Sanitaire de l'Empire Ottoman, *Rapport générale sur la campagne du pèlerinage de 1909 au lazaret de Tébuk*. For a less optimistic view about the ability of the lazaretto to act as a barrier to disease, especially cholera, see Antoine Lorty, "La menace du choléra en Europe et le chemin de fer du Hedjaz," *Questions diplomatiques et coloniales* 32 (July-December 1911): 98–107.

47. Chiffoleau, *Genèse de la santé*, 163, my translation.

48. Bulmuş, *Plague, Quarantines*, 160. In particular, Clemow disapproved of the earlier established quarantine station at Medain-I Salihi, for practical as well as political reasons, and suggested Tabuk as an alternative site.

49. Low, "Empire and the Hajj."

50. Elizabeth Edwards, "Photographic uncertainties: Between evidence and reassurance," *History and Anthropology* 25, no. 2 (2014), 174.

51. Jennifer Tucker, "Photography and the making of modern science," in *The Handbook of Photography Studies*, ed. Gil Pasternak, 235–254 (London, UK: Routledge, 2020).

52. Tucker, "Photography," 236.

53. Lorraine J. Daston, and Peter Galison, *Objectivity* (New York, NY: Zone Books, 2007).

54. Zeynep Çelik, *Displaying the Orient: Architecture of Islam at 19th Century World's Fairs* (Berkeley, CA: University of California Press, 1992); Michelle L. Woodward, "Between orientalist clichés and images of modernization," *History of Photography* 27, no. 4 (2003): 363–374.

55. Wendy M. K. Shaw, "Ottoman photography of the late nineteenth century: An 'innocent' modernism?" *History of Photography* 33, no. 1 (2009), 93.

56. Baldwin, *Contagion and the State in Europe*.

57. Muslim pilgrims subjected to quarantine did of course frequently decry the horrendous conditions of detention; for discussion, see Chiffoleau, *Le voyage à La Mecque*; Mishra, *Pilgrimage, Politics, and Pestilence*.

58. Jacques Chevallier, "Une quarantaine de peste au lazaret de Frioul en 1901," *Histoire des sciences médicales* 49, no. 2 (2015): 179–188. On the history of educational, scientific cruises organized by the *Revue générale des sciences pures et appliquées*, see Veronica della Dora, "Making mobile knowledges: The educational cruises of the *Revue générale des sciences pures et appliquées*, 1897–1914," *Isis* 101, no. 3 (September 2010): 467–500.

59. On the questions arising as to how the man was infected and the impact of the incident in the development of maritime sanitation, see Engelmann and Lynteris, *Sulphuric Utopias*.

60. Fabre succumbed a few days later, but the second patient survived; no one else became infected during the incident. For a synoptic history of the Frioul lazaretto,

see Georges François, "Les lazarets de Marseille," *Association des Amis du Patrimoine Médical de Marseille*, http://patrimoinemedical.univmed.fr/articles/article_lazarets.pdf. For situating the Frioul lazaretto within Europe's defense against the importation of diseases for the East, see Daniel Panzac, *Quarantaines et lazarets: L'Europe et la peste d' Orient (XVIIe–XXe siècles)* (Aix-en-Provence, France: Édisud, 1986).

61. Chevallier, "Une quarantaine de peste."

62. Jean Bertot, *Au lazaret: Souvenirs de quarantaine* (Tours, France: Deslis Freres, 1902), 144. Bertot's published memoir of the quarantine includes a photograph of "vaccination des dames" by Mrs. Richardière (the doctor or the editor of the book is here confusing serotherapy with vaccination) (144). For a detailed examination of the cases treated in Frioul and of the after-effects of the serotherapy delivered during this incident, see, respectively, Joseph Pellisier, *La peste au Frioul, lazaret de Marseille en 1900 et 1901* (Paris, France: Stein-heil, 1902); and Charles Leroux, "Des accidents consécutifs aux injections préventives du sérum antipesteux," *Gazette hebdomadaire de médecine et de chirurgie* 98 (December 8, 1901): 1172–1176; also contained in Bertot, *Au lazaret*, 289–295.

63. Chevallier, "Une quarantaine de peste."

64. Gustave Autran, "Ballade des 80 rats morts," in Anon., *Le "Sénégal" au Frioul (vers)*, 44–47 (Paris, France: Imprimerie de la Court d'Appel, 1902). For a description of the celebrations, including the program and copies of recited poems, see Bertot, *Au lazaret*.

65. Léo D'Hampol, "La peste en Europe—A Marseille et à Naples," *La vie illustrée* 156 (October 11, 1901): 19–21, 20, my translation.

66. Bertot, *Au lazaret*, 107.

67. Anon., "Nos lazarets," *Le matin* 18, no. 6427 (September 30, 1901): 1, my translation.

68. Anon., "Nos lazarets," 1, my translation.

69. Anon., "Nos lazarets," 1, my translation.

70. For a particularly vitriolic anonymous account, see Anon., "Le lazaret du Frioul," *L'actualité* 2, no. 90 (October 20, 1901): 659. It is important to note that this sense of superiority risked the lives of those the passengers considered as inferior to themselves: the boat's one-hundred crew members were not allowed to disembark and be quarantined together with the passengers, all of them remaining on the boat—something that, as has been pointed out by Pierre Carrey, exposed them to plague-carrying rats, the cadavers of which had been discovered on board; Pierre Carrey, "Marseille, 1901: Le paquebot de la peste, la quarantaine et les caprices de riches," *Libération*, April 25, 2020, https://www.liberation.fr/france/2020/04/25/marseille-1901-le-paquebot-de-la-peste-la-quarantaine-et-les-caprices-de-riches_1786369.

71. M. Branger, "La peste au Frioul," *Armée et marine* 3, no. 41 (October 13, 1901): 138–140.

72. Anon., "Les passagers du *Sénégal*, rélegués derriére la grille du lazaret, dans l'île Ratonneau (Photographie de Chusseau-Flaviers)," *La vie illustrée* 156 (October 11, 1901): 3.

73. Anon., "Au lazaret du Frioul," *La petit gironde* 31, no. 10,698 (October 7, 1901): 1.

74. Ariella Azoulay, *Civil Imagination: A Political Ontology of Photography*, trans. Louise Bethlehem (London, UK: Verso, 2012), 15.

75. Christos Lynteris and Ruth J. Prince, "Introduction: Medical photography," *Visual Anthropology* 29, no. 2 (2016), 104.

76. "Views of the various officers regarding the establishment of detention camps," MSA General Department (Plague), vol. 617, 1899, quoted in Aidan Forth, *Barbed-Wire Imperialism: Britain's Empire of Camps, 1876–1903* (Berkeley, CA: University of California Press, 2017), 78.

77. Key works include David Arnold, *Colonizing the Body: State Medicine and Epidemic Disease in Nineteenth Century India* (Cambridge, UK: Cambridge University Press, 1993); Ian Catanach, "Plague and the tensions of Empire: India, 1896–1918," in *Imperial Medicine and Indigenous Societies*, ed. David Arnold, 149–171 (Manchester, UK: Manchester University Press, 1988); Dipesh Chakrabarty, "Community, state and the body: Epidemics and popular culture in colonial India," in *Medical Marginality in South Asia: Situating Subaltern Therapeutics*, ed. David Hardiman and Projit Bihari Mukharji, 36–58 (London, UK: Routledge, 2012); Rajnarayan Chandavarkar, "Plague panic and epidemic politics in India, 1896–1914," in *Epidemics and Ideas: Essays on the Historical Perception of Pestilence*, ed. Paul Slack, 203–240 (Cambridge, UK: Cambridge University Press, 1992); Ira Klein, "Plague, policy and popular unrest in British India," *Modern Asian Studies* 22, no. 4 (1988): 723–755.

78. Aditya Sarkar, "The tie that snapped: Bubonic plague and mill labour in Bombay, 1896–1898," *International Review of Social History* 59, no. 2 (August 2014), 184. It is here interesting to note that the Epidemic Diseases Act, 1897, was reinstated in 2020 in India's fight against COVID-19; Pratik Chakrabarti, "Covid-19 and the spectres of colonialism," *India Forum*, July 14, 2020, https://www.theindiaforum .in/article/covid-19-and-spectres-colonialism; Dwai Banerjee, "Fantasies of control: The colonial character of the Modi government's actions during the pandemic," *Caravan Magazine*, June 30, 2020, https://caravanmagazine.in/perspectives /colonial-character-of-the-modi-governments-actions-during-the-pandemic.

79. Forth, *Barbed-Wire Imperialism*, 77.

80. Forth, *Barbed-Wire Imperialism*, 77.

81. Forth, *Barbed-Wire Imperialism*, 77. Natasha Sarkar in turn describes three camp categories in place in Bombay—"hospital camps, segregation camps and observation

camps"—with the same structure sometimes incorporating several functions; Natasha Sarkar, "Fleas, Faith and Politics: Anatomy of an Indian Epidemic, 1890–1925," PhD diss. (National University of Singapore, 2011), 83, 72.

82. Sarkar, "Fleas, Faith and Politics"; Klein, "Plague, policy"; Anita Prakash, "Plague riot in Kanpur—Perspectives on colonial public health," *Proceedings of the Indian History Congress* 69 (2008): 839–846.

83. On the number kept in Bombay's camps: NLS, 9937335823804341, *Report of the Municipal Commissioner on the Plague in Bombay for the Year Ending 31st May 1900*, vol. 2 (Bombay, India: Times of India, 1901). Forth estimates that over a million people were kept in camps across India during the pandemic (*Barbed-Wire Imperialism*, 77).

84. WL, b32162698, *Karachi Plague Committee in 1897*; BL, *Plague Visitation, Bombay, 1896–97*, photographer(s): Moss, C., photo 311/1: 1896–1897; WL, 24258i, *Bombay Plague Epidemic*; Getty Research Institute, 1384–039/96.R.81, *Plague Visitation*; Getty Research Institute, 96.R.95, *Poona Plague Pictures, 1897–1908* (undated).

85. I am here borrowing the term from Jeanne Haffner, *The View from Above: The Science of Social Space* (Cambridge, MA: MIT Press, 2013).

86. Louis Marin, *Utopics: Spatial Play* (Atlantic Highlands, NJ: Humanities Press, 1984), 207; Kelsey, *Archive Style*, 93.

87. Marin Warner, "Intimate communiqués: Melchior Lorck's flying tortoise," in *Seeing from Above: The Aerial View in Visual Culture*, ed. Mark Dorrian and Frédéric Pousin, 11–45 (London, UK: I. B. Tauris, 2013).

88. James R. Ryan, *Picturing Empire: Photography and the Visualization of the British Empire* (London, UK: Reaktion Books, 1997).

89. Ryan, *Picturing Empire*, 81.

90. Ryan, *Picturing Empire*, 81.

91. Jean-Marc Besse, "European cities from bird's-eye views: The case of Alfred Guesdon," in *Seeing from Above: The Aerial View in Visual Culture*, ed. Mark Dorrian and Frédéric Pousin, 66–82 (London, UK: I. B. Tauris, 2013).

92. Ryan, *Picturing Empire*, 96. On the use of panopticism as a colonial technique in British India, see Martha Kaplan, "Panopticon in Poona: An essay on Foucault and colonialism," *Cultural Anthropology* 10, no. 1 (February 1995): 85–98. On deciphering hidden or invisible information from above, see Haffner, *View from Above*. For examples of the "view from above" techniques used to photograph plague camps in Kumasi, see P. S. Selwyn-Clarke, *Report on the Outbreak of Plague in Kumasi, Ashanti* (Accra, Gold Coast [Ghana]: Government Printing Department, 1925), for example, Apollo/VR3PP, PhotoID_11977, https://www.repository.cam.ac.uk/handle/1810/281836.

93. Apollo/VR3PP, PhotoID_3993, https://www.repository.cam..ac.uk/handle/1810/282650.

94. Mark Harrison, "The medicalization of war—the militarization of medicine," *Social History of Medicine* 9, no. 2 (1996): 267–276.

95. WL, b32162698, *Karachi Plague Committee.*

96. Adia Benton, "Risky business: Race, nonequivalence and the humanitarian politics of life," *Visual Anthropology* 29, no. 2 (2016): 187–203, 193.

97. Anon., "The pool of Siloam: In a plague segregation camp at Karachi," *The Graphic*, August 21, 1897, 268.

98. Branwyn Poleykett, "Pasteurian tropical medicine and colonial scientific vision," *Subjectivity* 10 (2017): 190–203, 192.

99. Jacob Steere-Williams, "'Coolie' control: State surveillance and the labour of disinfection across the late Victorian British Empire," in *Making Surveillance States: Transnational Histories*, ed. Robert Heynen and Emily van der Meulen, 35–57 (Toronto, Ontario: University of Toronto Press, 2019), 47, 38.

100. Christopher Pinney, "Introduction: 'How the other half . . . ,'" in *Photography's Other Histories*, ed. Christopher Pinney and Nicolas Peterson, 1–14 (Durham, NC: Duke University Press, 2003), 4.

101. HCPP, Cd.140, Indian Plague Commission, 1898–99. "Minutes of evidence taken by the Indian Plague Commission with appendices. Vol. II. Evidence taken from 11th January 1899 to 8th February 1899." In the course of the first Karachi outbreak (December 1896–June 1897), including the province of Sind as a whole, 6,063 people were infected, of whom 4,779 died; in the camps themselves, 242 people were infected, and 144 died; "Report on Sind by Mr. Wingate, Acting Commissioner," in R. Nathan, *The Plague in India, 1896, 1897*, vol. 2, appendix VI (Simla, India: Government Central Printing Office, 1898), 402, 417.

102. HCPP, Cd.140, 132. More detail on this camp is provided in the same volume by Dr. Kaka (155). For a detailed timeline on deciding whether to implement compulsory evacuation in Karachi, see "Report on Sind by Mr. Wingate," in Nathan, *Plague in India.*

103. HCPP, Cd.140, 367.

104. HCPP, Cd.140, 367.

105. HCPP, Cd.140, 133.

106. HCPP, Cd.140, 133.

107. HCPP, Cd.140, 133.

108. For a discussion of the various plague commissions in India, see Mark Harrison, *Public Health in British India: Anglo-Indian Preventive Medicine 1859–1914* (Cambridge, UK: Cambridge University Press, 1994).

109. Nathan, *Plague in India*, "Report on Sind by Mr. Wingate," 134. For these regulations as detailed in Notification No.1518–970.P, dated March 17, 1897, see Nathan, *Plague in India*, 166–168.

110. HCPP, Cd.140, 134.

111. The Indian Plague Commission calculated the cases in the second epidemic to be 6,301, of which 4,731 were casualties; HCPP, Cd.810, Indian Plague Commission, 1898–99, "Report of the Indian Plague Commission with appendices and summary. Vol. V", 26, session 1902.

112. HCPP, Cd.140, 136.

113. Nicholas H. Evans, "Blaming the rat? Accounting for plague in colonial Indian medicine," *Medicine, Anthropology, Theory* 5, no. 3 (2018): 15–42, 130. For the original: BL, IOR/V/25/840/23, "Health Officer's Report for the 1st Quarter of 1903." Following Lieut.-Col. McCloghry's calculations in the first months of the second Karachi epidemic (spring 1898) one-third of the population evacuated the city, while according to the Health Officer of the Karachi Municipality, Dr. S. M. Kaka, at the peak of the second outbreak there were more than 26,000 individuals held in plague camps around the city; HCPP, Cd.140, 143, 147.

114. In Nathan, *Plague in India*, 292. On how "voluntary camps" were further encouraged in the second Karachi outbreak, see HCPP, Cd.140, 137. The only recorded resistance in the course of the first outbreak took place on January 18, 1897, with regards to the burning down of a house in the Muslim quarter of the city across the Lyari River; Nathan, *Plague in India*, "Report on Sind by Mr. Wingate," 366.

115. HCPP, Cd.140, 158.

116. HCPP, Cd.140, 136.

117. HCPP, Cd.140, 136

118. HCPP, Cd.140, 158.

119. See, for example, the testimony of J. H. Duboulay, Deputy Commissioner for Plague Operations in Bombay, to the Plague Commission in HCPP, Cd.139, Indian Plague Commission, 1898–99, "Minutes of evidence taken by the Indian Plague Commission with appendices. Vol. I. Evidence taken from 29th November 1898 to 5th January 1899," 57. The Commission made an effort to quantify the relevant data, finding, for example, that, between March and May 1898, out of a total of 103 cases occurring in Banga, a town in the Punjab, sixty-two occurred in the plague camps of the region; HCPP, Cd.140, 99.

120. NLS, IP/13/PC.4, Malcolm Edward Couchman, *Account of Plague Administration in the Bombay Presidency from September 1896 till May 1897* (Bombay, India: Government Central Press, 1897).

121. On the infectivity of clothing, see Giles's and Lieut.-Col. McCloghry's testimonies to the Plague Commission, especially HCPP, Cd.140. On the difficulty in distinguishing the two, see HCPP, Cd.180, 111–112.

122. HCPP, Cd.141, Indian Plague Commission, 1898–99. "Minutes of evidence taken by the Indian Plague Commission with appendices. Vol. III. Evidence taken from 11th February 1898 to 20th May 1899," 162.

123. Nathan, *Plague in India*, "Report on Sind by Mr. Wingate," 393. We may assume this to be the liquid used in figure 3.6.

124. For a discussion of the use of this chemical in human disinfection in British India, see Steere-Williams, "'Coolie' control."

125. The lack of depictions of suffering in British India's plague camps may be here compared to the visualization of suffering in photographs of concentration camps during the Boer War in South Africa; Michael Godby, "Confronting horror: Emily Hobhouse and the concentration camp photographs of the South African War," *Kronos* 32 (November 2006): 34–48.

126. For a reading of quarantine in terms of "imagining the geo-body of the nation," see Bashford, *Imperial Hygiene*, chapter 5.

127. Bashford, "Maritime quarantine," 10.

128. Sivasundaram, "Towards a critical history," 382.

129. Sivasundaram, "Towards a critical history," 382.

130. Sivasundaram, "Towards a critical history"; Jane Stevens Crawshaw, "The places and spaces of early modern quarantine," in *Quarantine: Local and Global Histories*, ed. Alison Bashford, 15–53 (London, UK: Palgrave Macmillan, 2016).

CHAPTER 4

Research leading to this chapter and making this chapter available as Open Access was funded by the Wellcome Trust with a Wellcome Investigator Award, grant ID 217988/Z/19/Z, for the project "The Global War Against the Rat and the Epistemic Emergence of Zoonosis."

1. See, for example, Rebecca Morrell, "'Gerbils replace rats' as main cause of Black Death," *BBC News*, February 24, 2015, https://www.bbc.co.uk/news/science -environment-31588671. The article is based on a misinterpretation of the following scientific paper: Boris V. Schmid, Ulf Büntgen, W. Ryan Easterday, Christian Ginzler, Lars Walløe, Barbara Bramanti, and Nils Chr. Stenseth, "Climate-driven introduction of the Black Death and successive plague reintroductions into Europe," *Proceedings of the National Academy of Sciences of the United States of America* 112, no. 10 (2015): 3020–3025. In fact, marmots were identified as carriers of plague as far back as 1894, with scientific literature covering this zoonotic host of the disease predating that covering the rat's similar role; Christos Lynteris, *Ethnographic Plague: Configuring Disease on the Russian-Chinese Frontier* (London, UK: Palgrave Macmillan, 2016).

2. See chapters in Christos Lynteris, ed., *Framing Animals as Epidemic Villains: Histories of Non-Human Disease Vectors* (London, UK: Palgrave Macmillan, 2019); James Robert Fairhead, "Technology, inclusivity and the rogue: Bats and the war against the 'invisible enemy,'" *Conservation and Society* 16, no. 2 (2018): 170–180.

3. Nicholas B. King, "The scale politics of emerging diseases," *Osiris*, 2nd Series, 19, (2004): 62–76.

4. For a review of these approaches in the context of the pandemic imaginary, see Christos Lynteris, *Human Extinction and the Pandemic Imaginary* (London, UK: Routledge, 2019).

5. Neil Pemberton, "The rat-catcher's prank: Interspecies cunningness and scavenging in Henry Mayhew's London," *Journal of Victorian Culture* 19 (2014): 520–535.

6. Mary Fissell, "Imagining vermin in early modern England," *History Workshop Journal* 47 (1999): 1–29.

7. Carlo M. Cipolla, *Cristofano and the Plague: A Study in the History of Public Health in the Age of Galileo* (Berkeley, CA: University of California Press, 1973).

8. C. R. Francis and Frank Pearson, "Mahamurree, or Indian plague," *Indian Annals of Medical Science* 2 (1854): 609–645.

9. Pemberton, "Rat-catcher's prank," 532.

10. Pemberton, "Rat-catcher's prank," 533. Rodwell was the author of a popular treatise: James Rodwell, *The Rat: Its History and Destructive Character* (London, UK: Routledge, 1858).

11. Carol A. Benedict, *Bubonic Plague in Nineteenth-Century China* (Redwood City, CA: Stanford University Press, 1996); Myron J. Echenberg, *Plague Ports: The Global Urban Impact of Bubonic Plague, 1894–1901* (New York, NY: New York University Press, 2007).

12. Nicholas H. Evans, "Blaming the rat? Accounting for plague in colonial Indian medicine," *Medicine, Anthropology, Theory* 5, no. 3 (2018): 15–42.

13. B. E. Holsendorf, "Rat surveys and rat proofing," *American Journal of Public Health and the Nation's Health* 27, no. 9 (1937): 883–888.

14. W. R. Boetler, *The Rat Problem* (London, UK: Bale and Danielsson, 1909). The war metaphor was used in various permutations by a wide range of scientists, journalists, and functionaries at the time; see, for example, Albert Calmette, "Déclarons la guerre aux rats," *La revue du mois* 3, no. 28 (April 10, 1908): 432–444.

15. In anthropological literature, the term "global war against the rat" was coined in Branwyn Poleykett, "Building out the rat: Animal intimacies and prophylactic settlement in 1920s South Africa," *American Anthropological Association: Engagement*, February 7, 2017, https://aesengagement.wordpress.com/2017/02/07/building-out-the-rat-animal-intimacies-and-prophylactic-ssettlement-in-1920s-south-africa/.

16. Éric Baratay, *Bêtes des tranchées, des vécus oubliés* (Paris, France: CNRS Éditions, 2013); L. C. Murphy and A. D. Alexander, "Significance of the leptospiroses in military medicine," *Military Medicine* 121, no. 1 (1957): 1–10; Poleykett, "Building

out the rat"; Karen Sayer, "The 'modern' management of rats: British agricultural science in farm and field during the twentieth century," *British Journal for the History of Science* 2 (2017): 235–263.

17. David E. Lantz, *House Rats and Mice*, Farmer's Bulletin 896, United States Department of Agriculture (Washington, DC: Government Printing Office, 1917). On rats and quarantine, see Birsen Bulmuş, *Plague, Quarantines and Geopolitics in the Ottoman Empire* (Edinburgh, UK: Edinburgh University Press, 2012); Echenberg, *Plague Ports*; Lukas Engelmann and Christos Lynteris, *Sulphuric Utopias: A History of Maritime Fumigation* (Cambridge, MA: MIT Press, 2020); Robert Peckham, "Spaces of quarantine in colonial Hong Kong," in *Quarantine: Local and Global Histories*, ed. Alison Bashford, 66–84 (London, UK: Palgrave Macmillan, 2017).

18. For an excellent history of the use of the Danysz Virus against rats, see Lukas Engelmann, "An epidemic for sale: Observation, modification, and commercial circulation of the Danysz Virus, 1890-1910," *Isis* 112, no. 3 (2021): 439–460.

19. Timothy P. Barnard, *Imperial Creatures: Humans and Other Animals in Colonial Singapore, 1819–1942* (Singapore: Singapore University Press, 2019); Lukas Engelmann, "Fumigating the hygienic model city: Bubonic plague and the sulfurozador in early-twentieth-century Buenos Aires," *Medical History* 62, no. 3 (2018): 360–382; Projit Bihari Mukharji, "Cat and mouse: Animal technologies, trans-imperial networks and public health from below, British India, c. 1907–1918," *Social History of Medicine* 31, no. 3 (2017): 510–532; Poleykett, "Building out the rat"; Karen Sayer, "Vermin landscapes: Suffolk, England, shaped by plague, rat and flea (1906–1920)," in *Framing Animals as Epidemic Villains: Histories of Non-Human Disease Vectors*, ed. Christos Lynteris, 27–64 (London, UK: Palgrave Macmillan, 2019); Megan Vaughan, *Curing Their Ills: Colonial Power and African Illness* (Redwood City, CA: Stanford University Press, 1991); Ann Zulawski, "Environment, urbanization, and public health: The bubonic plague epidemic of 1912 in San Juan, Puerto Rico," *Latin American Research Review* 53, no. 3 (2018): 500–516.

20. On rats and the International Sanitary Conferences, see Engelmann and Lynteris, *Sulphuric Utopias*. For the minutes of the two international rat conferences, see Gabriel Petit, ed., *Première conférence internationale du rat, Paris—Le Havre 16–22 Mai 1928* (Paris, France: Vigot Frères, 1928); Gabriel Petit, ed., *Deuxième conférence internationale et congrès colonial du rat et de la peste: Paris, 7–12 octobre 1931* (Paris, France: Vigot Frères, 1932).

21. Koen Beumer, "Catching the rat: Understanding multiple and contradictory human-rat relations as situated practices," *Society and Animals* 22 (2014): 8–25; Jonathan Burt, *Rat* (London, UK: Reaktion Books, 2006); Maud Ellmann, "Writing like a rat," *Critical Quarterly* 46, no. 4 (2004): 59–76; Albert Calmette, "Discours (7/10/1931)," in *Deuxième conférence internationale et congrès colonial du rat et de la peste: Paris, 7–12 octobre 1931*, ed. Gabriel Petit, 48 (Paris, France: Vigot Fr. 1932).

22. Mukharji, "Cat and mouse."

23. I borrow here the idea of the rat as an "infrastructure" from Genese Marie Sodikoff, "The multispecies infrastructure of zoonosis," in *The Anthropology of Epidemics*, ed. Ann H. Kelly, Frédéric Keck, and Christos Lynteris, 102–120 (London, UK: Routledge, 2019).

24. On the development of sanitary hygienic utopias at the turn of the nineteenth century, see Engelmann and Lynteris, *Sulphuric Utopias*; Mark Harrison, "Towards a sanitary utopia? Professional visions and public health in India, 1880–1914," *South Asia Research* 10, no. 1 (1990): 19–41.

25. H. J. Sears, "The problem of plague as an epidemic disease," *Bulletin of the Medical Library Association* 29, no. 1 (October 1940), 10.

26. Paul-Louis Simond, "La propagation de la peste," *Annales de l'Institut Pasteur* (Paris) 12 (1898): 625–687. In reality, Simond was not the first to make this identification, and the notes of his experiment suggest it may not have been as successful as suggested by the 1898 publication in the *Annales de l'Institut Pasteur*. Simond's notes and notebooks on his plague research in India (1897–1898) contain a rich trail of visual material but no images of rats or fleas, or of experiments on them; the key notebook here being AIP, Lieu SIM.2, A3/81–84, "Observ. concern. épid. de peste."

27. Evans, "Blaming the rat?"

28. For what seem to be the first images of rat-catching in British India, see WL, b32162698, *Karachi Plague Committee in 1897* (e.g., Apollo/VR3PP, PhotoID_4045, https://www.repository.cam.ac.uk/handle/1810/282705).

29. For example, a lecture slide (85 × 100 mm) from 1900, tagged "Bacille de la peste. Bubon pesteux. Rat et mangouste," showed the image of a plague bacillus, two photographs of patients with cervical and axillary buboes, respectively, the microphotograph of a flea, and the photograph of a rat and a mongoose; Musée National de l'Éducation (Rouen), 0003.00539.11, Projections Molteni, Radiguet & Massiot, "Prophylaxie des maladies contagieuses. 1ère série. Transmises par les déjections, les matières fécales, l'eau souillée; les sécrétions respiratoire. Bacille de la peste. Bubon pesteux. Rat et mangouste."

30. For a history of the emergence of systematic images of animal dissection in the seventeenth century, see Anita Guerrini, *The Courtiers' Anatomists: Animals and Humans in Louis XIV's Paris* (Chicago, IL: University of Chicago Press, 2015).

31. Domenico Bertoloni Meli, *Visualizing Disease: The Art History of Pathological Illustrations* (Chicago, IL: University of Chicago Press, 2017).

32. Plague Commission, "XI. The diagnosis of natural rat plague," *Journal of Hygiene* 7, no. 3 (1907): 324–358. For a discussion, see Evans, "Blaming the rat?" See also Katherine Royer, "The blind men and the elephant: Imperial medicine, medieval historians and the role of rates in the historiography of plague," in *Medicine and Colonialism: Historical Perspectives in India and South Africa*, ed. Poonam Bala, 99–110 (London, UK: Routledge, 2015).

33. For examples of organ pathology, see B. Burnett Ham, *Report on Plague in Queensland, 1900–1907 (26th February, 1900, to 30th June, 1907)* (Brisbane, Australia: Government Printer, 1907), from which the image "Lungs of naturally-infected plague rats, showing general congestion and a few scattered grey nodules" is available at Apollo/VR3PP, PhotoID_3522, https://www.repository.cam.ac.uk/handle /1810/282405. For examples of the photography of rats with buboes, or of bubo-related pathology, see Ham, *Report on Plague in Queensland, 1900–1907,* from which the image "Dissections of fore and hind legs of naturally-infected plague rats, showing in No. I. enlarged axillary gland, and in Nos II. and III. enlarged femoral gland," is available at Apollo/VR3PP, PhotoID_3521, https://www.repository.cam.ac.uk /handle/1810/282404.

34. See, for example, BANC PIC 1988.052:037-PIC, "Tumor on Norway rat— open beneath and exceeding in weight the animal's body. Taken in the heart of Los Angeles," Available via Online Archive of California, https://calisphere.org/item /ark:/13030/tf3v19p3d9/.

35. Evans, "Blaming the rat?"

36. See, for example, J. A. Lopez del Valle and E. B. Barnet, *Plan de campaña sanitaria contra la peste bubonica* (Havana, Cuba: La Moderna Poesia, 1915).

37. For a full discussion of these, see Christos Lynteris, "Zoonotic diagrams: Mastering and unsettling human-animal relations," *Journal of the Royal Anthropological Institute* 23, no. 3 (2017): 463–485. For the application of such diagrams in the work of Marcel Baltazard, see Lukas Engelmann, Caroline Humphrey, and Christos Lynteris, "Introduction: Diagrams beyond mere tools," in "Working with Diagrams," edited by Lukas Engelmann, Caroline Humphrey, and Christos Lynteris, special issue, *Social Analysis* 63, no. 4 (Winter 2019): 1–19.

38. For example, William Hunter, *A Research into Epidemic and Epizootic Plague* (Hong Kong: Noronha & Co., 1904). Another visual device used to demonstrate the same process involved the visualization of plague's annual cycle by means of a disk representing the solar year in monthly slices, with concentric cycles showing human plague, "chronic rat plague," "acute rat plague," and "rat prolificity," with curves in each cycle showing the rise and fall of cases and correlating these to the monsoon seasons and the harvest of different crops; A. F. Stevens, "The natural history of plague," *Indian Medical Gazette* (July 1906), 254. For discussion of these diagrams, see Lukas Engelmann, "Making a model plague: Paper technologies and epidemiological casuistry in the early twentieth century," in *Plague Image and Imagination from Medieval to Modern Times,* ed. Christos Lynteris, 235–266 (London, UK: Palgrave Macmillan, 2021).

39. William J. R. Simpson, *Report on the Causes and Continuance of Plague in Hongkong and Suggestions as to Remedial Measures* (London, UK: Waterlow and Sons, 1903); Anon., "Observations on rat and human plague in Belgaum," *Journal of Hygiene* 10, no. 3 (1910): 446–482. For a critical discussion of Snow's map and its uses and

reception, see Tom Koch, "The map as intent: Variations on the theme of John Snow," *Cartographica* 39, no. 4 (Winter 2004): 1–14.

40. For example, Valle and Barnet, *Plan de campaña sanitaria.*

41. Hans-Jörg Rheinberger, "Difference machines: Time in experimental systems," *Configurations* 23, no. 2 (Spring 2015): 165–176.

42. For a broader reading of disease cartography in Rheinberger's terms of an experimental system, see Tom Koch, *Disease Maps: Epidemics on the Ground* (Chicago, IL: University of Chicago Press, 2011). On plague maps as experimental systems, see Lukas Engelmann, "Configurations of plague: Spatial diagrams in early epidemiology," *Social Analysis* 63, no. 4 (Winter 2019): 89–109.

43. Frank Morton Todd, *Eradicating Plague from San Francisco: Report of the Citizens' Health Committee and an Account of Its Work* (San Francisco, CA: Press of C. A. Murdock & Co., 1909), 57.

44. Todd, *Eradicating Plague from San Francisco*, frontispiece.

45. Guenter B. Risse, *Plague, Fear, and Politics in San Francisco's Chinatown* (Baltimore, MD: Johns Hopkins University Press, 2012).

46. Risse, *Plague, Fear, and Politics*. On the visualization of the hostility against Kinyoun in the local press, see Lukas Engelmann, "A Plague of Kinyounism: The caricatures of bacteriology in 1900 San Francisco," *Social History of Medicine* 33, no. 2 (May 2020): 489–514.

47. Anon., "The arrest of plague in Japan," *Illustrated London News* 3624 (October 3, 1908): 458.

48. David J. Bibel and T. E. Chen, "Diagnosis of plague: An analysis of the Yersin-Kitasato controversy," *Bacteriological Reviews* 40, no. 3 (September 1976): 633–651.

49. Evans, "Blaming the rat?"

50. On similar bounty-led rat-catching practices in other parts of the world, see below.

51. Anon., "Arrest of plague in Japan," 458.

52. Anon., "Arrest of plague in Japan," 458..

53. Shibasaburō Kitasato, "Combating plague in Japan," *Philippine Journal of Science* 1 (1906): 465–481, reprinted in K. Mizunoe, ed., *The Collected Papers of Shibasaburo Kitasato* (Tokyo, Japan: Kitasato University, 1977). Whether this was the same person as the famous theosophist and biographer of Madame Blavatsky and Annie Besant is open to speculation. Kitasato's paper had also appeared translated in French, but carrying no images: Shibasaburō Kitasato, "La lute contre la peste," *Archives de Medicine Navale* 86 (1906): 289–308.

54. The same visual strategy would be employed, if less elaborately, a month later by the *Adelaide Chronicle* issue of November 7, 1908, where the two top laboratory images

of the *Illustrated London News* article would be combined in a quarter-page composite with one of the images carried from the latter in the second illustrated page of its "Arrest of plague in Japan" article, showing the evacuation of shops in a Japanese city in the process of disinfection. The *Adelaide Chronicle* composite bore the title "Exterminating the Microbe Carrying Rat" and once again visually linked lab research with street-level operations as plague-control processes underscored by the same scientific principles; Anon., "Precautions taken against the plague in Japan," *Adelaide Chronicle* 51, no. 2620 (November 7, 1908): 30. The second page of the *Illustrated London News* issue contained two photographs on the same subject bearing the title "An Example to Russia: House Cleaning by Law."

55. Rotem Kowner, "Becoming an honorary civilized nation: Remaking Japan's military image during the Russo-Japanese War, 1904–1905," *The Historian* 64, no. 1 (2001): 19–38.

56. Pemberton, "Rat-catcher's prank," 526.

57. Pemberton, "Rat-catcher's prank," 528.

58. Henry Mayhew, *London Labour and the London Poor* (London, UK: Dover, 1860–1861).

59. Pemberton, "Rat-catcher's prank," 523.

60. Mayhew, *London Labour*.

61. WL, 38263i, "A rat-catcher enticing rats in to a tray which is strapped around his shoulder; he also holds a pole with a cage on top of it in which rats are trapped. Etching by Vliet," https://wellcomecollection.org/works/ztuzxcxs ?wellcomeImagesUrl=/indexplus/image/V0020297.html; WL, 38321i, "A crowd gathered around a mountebank who points to a banner illustrating various methods of execution; to the left stands a rat-catcher who holds a long stick with a cage on top of it from which rats dangle. Etching by C.W.E. Dietrich, 1740, after A. van Ostade," https://wellcomecollection.org/works/ys7fmf6p; WL, 38254i, "A rat-catcher and his young assistant standing outside a doorway having their services refused by an old man: the rat-catcher holds a long stick with a cage on top of it containing rats, on his right shoulder sits a rat. Etching after Rembrandt van Rijn, c. 1632," https://wellcomecollection.org/works/x7sxdsvw. For discussion of Rembrandt's drawing, see Stanley M. Aronson, "Rembrandt and the rat catchers," *Medicine and Health Rhode Island* 87, no. 6 (June 2004): 167.

62. WL, 42250i, "A boy kneeling down opening a rat-trap with two dogs eagerly awaiting the appearance of the rat. Etching by J. Scott after A. Cooper," https://wellcomecollection.org/works/mwr87p2g.

63. WL, 41285i, "A terrier dog has chased a rat into a corner and is about to kill it. Wood engraving by E. Griset," https://wellcomecollection.org/works/ujg2b6wh.

64. NARA, RG90, Central File 1897–1923 537–544, Box 065, "US Consul General Copenhagen, January 16, 1909, Extermination of Rats in Denmark." On Zuschlag's

rat-related research, see Emil Zuschlag, *Le rat migratoire et sa destruction rationnelle*, trans. M. Pierre Oesterby (Copenhagen, Denmark: Impr. F. Bagge, 1903).

65. The Danish state-organized war against rats may here be compared to one in colonial Hanoi in 1902, as examined in Michael G. Vann, "Of rats, rice, and race: The great Hanoi rat massacre, an episode in French colonial history," *French Colonial History* 4 (2003): 191–203. For works examining campaigns of rat-catching in British colonies in other parts of Southeast Asia, see Barnard, *Imperial Creatures*; Lenore Manderson, *Sickness and the State: Health and Illness in Colonial Malaya, 1870–1940* (Cambridge, UK: Cambridge University Press, 1996).

66. See, for example, Dorothy Worell, *The Women's Municipal League of Boston: A History of Thirty Five Years of Civic Endeavor* (Boston, MA: Women's Municipal League of Committees, 1943); Countway Library (Harvard University), P.6679, Mrs. Albert T. Leatherbee and the Women's Municipal League of Boston, *Plague Conditions in Boston*, 1921 [pamphlet]; Anon., "Elimination of the rat," *Boston Medical and Surgical Journal* 174, no. 2 (October 19, 1916): 576. Similar campaigns were frequently organized around a Rat Day or Rat Week theme across the East Coast. For examples, see NARA, RG90, Central File, 1897–1923, 544 Box 066.

67. Sayer, "'Modern' management of rats."

68. For images of these Indian laborers, see the "Reports on Plague Investigations in India" in the *Journal of Hygiene*.

69. Vann, "Of rats, rice, and race."

70. Echenberg, *Plague Ports*.

71. Lukas Engelmann, "Fumigating the hygienic model city: Bubonic plague and the sulfurozador in early-twentieth-century Buenos Aires," *Medical History* 62, no. 3 (2018): 360–382, 364.

72. Engelmann, "Fumigating," 374.

73. Engelmann, "Fumigating," 378.

74. Anon., "La bubónica y las ratas," *Caras y Caretas* 727 (September 7, 1912): 92–93.

75. Anon., "El amigo del hombre: El perro. La lucha contra las ratas en el Puerto," *Caras y Caretas* 1281 (April 21, 1923): 56–57.

76. On bounty rat-catching, see Vann, "Of rats, rice, and race"; Peter Soppelsa, "Losing France's imperial war on rats," *Journal of the Western Society for French History* 47 (2021): 67–87.

77. Poleykett "Building out the rat."

78. Hannah Appel, Nikhil Anand, and Akhil Gupta, "Temporality, politics and the promise of infrastructure," in *The Promise of Infrastructure*, ed. Nihil Anand, Akhil Gupta, and Hannah Appel, 1–40 (Durham, NC: Duke University Press, 2018).

79. Uli Beisel, "Markets and mutations: Mosquito nets and the politics of disentanglement in global health," *Geoforum* 66 (2015): 146–155; Maurice Lagarrigue, *La lutte contre le rat* (Paris, France: Jouve & Cie, 1911); S. W. Lindsay and M. E. Gibson, "Bednets revisited—Old idea, new angle," *Trends in Parasitology* 4, no. 10 (1988): 270–272.

80. Vinciane Despret, *Penser comme un rat* (Versailles, France: Quae, 2009); Richard H. Harte, *Protect Your Home and Public Health against Rats* (Philadelphia, PA: Bureau of Health, 1941).

81. Poleykett "Building out the rat"; see also R. K. K. Molefi, "Of rats, fleas, and peoples: Towards a history of bubonic plague in Southern Africa, 1890–1950," *Pula: Botswana Journal of African Studies* 15, no. 2 (2001): 259–267. And for the post-third-pandemic period: Dawn D. Biehler, *Pests in the City: Flies, Bedbugs, Cockroaches, and Rats* (Washington, DC: University of Washington Press, 2013).

82. I would like to thank Jules Skotnes-Brown and Maurits Bastiaan Meerwijk for information about colonial exhibitions. For an image of the latter at Klaten, in the East Dutch Indies, see Apollo/VR3PP, PhotoID_11688, https://www.repository.cam.ac.uk/handle/1810/285221; PhotoID_11690, https://www.repository.cam.ac.uk/handle/1810/285223; PhotoID_11692, https://www.repository.cam.ac.uk/handle/1810/285226; PhotoID_11693, https://www.repository.cam.ac.uk/handle/1810/285227.

83. Maurits Bastiaan Meerwijk, "Bamboo dwellers: Plague, photography, and the house in colonial Java," in *Plague Image and Imagination*, ed. Christos Lynteris, 205–234 (London, UK: Palgrave Macmillan, 2021).

84. Graham Mooney, *Intrusive Interventions: Public Health, Domestic Space, and Infectious Disease Surveillance in England, 1840–1914* (Rochester, NY: University of Rochester Press, 2015).

85. Terence Hull, "Plague in Java," in *Death and Disease in Southeast Asia: Explorations in Social, Medical and Demographic History*, ed. Norman G. Owen, 210–234 (Oxford, UK: Oxford University Press, 1987).

86. Meerwijk, "Bamboo dwellers," 212, 221, 207.

87. Meerwijk, "Bamboo dwellers," 217; Ruth Rogaski, *Hygienic Modernity: Meanings of Health and Disease in Treaty-Port China* (Berkeley, CA: University of California Press, 2004). As Eric Stein has discussed, these operations were also captured and reproduced in public health campaign films; Eric A. Stein, "Colonial theatres of proof: Representation and laughter in 1930s Rockefeller Foundation hygienic cinema in Java," in "Health, Medicine and the Media," special issue, *Health and History* 8, no. 2 (2006): 14–44.

88. Sayer, "Vermin Landscapes," 18.

89. On this problem, see Evans, "Blaming the rat?" 34.

90. NYAML, WA 243 U58 1949, *Rat-Borne Disease Prevention and Control* (Atlanta, GA: Communicable Disease Center, Public Health Service, Federal Security Agency, 1949).

91. NYAML, WA 243 U58 1949, *Rat-Borne Disease*, 41, 45.

92. NYAML, WA 243 U58 1949, *Rat-Borne Disease*, 41, capitalization in the original, where text is framed in a box.

93. NYAML, WA 243 U58 1949, *Rat-Borne Disease*, 41.

94. NYAML, WA 243 U58 1949, *Rat-Borne Disease*, 45

95. NYAML, WA 243 U58 1949, *Rat-Borne Disease*, 45, capitalization in the original.

96. NYAML, WA 243 U58 1949, *Rat-Borne Disease*, 46–47.

97. NYAML, WA 243 U58 1949, *Rat-Borne Disease*, Figure 19 is spread across pp. 52–54, quote on p. 42. Following the same boxed text, "These pictures parallel the CDC motion picture 'The Climbing Activity of the Norway Rat.'" The film referred to is United States Army, "Practical Rat Control: Ratproofing," T.F. 8-1673. (Atlanta, GA: Communicable Disease Center, United States Health Service, Federal Security Agency, 1950), U.S. National Library of Medicine, *YouTube*, December 20, 2016, https://www.youtube.com/watch?v=4lgS0X0YfPg.

98. The manual also contained actual comic strips, which were used in order to punctuate points, in an often reflexive manner. This visual trope centered on a protagonist, Roscoe the Rat-Ridder, who assumed the role of an instructor and commentator. But not all strips in the manual include Roscoe. As the volume progresses, rats also appear as protagonists or antiheroes, in some cases directly confronting their nemesis.

99. Figure 19 is in fact a hybrid composite made of photographs that parallel the CDC motion picture "The Climbing Activity of the Norway Rat" and others "taken by Mr. John Grennor, Typhus Control Officer of the City of Atlanta"; NYAML, WA 243 U58 1949, *Rat-Borne Disease*, 52.

100. Walter Benjamin, *Reflections: Essays, Aphorism, Autobiographical Writings*, ed. Peter Demetz (New York, NY: Schocken, 1986).

101. Benjamin, *Reflections*, 93.

102. For discussion, see Lynteris, *Human Extinction*.

103. On the soil-rat interrelation, see Christos Lynteris, "A 'suitable soil': Plague's urban breeding grounds at the dawn of the third pandemic," *Medical History* 61, no. 3 (2017): 343–357; Sodikoff, "Multispecies infrastructure."

104. Sodikoff, "Multispecies infrastructure," 103.

105. Sodikoff, "Multispecies infrastructure," 103.

106. Maan Barua, "Nonhuman life as infrastructure," *Society and Space*, November 30, 2020, https://www.societyandspace.org/articles/nonhuman-life-as-infrastructure.

CHAPTER 5

1. Available online: http://www.scmp.com/magazines/post-magazine/article/1367
769/germ-warfare-hong-kongs-never-ending-fight-against-viruses.

2. S. Lazarus, "Germ warfare: Hong Kong's never-ending fight against viruses,"
Post Magazine (December 1, 2013), 21.

3. For a discussion of the image and imaginary of the "next pandemic," see Christos Lynteris, *Human Extinction and the Pandemic Imaginary* (London, UK: Routledge, 2019).

4. Laurie Garrett, *The Coming Plague: Newly Emerging Diseases in a World Out of Balance* (London, UK: Penguin, 1994).

5. L. M. Casanova et al., CDC Prevention Epicenters Program, "Assessment of self-contamination during removal of personal protective equipment for Ebola patient care," *Infection Control and Hospital Epidemiology* 37, no. 10 (2016): 1156–1161; C. R. Biscotto et al., "Evaluation of N95 respirator use as a tuberculosis control measure in a resource-limited setting," *International Journal of Tuberculosis and Lung Disease* 9, no. 5 (2005): 545–549; B. J. Cowling et al., "Face masks to prevent transmission of influenza virus: A systematic review," *Epidemiology and Infection* 138, no. 4 (2010): 449–456.

6. Indicatively: Y. C. Chuang et al., "Social capital and health-protective behavior intentions in an influenza pandemic," *PLOS One* 10, no. 4 (2015): e0122970; B. J. Condon and T. Sinha, "Who is that masked person: The use of face masks on Mexico City public transportation during the influenza A (H1N1) outbreak," *Health Policy* 95, no. 1 (2010): 50–56; J. T. Lau et al., "Perceptions related to bird-to-human avian influenza, influenza vaccination, and use of face mask," *Infection* 36, no. 5 (2008): 434–443; Maria S. Y. Sin, "Masking fears: SARS and the politics of public health in China," *Critical Public Health* 26, no. 1 (2016): 88–98.

7. There are by now dozens of articles on mask use during the COVID-19 pandemic. For a good summary, see Jiao Wang et al., "Mask use during COVID-19: A risk adjusted strategy," *Environmental Pollution* 266 (2020): 115099.

8. Françoise Frontisi-Ducroux, *Du masque au visage: Aspects de l'identité en Grèce ancienne* (Paris, France: Flammarion, 1995); Donald Pollock, "Masks and the semiotics of identity," *Journal of the Royal Anthropological Institute*, n.s., 1, no. 3 (1995): 581–597; Hans Belting, *Face and Mask: A Double History*, trans. Thomas S. Hansen and Abby J. Hansen (Princeton, NJ: Princeton University Press, 2017).

9. See, for example, Laurel Birch de Aguilar, *Inscribing the Mask: Interpretation of Nyau Masks and Ritual Performance among the Chewa of Central Malawi* (Sankt Augustin, Germany: Anthropos Institut, 1996); A. Fienup-Riordan, *The Living Tradition of Yup'ik Masks: Agayuliyararput (Our Way of Making Prayer)* (Seattle, WA: University of Washington Press, 1996); Jarich Oosten, "Representing the spirits: The masks of

the Alaskan Inuit," in *Anthropology, Art and Aesthetics*, ed. Jeremy Coote and Anthony Shelton, 113–134 (Oxford, UK: Clarendon Press, 1992); A. David Napier, *Masks, Transformation, and Paradox* (Berkeley, CA: University of California Press, 1986), xxiii.

10. Elizabeth Tonkin, "Masks and powers," *Man*, n.s., 14, no. 2 (1979), 240.

11. Napier, *Masks, Transformation*, xxiii.

12. Ruth Rogaski, *Hygienic Modernity. Meaning of Health and Disease in Treaty-Port China* (Berkeley, CA: University of California Press, 2004).

13. Mark Gamsa, "The epidemic of pneumonic plague in Manchuria 1910–1911," *Past and Present* 190, no. 1 (2006): 147–183; Christos Lynteris, *Ethnographic Plague: Configuring Disease on the Chinese-Russian Frontier* (London, UK: Palgrave Macmillan, 2016); Carl F. Nathan, *Plague Prevention and Politics in Manchuria 1910–1931* (Cambridge, MA: Harvard East Asian Monographs, 1967); William C. Summers, *The Great Manchurian Plague of 1910–1911: The Geopolitics of an Epidemic Disease* (New Haven, CT: Yale University Press, 2012).

14. Sean Hsiang-lin Lei, "Sovereignty and the microscope: Constituting notifiable infectious disease and containing the Manchurian plague (1910–11)," in *Health and Hygiene in Chinese East Asia: Policies and Publics in the Long Twentieth Century*, ed. Angela Ki Che Leung and Charlotte Furth, 73–106 (Durham, NC: Duke University Press, 2011).

15. On previous masks and respirators and the question of whether this was in fact Wu's invention or one usurped by him, see Zhang Meng, "From respirator to Wu's mask: The transition of personal protective equipment in the Manchurian plague," *Journal of Modern Chinese History* 14, no. 2 (2021): 221–239. For a discussion between Zhang, Tomohisa Sumida, and myself regarding the history of this device in East Asia, see Christos Lynteris, Tomohisa Sumida, and Meng Zhang, "The history of plague masks in East Asia: A conversation between Christos Lynteris, Tomohisa Sumida, and Meng Zhang," *The Mask—Arrayed*, April 26, 2021, https://themaskarrayed.net/2021/04/26/the-history-of-plague-masks-in-east-asia-a-conversation-between-christos-lynteris-tomohisa-sumida-and-meng-zhang/.

16. John L. Spooner, "History of surgical face masks," *AORN Journal* 5 (1967): 76–80.

17. Wu Lien-teh, *Treatise on Pneumonic Plague* (Geneva, Switzerland: League of Nations, 1926), 393–394. Figure 4.1 shows Wu Liande wearing a mask, possibly from a later development of the device. HKUL, U 614.42518 M26 e, Manchurian Plague Prevention Service (Harbin), Early photos of pneumonic plague epidemics, 1910–11 and 1920–21, Manchuria.

18. Bradford Luckingham, "To mask or not to mask: A note on the 1918 Spanish influenza epidemic in Tucson," *Journal of Arizona History* 25, no. 2 (1984): 191–204; Nancy Tomes, "'Destroyer and Teacher': Managing the masses during the

1918–1919 influenza pandemic," supplement, *Public Health Reports* 125, no. S3 (2010): 48–62.

19. Wu Lien-teh, *Plague Fighter, the Autobiography of a Modern Chinese Physician* (Cambridge, UK: W. Heffer & Sons, 1959), 19.

20. Wu, *Plague Fighter*, 22.

21. NRI, 808.24za WLD:1 (RBR), Wu Lien-teh, *Views of Harbin (Fuchiatien) Taken during the Plague Epidemic, December 1910-March 1911* (Shanghai, China: Commercial Press, [1911]).

22. Wu, *Plague Fighter*.

23. Lynteris, *Ethnographic Plague*.

24. Fang Chin, "Individual precautions taken by the medical staff during the recent epidemic at Fuchiatien," in *Report of the International Plague Conference Held at Mukden April 1911*, ed. Richard Pearson Strong et al. 287–289 [discussion 289–303] (Manila, Philippines: Bureau of Printing, 1912), 287. I have not managed to locate images of the masks presented by Fang Chin or of the mannequins exhibited during the conference.

25. Charles Broquet, *La conférence de la peste à Moukden, avril 1911* (Cahors & Alençon, France: Imprimeries de A. Coueslant, 1914), 7.

26. Laveran in "Séance du 30 mai 1911: Presentations d'ouvrages manuscrits et imprimés," *Bulletin de l'Académie Nationale de Medicine* 3e séries, 65 (1911), 627. Again, I have not been able to locate images or further descriptions of Matignon's samples.

27. Several mask models are displayed, for example, in Wu, *Treatise on Pneumonic Plague*, figure 28.

28. UAB, Series/Collection MC12, Folder 1.14., M. A. Barber and O. Teague, "Studies on Pneumonic Plague and Plague Immunization, XII," in *Some Experiments to Determine the Efficacy of Various Masks for Protection against Pneumonic Plague* (Manila, Philippines: Bureau of Printing, 1912), 244. With thanks to Timothy Lee Pennycuff for his help in locating and accessing these sources.

29. Anon., "Plague in Manchuria," *North-China Herald* 2267 (January 20, 1911): 114; Charles Broquet, "Le masque dans la peste: Présentation d'un modèle de masque antipesteux," *Bulletin de la Société de Pathologie Exotique* 4 (1911): 636–645, 642, my translation.

30. Kévin Seivert, "Les débuts du territoire français de Kouang-Tchéou-Wan," *Annales de Bretagne et des pays de l'Ouest* 124, no. 1 (2017): 113–134; For Broquet's work on plague in the region, see Charles Broquet, *Foyer de peste bubonique dans la Chine méridionale* (Paris, France: Gainche, 1902). For Broquet's view on the conference, see Broquet, *La conférence de la peste*. The Médiathèque F. Mitterrand - les Capucins (Brest) attribute the authorship of an album of photographs covering the 1910–1911 outbreak in Manchuria to Broquet (RES FB C710—f). However,

multiple copies of the same album, some with important differences in both content and form, exist in the University of Alabama at Birmingham Archives, the archives of the Institute of Experimental Medicine in Saint Petersburg, and the Countway Library of Harvard University. These versions cast doubt to the provenance attribution of the Médiathèque F. Mitterrand - les Capucins. Given the lack of any supporting or contextual information on this album I have avoided discussing it in this book.

31. Broquet, "Le masque dans la peste," 641, my translation.

32. Broquet, "Le masque dans la peste," 641, my translation.

33. Broquet, "Le masque dans la peste," 641, my translation. For images of Broquet's different models, see NLM, 101405394, Clothing—protective: Protective mask after Dr. Broquet—used during the epidemic of pneumonic plague in Manchuria, available at https://collections.nlm.nih.gov/catalog/nlm:nlmuid-101405394-img; Apollo/VR3PP, PhotoID_67, https://www.repository.cam.ac.uk/handle/1810/284772.

34. Broquet, "Le masque dans la peste."

35. Broquet, "Le masque dans la peste," 642, 643, my translation. In later publications, the 1819 prototype was represented as a medieval device; B. J. Hendrick, "Fighting 'Black Death' in Manchuria," *The World's Work* 27 (1914): 210–222.

36. Aspland in the discussion in *Report of the International Plague Conference Held at Mukden April 1911*, ed. Richard Pearson Strong et al. (Manila, Philippines: Bureau of Printing, 1912), 304.

37. *Report of the International Plague Conference*, 304.

38. Anon., "The plague—from our correspondents," *North-China Herald* 2272 (February 24, 1911): 418, 422.

39. Aspland in *Report of the International Plague Conference*, 377.

40. J. Chabaneix, *Notes sur la défense contre la peste pulmonaire dans la province du Tcheli (1911)* (Tianjin, China: Imprimerie de l'echo de Tientsin, 1911). The same text appears in the fifteenth volume of the *Annales d'hygiène et de médecine coloniales* (1912), 85–103. On Chabaneix's anti-plague work, see J.-M. Milleliri and E. Deroo, "Joseph Chabaneix (1870–1913). Un médecin au coeur de l'histoire française outremer," *Medecine tropicale: Revue du Corps de sante colonial* 65, no. 3 (2005): 285–289; Jacqueline Brossollet, "Segalen et Chabaneix en Chine pendant la peste de Mandchourie," *Revue du praticien* 43, no. 6 (March 15, 1993): 742–745.

41. Chabaneix, *Notes sur la défense*, 28, my translation.

42. Chabaneix, *Notes sur la défense*. This story was repeated by Broquet, who compared Chinese doctors to fourteenth-century physicians in their supposed ignorance and to the Boxers in their "belief in invulnerability"; Broquet, "Le masque dans la peste," 645, my translation. In another version, Broquet frames this as a

confrontation between young, scientifically trained Chinese doctors and senior/elder Chinese doctors; Broquet, *La conférence de la peste*, 12.

43. Farrar in *Report of the International Plague Conference*, 303.

44. Strong in *Report of the International Plague Conference*, 394n1.

45. UAB, Series/Collection MC12, Folder 1.14., Barber and Teague, "Studies on Pneumonic Plague," 268. Doubts regarding the efficacy of the masks continued to haunt their application in the course of the 1918 influenza pandemic and in the context of later plague outbreaks in China. I thank Freddie Stephenson for bringing to my attention historical material attesting to the latter.

46. Susan Buck-Morss, *The Origin of Negative Dialects: Theodor W. Adorno, Walter Benjamin, and the Frankfurt Institute* (New York, NY: Free Press, 1977).

47. Pollock, "Masks and the semiotics," 586.

48. Buck-Morss, *Origin of Negative Dialects*, 106.

49. Bruce Kapferer, "Anthropology and the dialectic of enlightenment: A discourse on the definition and ideals of a threatened discipline," *Australian Journal of Anthropology* 18, no. 1 (2007): 72–94, 86.

50. Michael Taussig, "History as commodity in some recent American (anthropological) literature," *Critique of Anthropology* 9, no. 1 (1989), 12.

51. I am borrowing the latter term from Rogaski, *Hygienic Modernity*.

52. Anon., "How our forefathers fought the plague," *British Medical Journal* 2, no. 1969 (1898): 903–908; Anon., "The management of pneumonic plague epidemics," *The Lancet* 209, no. 5403 (1927): 611–612.

53. See Poussin's painting *The Plague of Ashdod* (1630), on which more details are provided below. This practice was replicated by British soldiers involved in anti-plague work in 1894 Hong Kong, with handkerchiefs soaked in carbolic acid being pressed against their noses and mouths as they operated in the city; Robert Peckham, "Hong Kong junk: Plague and the economy of Chinese things," *Bulletin of the History of Medicine* 90 (2016): 32–60.

54. Laveran replying to A. Manaud, "Le peste au Siam," *Bulletin de la Société de Pathologie Exotique* 6 (1911), 356, my translation.

55. Carlo M. Cipolla, "A plague doctor," in *The Medieval City*, ed. Harry A. Miskimin, David Herlihy, and A. L. Udovitch, 65–72 (New Haven, CT: Yale University Press, 1977). A century later, in the Swiss physician and alchemist Jean-Jacques Manget's 1720 treatise on plague, a costume resembling that of De l'Orme's appears in a famous etching of the plague doctor; R. Blanchard, "Notes historiques sur la peste," *Archives de parasitologie* 3 (1900): 589–646.

56. Broquet, "Le masque dans la peste"; Johann Melchior Füssli's image of a 1720 plague doctor in Marseille was suspected by early-twentieth-century plague experts

like Broquet to be no more than a German caricature; Johann Melchior Füssli, "Sketch of a Cordovan-leather-clad doctor of Marseille," https://commons.wikimedia.org /wiki/File:Johann_Melchior_Füssli_(1677–1736),_Sketch_of_a_Cordovan-leather -clad_doctor_of_Marseilles.png.

57. Broquet, "Le masque dans la peste."

58. Daniel Panzac, "Médecine révolutionnaire et révolution de la médecine dans l'Egypte de Muhammad Ali: Le Dr Clot-Bey," *Revue des mondes musulmans et de la Méditerranée* 52–53 (1989): 95–110; Christian Jean Dubois, *Clot Bey: Médecin de Marseille (1793—1868), chirurgien du vice-roi d'Egypte* (Marseille, France: Jeanne Laffitte, 2013); Bruno Argémi, *Clot-Bey: Ou l'étonnante aventure d'un médecin marseillais en Egypte au XIXe siècle* (Paris, France: Gaussen, 2018); G. N. Burrow, "Clot-Bey: Founder of Western Medical Practice in Egypt," *Yale Journal of Biology and Medicine* 48 (1975): 251–257.

59. LaVerne Kuhnke, *Lives at Risk: Public Health in Nineteenth-Century Egypt* (Berkeley, CA: University of California Press, 1990).

60. George Michael La Rue, "Treating black deaths in Egypt: Clot-Bey, African slaves, and the plague epidemic of 1834–1835," in *Histories of Medicine and Healing in the Indian Ocean World*, vol. 2: *The Modern Period*, ed. Anna Winterbottom and Facil Tesfaye, 27–59 (London, UK: Palgrave Macmillan, 2016), 28. La Rue estimates the total toll between 80,000 and 100,000 individuals in the 1834–1835 phase of the epidemic, with Black communities being most seriously affected.

61. Kuhnke, *Lives at Risk*. On Pariset and his theory, see Alan Mikhail, "The nature of plague in late eighteenth-century Egypt," *Bulletin of the History of Medicine* 82, no. 2 (Summer 2008): 249–275.

62. Kuhnke, *Lives at Risk*, 70.

63. Kuhnke, *Lives at Risk*; La Rue, "Treating black deaths in Egypt"; Khaled Fahmy, *In Quest of Justice: Islamic Law and Forensic Medicine in Modern Egypt* (Berkeley, CA: University of California Press, 2018). Although he maintained his anticontagionist stance for decades to come, Clot did support the implementation of quarantine measures when these were ordered by the Pasha; La Rue "Treating black deaths in Egypt." On Clot-Bey's insistence that plague is not contagious, see A. B. Clot-Bey, *Derniers mots sur la non-contagion de la peste* (Paris, France: Victor Masson & fils, 1866).

64. A. B. Clot-Bey, *De la peste observée en Egypte: Recherches et considérations sur cette maladie* (Paris, France: Fortin Masson et Cie, 1840), 425.

65. Clot-Bey, *De la peste observée*, 389, my translation.

66. It is worth noting that this idea of fear leading to plague was also shared by local religious leaders at the time in Egypt. Fahmy quotes the fatwa against quarantine issued by the mufti of Alexandria to Muhammad Ali as explaining that quarantines

"evoke fear and anxiety, and these feelings are the strongest causes of diseases and the plague"; Fahmy, *In Quest of Justice*, 60.

67. Sheila Barker, "Poussin, plague, and early modern medicine," *Art Bulletin* 86, no. 4 (2004): 659–689.

68. Barker, "Poussin, plague," 661. On other aspects of plague's relation to fear in early modern times, see Stevens Crawshaw's analysis of Antero Maria da San Bonaventura's 1658 writings on quarantine: Jane Stevens Crawshaw, "The places and spaces of early modern quarantine," in *Quarantine: Local and Global Histories*, ed. Alison Bashford, 15–34 (London, UK: Palgrave Macmillan, 2017).

69. Barker, "Poussin, plague".

70. Pierre-Jean Fabre, *Remèdes curatifs et préservatifs de la peste donnez au public en 1652* (Toulouse, France: Claude-Gilles Lecamus, 1720).

71. Fabre, *Remèdes curatifs*, 5, my translation.

72. Barker, "Poussin, plague," 668.

73. Darcy Grimaldo Grigsby, "Rumour, contagion and colonization in Gros's plague-stricken of Jaffa (1804)," *Representations* 51, no. (1995): 1–46.

74. Grigsby, "Rumour, contagion"; Marc Bloch, *Les rois thaumaturges: Étude sur le caractère surnaturel attribué à la puissance royale particulièrement en France et en Angleterre* (Paris, France: Gallimard, 1983).

75. In Grigsby, "Rumour, contagion," 9. On Napoleonic medicine, the Egyptian Campaign, and plague, see Thomas G. Russell and Terence M. Russell, "Medicine in Egypt at the time of Napoleon Bonaparte," *British Medical Journal* 327, no. 7429 (2003): 1461–1464; Jean-François Hutin, "La littérature médicale de la campagne d'Égypte," *Histoire des sciences médicales* 46, no. 1 (2012): 19–30; Catherine Kelly, "Medicine and the Egyptian campaign: The development of the military medical officer during the Napoleonic Wars c. 1798–1801," *Canadian Bulletin of Medical History* 27, no. 2 (2010): 321–342.

76. Yvonne Hibbot, "'Bonaparte visiting the plague-stricken at Jaffa' by Antoine Jean Gros (1771–1835)," *British Medical Journal* 1, no. 5642 (1969): 501–502.

77. Clot admired and replicated the self-inoculation of Napoleon Bonaparte's chief military doctor in the Egyptian Campaign, René-Nicolas Dufriche Desgenettes, with puss from axillary buboes of plague victims, a feat meant to prove that plague was not contagious. Desgenettes's act became part of the visual culture of the era. Examples of visual art focusing on Desgenettes and plague include Pierre Antoine Augustin Vafflard's lithograph *Desgenettes, médecin en chef de l'armeé d'Egypte, s'inocule la peste en présence des soldats malades afin de calmer leur imagination* (Victoria and Albert Museum, SP.598, [ca. 1820–1835]), https://collections.vam.ac.uk/item/O1105684 /desgenettes-médecin-en-chef-de-lithograph-pierre-antoine-augustin/. A modern mural on the subject by Jean Coquet (1946) adorns the hall of L'Hôpital Desgenettes

in Lyon; Frédéric Chauvin and Louis-Paul Fischer, "Les peintures murales de Jean Coquet de l'hôpital Desgenettes à Lyon," *Histoire des Sciences Médicales* 44, no. 1 (2010): 23–34.

78. Farrar in *Report of the International Plague Conference*, 303.

79. For discussion, see Lynteris, *Ethnographic Plague*.

80. E. Kinnear, "Propitiating the plague spirits," *China Medical Missionary Journal* 264 (1902): 204.

81. The incident also underlined in the eyes of medical modernizers that "'coolies' were not simply unskilled or degenerate, they were culturally contagious: their touch was imagined as exercising a degenerative power on the very means employed for the hygienic modernization of China"; Lynteris, *Ethnographic Plague*, 315.

82. Peter Redfield, "Fluid technologies: The Bush Pump, the LifeStraw® and microworlds of humanitarian design," *Social Studies of Science* 46, no. 2 (2016): 159–183.

83. Alfred Gell, *Metamorphosis of the Cassowaries* (London, UK: Athlone Press, 1975), 301.

84. For a discussion of Wu's mask in China after 1911, see Zhang, "From respirator to Wu's mask."

85. Wu Lien-teh, "Practical points in the treatment of plague," *The Lancet* 198, no. 5121 (1921): 853–854; After World War II, the mask would carry on its material as well as visual social life in Communist China, where it would systematically feature in dramatic and info-sheet-like public health posters. See the following collections: NLM, Chinese Public Health Posters, https://www.nlm.nih.gov/hmd /chineseposters/index.html; WL, 660567i, *China: Protection against Nuclear, Chemical, and Germ Warfare*, color lithographs, 1971, https://wellcomecollection.org /works/z2avkryh.

86. Branwyn Poleykett, "Ethnohistory and the dead: Cultures of colonial epidemiology," *Medical Anthropology* 37, no. 6 (2018): 472–485; Genese Marie Sodikoff, "The multispecies infrastructures of zoonosis," in *The Anthropology of Epidemics*, ed. Ann H. Kelly, Frédéric Keck, and Christos Lynteris, 102–120 (London, UK: Routledge, 2019).

87. Roger Pollitzer, *Plague* (Geneva, Switzerland: World Health Organization, 1954). Genese Sodikoff and Dieudonné Rasolonomenjanahary point out that in some cases these workers were actually prisoners; Genese Sodikoff and Z. R. Dieudonné Rasolonomenjanahary, "Ethnographic images of the plague: Outbreak and the landscape of memory in Madagascar," in *Plague Image and Imagination*, ed. Christos Lynteris (London, UK: Palgrave, 2021). On the reception of and resistance to these hygienic burials and the banning of *famadihana*, see Faranirina Esoavelomandroso, "Résistance à la médecine en situation coloniale: La peste à Madagascar," *Annales* 36, no. 2 (1981): 168–190.

88. PIP, MP35722, "Mise en bière d'un cadavre pesteux par une équipe d'hygiène à Madagascar vers 1935." Sodikoff and Rasolonomenjanahary have identified a follow-up caption with the coffin being carried away: Agence Nationale Taratra, Antananarivo. Album AS 5 No. 9; Sodikoff and Rasolonomenjanahary, "Ethnographic Images of the Plague."

89. Gordon Henry Hirshberg, "Medical science's newest discoveries about the 'Spanish influenza,'" *Washington Times*, October 6, 1918, National Edition, American Weekly Section, 22.

90. Hirshberg, "Medical science's newest."

91. Hirshberg, "Medical science's newest."

92. Anon., "Hospital which no patient leaves alive. A visit to the plague sufferers at Harbin," *The Sun* (New York) 78, no. 256 (May 14, 1911): 9.

93. Anon., "How science masks itself against the Black Plague," *Richmond Palladium and Sun-Telegram* 36, no. 218 (July 15, 1911): 2.

94. Anon., "How science masks itself."

95. Anon., "How science masks itself."

96. Anon., "Le pestiféré," frontispiece, supplement, *L'illustration* 69, no. 3551 (March 18, 1911): 1; Anon., "The Plague in Manchuria: Direct Camera Pictures by Frederick Moore," *The Sphere* 44, no. 582 (March 18, 1911): 233.

97. Anon., "How science masks itself," 2.

98. Both this and the burning coffin photograph were originally printed (uncropped) in Anon., "Plague in Manchuria: Direct Camera Pictures."

99. For a discussion of the apotropaic properties of masks, see Napier, *Masks, Transformation*.

CONCLUSION

1. Erin O'Connor, "Camera medica: Towards a morbid history of photography," *History of Photography* 23, no. 3 (1999), 234.

2. On visualizing epidemics since the second half of the twentieth century, see Roger Cooter and Claudia Stein, "Visual imagery and epidemics in the twentieth century," in *Imagining Illness: Public Health and Visual Culture*, ed. David Harley Serlin, 169–192 (Minneapolis, MN: University of Minnesota Press, 2010); Lukas Engelmann, "Photographing AIDS: On capturing a disease in pictures of people with AIDS," *Bulletin of the History of Medicine* 90, no. 2 (Summer 2016): 250–278; Neil A. Gerlach, "Visualizing Ebola: Hazmat suit imagery, the press, and the production of biosecurity," *Canadian Journal of Communication* 44, no. 2 (2019): 191–210; Ingrid Gessner, "Picturing Ebola: Photography as an instrument of biopolitical (in)justice," March 16, 2020, https://dx.doi.org/10.13140/RG.2.2.32358

.37447. On visualizing contagion and the "next pandemic," see Priscilla Wald, *Contagious: Cultures, Carriers, and the Outbreak Narrative* (Durham, NC: Duke University Press, 2008); Christos Lynteris, *Human Extinction and the Pandemic Imaginary* (London, UK: Routledge, 2019); Dahlia Schweitzer, *Going Viral: Zombies, Viruses, and the End of the World* (New Brunswick, NJ: Rutgers University Press, 2018); On the emerging infectious diseases framework, see Nicholas B. King, "The scale politics of emerging diseases," *Osiris* 19 (2004): 62–76.

3. Andrew Lakoff, *Unprepared: Global Health in a Time of Emergency* (Berkeley, CA: University of California Press, 2017); Limor Samimian Darash, "Governing future potential biothreats: Toward an anthropology of uncertainty," *Current Anthropology* 54, no. 1 (2013): 1–22; Carlo Caduff, *The Pandemic Perhaps: Dramatic Events in a Public Culture of Danger* (Berkeley, CA: University of California Press, 2015); Lynteris, *Human Extinction*.

4. Christos Lynteris, "The prophetic faculty of epidemic photography: Chinese wet markets and the imagination of the next pandemic," *Visual Anthropology* 29, no. 2 (2016), 129.

5. See, for example, Brian Callender et al., "COVID-19, comics, and the visual culture of contagion," *The Lancet* 396, no. 10257 (October 10, 2020): 1061–1063; Gloria Yan Dow, "Toward a non-binary sense of mobility: Insights from self-presentation in Instagram photography during COVID-19 pandemic," *Media, Culture and Society*, April 15, 2021, https://doi.org/10.1177/01634437211008734; Megan Williams, "Five photographers interpret anxiety in Wellcome Covid-19 project," *Creative Review*, October 29, 2020, https://www.creativereview.co.uk/wellcome-anxiety -covid-project.

6. Christos Lynteris, "Why do people really wear face masks during an epidemic?" *New York Times*, February 13, 2020, https://www.nytimes.com/2020/02/13/opinion /coronavirus-face-mask-effective.html. See also the essays published in "The Mask— Arrayed" project of Department III of the Max Planck Institute for the History of Science (https://themaskarrayed.net).

7. See, for example, the first issue of the German arts periodical *Pictoplasma* ("Face Value," Spring 2021), dedicated to masks and PPE.

8. For discussion, see Kamayani Sharma, "Why the world must witness pictures of India's mass COVID-19 cremations," *Vox*, May 21, 2021, https://www.vox.com /first-person/22434028/india-covid-cremations.

9. Christos Lynteris, "Sinophobia, epidemics, and interspecies catastrophe," in "Hot Spots, Responding to an Unfolding Pandemic: Asian Medicines and COVID-19," *Cultural Anthropology: Editor's Forum*, June 23, 2020, https://culanth.org/fieldsights /sinophobia-epidemics-and-interspecies-catastrophe. On the question of wet markets and COVID-19 as entangled in Sinophobic readings of the origin of the pandemic, see Christos Lynteris, "The imperative origins of COVID-19," *L'Homme:*

Revue française d'anthropologie 234–235 (2020): 21–32. For an example of a SARS image of a wet market used for a COVID-19 wet market article, see the lead image in Dina Fine Maron, "China's exotic farms may be a missing link behind the pandemic's leap to people," *National Geographic*, March 26, 2021, https://www.nationalgeographic.co .uk/science-and-technology/2021/03/chinas-exotic-farms-may-be-a-missing-link -behind-the-pandemics-leap.

10. For a critique of the latter as a colonially inflected visual trope akin to that employed in "before–after" images of removal of tumors (see chapters 1 and 2), see Christos Lynteris, "Emptiness and COVID-19 cartography," in "Theorizing the Contemporary: Emptiness," *Cultural Anthropology: Editor's Forum*, December 15, 2020, https://culanth.org/fieldsights/emptiness-and-covid-19-cartography.

11. Sophie Haigney, "Photos of locked-down cities sold us a fantasy that we were 'in it together,'" *The Guardian*, November 28, 2020, https://www.theguardian .com/commentisfree/2020/nov/28/photos-locked-down-cities-pictures-deserted -tourist-sites.

12. Haigney, "Photos of locked-down cities."

BIBLIOGRAPHY

ARCHIVAL SOURCES

Archives Institut Pasteur

 BPT.Doc.81, Lieu A7/244–267

 CAL.D16, Lieu 5/174–179

 IND.A1, Lieu 4/151–153

 IND.A2, Lieu: A4/151–153

 SIM.2, Lieu A3/81–84

 SIM.5, Lieu A3/81–84

 YER.6, Lieu A1/13

 YER.Cor1, Lieu A1/13

Archives Nationales d'Outre-Mer

 INDO GGI 4416

Bancroft Library

 BANC PIC 1988.052:037-PIC, "Tumor on Norway rat—open beneath and exceeding in weight the animal's body. Taken in the heart of Los Angeles."

 BANC PIC 1988.052-PIC, Photographic Documentation of Pneumonic Plague Outbreak Sites and Rats in Los Angeles, 1924.

British Library

 IOR/V/27856/58 *Punjab Plague Handbook, 1905* (Lahore, Pakistan: Punjab Government Press, 1905).

 IOR/V/25/840/23, Health Officer's Report for the 1st Quarter of 1903.

 Plague Visitation, Bombay, 1896–97. Photographer(s): Moss, C. Photo 311/1: 1896–1897.

Countway Library

 P.6679, Mrs. Albert T. Leatherbee and the Women's Municipal League of Boston, *Plague Conditions in Boston*, 1921. Pamphlet.

 Strong, Richard P. (Richard Pearson), 1872–1948. Papers, 1911–2004.

Getty Research Institute

96.R.95, *Poona Plague Pictures, 1897–1908*, undated.

1384–039/96.R.81, *Plague Visitation, Bombay, 1896–1897*.

Hawaii Historical Society Library

Photographic Collection, Nos. 691, 693, 699, 700, 701, 702, 4543, 4544.

Hawaii State Archives

501 v.2, Records of the Special Vector Eradication Campaign, Oahu and Maui Plague Records, 1899–1900, The Attack of Plague, December 12th 1899, 33.

Photograph Collection, Epidemics, Bubonic Plague, 1900, Nos. PP-19-1-007, PP-19-1-042, PP-18-9-027.

Photograph Collection, Albums, PA 4b, Photo Album Hawaiian Islands, 1898–1900, F.J.H. Rockon, Vol. 3 (untitled, no page number).

House of Commons Parliamentary Papers

Cd.139, Indian Plague Commission, 1898–99. "Minutes of evidence taken by the Indian Plague Commission with appendices. Vol. I. Evidence taken from 29th November 1898 to 5th January 1899," 57.

Cd.140 Indian Plague Commission, 1898–99. "Minutes of Evidence Taken by the Indian Plague Commission with Appendices. Vol. II. Evidence taken from 11th January 1899 to 8th February 1899"; Session: 1900, CH Microfiche number: 106.269–274.

Cd.141, Indian Plague Commission, 1898–99. "Minutes of evidence taken by the Indian Plague Commission with appendices. Vol. III. Evidence taken from 11th February 1898 to 20th May 1899," 162.

Cd.810, Indian Plague Commission, 1898–99. "Report of the Indian Plague Commission with Appendices and Summary. Vol. V"; Session: 1902, CH Microfiche number: 108.637, p. 61.

Institute of Experimental Medicine (Russian Federation)

10561 Vasily Pavlovich Kashkadamov, *Pis'ma iz Indii* (1898).

11043 N. N. Vestenrik, *Chuma v Bombeye* (Saint Petersburg, Russia: Tipografiya Morskogo Ministerstva, 1900).

11836 Vasily Pavlovich Kashkadamov, *Al'bom snimkov c chumnuikh bol'nuikh* (Saint Petersburg, Russia: Severnaya fototipiya, 1902).

14065 Vasily Pavlovich Kashkadamov, *O chume soglasno noveyshim dannuim* (Saint Petersburg, Russia: Tipografiya M. M. Stasyulevicha, 1901).

Joseph Needham Research Institute Library

808.24za WLD:1 (RBR), Wu Lien-teh, *Views of Harbin, Fuchiatien, Taken during the Plague Epidemic, December 1910–March 1911* (Shanghai, China: Commercial Press, [1911]).

Médiathèque F. Mitterrand - les Capucins

RES FB C710—f. Album de photos prises par le Dr Broquet lors de l'épidémie de peste en Mandchourie en 1910-1911.

Musée National de l'Éducation

0003.00539.11, Projections Molteni, Radiguet & Massiot. "Prophylaxie des maladies contagieuses. 1ère série. Transmises par les déjections, les matières fécales, l'eau souillée; les sécrétions respiratoire. Bacille de la peste. Bubon pesteux. Rat et mangouste."

National Archives (UK)

CO 129/263, 10928 Bubonic Plague; James Lowson, Government Civil Hospital Hong Kong, 16th May 1894, enclosed in William Robinson to the Marquess of Ripon, May 17, 1895, 48–69.

MH 19/274. "Plague Destruction of Rats on Ship; Plague Precautions. Destruction of Rats on Ships, 24 May 1900." Enclosed pamphlet "The Clayton Fire Extinguishing and Ventilating Company, Limited."

National Archives and Records Administration (USA)

RG90, Central File 1897–1923 537–544, Box 065. "US Consul General Copenhagen, January 16, 1909, Extermination of Rats in Denmark."

RG90, Central File, 1897–1923, 544, Box 066. Records of Rat Day or Rat Week themed campaigns on the East Coast.

National Library of Medicine (USA)

101405394, Clothing—protective: Protective mask after Dr. Broquet—used during the epidemic of pneumonic plague in Manchuria.

Chinese Public Health Posters. https://www.nlm.nih.gov/hmd/chineseposters/index.html.

National Library of Scotland

77505435, *Report of the Municipal Commissioner of the Plague in Bombay for the Year Ending 31st May 1899*, Part I. General Administration (Bombay, India: Times of India, 1899).

9937335823804341, *Report of the Municipal Commissioner on the Plague in Bombay for the Year Ending 31st May 1900*, Vol. 2 (Bombay, India: Times of India, 1901).

IP/13/PC.4, Malcolm Edward Couchman, *Account of plague administration in the Bombay Presidency from September 1896 till May 1897* (Bombay, India: Government Central Press, 1897).

New York Academy of Medicine Library

RBS74, Anon., *Chuma v Manchzhurii, v. 1910–11 g.g* (n.p., 1911).

WA 243 U58 1949. Federal Security Agency. *Rat-Borne Disease Prevention and Control*. Atlanta, GA: Communicable Disease Center, Public Health Service, 1949.

Photothèque, Institut Pasteur

MP24789, Portrait d'Alexandre Yersin (1863–1943) à l'âge de 30 ans en 1893, Photo Pierre Petit.

MP31294, Malade de la peste à Porto en 1899.

MP35722, Mise en bière d'un cadavre pesteux par une équipe d'hygiène à Madagascar vers 1935.

San Francisco Public Library

San Francisco Department of Public Health Records (SFH 63), September 12, 1907, 321.

Leather-bound album titled "J. M. Williamson M.D. Board of Health" (uncatalogued, no call number).

State Library of New South Wales

PXE 90–1001, Views taken during Cleansing Operations, Quarantine Area, Sydney, 1900, Vol. I to XI, under the supervision of Mr George McCredie, F.I.A., N.S.W.

University of Alabama at Birmingham Archives

Series/Collection MC12, Folder 1.14., M. A. Barber, and O. Teague. "Studies on Pneumonic Plague and Plague Immunization, XII." In *Some Experiments to Determine the Efficacy of Various Masks for Protection against Pneumonic Plague* (Manila, Philippines: Bureau of Printing, 1912).

The University of Hong Kong Libraries

U 614.42518 M26 e. Manchurian Plague Prevention Service (Harbin). Early photos of pneumonic plague epidemics, 1910–11 and 1920–21, Manchuria.

U 614.42518 M25 o, Manchurian Plague Prevention Service, Early photos of pneumonic plague epidemics, 1910–11 and 1920–21, Manchuria.

U 614.49518 W9, Views of Chinese plague epidemic expedition in west Manchuria, 1911 / headed by W.L.T.

Victoria and Albert Museum

NAL Pressmark PP.400.R. N. N. Karazin, "Zakaspiiskaia zheleznaia doroga," *Vsemirnaia illiustratsiia* 1888 (II), p. 181.

SP.598. Pierre Antoine Augustin Vafflard. *Desgenettes, médecin en chef de l'armeé d'Egypte, s'inocule la peste en présence des soldats malades afin de calmer leur imagination.* Lithograph [ca. 1820–1835].

Wellcome Library

+M289. *Report by Professor W. J. Simpson on Sanitary Matters in Various West African Colonies and the Outbreak of Plague in the Gold Coast* (London, UK: Darling & Son: His Majesty's Stationery Office 1909).

24258i. *The Bombay Plague Epidemic of 1896–1897: Work of the Bombay Plague Committee.* Photographs attributed to Capt. C. Moss, 1897.

38254i. "A rat-catcher and his young assistant standing outside a doorway having their services refused by an old man: The rat-catcher holds a long stick with a cage on top of it containing rats, on his right shoulder sits a rat. Etching after Rembrandt van Rijn, c. 1632."

38263i. "A rat-catcher enticing rats in to a tray which is strapped around his shoulder; he also holds a pole with a cage on top of it in which rats are trapped. Etching by Vliet."

38321i. "A crowd gathered around a mountebank who points to a banner illustrating various methods of execution; to the left stands a rat-catcher who holds a long stick with a cage on top of it from which rats dangle. Etching by C.W.E. Dietrich, 1740, after A. van Ostade."

41285i. "A terrier dog has chased a rat into a corner and is about to kill it. Wood engraving by E. Griset."

42250i. "A boy kneeling down opening a rat-trap with two dogs eagerly awaiting the appearance of the rat. Etching by J. Scott after A. Cooper."

660567i, *China: Protection against Nuclear, Chemical, and Germ Warfare.* Color lithographs, 1971. https://wellcomecollection.org/works/z2avkryh.

b32162698. *Karachi Plague Committee in 1897.* Album of photographs.

b29146318. *The Plague Expedition to Anzob in Russian Turkestan.* Photograph album by A. M. Levin, 1899.

DATABASE

Apollo—University of Cambridge Repository

Visual Representations of the Third Plague Pandemic Photographic Database, https://www.repository.cam.ac.uk/handle/1810/280684.

PRIMARY PUBLISHED SOURCES

Administration Sanitaire de l'Empire Ottoman. *Projets pour la réorganisation des lazarets de l'Empire Ottoman: Actes du Conseil supérieur de santé 1889–1894.* Constantinople, Turkey: Typographie et lithographie Osmanié, 1894.

Administration Sanitaire de l'Empire Ottoman. *Rapport de la Commission d'inspection des lazarets sur le lazaret de Beyrouth, presenté au Conseil supérieur de santé le 9 octobre, 1906.* Constantinople, Turkey: Imprimerie F. Loeffler, Lithographie de S.M.I le Sultan, 1906.

Administration Sanitaire de l'Empire Ottoman. *Rapport de la Commission d'inspection ses lazarets sur le lazaret de Camaran, présenté au Conseil supérieur de santé le 31 juillet 1906.* Constantinople, Turkey: Imprimerie Française E. Souma & cie 1906.

Administration Sanitaire de l'Empire Ottoman. *Rapport générale sur la campagne du pèlerinage de 1909 au lazaret de Tébuk.* Constantinople, Turkey: Gérard Frères, 1909.

Albrecht, Heinrich, Hermann Franz Müller, Anton Ghon, and Kaiserlichen Akademie der Wissenschaften in Wien. *Über die Beulenpest in Bombay, im Jahre 1897.* Vol. 1–3. Vienna, Austria: K. K. Hof- und Staatsdruckerei, in Commission bei Carl Gerold, 1898–1900.

Anon. "The arrest of plague in Japan." *Illustrated London News* 3624 (October 3, 1908): 458.

Anon. "Au lazaret du Frioul." *La petit gironde* 31, no. 10,698 (October 7, 1901): 1.

Anon. "The bubonic plague and the remedy." *The Worker* 11, no. 464 (March 24, 1900): 1.

Anon. "Commission men show the city what cleaning-up really means." *Merchant's Association Review* 12, no. 140 (April 1908): 1.

Anon. "Conditions in Harbin." *North-China Herald* 2271 (February 17, 1911): 357–358.

Anon. "El amigo del hombre: El perro. La lucha contra las ratas en el Puerto." *Caras y Caretas* 1281 (April 21, 1923): 56–57.

Anon. "Elimination of the rat." *Boston Medical and Surgical Journal* 174, no. 2 (October 19, 1916): 576.

Anon. "Fighting bubonic plague in the Chinese and native quarters, Honolulu, H.I." *Harper's Weekly*, February 3, 1900, 112.

Anon. "The great fire in Honolulu." *Harper's Weekly*, February 17, 1900, 149.

Anon. "Hong Kong during the plague." *Australian Town and Country Journal* (Sydney) 49, no. 1285 (September 22, 1894): 30.

Anon. "Hospital which no patient leaves alive: A visit to the plague sufferers at Harbin." *The Sun* (New York) 78, no. 256 (May 14, 1911): 9.

Anon. "How our forefathers fought the plague." *British Medical Journal* 2, no. 1969 (1898): 903–908.

Anon. "How science masks itself against the Black Plague." *Richmond Palladium and Sun-Telegram* 36, no. 218 (July 15, 1911): 2.

Anon. "In the plague-ridden country: Pest scenes in Manchuria." *Illustrated London News* 3750 (March 4, 1911): 310.

Anon. "La bubónica y las ratas." *Caras y Caretas* 727 (September 7, 1912): 92–93.

Anon. "La peste en Mandchourie." In "Supplément du Dimanche," *Le petit journal* 22, no. 1057 (February 19, 1911): 1.

Anon. "La peste en Mandchourie." *Journal des voyages et des aventures de terre et de mer* 747 (March 26, 1911): 1.

Anon. "Le cauchemar de Mandchourie." *L'illustration*, Supplement, 3551 (March 18, 1911): 190–195.

Anon. "Le lazaret du Frioul." *L'actualité* 2, no. 90 (October 20, 1901): 659.

Anon. "Le pestiféré," frontispiece. Supplement, *L'illustration* 69, no. 3551 (March 18, 1911): 1.

Anon. "Les passagers du *Sénégal*, rélegués derriére la grille du lazaret, dans l'île Ratonneau (Photographie de Chusseau-Flaviers)." *La vie illustrée* 156 (October 11, 1901): 3.

Anon. "The management of pneumonic plague epidemics." *The Lancet* 209, no. 5403 (1927): 611–612.

Anon. "A microbe manufactory." *Hickman Courier* 50, no. 34 (February 4, 1909): 1.

Anon. "Nos lazarets." *Le matin* 18, no. 6427 (September 30, 1901): 1.

Anon. "Observations on rat and human plague in Belgaum." *Journal of Hygiene* 10, no. 3 (1910): 446–482.

Anon. "Pandemic plague." *British Medical Journal* 2, no. 2078 (1900): 1255.

Anon. "The plague." *Hongkong Daily Press*, July 6, 1894, 2.

Anon. "The plague." *North-China Herald* 2269 (February 3, 1911): 245–248.

Anon. "The plague." *Truth* (Brisbane) 604 (March 2, 1902): 7.

Anon. "The plague at Hong Kong." *Illustrated London News* 2884 (July 28, 1894): 100.

Anon. "The plague at Hong Kong." *The Lancet* 143, no. 3695 (June 23, 1894): 1581–1582.

Anon. "The plague at Hong Kong: British troops destroying the refuse from infected houses at Tai-ping-shan." *The Graphic* (London) 1288 (August 4, 1894): 120.

Anon. "The plague at Vienna; Dr. Mueller, who attended Barisch, succumbs to the disease—his devotion to science." *New York Times*, October 24, 1898.

Anon. "Plague fought by fire." *New-York Tribune Illustrated Supplement*, January 28, 1900, 13.

Anon. "The plague—from our correspondents." *North-China Herald* 2272 (February 24, 1911): 418–422.

Anon. "The plague in Hyderabad State: A report by Lieutenant-Colonel Lawrie I.M.S." *The Lancet* 1, no. 3935 (January 28, 1899): 249–350.

Anon. "The plague in India: Fighting the epidemic in Bombay." *The Graphic* 1451 (September 18, 1897): 394.

Anon. "Plague in Manchuria." *North-China Herald* 2267 (January 20, 1911): 114.

Anon. "The plague in Manchuria: Direct camera pictures by Frederick Moore." *The Sphere* 44, no. 582 (March 18, 1911): 233.

Anon. "The plague panic in Calcutta and government." *Calcutta Journal of Medicine* 17, no. 4 (April 1898): 134–141.

Anon. "The pool of Siloam: In a plague segregation camp at Karachi." *The Graphic* (August 21, 1897): 268.

Anon. "Precautions taken against the plague in Japan." *Adelaide Chronicle* 51, no. 2620 (November 7, 1908): 30.

Anon. "The present pandemic of plague." *The Lancet* 172, no. 4440 (October 3, 1908): 1024–1025.

Anon. "A real Yellow Peril: The astonishingly virulent outbreak of pneumonic plague in the Far East." Supplement, *The Sphere* (February 18, 1911): i–iii.

Anon. "Recent experiments on plague disinfectants in India." *The Lancet*, September 26, 1908, 960–961.

Anon. "The scourge of the century." *Lincoln County Leader* 8, no. 10 (May 11, 1900): 2.

Anon. "The Turkish lazarets." *The Lancet* 169, no. 4365 (April 27, 1907): 1173.

Anon. "Two million dollar blaze razes Honolulu's Chinatown." *San Francisco Call*, February 1, 1900, 4.

Anon. "When first the plague came to our land: The Black Death." *Illustrated London News* 3733 (November 5, 1910): 710.

Apéry, Pierre. "Bulletin épidémiologique. L'utilité des quarantaines." *Revue médico-pharmaceutique* 14, no. 21 (November 1, 1901): 241–242.

Autran, Gustave. "Ballade des 80 rats morts." In Anon., *Le "Sénégal" au Frioul (vers)*, 44–47. Paris, France: Imprimerie de la Court d'Appel, 1902.

Bannerman, William Burney. *Plague in India, Past and Present*. London, UK: Research Defence Society, 1910.

Basello, Gian Pietro, and Paolo Ognibene. "A black dog from Marzic: Legends and facts about Anzob plague." In *Yaghnobi Studies I: Papers from the Italian Missions in Tajikistan*, edited by Antonio Panaino, Andrea Gariboldi, and Paolo Ognibene, 87–115. Milan, Italy: Mimesis, 2013.

Bertot, Jean. *Au lazaret: Souvenirs de quarantaine*. Tours, France: Deslis Freres, 1902.

Bienvenue. "Les semeurs de peste." *La médecine internationale illustrée* 19, no. 2 (March 1911): 75–81.

Blanchard, R. "Notes historiques sur la peste." *Archives de parasitologie* 3 (1900): 589–646.

Blue, Rupert. "Anti-plague measures in San Francisco, California, U.S.A." *Journal of Hygiene* 9, no. 1 (April 1909): 1–8.

Boetler, W. R. *The Rat Problem*. London, UK: Bale and Danielsson, 1909.

Branger, M. "La peste au Frioul." *Armée et marine* 3, no. 41 (October 13, 1901): 138–140.

British Delegate on the Constantinople Board of Health. "Some Turkish lazarets and other sanitary institutions in the Near East, I." *The Lancet* 169, no. 4365 (April 27, 1907): 1188–1189.

British Delegate on the Constantinople Board of Health. "Some Turkish lazarets and other sanitary institutions in the Near East, V. The Camaran lazaret." *The Lancet* 169, no. 4370 (June 1, 1907): 1518–1521.

Broquet, Charles. *Foyer de peste bubonique dans la Chine méridionale.* Paris, France: Gainche, 1902.

Broquet, Charles. *La conférence de la peste à Moukden, avril 1911.* Cahors & Alençon, France: Imprimeries A. de Coueslant, 1914.

Broquet, Charles. "Le masque dans la peste: Présentation d'un modèle de masque antipesteux." *Bulletin de la Société de Pathologie Exotique* 4 (1911): 636–645.

Budberg, Roger Baron. *Bilder aus der Zeit der Lungenpest-Epidemien in der Mandschurei 1910/1911 und 1921.* Hamburg, Germany: C. Behre, 1923.

Calmette, Albert. "Déclarons la guerre aux rats." *La revue du mois* 3, no. 28 (April 10, 1908): 432–444.

Calmette, Albert. "Discours (7/10/1931)." In *Deuxième conférence internationale et congrès colonial du rat et de la peste: Paris, 7–12 octobre 1931*, edited by Gabriel Petit, 48. Paris, France: Vigot Frères, 1932.

Chabaneix, J. *Notes sur la défense contre la peste pulmonaire dans la province du Tcheli (1911).* Tianjin, China: Imprimerie de l'echo de Tientsin, 1911.

Choksy, N. H. "An unrecognized type of plague." In *Transactions of the Seventh Congress Held in British India, December 1927, Far Eastern Association of Tropical Medicine*, edited by J. Cunningham, 40–43. Calcutta, India: Thacker's Press & Directories, 1927.

Clemow, Frank-Gerard. "Étude sur la défense sanitaire du chemin de fer du Hedjaz." *Revue d'hygiène et de police sanitaire* 32 (1910): 213–244.

Clot-Bey, A. B. *De la peste observée en Egypte: Recherches et considérations sur cette maladie.* Paris, France: Fortin Masson et Cie, 1840.

Clot-Bey, A. B. *Derniers mots sur la non-contagion de la peste.* Paris, France: Victor Masson & fils, 1866.

Colvin, Thomas. "Is bubonic plague still lurking in the city of Glasgow?" *The Lancet* 170, no. 4396 (November 30, 1907): 1522–1523.

Corporation of Glasgow. *Report on Certain Cases of Plague Occurring in Glasgow in 1900 by the Medical Officer of Health.* Glasgow, UK: Robert Anderson, 1900.

Courmont, Jules. "La peste." *Le monde médical, revue internationale de médecine et de thérapeutique* 21, no. 408 (February 25, 1911): 161–175.

Cozzonis Effendi. *Rapport sur la manifestation pestilentielle à Djeddah, en 1898 suivi d'une esquisse sur les conditions générales de la dite ville*. Constantinople, Turkey: Imprimerie Osmanié, 1898.

Delamare, Gabriel. *La défense sanitaire de la ligne Médine-Damas*. Constantinople, Turkey: Imprimerie L. Mourkidès, 1912.

Doyle, Arthur Conan. *The Poison Belt*. New York, NY: Hodder and Stoughton, 1913. Project Gutenberg. http://www.gutenberg.org/ebooks/126.

Dyson, Surgn.-Capt. T. E. "Memorandum. Plague and house disinfection." *Indian Medical Gazette* 32, no. 8 (August 1897): 298.

Eyzen, I. M. "Bor'ba chumoy." *Niva* 48 (1900): 952–959.

Fabre, Pierre-Jean. *Remèdes curatifs et préservatifs de la peste donnez au public en 1652*. Toulouse, France: Claude-Gilles Lecamus, 1720.

Fang Chin. "Individual precautions taken by the medical staff during the recent epidemic at Fuchiatien." In *Report of the International Plague Conference Held at Mukden April 1911*, edited by Richard Pearson Strong, G. F. Petrie, and Arthur Stanley, 287–289 [discussion 289–303] (Manila, Philippines: Bureau of Printing, 1912).

Gasquet, Francis Aidan. *The Black Death of 1348 and 1349*. 2nd ed. London, UK: George Bell and Sons, 1908.

Godfrey, Frank. "The Kaumakapili church fire." *Austin's Hawaiian Weekly* 2, no. 20 (February 3, 1900): 7.

Ham, B. Burnett. *Report on Plague in Queensland, 1900–1907 (26th February, 1900, to 30th June, 1907)*. Brisbane, Australia: Government Printer, 1907.

Hampol, Léo d'. "La peste en Europe—A Marseille et à Naples." *La vie illustrée* 156 (October 11, 1901): 19–21.

Harte, Richard H. *Protect Your Home and Public Health against Rats*. Philadelphia, PA: Bureau of Health, 1941.

Hecker, I. F. C. *The Black Death in the Fourteenth Century*. Translated by B. G. Babington. London, UK: A. Schloss, 1833 [1832].

Hendrick, Burton J. "Fighting the 'Black Death' in Manchuria." *The World's Work* 27 (1914): 210–222.

Hirshberg, Gordon Henry. "Medical science's newest discoveries about the 'Spanish influenza.'" *Washington Times*, October 6, 1918, National Edition, American Weekly Section, 22.

Hirst, L. Fabian. *The Conquest of Plague: A Study of the Evolution of Epidemiology*. New York, NY: Oxford University Press, 1953.

Holsendorf, B. E. "Rat surveys and rat proofing." *American Journal of Public Health and the Nation's Health* 27, no. 9 (1937): 883–888.

Hong Kong Government. "Report, Scheme for the Improvement of the Resumed Area in Taipingshan (Incorporating Correspondence No. 132 by Francis A. Cooper, Director of Public Works, 22 March 1895) (30 March 1895)," *Hong Kong Government Gazette*, no. 117 (GA 1895): 262–265.

Howard, John. *An Account of the Principal Lazarettos in Europe with Various Papers Relative to Plague*. Warrington, UK: William Eyres, 1789.

Hunter, William. "Buboes and their significance in plague." *The Lancet* 168, no. 4324 (July 14, 1906): 83–86.

Hunter, William. *A Research into Epidemic and Epizootic Plague*. Hong Kong: Noronha & Co., 1904.

Jorge, Ricardo. *La peste africaine: Rapport présenté au Comité permanent de l'Office International d'Hygiène Publique dans sa session d'avril–mai 1935*. Paris, France: Office International d'Hygiène Publique, 1935.

Kinnear, E. "Propitiating the plague spirits." *China Medical Missionary Journal* 264 (1902): 204.

Kitasato, Shibasaburō. "Combating plague in Japan." *Philippine Journal of Science* 1 (1906): 465–481.

Kitasato, Shibasaburō. "La lute contre la peste." *Archives de médecine navale* 86 (1906): 289–308.

Lagarrigue, Maurice. *La lutte contre le rat*. Paris, France: Jouve & Cie, 1911.

Lantz, David E. *House Rats and Mice*. Farmer's Bulletin 896, United States Department of Agriculture. Washington, DC: US Government Printing Office, 1917.

League of Nations, Health Organisation. *Report of Commission to Enquire into International Arrangements in Connection with Epidemic Disease Prevention in Certain Areas of the Near East (Basin of Eastern Mediterranean and Black Sea, etc.) and in Connection with the Mecca Pilgrimage*. February 20th to March 27th 1922, C 342. M 193. 122 II.

Leroux, Charles. "Des accidents consécutifs aux injections préventives du sérum antipesteux." *Gazette hebdomadaire de médecine et de chirurgie* 98 (December 8, 1901): 1172–1176.

Lorty, Antoine. "La menace du choléra en Europe et le chemin de fer du Hedjaz." *Questions diplomatiques et coloniales* 32 (July–December 1911): 98–107.

M, Dr. A. de. "La peste de la Mandchuria." *España médica* 1, no. 9 (April 20, 1911): 7–9.

Malinovsky, L. N., D. K. Zabolotny, and P. N. Bulatov. *Chuma v Odesse v 1910 g. Epidemiologiya, patologiya, klinika, bakteriologiya i meropriyatiya*. Saint Petersburg, Russia: Tip. A. S. Suvorna "novoye vremya," 1912.

Manaud, A. "Le peste au Siam." *Bulletin de la Société de Pathologie Exotique* 6 (1911): 351–358.

Manson-Bahr, Sir Philip H. *Manson's Tropical Diseases: A Manual of the Diseases of Warm Climates*. London, UK: Cassell & Company, 1898.

Marcó del Pont, Antonino. *Historia de la peste bubónica*. Buenos Aires, Argentina: Antonino Flaiban, 1917.

Mayhew, Henry. *London Labour and the London Poor*. London, UK: Dover, 1860–1861.

Meyer, Karl Friedrich. "The known and unknown in plague." *American Journal of Tropical Medicine and Hygiene* 1–22, no. 1 (January 1, 1942): 9–36.

Meyer, Karl Friedrich. "The sylvatic plague committee." *American Journal of Public Health and the Nation's Health* 26, no. 10 (October 1936): 961–969.

Ministère des Affaires Étrangère. *Conférence sanitaire internationale de Paris: 10 Octobre–3 décembre 1903, procès-verbaux*. Paris, France: Imprimerie Nationale, 1904.

Mizunoe, K., ed. *The Collected Papers of Shibasaburo Kitasato*. Tokyo, Japan: Kitasato University, 1977.

Muybridge, Eadweard J. *The Attitudes of Animals in Motion: A Series of Photographs Illustrating the Consecutive Positions Assumed by Animals in Performing Various Movements; Executed at Palo Alto, California, in 1878 and 1879*. [San Francisco, CA], 1881. Available at https://exhibits.stanford.edu/muybridge/catalog/qd999gm5772.

Nathan, R. *The Plague in India, 1896, 1897*. Vol. 2, Appendix VI. Simla, India: Government Central Printing Office, 1898.

Pellisier, Joseph. *La peste au Frioul, lazaret de Marseille en 1900 et 1901*. Paris, France: Stein-heil, 1902.

Petit, Gabriel, ed. *Deuxième conférence internationale et congrès colonial du rat et de la peste: Paris, 7–12 octobre 1931*. Paris, France: Vigot Frères, 1932.

Petit, Gabriel, ed. *Première conférence internationale du rat, Paris—Le Havre 16–22 Mai 1928*. Paris, France: Vigot Frères, 1928.

Philippe, Adrien. *Histoire de la peste noire (1346–1350) d'après des documents inédits*. Paris, France: À la Direction de Publicité Médicale, 1853.

Plague Commission. "XI. The diagnosis of natural rat plague." *Journal of Hygiene* 7, no. 3 (1907): 324–358.

Pollitzer, Roger. *Plague*. Geneva, Switzerland: World Health Organization, 1954.

Proust, Adrien. *La défense de l'Europe contre la peste et la conférence de Venise de 1897*. Paris, France: Masson, 1897.

Río, Alejandro del, Ramon Zegers, Ricardo D. Boza, and Louis Montero. *Informe sobre la epidemia de peste bubónica en Iquique en 1903: presentado al Supremo Gobierno por la comisión encargada de reconocer la naturaleza de la enfermedad*. Santiago, Chile: Impr. Cervantes, 1904.

Rodwell, James. *The Rat: Its History and Destructive Character.* London, UK: Routledge and Co., 1858.

Ruge, Reinhold Friedrich. *Krankheiten und Hygiene der warmen Länder: Ein Lehrbuch für die Praxis.* 4th ed. Leipzig, Germany: Georg Thieme, 1938.

Ruge, Reinhold Friedrich, and Max Zur Verth. *Tropenkrankheiten und Tropenhygiene.* Leipzig, Germany: Klinkhardt, 1912.

Savage, W. G., and D. A. Fitzgerald. "A case of the plague from a clinical and pathological point of view." *British Medical Journal* 2, no. 2078 (1900): 1232–1236.

Scott, Clement. "The Black Death in China." *Illustrated London News* 2880, no. 104 (June 30, 1894): 823.

Sears, H. J. "The problem of plague as an epidemic disease." *Bulletin of the Medical Library Association* 29, no. 1 (October 1940): 9–16.

Selwyn-Clarke, P. S. *Report on the Outbreak of Plague in Kumasi, Ashanti.* Accra, Gold Coast [Ghana]: Government Printing Department, 1925.

Simond, Paul-Louis. "La propagation de la peste." *Annales de l'Institut Pasteur* (Paris) 12 (1898): 625–687.

Simond, Paul-Louis. "Peste." In *Traité de pathologie exotique, clinique et thérapeutique. 6, Maladies parasitaires, peste,* edited by P. Lecompte, L. J. Gaide, C. Mathis, F. Noc, M. Léger, H. Angier, A. Duvigneau, A. Clarac, P. Leboeuf, L. Rigollet, and P.-L. Simond, 455–648. Paris, France: J.-B. Baillière et fils, 1913.

Simpson, William J. R. "The Croonian Lectures on Plague. Delivered before the Royal College of Physicians of London on June 18th, 20th, 25th, and 27th, 1907. Lecture 1." *The Lancet* 169, no. 4374 (June 29, 1907): 1757–1761.

Simpson, William J. R. "The Croonian Lectures on Plague—Lecture II." *The Lancet* 170, no. 4376 (July 13, 1907): 73–78.

Simpson, William J. R. "Plague viewed from several aspects." *The Lancet* 155, no. 3998 (April 14, 1900): 1063–1066.

Simpson, William J. R. *Report on Plague in the Gold Coast in 1908.* London, UK: J. & A. Churchill, 1909.

Simpson, William J. R. *Report on the Causes and Continuance of Plague in Hongkong and Suggestions as to Remedial Measures.* London, UK: Waterlow and Sons, 1903.

Simpson, William J. R. *A Treatise on Plague: Dealing with the Historical, Epidemiological, Clinical, Therapeutic and Preventive Aspects of the Disease.* Cambridge, UK: Cambridge University Press, 1905.

Stekoulis, D. "Bulletin épidémiologique." *Gazette médicale d'orient* 43, no. 24 (February 15, 1899): 353–354.

Stevens, A. F. "The natural history of plague." *Indian Medical Gazette* (July 1906): 254–270.

Strong, Richard Pearson, G. F. Petrie, and Arthur Stanley, eds. *Report of the International Plague Conference (Held at Mukden in April 1911)*. Manila, Philippines: Bureau of Printing, 1912.

Tardif, E. *La peste á Quang-Tchéou-Wan*. Paris, France: Ballière et fils, 1902.

Temporary Epidemic Prevention Department of the Governor's Office of Kwantung. *An Account of the Plague in South Manchuria 1910–11 Illustrated with Photographs Taken on the Spot*. Kwantung Metropolitan Government, 1912.

Thurston, Charles H. "The Honolulu fire department." *Pacific Commercial Advertiser* (Honolulu) 35, no. 6054 (January 1, 1902): 47.

Todd, Frank Morton. *Eradicating Plague from San Francisco: Report of the Citizens' Health Committee and an Account of Its Work*. San Francisco, CA: Press of C. A. Murdock & Co., 1909.

Valle, J. A. Lopez del, and E. B. Barnet. *Plan de campaña sanitaria contra la peste bubónica*. Havana, Cuba: La Moderna Poesia, 1915.

Williams, Edward T. "Moses as a sanitarian." *Boston Medical and Surgical Journal* 106 (1882): 6–8.

Wu Lien-teh. *Plague Fighter, the Autobiography of a Modern Chinese Physician*. Cambridge, UK: W. Heffer & Sons, 1959.

Wu Lien-teh. "Practical points in the treatment of plague." *The Lancet* 198, no. 5121 (1921): 853–854.

Wu Lien-teh. *Treatise on Pneumonic Plague*. Geneva, Switzerland: League of Nations, 1926.

Wu Lien-teh (G. L. Tuck) and The Hulun Taotai. "First report of the North Manchurian Plague Prevention Service." *Journal of Hygiene* 13, no. 3 (October 1913): 237–290.

Yersin, Alexandre. "La peste bubonique à Hong Kong." *Annales de l'Institut Pasteur* 8 (1894): 662–667.

Zuschlag, Emil. *Le rat migratoire et sa destruction rationnelle*. Translated by M. Pierre Oesterby. Copenhagen, Denmark: Impr. F. Bagge, 1903.

SECONDARY SOURCES

Abou-Hodeib, Toufoul. "Quarantine and trade: The case of Beirut, 1831–1840." *International Journal of Maritime History* 19, no. 2 (2007): 223–224.

Ackerknecht, Erwin H. "Anticontagionism between 1821 and 1867." *Bulletin of the History of Medicine* 22 (1948): 562–593.

Afanasyeva, Anna E. "Explaining and Managing Epidemics in Imperial Contexts: Russian Responses to Plague in the Kazakh Steppe in the Late 19th and Early

20th Centuries." Higher School of Economics Research Paper No. WP BRP 145/HUM/2017. 2017. http://dx.doi.org/10.2139/ssrn.2949792.

Agamben, Giorgio. *Creation and Anarchy: The Work of Art and the Religion of Capitalism*. Translated by Adam Kotsko. Redwood City, CA: Stanford University Press, 2019.

Aisenberg, Andrew Robert. *Disease, Government, and the "Social Question" in Nineteenth-Century France*. Redwood City, CA: Stanford University Press, 1999.

Alloula, Malek. *The Colonial Harem*. Minneapolis, MN: University of Minnesota Press, 1988.

Amirault, Chris. "Posing the subject of early medical photography." In "Expanded Photography." Special issue, *Discourse* 16, no. 2 (Winter 1993–94): 51–76.

Amoako-Gyampah, Akwasi Kwarteng. "Sanitation and Public Hygiene in the Gold Coast (Ghana) from the Late 19th Century to 1950." PhD diss., University of Johannesburg, 2019.

Appel, Hannah, Nikhil Anand, and Akhil Gupta. "Temporality, politics and the promise of infrastructure." In *The Promise of Infrastructure*, edited by Nihil Anand, Akhil Gupta, and Hannah Appel, 1–40. Durham, NC: Duke University Press, 2018.

Argémi, Bruno. *Clot-Bey: Ou l'étonnante aventure d'un médecin marseillais en Egypte au XIXe siècle*. Paris, France: Gaussen, 2018.

Arnold, David. *Colonizing the Body: State Medicine and Epidemic Disease in Nineteenth Century India*. Cambridge, UK: Cambridge University Press, 1993.

Arnold, David. "Picturing plague: Photography, pestilence, and cremation in late nineteenth- and early twentieth-century India." In *Plague Image and Imagination from Medieval to Modern Times*, edited by Christos Lynteris, 111–139. London, UK: Palgrave Macmillan, 2021.

Arnold, David. *The Problem of Nature: Environment, Culture and European Expansion*. Oxford, UK: Blackwell, 1997.

Aronson, Stanley M. "Rembrandt and the rat catchers." *Medicine and Health Rhode Island* 87, no. 6 (June 2004): 167.

Arslan, A., and H. A. Polat. "Travel from Europe to Istanbul in the 19th century and the quarantine of Çanakkale." *Journal of Transport and Health* 4 (2017): 10–17.

Ayyadurai, S., L. Houhamdi, H. Lepidi, C. Nappez, D. Raoult, and M. Drancourt. "Long-term persistence of virulent *Yersinia pestis* in soil." *Microbiology* 154 (2008): 2865–2871.

Azoulay, Ariella. *Civil Imagination: A Political Ontology of Photography*. Translated by Louise Bethlehem. London, UK: Verso, 2012.

Bailey, Gauvin Alexander. *Hope and Healing: Painting in Italy in a Time of Plague, 1500–1800*. Chicago, IL: Chicago University Press, 2005.

Baldwin, Peter. *Contagion and the State in Europe, 1830–1930*. Cambridge, UK: Cambridge University Press, 1994.

Banerjee, Dwai. "Fantasies of control: The colonial character of the Modi government's actions during the pandemic." *Caravan Magazine*, June 30, 2020. https://caravanmagazine.in/perspectives/colonial-character-of-the-modi-governments-actions-during-the-pandemic.

Baratay, Éric. *Bêtes des tranchées, des vécus oubliés*. Paris, France: CNRS Éditions, 2013.

Barker, Sheila. "Poussin, plague, and early modern medicine." *Art Bulletin* 86, no. 4 (December 2004): 659–689.

Barnard, Timothy. *Imperial Creatures: Humans and Other Animals in Colonial Singapore, 1819–1942*. Singapore: National University of Singapore Press, 2019.

Barnes, David S. "Cargo, 'infection,' and the logic of quarantine in the nineteenth century." *Bulletin of the History of Medicine* 88, no. 1 (2014): 75–101.

Barnes, David S. *The Great Stink of Paris and the Nineteenth-Century Struggle against Filth and Germs*. Baltimore, MD: Johns Hopkins University Press, 2006.

Barua, Maan. "Nonhuman life as infrastructure." *Society and Space*, November 30, 2020. https://www.societyandspace.org/articles/nonhuman-life-as-infrastructure.

Bashford, Alison. *Imperial Hygiene: A Critical History of Colonialism, Nationalism and Public Health*. Basingstoke, UK: Palgrave Macmillan, 2004.

Bashford, Alison. "Maritime quarantine: Linking Old World and New World histories." In *Quarantine: Local and Global Histories*, edited by Alison Bashford, 1–12. London, UK: Palgrave Macmillan, 2016.

Bayless, Martha. *Sin and Filth in Medieval Culture*. London, UK: Routledge, 2012.

Beattie, Martin. "Colonial space: Health and modernity in Barabazaar, Kolkata." *Traditional Dwellings and Settlements Review* 14, no. 2 (Spring 2003): 7–19.

Beisel, Uli. "Markets and mutations: Mosquito nets and the politics of disentanglement in global health." *Geoforum* 66 (2015): 146–155.

Bell, Joshua A. "Out of the mouths of crocodiles: Eliciting histories in photographs and string-figures." *History and Anthropology* 21, no. 4 (December 2010): 351–373.

Belting, Hans. *Face and Mask: A Double History*. Translated by Thomas S. Hansen and Abby J. Hansen. Princeton, NJ: Princeton University Press, 2017.

Benedict, Carol A. *Bubonic Plague in Nineteenth-Century China*. Redwood City, CA: Stanford University Press, 1996.

Benjamin, Walter. "Little history of photography." In *Selected Writings*, Volume 2: *1927–1934*, 507–530. Cambridge, MA: Belknap Press of Harvard University Press, 1991.

Benjamin, Walter. *Reflections: Essays, Aphorism, Autobiographical Writings*. Edited by Peter Demetz. New York, NY: Schocken, 1986.

Benton, Adia. "Risky business: Race, nonequivalence and the humanitarian politics of life." *Visual Anthropology* 29, no. 2 (February 2016): 187–203.

Besse, Jean-Marc. "European cities from bird's-eye views: The case of Alfred Guesdon." In *Seeing from Above: The Aerial View in Visual Culture*, edited by Mark Dorrian and Frédéric Pousin, 66–82. London, UK: I. B. Tauris, 2013.

Beumer, Koen. "Catching the rat: Understanding multiple and contradictory human-rat relations as situated practices." *Society and Animals* 22 (2014): 8–25.

Bibel, David J., and T. E. Chen. "Diagnosis of plague: An analysis of the Yersin-Kitasato controversy." *Bacteriological Reviews* 40, no. 3 (September 1976): 633–651.

Biehler, Dawn D. *Pests in the City: Flies, Bedbugs, Cockroaches, and Rats*. Seattle, WA: University of Washington Press, 2013.

Bigon, Liora. "Bubonic plague, colonial ideologies, and urban planning policies: Dakar, Lagos, and Kumasi." *Planning Perspectives* 31, no. 2 (2016): 205–226.

Birch de Aguilar, Laurel. *Inscribing the Mask: Interpretation of Nyau Masks and Ritual Performance among the Chewa of Central Malawi*. Sankt Augustin, Germany: Anthropos Institut, 1996.

Biscotto, C. R., E. R. P. Pedroso, C. E. F. Starling, and V. R. Roth. "Evaluation of N95 respirator use as a tuberculosis control measure in a resource-limited setting." *International Journal of Tuberculosis and Lung Disease* 9, no. 5 (2005): 545–549.

Bloch, Marc. *Les rois thaumaturges: Étude sur le caractère surnaturel attribué à la puissance royale particulièrement en France et en Angleterre*. Paris, France: Gallimard, 1983.

Boeckl, Christine M. *Images of Plague and Pestilence: Iconography and Iconology*. University Park, PA: Pennsylvania State University Press, 2001.

Borasi, Giovanna, and Mirko Zardini. "Demedicalize architecture." In *Imperfect Health: The Medicalization of Architecture*, edited by Giovanna Borasi and Mirko Zardini, 15–37. Montreal, Quebec: Canadian Centre for Architecture/Lars Müller, 2012.

Bouhdiba, Sofiane. *Pavillon jaune: Histoire de la quarantaine, de la Peste à Ebola*. Paris, France: L'Harmattan, 2016.

Bretelle-Establet, Florence. "Les épidémies en Chine à la croisée des savoirs et des imaginaires: Le Grand Sud aux xviiie et xixe siècles." *Extrême-orient extrême-occident* 34 (2014): 21–60.

Brossollet, Jacqueline. "Segalen et Chabaneix en Chine pendant la peste de Mandchourie." *Revue du praticien* 43, no. 6 (March 15, 1993): 742–745.

Brusatin, Manlio. *Il muro della peste: Spazio della pieta e governo del lazaretto*. Venice, Italy: Cluva Libraria Editrice, 1981.

Bruzzone, Rachel. "*Polemos, pathemata*, and plague: Thucydides' narrative and the tradition of upheaval." *Greek, Roman, and Byzantine Studies* 57 (2017): 882–909.

Buck-Morss, Susan. *The Origin of Negative Dialects: Theodor W. Adorno, Walter Benjamin, and the Frankfurt Institute*. New York, NY: Free Press, 1977.

Bulmuş, Birsen. *Plague, Quarantines and Geopolitics in the Ottoman Empire*. Edinburgh, UK: Edinburgh University Press, 2012.

Burrow, G. N. "Clot-Bey: Founder of Western medical practice in Egypt." *Yale Journal of Biology and Medicine* 48 (1975): 251–257.

Burt, Jonathan. *Rat*. London, UK: Reaktion Books, 2006.

Bynum, W. F. "Policing hearts of darkness: Aspects of the international sanitary conferences." *History and Philosophy of the Life Sciences* 15, no. 3 (1993): 421–434.

Caduff, Carlo. *The Pandemic Perhaps: Dramatic Events in a Public Culture of Danger*. Berkeley, CA: University of California Press, 2015.

Caduff, Carlo. "Sick weather ahead: On data-mining, crowd-sourcing, and white noise." *Cambridge Journal of Anthropology* 32, no. 1 (June 2014): 32–46.

Calain, Philippe. "Ethics and images of suffering bodies in humanitarian medicine." *Social Science and Medicine* 98 (December 2013): 278–285.

Callender, Brian, Shirlene Obuobi, M. K. Czerwiec, and Ian Williams. "COVID-19, comics, and the visual culture of contagion." *The Lancet* 396, no. 10257 (October 10, 2020): 1061–1063.

Canales, Jimena. *A Tenth of a Second: A History*. Chicago, IL: University of Chicago Press, 2009.

Carmichael, Ann G. "Pesthouse Imaginaries." In *Plague Image and Imagination from Medieval to Modern Times*, edited by Christos Lynteris, 69–110. London, UK: Palgrave Macmillan, 2021.

Carrey, Pierre. "Marseille, 1901: Le paquebot de la peste, la quarantaine et les caprices de riches." *Libération*, April 25, 2020. https://www.liberation.fr/france/2020/04/25/marseille-1901-le-paquebot-de-la-peste-la-quarantaine-et-les-caprices-de-riches_1786369.

Cartwright, Lisa "'Experiments of destruction': Cinematic inscriptions of physiology." In "Seeing Science." Special issue, *Representations* 40 (Autumn 1992): 129–152.

Casanova, L. M., L. J. Teal, E. E. Sickbert-Bennett, D. J. Sexton, W. A. Rutala, and D. J. Weber, CDC Prevention Epicenters Program. "Assessment of self-contamination during removal of personal protective equipment for Ebola patient care." *Infection Control and Hospital Epidemiology* 37, no. 10 (2016): 1156–1161.

Catanach, Ian. "Plague and the tensions of Empire: India, 1896–1918." In *Imperial Medicine and Indigenous Societies*, edited by David Arnold, 149–171. Manchester, UK: Manchester University Press, 1988.

Çelik, Zeynep. *Displaying the Orient: Architecture of Islam at 19th Century World's Fairs*. Berkeley, CA: University of California Press, 1992.

Chakrabarti, Pratik. *Bacteriology in British India: Laboratory Medicine and the Tropics*. Rochester, NY: University of Rochester Press, 2012.

Chakrabarti, Pratik. "Covid-19 and the spectres of colonialism." *India Forum*, July 14, 2020. https://www.theindiaforum.in/article/covid-19-and-spectres-colonialism.

Chakrabarti, Pratik. *Medicine and Empire 1600–1960*. London, UK: Palgrave Macmillan, 2014.

Chakrabarty, Dipesh. "Community, state and the body: Epidemics and popular culture in colonial India." In *Medical Marginality in South Asia: Situating Subaltern Therapeutics*, edited by David Hardiman and Projit Bihari Mukharji, 36–58. London, UK: Routledge, 2012.

Chalhoub, Sidney. "The politics of disease control: Yellow fever and race in nineteenth century Rio de Janeiro." *Journal of Latin American Studies* 25, no. 3 (October 1993): 441–463.

Chandavarkar, Rajnarayan. "Plague panic and epidemic politics in India, 1896–1914." In *Epidemics and Ideas: Essays on the Historical Perception of Pestilence*, edited by Paul Slack, 203–240. Cambridge, UK: Cambridge University Press, 1992.

Chang, Jiat-Hwee. *A Genealogy of Tropical Architecture: Colonial Networks, Nature and Technoscience*. London, UK: Routledge, 2016.

Chase, Marilyn. *The Barbary Plague: The Black Death in Victorian San Francisco*. London, UK: Random House, 2004.

Chaudhary, Zahid R. *Afterimage of Empire: Photography in Nineteenth-Century India*. Minneapolis, MN: University of Minnesota Press, 2012.

Chaudhury, Zinnia Ray. "How the British used postcards as a propaganda tool during the Bombay plague of 1896." *Scroll.in*, September 22, 2018. https://scroll.in/magazine/891745/how-the-british-used-postcards-as-a-propaganda-tool-during-the-bombay-plague-of-1896.

Chauvin, Frédéric, and Louis-Paul Fischer. "Les peintures murales de Jean Coquet de l'hôpital Desgenettes à Lyon." *Histoire des sciences médicales* 44, no. 1 (2010): 23–34.

Chevallier, Jacques. "Une quarantaine de peste au lazaret de Frioul en 1901." *Histoire des sciences médicales* 49, no. 2 (2015): 179–188.

Chevé, Dominique, and Michel Signoli. "Corps dans la tournmente epidemique de peste en Madchourie." *Corps* 1, no. 2 (2007): 75–92.

Chiffoleau, Sylvia. *Genèse de la santé publique internationale: De la peste d'Orient à l'OMS*. Rennes, France: Presses Universitaires de Rennes 2012.

Chiffoleau, Sylvia. "Les pèlerins de La Mecque, les germes et la communauté international." *Médecine/Sciences* (Paris) 27, no. 12 (December 2011): 1121–1126.

Chiffoleau, Sylvia. *Le voyage à La Mecque: Un pèlerinage mondial en terre d'Islam*. Paris, France: Belin, 2015.

Chircop, John. "Quarantine, sanitization, colonialism and the construction of the 'contagious Arab' in the Mediterranean, 1830s–1900." In *Mediterranean Quarantines, 1750–1914: Space, Identity and Power*, edited by John Chircop and Francisco Javier Martínez, 199–231. Manchester, UK: Manchester University Press, 2018.

Christensen, Allan Conrad. *Nineteenth-Century Narratives of Contagion: "Our Feverish Contact."* London, UK: Routledge, 2005.

Chu, Cecilia. "Combatting nuisance: Sanitation, regulation and politics of property in colonial Hong Kong." In *Imperial Contagions: Medicine, Hygiene, and Cultures of Planning in Asia*, edited by Robert Peckham and David Pomfret, 17–36. Hong Kong: Hong Kong University Press, 2013.

Chuang, Ying-Chih, Ya-Li Huang, Kuo-Chien Tseng, Chia-Hsin Yen, and Lin-Hui Yang. "Social capital and health-protective behavior intentions in an influenza pandemic." *PLOS One* 10, no. 4 (2015): e0122970. https://doi.org/10.1371/journal.pone.0122970.

Cipolla, Carlo M. *Cristofano and the Plague: A Study in the History of Public Health in the Age of Galileo*. Berkeley, CA: University of California Press, 1973.

Cipolla, Carlo M. "A plague doctor." In *The Medieval City*, edited by Harry A. Miskimin, David Herlihy, and A. L. Udovitch, 65–72. New Haven, CT: Yale University Press, 1977.

Cohn Jr, Samuel K. *Epidemics: Hate and Compassion from the Plague of Athens to AIDS*. Oxford, UK: Oxford University Press, 2018.

Coleman, William. *Yellow Fever in the North: The Methods of Early Epidemiology*. Madison, WI: University of Wisconsin Press, 1987.

Condon, Bradly J., and Tapen Sinha. "Who is that masked person: The use of face masks on Mexico City public transportation during the influenza A (H1N1) outbreak." *Health Policy* 95, no. 1 (2010): 50–56.

Cooter, Roger, and Claudia Stein. "Visual imagery and epidemics in the twentieth century." In *Imagining Illness: Public Health and Visual Culture*, edited by David Harley Serlin, 169–192. Minneapolis, MN: University of Minnesota Press, 2010.

Correa, Sílvio Marcus de Souza. "O 'combate' às doenças tropicais na imprensa colonial alemã." *História, Ciências, Saúde—Manguinhos* 20, no. 1 (2013): 69–91.

Cowling, B. J., Y. Zhou, D. K. Ip, G. M. Leung, and A. E. Aiello. "Face masks to prevent transmission of influenza virus: A systematic review." *Epidemiology and Infection* 138, no. 4 (2010): 449–456.

Craddock, Susan. *City of Plagues: Disease, Poverty, and Deviance in San Francisco*. Minneapolis, MN: University of Minnesota Press, 2000.

Craddock, Susan. "Sewers and scapegoats: Spatial metaphors of smallpox in nineteenth century San Francisco." *Social Science and Medicine* 41, no. 7 (1995): 957–968.

Crossland, Zoe. "Of clues and signs: The dead body and its evidential traces." *American Anthropologist* 111, no. 1 (2009): 69–80.

Cunningham, Andrew. "Transforming plague, the laboratory and the identity of infectious disease." In *The Laboratory Revolution in Medicine*, edited by Andrew Cunningham and Perry Williams, 209–244. Cambridge, UK: Cambridge University Press, 1992.

Curson, Peter, and Kevin McCracken. *Plague in Sydney: The Anatomy of an Epidemic.* Kensington, Australia: New South Wales University Press, 1989.

Czitrom, Daniel, and Bonnie Yochelson. *Rediscovering Jacob Riis: Exposure Journalism and Photography in Turn-of-the-Century New York.* New York, NY: New Press, 2007.

Daston, Lorraine, and Peter Galison. *Objectivity.* New York, NY: Zone Books, 2007.

Dean, Katharine R., Fabienne Krauer, and Boris V. Schmid. "Epidemiology of a bubonic plague outbreak in Glasgow, Scotland in 1900." *Royal Society Open Science* 6, no. 1 (2019): 6181695. https://doi.org/10.1098/rsos.181695.

Deleuze, Gilles, and Felix Guattari. *Capitalism and Schizophrenia I: Anti-Oedipus.* Translated by Robert Hurley. 1972. Reprint, London, UK: Penguin, 2009.

Della Dora, Veronica. "Making mobile knowledges: The educational cruises of the *Revue générale des sciences pures et appliquées*, 1897–1914." *Isis* 101, no. 3 (September 2010): 467–500.

Despret, Vinciane. *Penser comme un rat.* Versailles, France: Quae, 2009.

Deverell, William F. *Whitewashed Adobe: The Rise of Los Angeles and the Remaking of Its Mexican Past.* Berkeley, CA: University of California Press, 2004.

Dicker, Lavern Mau. "The San Francisco earthquake and fire: Photographs and manuscripts from the California Historical Society Library." *California History* 59, no. 1 (1980): 33–65.

Dow, Gloria Yan. "Toward a non-binary sense of mobility: Insights from self-presentation in Instagram photography during COVID-19 pandemic." *Media, Culture and Society,* April 15, 2021. https://doi.org/10.1177/01634437211008734.

Dubois, Christian Jean. *Clot Bey: Médecin de Marseille (1793—1868), chirurgien du vice-roi d'Egypte.* Marseille, France: Jeanne Laffitte, 2013.

Dyl, Joanna L. *Seismic City: An Environmental History of San Francisco's 1906 Earthquake.* Seattle, WA: University of Washington Press, 2017.

Eastgate Brink, Emily. "Ordering the invisible." *Antennae: The Journal of Nature in Visual Culture* 49 (2019): 129–147.

Echenberg, Myron J. *Black Death, White Medicine: Bubonic Plague and the Politics of Public Health in Colonial Senegal, 1914–1945.* Oxford, UK: James Currey, 2002.

Echenberg, Myron J. *Plague Ports: The Global Urban Impact of Bubonic Plague, 1894–1901.* New York, NY: New York University Press, 2007.

Edwards, Elizabeth, ed. *Anthropology and Photography, 1860–1920.* New Haven, CT: Yale University Press, 1992.

Edwards, Elizabeth. *The Camera as Historian: Amateur Photographers and Historical Imagination, 1885–1918.* Durham, NC: Duke University Press, 2012.

Edwards, Elizabeth. "Performing science: Still photography and the Torren Strait expedition." In *Cambridge and the Torres Strait: Centenary Essays on the 1898 Anthropological Expedition*, edited by Anita Herle and Sandra Rouse, 106–135. Cambridge, UK: Cambridge University Press, 1998.

Edwards, Elizabeth. "Photographic uncertainties: Between evidence and reassurance." *History and Anthropology* 25, no. 2 (2014): 171–188.

Eisenberg, Merle, and Lee Mordechai. "The Justinianic plague and global pandemics: The making of the plague concept." *Historical American Review* 125, no. 5 (December 2020): 1632–1667.

Ekcan, Esra. "Off the frame: The panoramic city albums of Istanbul." In *Photography's Orientalism: New Essays on Colonial Representation*, edited by Ali Behdad and Luke Gartland, 93–114. Los Angeles, CA: Getty Research Institute, 2013.

Ellmann, Maud. "Writing like a rat." *Critical Quarterly* 46, no. 4 (2004): 59–76.

Engelmann, Lukas. "Configurations of plague: Spatial diagrams in early epidemiology." In "Working with Diagrams," edited by Lukas Engelmann, Caroline Humphrey, and Christos Lynteris. Special issue, *Social Analysis* 63, no. 4 (Winter 2019): 89–109.

Engelmann, Lukas. "An epidemic for sale: Observation, modification, and commercial circulation of the Danysz Virus, 1890-1910." *Isis* 112, no. 3 (2021): 439–460.

Engelmann, Lukas. "Fumigating the hygienic model city: Bubonic plague and the sulfurozador in early-twentieth-century Buenos Aires." *Medical History* 62, no. 3 (2018): 360–382.

Engelmann, Lukas. "Making a model plague: Paper technologies and epidemiological casuistry in the early twentieth century." In *Plague Image and Imagination from Medieval to Modern Times*, edited by Christos Lynteris, 235–266. London, UK: Palgrave Macmillan, 2021.

Engelmann, Lukas. *Mapping AIDS: Visual Histories of an Enduring Epidemic.* Cambridge, UK: Cambridge University Press, 2018.

Engelmann, Lukas. "Photographing AIDS: On capturing a disease in pictures of people with AIDS." *Bulletin of the History of Medicine* 90, no. 2 (Summer 2016): 250–278.

Engelmann, Lukas. "Picturing the unusual: Uncertainty in the historiography of medical photography." *Social History of Medicine* 34, no. 2 (2021): 375–398.

Engelmann, Lukas. "A Plague of Kinyounism: The caricatures of bacteriology in 1900 San Francisco." *Social History of Medicine* 33, no. 2 (May 2020): 489–514.

Engelmann, Lukas. "'A source of sickness': Photographic mapping of the plague in Honolulu in 1900." In *Plague and the City*, edited by Lukas Engelmann, John Henderson, and Christos Lynteris, 139–158. London, UK: Routledge, 2018.

Engelmann, Lukas, John Henderson, and Christos Lynteris. "Introduction: The plague and the city in history." In *Plague and the City*, edited by Lukas Engelmann, John Henderson, and Christos Lynteris, 1–17. London, UK: Routledge, 2018.

Engelmann, Lukas, John Henderson, and Christos Lynteris, eds. *Plague and the City*. London, UK: Routledge, 2019.

Engelmann, Lukas, Caroline Humphrey, and Christos Lynteris. "Introduction: Diagrams beyond mere tools." In "Working with Diagrams," edited by Lukas Engelmann, Caroline Humphrey, and Christos Lynteris. Special issue, *Social Analysis* 63, no. 4 (2019): 1–19.

Engelmann, Lukas, and Christos Lynteris, *Sulphuric Utopias: A History of Maritime Fumigation*. Cambridge, MA: MIT Press, 2020.

Erso, Ahmet A. "Ottomans and the Kodak galaxy: Archiving everyday life and historical space in Ottoman illustrated journals." *History of Photography* 40, no. 3 (2016): 330–357.

Escande, Laurent, ed. *Avec les pèlerins de La Mecque: Dossiers numériques*. Aix-en-Provence, France: Presses Universitaires de Provence, Maison Méditerranéenne des Sciences de l'Homme, 2013.

Esoavelomandroso, Faranirina. "Résistance à la médecine en situation coloniale: La peste à Madagascar." *Annales* 36, no. 2 (1981): 168–190.

Evans, Nicholas H. "Blaming the rat? Accounting for plague in colonial Indian medicine." *Medicine, Anthropology, Theory* 5, no. 3 (2018): 15–42.

Evans, Nicholas H. "The disease map and the city: Desire and imitation in the Bombay plague, 1896–1914." In *Plague and the City*, edited by Lukas Engelmann, John Henderson, and Christos Lynteris, 116–138. London, UK: Routledge, 2018.

Fahmy, Khaled. *In Quest of Justice: Islamic Law and Forensic Medicine in Modern Egypt*. Berkeley, CA: University of California Press, 2018.

Fairhead, James Robert. "Technology, inclusivity and the rogue: Bats and the war against the 'invisible enemy,'" *Conservation and Society* 16, no. 2 (2018): 170–180.

Fehrenbach, Heide, and Davide Rodogno, eds. *Humanitarian Photography: A History*. Cambridge, UK: Cambridge University Press, 2015.

Fienup-Riordan, A. *The Living Tradition of Yup'ik Masks: Agayuliyararput (Our Way of Making Prayer)*. Seattle, WA: University of Washington Press, 1996.

Fissell, Mary. "Imagining vermin in early modern England." *History Workshop Journal* 47 (1999): 1–29.

Fissell, Mary E., Jeremy A. Greene, Randall M. Packard, and James A. Schafer Jr, eds. "Reimagining Epidemics." Special issue, *Bulletin of the History of Medicine* 94, no. 4, (Winter 2020): 543–561.

Fitzharris, Lindsey. *The Butchering Art: Joseph Lister's Quest to Transform the Grisly World of Victorian Medicine*. London, UK: Penguin, 2017.

Forth, Aidan. *Barbed-Wire Imperialism: Britain's Empire of Camps, 1876–1903*. Berkeley, CA: University of California Press, 2017.

François, Georges. "Les lazarets de Marseille." Association des amis du patrimoine médical de Marseille, September 28, 2017. http://patrimoinemedical.univmed.fr /articles/article_lazarets.pdf.

Fredj, Claire. "Le laboratoire et le bled: L'Institut Pasteur d'Alger et les médecins de colonisation dans la lutte contre le paludisme (1904–1939)." *Dynamis* 36, no. 2 (2016): 293–316.

Frontisi-Ducroux, Françoise. *Du masque au visage: Aspects de l'identité en Grèce ancienne*. Paris, France: Flammarion, 1995.

Gage, Kenneth L., and Michael Y. Kosoy. "Natural history of plague: Perspectives from more than a century of research." *Annual Review of Entomology* 50 (2005): 505–528.

Gamsa, Mark. "The epidemic of pneumonic plague in Manchuria 1910–1911." *Past and Present* 90 (2006): 147–184.

Gardner, Hunter H. *Pestilence and the Body in Latin Literature*. Oxford, UK: Oxford University Press, 2019.

Garrett, Laurie. *The Coming Plague: Newly Emerging Diseases in a World Out of Balance*. London, UK: Penguin Books, 1994.

Gell, Alfred. *Metamorphosis of the Cassowaries*. London, UK: Athlone Press, 1975.

Gentilcore, David. "Purging filth: Plague and responses to it in Rome, 1656–1657." In *Rome, Pollution and Propriety: Dirt, Disease and Hygiene in the Eternal City from Antiquity to Modernity*, edited by Mark Bradley and Kenneth Stow, 153–168. Cambridge, UK: Cambridge University Press, 2012.

Gerlach, Neil A. "Visualizing Ebola: Hazmat suit imagery, the press, and the production of biosecurity." *Canadian Journal of Communication* 44, no. 2 (2019): 191–210.

Gessner, Ingrid. "Epidemic iconographies: Toward a disease aesthetics of the destructive sublime." In "Iconographies of the Calamitous in American Visual Culture," edited by Ingrid Gessner and Susanne Leikam. Special issue, *Amerikastudien/American Studies* 58, no. 4 (2013): 559–582.

Gessner, Ingrid. "Picturing Ebola: Photography as an instrument of biopolitical (in)justice." March 16, 2020. https://dx.doi.org/10.13140/RG.2.2.32358.37447.

Getz, Faye Marie. "Black Death and the silver lining: Meaning, continuity, and revolutionary change in histories of medieval plague." *Journal of the History of Biology* 24, no. 2 (1991): 265–289.

Gilfoyle, Daniel. "Researching Colonial Office correspondence: Plague in Gold Coast." *National Archives Blog*, March 26, 2018. https://blog.nationalarchives.gov .uk/researching-colonial-office-correspondence-plague-in-gold-coast/.

Gilman, Sander L. *Disease and Representation: Images of Illness from Madness to AIDS.* Ithaca, NY: Cornell University Press, 1988.

Gilman, Sander L. *Picturing Health and Illness: Images of Identity and Difference.* Baltimore, MD: Johns Hopkins University Press, 1995.

Gilroy, Paul. *Against Race: Imagining Political Culture beyond the Color Line.* Cambridge, MA: Belknap Press of Harvard University Press, 2000.

Ginzburg, Carlo. *Threads and Traces: True False Fictive.* Translated by Anne C. Tedeschi and John Tedeschi. Berkeley, CA: University of California Press, 2012.

Godby, Michael. "Confronting horror: Emily Hobhouse and the concentration camp photographs of the South African War." *Kronos* 32 (November 2006): 34–48.

Grace, Helen. "A new journal of the plague year." *Cultural Studies* 1, no. 1 (1987): 75–91.

Green, Monica H. "Taking 'pandemic' seriously: Making the Black Death global." *Medieval Globe* 1, no. 1 (2014). https://scholarworks.wmich.edu/tmg /vol1/iss1/4.

Greer, Richard A. "'Sweet and clean': The Chinatown fire of 1886." *Hawaiian Journal of History* 10 (1976): 33–51.

Grigsby, D. G. "Rumour, contagion and colonization in Gros's plague-stricken of Jaffa (1804)." *Representations* 51 (1995): 1–46.

Guerrini, Anita. *The Courtiers' Anatomists: Animals and Humans in Louis XIV's Paris.* Chicago, IL: University of Chicago Press, 2015.

Gürsel, Zeynep Devrim. "A picture of health: The search for a genre to visualize care in late Ottoman Istanbul." *Grey Room* 72 (Summer 2018): 36–67.

Gürsel, Zeynep Devrim. "Thinking with X-rays: Investigating the politics of visibility through the Ottoman Sultan Abdülhamid's photography collection." *Visual Anthropology* 29, no. 3 (2016): 229–242.

Haffner, Jeanne. *The View from Above: The Science of Social Space.* Cambridge, MA: MIT Press, 2013.

Haigney, Sophie. "Photos of locked-down cities sold us a fantasy that we were 'in it together.'" *The Guardian*, November 28, 2020. https://www.theguardian.com/commentisfree/2020/nov/28/photos-locked-down-cities-pictures-deserted-tourist-sites.

Hanssen, Jens. *Fin de Siècle Beirut: The Making of an Ottoman Provincial Capital.* Oxford, UK: Oxford University Press, 2005.

Harrison, Mark. *Contagion: How Commerce Has Spread Disease.* New Haven, CT: Yale University Press, 2012.

Harrison, Mark. "The medicalization of war—the militarization of medicine." *Social History of Medicine* 9, no. 2 (1996): 267–276.

Harrison, Mark. "Pandemic." In *The Routledge History of Disease*, edited by Mark Jackson, 129–146. London, UK: Routledge, 2017.

Harrison, Mark. *Public Health in British India: Anglo-Indian Preventive Medicine 1859–1914.* Cambridge, UK: Cambridge University Press, 1994.

Harrison, Mark. "Quarantine, pilgrimage, and colonial trade: India 1866–1900." *Indian Economic and Social History Review* 29 (1992): 117–144.

Harrison, Mark. "Towards a sanitary utopia? Professional visions and public health in India, 1880–1914." *South Asia Research* 10 (1990): 19–41.

Hattori, Ann Perez. "Re-membering the Past: Photography, leprosy and the Chamorros of Guam, 1898–1924." *Journal of Pacific History* 46, no. 3 (December 2011): 293–318.

Headrick, Daniel R. *The Tools of Empire: Technology and European Imperialism in the Nineteenth Century.* Oxford, UK: Oxford University Press, 1981.

Heinrich, Larissa N. *The Afterlife of Images: Translating the Pathological Body between China and the West.* Durham, NC: Duke University Press, 2008.

Heinrich, Larissa N. "The pathological empire: Early medical photography in China." *History of Photography* 30, no. 1 (2006): 25–38.

Henderson, John. "'Filth is the mother of corruption': Plague, the poor, and the environment in early modern Florence." In *Plague and the City*, edited by Lukas Engelmann, John Henderson, and Christos Lynteris, 69–90. London, UK: Routledge, 2018.

Hibbot, Yvonne. "'Bonaparte visiting the plague-stricken at Jaffa' by Antoine Jean Gros (1771–1835)." *British Medical Journal* 1, no. 5642 (1969): 501–502.

Hight, Eleanor M., and Gary D. Sampson, eds. *Colonialist Photography: Imag(in)ing Race and Place.* London, UK: Routledge, 2002.

Honigsbaum, Mark. "Defining pandemics: The coronavirus conundrum." *Hurst*, February 10, 2020. https://www.hurstpublishers.com/defining-pandemics-the-coronavirus-conundrum/.

Honigsbaum, Mark. "'Tipping the balance': Karl Friedrich Meyer, latent infections, and the birth of modern ideas of disease ecology." *Journal of the History of Biology* 49 (2016): 261–309.

Hu, Cheng. "Quarantine sovereignty during the pneumonic plague in Northeast China (November 1910-April 1911)." *Frontier History of China* 5, no. 2 (2010): 294–295.

Hull, Terence. "Plague in Java." In *Death and Disease in Southeast Asia: Explorations in Social, Medical and Demographic History*, edited by Norman G. Owen, 210–234. Oxford, UK: Oxford University Press, 1987.

Hutin, Jean-François. "La littérature médicale de la campagne d'Égypte." *Histoire des sciences médicales* 46, no. 1 (2012): 19–30.

Ibarra, Macarena. "Hygiene and public health in Santiago de Chile's urban agenda, 1892–1927." *Planning Perspectives* 31, no. 2 (2016): 181–203.

Imada, Adria L. "Promiscuous signification: Leprosy suspects in a photographic archive of skin." *Representations* 138, no. 1 (Spring 2017): 1–36.

Johnson, Reed, and Rogerio Jelmayer. "Brazil to allow aircraft to spray for mosquitoes to combat Zika." *Wall Street Journal*, July 1, 2016. https://www.wsj.com/articles/brazil-to-allow-aircraft-to-spray-for-mosquitoes-to-combat-zika-1467382925.

Johnson, Ryan. "Mantsemei, interpreters, and the successful eradication of plague: The 1908 plague epidemic in colonial Accra." In *Public Health in the British Empire: Intermediaries, Subordinates, and the Practice of Public Health, 1850–1960*, edited by Ryan Johnson and Amna Khalid, 135–153. London, UK: Routledge, 2011.

Jones, Andrew F. "Portable monuments: Architectural photography and the 'forms' of empire in modern China." *Positions* 18 no. 3 (2010): 599–631.

Juengel, Scott J. "Writing decomposition: Defoe and the corpse." *Journal of Narrative Technique* 25, no. 2 (Spring 1995): 139–153.

Kapferer, Bruce. "Anthropology and the dialectic of enlightenment: A discourse on the definition and ideals of a threatened discipline." *Australian Journal of Anthropology* 18, no. 1 (2007): 72–94.

Kaplan, Martha. "Panopticon in Poona: An essay on Foucault and colonialism." *Cultural Anthropology* 10, no. 1 (February 1995): 85–98.

Karlekar, Malavika. *Visual Histories: Photography in the Popular Imagination*. New Delhi, India: Oxford University Press, 2013.

Keating, Jennifer Mary. "Space, Image and Display in Russian Central Asia, 1881–1914." PhD diss. University College London, 2016.

Keck, Frédéric. "Une sentinelle sanitaire aux frontières du vivant: Les experts de la grippe aviaire à Hong Kong." *Terrain* 54 (2010): 26–41.

Kelly, Catherine. "Medicine and the Egyptian campaign: The development of the military medical officer during the Napoleonic Wars c. 1798–1801." *Canadian Bulletin of Medical History* 27, no. 2 (2010): 321–342.

Kelsey, Robin. *Archive Style: Photographs and Illustrations for U.S. Surveys, 1850–1890.* Berkeley, CA: University of California Press, 2007.

Kidambi, Prashant. "'An infection of locality': Plague, pythogenesis and the poor in Bombay, c. 1896–1905." *Urban History* 31, no. 2 (August 2004): 249–267.

King, Nicholas B. "The scale politics of emerging diseases." *Osiris*, 2nd Series, 19 (2004), 62–76.

Klein, Ira. "Plague, policy and popular unrest in British India." *Modern Asian Studies* 22, no. 4 (1988): 723–755.

Klett, Mark, and Michael Lundgren. *After the Ruins, 1906 and 2006: Rephotographing the San Francisco Earthquake and Fire.* Berkeley, CA: University of California Press, 2006.

Koch, Tom. *Disease Maps: Epidemics on the Ground.* Chicago, IL: University of Chicago Press, 2011.

Koch, Tom. "The map as intent: Variations on the theme of John Snow." *Cartographica* 39, no. 4 (Winter 2004): 1–14.

Kosoy, Michael Y. "Deepening the conception of functional information in the description of zoonotic infectious diseases." *Entropy* 15 (2013): 1929–1962.

Kowner, Rotem. "Becoming an honorary civilized nation: Remaking Japan's military image during the Russo-Japanese War, 1904–1905." *The Historian* 64, no. 1 (2001): 19–38.

Krauss, Rosalind E. *The Optical Unconscious.* Cambridge, MA: MIT Press, 1993.

Krell, David Farrell. *Contagion: Sexuality, Disease, and Death in German Idealism and Romanticism.* Bloomington, IN: Indiana University Press, 1998.

Krstić, Igor. *Slums on Screen: World Cinema and the Planet of Slums.* Edinburgh, UK: Edinburgh University Press, 2016.

Kuhnke, LaVerne. *Lives at Risk: Public Health in Nineteenth-Century Egypt.* Berkeley, CA: University of California Press, 1990.

Kusiak, Pauline. "Instrumentalizing rationality, cross-cultural mediators, and civil epistemologies of late colonialism." *Social Studies of Science* 40, no. 6 (2010): 871–902.

Laget, Pierre-Louis. "Les lazarets et l'émergence de nouvelles maladies pestilentielles au XIXe et au début du XXe siècle." *In situ: Revue des patrimoines* 2 (2002). https://dx.doi.org/10.4000/insitu.1225.

Lakoff, Andrew. *Unprepared: Global Health in a Time of Emergency.* Berkeley, CA: University of California Press, 2017.

Landau, Paul S. "Empires of the visual: Photography and colonial administration in Africa." In *Images and Empires: Visuality in Colonial and Postcolonial Africa*, edited

by Paul S. Landau and Deborah D. Kaspin, 141–171. Berkeley, CA: University of California Press, 2002.

La Rue, George Michael. "Treating black deaths in Egypt: Clot-Bey, African slaves, and the plague epidemic of 1834–1835." In *Histories of Medicine and Healing in the Indian Ocean World*, Volume 2: *The Modern Period*, edited by Anna Winterbottom and Facil Tesfaye, 27–59. London, UK: Palgrave Macmillan, 2016.

Latour, Bruno. *The Pasteurization of France*. Translated by Alan Sheridan and John Law. Cambridge, MA: Harvard University Press, 1988.

Lau, J. T., J. H. Kim, H. Y. Tsui, and S. Griffiths. "Perceptions related to bird-to-human avian influenza, influenza vaccination, and use of face mask." *Infection* 36, no. 5 (2008): 434–443.

Lazarus, S. "Germ warfare: Hong Kong's never-ending fight against viruses." *Post Magazine*, December 1, 2013, 20–24.

Lefrère, Jean-Jacques, and Bruno Danic. "Pictorial representation of transfusion over the years." *Transfusion* 49, no. 5 (2009): 1007–1017.

Lei, Sean Hsiang-lin. "Sovereignty and the microscope: Constituting notifiable infectious disease and containing the Manchurian plague (1910–11)." In *Health and Hygiene in Chinese East Asia: Policies and Publics in the Long Twentieth Century*, edited by Angela Ki Che Leung and Charlotte Furth, 73–106. Durham, NC: Duke University Press, 2011.

Leviton, Alan E., Michele L. Aldrich, and Karren Elsbernd. "The California Academy of Sciences, Grove Karl Gilbert, and photographs of the 1906 earthquake, mostly from the archives of the Academy." *Proceedings of the California Academy of Sciences* 57, no. 1 (2006): 1–34.

Lewthwaite, Stephanie. *Race, Place, and Reform in Mexican Los Angeles: A Transnational Perspective, 1890–1940*. Tucson, AZ: University of Arizona Press, 2009.

Lindsay, S. W., and M. E. Gibson. "Bednets revisited—old idea, new angle." *Trends in Parasitology* 4, no. 10 (1988): 270–272.

Low, Michael Christopher. "Empire and the Hajj: Pilgrims, plagues, and pan-Islam under British surveillance, 1865–1908." *International Journal of Middle East Studies* 40, no. 2 (May 2008): 269–290.

Low, Michael Christopher. "Ottoman infrastructures of the Saudi hydro-state: The technopolitics of pilgrimage and potable water in the Hijaz." *Comparative Studies in Society and History* 57, no. 4 (2015): 942–974.

Low, Morris. "The Japanese eye: Science, exploration and empire." In *Photography's Other Histories*, edited by Christopher Pinney, Nicolas Peterson, and Nicholas Thomas, 100–188. Durham, NC: Duke University Press, 2003.

Luckingham, Bradford. "To mask or not to mask: A note on the 1918 Spanish influenza epidemic in Tucson." *Journal of Arizona History* 25, no. 2 (1984): 191–204.

Lynteris, Christos. "Emptiness and COVID-19 cartography." In "Theorizing the Contemporary: Emptiness." *Cultural Anthropology: Editor's Forum*, December 15, 2020. https://culanth.org/fieldsights/emptiness-and-covid-19-cartography.

Lynteris, Christos. *Ethnographic Plague: Configuring Disease on the Chinese-Russian Frontier*. London, UK: Palgrave Macmillan 2016.

Lynteris, Christos, ed. *Framing Animals as Epidemic Villains: Histories of Non-Human Disease Vectors*. London, UK: Palgrave Macmillan, 2019.

Lynteris, Christos. *Human Extinction and the Pandemic Imaginary*. London, UK: Routledge, 2019.

Lynteris, Christos. "The imperative origins of COVID-19." *L'Homme: Revue française d'anthropologie* 234–235 (2020): 21–32.

Lynteris, Christos. "Introduction: Infectious animals and epidemic blame." In *Framing Animals as Epidemic Villains: Histories of Non-Human Disease Vectors*, edited by Christos Lynteris, 1–25. London, UK: Palgrave Macmillan, 2019.

Lynteris, Christos. "*Pestis minor*: The history of a contested plague pathology." *Bulletin of the History of Medicine* 93, no. 1 (Spring 2019): 55–58.

Lynteris, Christos. "Photography, zoonosis and epistemic suspension after the end of epidemics." In *The Anthropology of Epidemics*, edited by Ann H. Kelly, Frédéric Keck, and Christos Lynteris, 84–101. London, UK: Routledge, 2019.

Lynteris, Christos. "Plague masks: The visual emergence of anti-epidemic personal protection equipment." *Medical Anthropology* 36, no. 6 (2018): 442–457.

Lynteris, Christos. "The prophetic faculty of epidemic photography: Chinese wet markets and the imagination of the next pandemic." *Visual Anthropology* 29, no. 2 (February 2016): 118–132.

Lynteris, Christos. "Sinophobia, epidemics, and interspecies catastrophe." In "Hot Spots, Responding to an Unfolding Pandemic: Asian Medicines and COVID-19." *Cultural Anthropology: Editor's Forum*, June 23, 2020. https://culanth.org/fieldsights /sinophobia-epidemics-and-interspecies-catastrophe.

Lynteris, Christos. "A 'suitable soil': Plague's urban breeding grounds at the dawn of the third pandemic." *Medical History* 61, no. 3 (2017): 343–357.

Lynteris, Christos. "Tarbagan's winter lair: Framing drivers of plague persistence in Inner Asia." In *Framing Animals as Epidemic Villains: Histories of Non-Human Disease Vectors*, edited by Christos Lynteris, 65–90. London, UK: Palgrave Macmillan, 2019.

Lynteris, Christos. "Vagabond microbes, leaky laboratories and epidemic mapping: Alexandre Yersin and the 1898 plague epidemic in Nha Trang." *Social History of Medicine* 34, no. 1 (2021): 190–213.

Lynteris, Christos. "Why do people really wear face masks during an epidemic?" *New York Times*, February 13, 2020. https://www.nytimes.com/2020/02/13/opinion /coronavirus-face-mask-effective.html.

Lynteris, Christos. "Yellow Peril epidemics: The political ontology of degeneration and emergence." In *Yellow Perils: China Narratives in the Contemporary World*, edited by Frank Billé and Sören Urbansky, 35–59. Honolulu, HI: University of Hawai'i Press, 2018.

Lynteris, Christos. "Zoonotic diagrams: Mastering and unsettling human-animal relations." *Journal of the Royal Anthropological Institute* 23, no. 3 (2017): 463–485.

Lynteris, Christos, and Nicholas H. Evans, eds. *Histories of Post-Mortem Contagion: Infectious Corpses and Contested Burials*. London, UK: Palgrave Macmillan, 2018.

Lynteris, Christos, and Nicholas H. Evans. "Introduction: The challenge of the epidemic corpse." In *Histories of Post-Mortem Contagion: Infectious Corpses and Contested Burials*, edited by Christos Lynteris and Nicholas H. Evans, 1–25. London, UK: Palgrave Macmillan, 2018.

Lynteris, Christos, and Ruth J. Prince. "Introduction: Medical photography." *Visual Anthropology* 29, no. 2 (2016): 101–117.

Lynteris, Christos, and Rupert Stasch. "Photography and the unseen." *Visual Anthropology Review* 35, no. 1 (2019): 5–9.

Lynteris, Christos, Tomohisa Sumida, and Meng Zhang. "The history of plague masks in East Asia: A conversation between Christos Lynteris, Tomohisa Sumida, and Meng Zhang." *The Mask—Arrayed*, April 26, 2021. https://themaskarrayed .net/2021/04/26/the-history-of-plague-masks-in-east-asia-a-conversation-between -christos-lynteris-tomohisa-sumida-and-meng-zhang/.

Maglen, Krista. *The English System: Quarantine, Immigration and the Making of a Port Sanitary Zone*. Manchester, UK: Manchester University Press, 2014.

Mah, Alice. "Demolition for development: A critical analysis of official urban imaginaries in past and present UK cities." *Journal of Historical Sociology* 25, no. 1 (March 2012): 151–176.

Manderson, Lenore. *Sickness and the State: Health and Illness in Colonial Malaya, 1870–1940*. Cambridge, UK: Cambridge University Press, 1996.

Marin, Louis. *Utopics: Spatial Play*. Atlantic Highlands, NJ: Humanities Press, 1984.

Markel, Howard. *Quarantine!: East European Jewish Immigrants and the New York City Epidemics of 1892*. Baltimore, MD: Johns Hopkins University Press, 1999.

Maron, Dina Fine. "China's exotic farms may be a missing link behind the pandemic's leap to people." *National Geographic*, March 26, 2021. https://www .nationalgeographic.co.uk/science-and-technology/2021/03/chinas-exotic-farms -may-be-a-missing-link-behind-the-pandemics-leap.

Martínez, Francisco Javier. "Mending 'Moors' in Mogador: *Hajj*, cholera and Spanish-Moroccan regeneration, 1890–99." In *Mediterranean Quarantines, 1750–1914: Space, Identity and Power*, edited by John Chircop and Francisco Javier Martínez, 66–106. Manchester, UK: Manchester University Press, 2018.

Meerwijk, Maurits Bastiaan. "Bamboo dwellers: Plague, photography, and the house in colonial Java." In *Plague Image and Imagination from Medieval to Modern Times*, edited by Christos Lynteris, 205–234. London, UK: Palgrave Macmillan, 2021.

Meli, Domenico Bertoloni. *Visualizing Disease: The Art and History of Pathological Illustrations*. Chicago, IL: University of Chicago Press, 2017.

Mifflin, Jeffrey. "Visual archives in perspective: Enlarging on historical medical photographs." *American Archivist* 70 (Spring/Summer 2007): 32–69.

Mikhail, Alan. "The nature of plague in late eighteenth-century Egypt." *Bulletin of the History of Medicine* 82, no. 2 (Summer 2008): 249–275.

Mikhel, Dmitry. "Chuma i epidemiologicheskaya revolyutsiya v Rossii, 1897–1914." *Vestnik Evrazii* 3 (2008): 142–164.

Milleliri, J.-M., and E. Deroo. "Joseph Chabaneix (1870–1913): Un médecin au coeur de l'histoire française outre-mer." *Medecine tropicale: Revue du Corps de sante colonial* 65, no. 3 (2005): 285–289.

Mirchanov, L. I., et al. *Fort "Imperator Aleksandr I."* Ostrov, Russia, 2008.

Mirzoeff, Nicholas. "The multiple viewpoint: Diasporic visual cultures." In *Diaspora and Visual Culture: Representing Africans and Jews*, edited by Nicholas Mirzoeff, 1–18. London, UK: Routledge 2000.

Mishra, Saurab. "Incarceration and resistance in a Red Sea lazaretto, 1880–1930." In *Quarantine: Local and Global Histories*, edited by Alison Bashford, 54–65. London, UK: Palgrave Macmillan, 2016.

Mishra, Saurab. *Pilgrimage, Politics, and Pestilence: The Haj from the Indian Subcontinent*. Oxford, UK: Oxford University Press, 2011.

Mohr, James C. *Plague and Fire: Battling Black Death and the 1900 Burning of Honolulu's Chinatown*. Oxford, UK: Oxford University Press, 2004.

Molefi, R. K. K. "Of rats, fleas, and peoples: Towards a history of bubonic plague in Southern Africa, 1890–1950." *Pula: Botswana Journal of African Studies* 15, no. 2 (2001): 259–267.

Mondragón, Carlos. "Concealment, revelation and cosmological dualism: Visibility, materiality and the spiritscape of the Torres Islands, Vanuatu." In "Montrer/Occulter," edited by Jacques Galinier. Special issue, *Cahiers d'anthropologie sociale* 11 (2015): 38–50.

Mooney, Graham. *Intrusive Interventions: Public Health, Domestic Space, and Infectious Disease Surveillance in England, 1840–1914*. Rochester, NY: University of Rochester Press, 2015.

Mormando, Franco, and Thomas Worcester, eds. *Piety and Plague from Byzantium to the Baroque*. Kirksville, MO: Truman State University Press, 2007.

Morrell, Rebecca. "'Gerbils replace rats' as main cause of Black Death." *BBC News*, February 24, 2015. https://www.bbc.co.uk/news/science-environment-31588671.

Moscow Economic and Law Institute. "Geroi dolga. Na Forte 'Imperator Aleksandr I'. (ocherk I. M. Eyzena, 1907 god)." *Problemui mectonogo samoypravleniya*, n.d. http://www.samoupravlenie.infobox.ru/38-11.php.

Moulin, Anne-Marie. "Tropical without tropics: The turning point of Pastorian medicine in North Africa." In *Warm Climates and Western Medicine: The Emergence of Tropical Medicine*, edited by David Arnold, 160–180. Amsterdam, Netherlands: Rodopi, 1996.

Mukharji, Projit Bihari. "Cat and mouse: Animal technologies, trans-imperial networks and public health from below, British India, c. 1907–1918." *Social History of Medicine* 31, no. 3 (2017): 510–532.

Murphy, L. C., and A. D. Alexander. "Significance of the leptospiroses in military medicine." *Military Medicine* 121, no. 1 (1957): 1–10.

Nadal, Deborah. *Rabies in the Streets: Interspecies Camaraderie in Urban India*. University Park, PA: Pennsylvania State University Press, 2020.

Napier, A. David. *Masks, Transformation, and Paradox*. Berkeley, CA: University of California Press, 1986.

Nathan, Carl F. *Plague Prevention and Politics in Manchuria 1910–1931*. Cambridge, MA: Harvard East Asian Monographs, 1967.

Nicolas, Michele. "Pierre Apéry et ses publications scientifiques." *Revue d'histoire de la pharmacie* 94, no. 350 (2006): 237–247.

O'Connor, Erin. "Camera medica: Towards a morbid history of photography." *History of Photography* 23, no. 3 (1999): 232–244.

O'Connor, Erin. "Pictures of health: Medical photography and the emergence of anorexia nervosa." *Journal of the History of Sexuality* 5 (1995): 535–572.

Oosten, Jarich. "Representing the spirits: The masks of the Alaskan Inuit." In *Anthropology, Art and Aesthetics*, edited by Jeremy Coote and Anthony Shelton, 113–134. Oxford, UK: Clarendon Press, 1992.

Opinel, Annick. "Corps sommeilleux, déformés, interrompus: Les tableaux cliniques des maladies parasitaires (début XXe siècle)." *Corps* 2, no. 5 (2008): 49–56.

Opinel, Annick. "La photographie et la clinique des maladies parasitaires dans le premier tiers du XXe siècle." In "Actes du Congrès d'histoire des sciences et techniques organisé à Poitiers du 20 au 22 mai 2004 par la Société française d'histoire des sciences et techniques," edited by Anne Bonnefoy and Bernard Joly, *Cahiers d'histoire et de philosophie des sciences,* hors-série, 2006: 166–167.

Ostherr, Kirsten. *Cinematic Prophylaxis: Globalization and Contagion in the Discourse of World Health*. Durham, NC: Duke University Press, 2005.

Ostherr, Kirsten. "Empathy and objectivity. Health education through corporate publicity films." In *Imagining Illness: Public Health and Visual Culture*, edited by David Harley Serlin, 62–82. Minneapolis, MN: University of Minnesota Press, 2010.

Ostherr, Kirsten. *Medical Visions: Producing the Patient through Film, Television, and Imaging Technologies*. Oxford, UK: Oxford University Press, 2013.

Ott, Katherine. "Contagion, public health and visual culture of nineteenth-century skin." In *Imagining Illness: Public Health and Visual Culture*, edited by David Harley Serlin, 85–107. Minneapolis, MN: University of Minnesota Press, 2010.

Panzac, Daniel. "Médecine révolutionnaire et révolution de la médecine dans l'Egypte de Muhammad Ali: Le Dr Clot-Bey." *Revue des monde musulman et de la Méditerranée* 52–53 (1989): 95–110.

Panzac, Daniel. *Quarantaines et lazarets: L'Europe et la peste d' Orient (xviie–xxe siècles)*. Aix-en-Provence, France: Édisud, 1986.

Peckham, Robert. *Epidemics in Modern Asia*. Cambridge, UK: Cambridge University Press, 2016.

Peckham, Robert. "Hong Kong junk: Plague and the economy of Chinese things." *Bulletin of the History of Medicine* 90, no. 1 (2016): 32–60.

Peckham, Robert. "Matshed laboratory: Colonies, cultures, and bacteriology." In *Imperial Contagions: Medicine, Hygiene, and Cultures of Planning in Asia*, edited by Robert Peckham and David M. Pomfret, 123–147. Hong Kong: Hong Kong University Press, 2013.

Peckham, Robert. "Panic encabled: Epidemics and the telegraphic world." In *Empires of Panic: Epidemics and Colonial Anxieties*, 131–154. Hong Kong: Hong Kong University Press, 2015.

Peckham, Robert. "Plague views: Epidemics, photography and the ruined city." In *Plague and the City*, edited by Lukas Engelmann, John Henderson, and Christos Lynteris, 91–115. London, UK: Routledge, 2018.

Peckham, Robert. "Spaces of quarantine in colonial Hong Kong." In *Quarantine: Local and Global Histories*, edited by Alison Bashford, 66–84. London, UK: Palgrave Macmillan, 2016.

Pemberton, Neil. "The rat-catcher's prank: Interspecies cunningness and scavenging in Henry Mayhew's London." *Journal of Victorian Culture* 19 (2014): 520–535.

Peterson, Nicolas. "Early 20th century photography of Australian Aboriginal families: Illustration or evidence?" *Visual Anthropology Review* 21, no. 1–2 (2006): 11–26.

Pichel, Beatriz. "From facial expressions to bodily gesture: Passions, photography and movement in French 19th-century sciences." *History of the Human Sciences* 29 no. 1 (1016): 27–48.

Pietrzak-Franger, Monika. *Syphilis in Victorian Literature and Culture: Medicine, Knowledge and the Spectacle of Victorian Invisibility*. London, UK: Palgrave Macmillan, 2017.

Pinney, Christopher. "Civil contract of photography in India." *Comparative Studies of South Asia, Africa and the Middle East* 35, no. 1 (2015): 21–34.

Pinney, Christopher. "Introduction: 'How the other half . . .'." In *Photography's Other Histories*, edited by Christopher Pinney and Nicolas Peterson, 1–14. Durham, NC: Duke University Press, 2003.

Pinney, Christopher. "The prosthetic eye: Photography as cure and poison." In "The Objects of Evidence: Anthropological Approaches to the Production of Knowledge." Special issue, *Journal of the Royal Anthropological Institute* 14, no. 1 (2008): 33–46.

Platt, Jerome J., Maurice E. Jones, and Arleen Kay Platt. *The Whitewash Brigade: The Hong Kong Plague, 1894*. London, UK: Dix Noonan Webb, 1998.

Poleykett, Branwyn. "Building out the rat: Animal intimacies and prophylactic settlement in 1920s South Africa." *American Anthropological Association: Engagement*, February 7, 2017. https://aesengagement.wordpress.com/2017/02/07/building-out-the-rat-animal-intimacies-and-prophylactic-ssettlement-in-1920s-south-africa/.

Poleykett, Branwyn. "Ethnohistory and the dead: Cultures of colonial epidemiology." *Medical Anthropology* 37, no. 6 (2018): 472–485.

Poleykett, Branwyn. "Pasteurian tropical medicine and colonial scientific vision." *Subjectivity* 10 (2017): 190–203.

Poleykett, Branwyn. "Public culture and the spectacle of epidemic disease in Rabat and Casablanca." In *Plague and the City*, edited by Lukas Engelmann, John Henderson, and Christos Lynteris, 159–171. London, UK: Routledge, 2018.

Poleykett, Branwyn, Nicholas H. A. Evans, and Lukas Engelmann. "Fragments of plague." In "The Total Archive," edited by Boris Jardine and Christopher M. Kelty. Special issue, *Limn* 6 (2016). https://limn.it/articles/fragments-of-plague/

Pollock, Donald. "Masks and the semiotics of identity." *Journal of the Royal Anthropological Institute*, n.s., 1, no. 3 (1995): 581–597.

Poole, Deborah. *Vision, Race, and Modernity: A Visual Economy of the Andean Image World*. Princeton, NJ: Princeton University Press, 1997.

Prakash, Anita. "Plague riot in Kanpur—Perspectives on colonial public health." *Proceedings of the Indian History Congress* 69 (2008): 839–846.

Pratt, Mary Louise. *Imperial Eyes: Travel Writing and Transculturation*. London, UK: Routledge, 1992.

Prodger, Phillip. *Time Stands Still: Muybridge and the Instantaneous Photography Movement with an Essay by Tom Gunning*. Oxford, UK: Oxford University Press, 2003.

Promitzer, Christian. "Prevention and stigma: The sanitary control of Muslim pilgrims from the Balkans, 1830–1914." In *Mediterranean Quarantines, 1750–1914: Space, Identity and Power*, edited by John Chircop and Francisco Javier Martinez, 145–169. Manchester, UK: Manchester University Press, 2018.

Ramesh, Aditya, and Vidhya Raveendranathan. "Infrastructure and public works in colonial India. Towards a conceptual history." *History Compass* 13 (2020): e12614.

Rawcliffe, Carole. "'Great stenches, horrible sights, and deadly abominations': Butchery and the battle against plague in late medieval English towns." In *Plague and the City*, edited by Lukas Engelmann, John Henderson, and Christos Lynteris, 18–39. London, UK: Routledge, 2018.

Redfield, Peter. "Fluid technologies: The Bush Pump, the LifeStraw and microworlds of humanitarian design." *Social Studies of Science* 46, no. 2 (2016): 159–183.

Rheinberger, Hans-Jörg. "Difference machines: Time in experimental systems." *Configurations* 23, no. 2 (Spring 2015): 165–176.

Rheinberger, Hans-Jörg. *Toward a History of Epistemic Things: Synthesizing Proteins in the Test Tube.* Redwood City, CA: Stanford University Press, 1997.

Risse, Gunther B. *Plague, Fear, and Politics in San Francisco's Chinatown.* Baltimore, MD: Johns Hopkins University Press, 2012.

Rogaski, Ruth. *Hygienic Modernity: Meanings of Health and Disease in Treaty-Port China.* Berkeley, CA: University of California Press, 2004.

Rosenberg, Charles E. "Disease in history: Frames and framers." In Supplement 1, "Framing Disease: The Creation and Negotiation of Explanatory Schemes." *Milbank Quarterly* 67 (1989): 1–15.

Rosenberg, Charles E. "What is an epidemic? AIDS in historical perspective." In "Living with AIDS." Special issue, *Daedalus* 118, no. 2 (Spring, 1989): 1–17.

Roy, Rohan Deb. *Malarial Subjects: Empire, Medicine and Nonhumans in British India, 1820–1909.* Cambridge, UK: Cambridge University Press, 2017.

Royer, Katherine. "The blind men and the elephant: Imperial medicine, medieval historians and the role of rates in the historiography of plague." In *Medicine and Colonialism: Historical Perspectives in India and South Africa*, edited by Poonam Bala, 99–110. London, UK: Routledge, 2015.

Russell, Thomas G., and Terence M. Russell. "Medicine in Egypt at the time of Napoleon Bonaparte." *British Medical Journal* 327, no. 7429 (2003): 1461–1464.

Russian Academy of Sciences/North-West Branch of RAMS. *Institute of Experimental Medicine.* Saint Petersburg, Russia: Khromis, 2005.

Ryan, James R. *Picturing Empire: Photography and the Visualization of the British Empire.* London, UK: Reaktion Books, 1997.

Samimian Darash, Limor. "Governing future potential biothreats: Toward an anthropology of uncertainty." *Current Anthropology* 54, no. 1 (2013): 1–22.

Santer, Melvin. *Confronting Contagion: Our Evolving Understanding of Disease.* Oxford, UK: Oxford University Press, 2015.

Sariyildiz, G., and O. D. Macar. "Cholera, pilgrimage, and international politics of sanitation: The quarantine station on the island of Kamaran." In *Plague and Contagion in the Islamic Mediterranean*, edited by Nukhet Varlık, 243–274. Croydon, UK: ARC Humanities Press, 2017.

Sarkar, Abhijit. "Reflexive gaze and constructed meanings: Photographs of plague hospitals in colonial Bombay." In *Plague Image and Imagination from Medieval to Modern Times*, edited by Christos Lynteris, 141–189. London, UK: Palgrave Macmillan 2021.

Sarkar, Aditya. "The tie that snapped: Bubonic plague and mill labour in Bombay, 1896–1898." *International Review of Social History* 59, no. 2 (August 2014): 181–214.

Sarkar, Natasha. "Fleas, Faith and Politics: Anatomy of an Indian Epidemic, 1890–1925." PhD diss., National University of Singapore, 2011.

Sayer, Karen. "The 'modern' management of rats: British agricultural science in farm and field during the twentieth century." *British Journal for the History of Science* 2 (2017): 235–263.

Sayer, Karen. "Vermin landscapes: Suffolk, England, shaped by plague, rat and flea (1906–1920)." In *Framing Animals as Epidemic Villains: Histories of Non-human Disease Vectors*, edited by Christos Lynteris, 27–64. London, UK: Palgrave Macmillan, 2019.

Schlesinger, Jonathan. *A World Trimmed with Fur: Wild Things, Pristine Places, and the Natural Fringes of Qing Rule*. Redwood City, CA: Stanford University Press, 2017.

Schlich, Thomas. "Linking cause and disease in the laboratory: Robert Koch's method of superimposing visual and 'functional' representations of bacteria." *History and Philosophy of the Life Sciences* 22, no. 1 (2000): 43–58.

Schmid, Boris V., Ulf Büntgen, W. Ryan Easterday, Christian Ginzler, Lars Walløe, Barbara Bramanti, and Nils Chr. Stenseth. "Climate-driven introduction of the Black Death and successive plague reintroductions into Europe." *Proceedings of the National Academy of Sciences of the United States of America* 112, no. 10 (2015): 3020–3025.

Schweitzer, Dahlia. *Going Viral: Zombies, Viruses, and the End of the World*. New Brunswick, NJ: Rutgers University Press, 2018.

Seivert, Kévin. "Les débuts du territoire français de Kouang-Tchéou-Wan." *Annales de Bretagne et des pays de l'Ouest* 124, no. 1 (2017): 113–134.

Serlin, David Harley "Introduction: Towards a visual culture of public health." In *Imagining Illness: Public Health and Visual Culture*, edited by David Harley Serlin, xi–xxxvii. Minneapolis, MN: University of Minnesota Press, 2010.

Shah, Nayan. *Contagious Divides: Epidemics and Race in San Francisco's Chinatown*. Berkeley, CA: University of California Press, 2001.

Shapira, Yael. *Inventing the Gothic Corpse: The Thrill of Human Remains in the Eighteenth-Century Novel*. London, UK: Palgrave Macmillan, 2018.

Shapiro, Ann-Louise. *Housing the Poor of Paris, 1850–1902*. Madison, WI: University of Wisconsin Press, 1985.

Sharma, Kamayani. "Why the world must witness pictures of India's mass COVID-19 cremations." *Vox*, May 21, 2021. https://www.vox.com/first-person/22434028 /india-covid-cremations.

Shaw, Wendy M. K. "Ottoman photography of the late nineteenth century: An 'innocent' modernism?" *History of Photography* 33, no. 1 (2009): 80–93.

Sheehan, Tanya. *Doctored: The Medicine of Photography in Nineteenth-Century America*. University Park, PA: Pennsylvania State University Press, 2011.

Signoli, Michel. "Reflections on crisis burials related to past plague epidemics." *Clinical Microbiology and Infection* 18, no. 3 (2012): 218–223.

Silva, Matheus Alves Duarte da. "From Bombay to Rio de Janeiro: The circulation of knowledge and the establishment of the Manguinhos Laboratory, 1894–1902." *História, Ciências, Saúde—Manguinhos, Rio de Janeiro* 25, no. 3 (July-September 2018). https://www.scielo.br/pdf/hcsm/v25n3/en_0104-5970-hcsm-25-03-0639.pdf.

Silva, Matheus Alves Duarte da. "Quand la peste connectait le monde: Production et circulation de savoirs microbiologiques entre Brésil, Inde et France (1894–1922)." PhD diss., École des Hautes Études en Sciences Sociales, 2020.

Sin, Maria S. Y. "Masking fears: SARS and the politics of public health in China." *Critical Public Health* 26, no. 1 (2016): 88–98.

Sivasundaram, Sujit. "Towards a critical history of connection: The port of Colombo, the geographical 'circuit,' and the visual politics of new imperialism, ca. 1880–1914." *Comparative Studies in Society and History* 59, no. 2 (2017): 346–384.

Smith, Shawn Michelle. *At the Edge of Sight: Photography and the Unseen*. Durham, NC: Duke University Press, 2013.

Smoller, Laura A. "Of earthquakes, hail, frogs, and geography: Plague and the investigation of the apocalypse in the later Middle Ages." In *Last Things: Death and the Apocalypse in the Middle Ages*, edited by Caroline Walker Bynum and Paul Freedman, 156–186. Philadelphia, PA: University of Pennsylvania Press, 2000.

Sobol, Valeria. *Haunted Empire: Gothic and the Russian Imperial Uncanny*. Ithaca, NY: Cornell University Press, 2020.

Sodikoff, Genese Marie. "The multispecies infrastructure of zoonosis." In *The Anthropology of Epidemics*, edited by Ann H. Kelly, Frédéric Keck, and Christos Lynteris, 102–120. London, UK: Routledge, 2019.

Sodikoff, Genese Marie, and Z. R. Dieudonné Rasolonomenjanahary. "Ethnographic images of the plague: Outbreak and the landscape of memory in Madagascar." In *Plague Image and Imagination from Medieval to Modern Times*, edited by Christos Lynteris, 267–288. London, UK: Palgrave, 2021.

Sontag, Susan. *On Photography*. 1977. Reprint, New York, NY: Picador, 2001.

Soppelsa, Peter. "Losing France's imperial war on rats." *Journal of the Western Society for French History* 47 (2021): 67–87.

Spooner, John L. "History of surgical face masks." *AORN Journal* 5 (1967): 76–80.

Stallybrass, Peter, and Allon White. *The Politics and Poetics of Transgression*. London, UK: Methuen, 1986.

Steere-Williams, Jacob. "'Coolie' control: State surveillance and the labour of disinfection across the late Victorian British Empire." In *Making Surveillance States: Transnational Histories*, edited by Robert Heynen and Emily van der Meulen, 35–57. Toronto, Ontario: University of Toronto Press, 2019.

Stein, Eric A. "Colonial theatres of proof: Representation and laughter in 1930s Rockefeller Foundation hygiene cinema in Java." In "Health, Medicine and the Media." Special issue, *Health and History* 8, no. 2 (2006): 14–44.

Stepan, Nancy Leys. *Picturing Tropical Nature*. London, UK: Reaktion Books, 2001.

Stevens Crawshaw, Jane. "The places and spaces of early modern quarantine." In *Quarantine: Local and Global Histories*, edited by Alison Bashford, 15–34. London, UK: Palgrave Macmillan, 2017.

Stevens Crawshaw, Jane. "The Renaissance invention of quarantine." In *The Fifteenth Century XII: Society in an Age of Plague*, edited by Linda Clark and Carole Rawcliffe, 161–174. Cambridge, UK: Cambridge University Press, 2013.

Stoler, Ann Laura. *Duress: Imperial Durabilities in Our Times*. Durham, NC: Duke University Press, 2016.

Sud, Shivani. "Bombay plague visitation, 1896–97." *Asian and African Studies Blog* (British Library), July 22, 2020. https://blogs.bl.uk/asian-and-african/index.html.

Sud, Shivani. "Water, air, light: The materialities of plague photography in colonial Bombay, 1896–97." *Getty Research Journal* 12 (2020): 219–230.

Summers, William C. *The Great Manchurian Plague of 1910–1911: The Geopolitics of an Epidemic Disease*. New Haven, CT: Yale University Press, 2012.

Sutphen, Mary. "Not what, but where: Bubonic plague and the reception of germ theories in Hong Kong and Calcutta, 1894–1897." *Journal of History of Medicine and Allied Sciences* 52, no. 1 (January 1997): 81–113.

Swanson, Maynard W. "The sanitation syndrome: Bubonic plague and urban native policy in the Cape Colony, 1900–1909." *Journal of African History* 18, no. 3 (1977): 387–410.

Tagg, John. *The Burden of Representation: Essays on Photographies and Histories*. London, UK: Macmillan, 1988.

Talton, Benjamin. "'Kill rats and stop plague': Race, space and public health in postconquest Kumasi." *Ghana Studies* 22 (2019): 95–113.

Taussig, Michael. "History as commodity in some recent American (anthropological) literature." *Critique of Anthropology* 9, no. 1 (1989): 7–23.

Taussig, Michael. *What Colour Is the Sacred?* Chicago, IL: University of Chicago Press, 2009.

Tomes, Nancy. "'Destroyer and Teacher': Managing the masses during the 1918–1919 influenza pandemic." Supplement, *Public Health Reports* 125, no. S3 (2010): 48–62.

Tonkin, Elizabeth. "Masks and powers." *Man*, n.s., 14, no. 2 (1979): 237–248.

Tucker, Jennifer. "The historian, the picture, and the archive." *Isis* 97, no. 1 (March 2006): 111–120.

Tucker, Jennifer. *Nature Exposed: Photography as Eyewitness in Victorian Science.* Baltimore, MD: Johns Hopkins University Press, 2013.

Tucker, Jennifer. "Photography and the making of modern science." In *The Handbook of Photography Studies*, edited by Gil Pasternak, 235–254. London, UK: Routledge, 2020.

Trumbull IV, George R. *An Empire of Facts: Colonial Power, Cultural Knowledge, and Islam in Algeria, 1870–1914.* Cambridge, UK: Cambridge University Press, 2009.

Twomey, Christina. "Framing atrocity: Photography and humanitarianism." *History of Photography* 36, no. 3 (2012): 255–264.

Vann, Michael G. "Of rats, rice, and race: The great Hanoi rat massacre, an episode in French colonial history." *French Colonial History* 4 (2003): 191–203.

Varlık, Nükhet. *Plague and Empire in the Early Modern Mediterranean World: The Ottoman Experience, 1347–1600.* Cambridge, UK: Cambridge University Press, 2015.

Varlık, Nükhet. "Why is Black Death *black*? European gothic imaginaries of 'oriental' plague." In *Plague Image and Imagination from Medieval to Modern Times*, edited by Christos Lynteris, 11–35. London, UK: Palgrave Macmillan, 2021.

Vaughan, Megan. *Curing Their Ills: Colonial Power and African Illness.* Cambridge, UK: Polity Press, 1991.

Velmet, Aro. *Pasteur's Empire: Bacteriology and Politics in France, Its Colonies and the World.* Oxford, UK: Oxford University Press, 2020.

Viseltear, A. J. "The pneumonic plague epidemic of 1924 in Los Angeles." *Yale Journal of Biological Medicine* 47, no. 1 (1974): 40–54.

Vokes, Richard. "Reflections on a complex (and cosmopolitan) archive: Postcards and photography in early colonial Uganda, c.1904–1928." *History and Anthropology* 21, no. 4 (2010): 375–409.

Wald, Priscilla. *Contagious: Cultures, Carriers, and the Outbreak Narrative.* Durham, NC: Duke University Press, 2008.

Walløe, Lars. "Medieval and modern bubonic plague: Some clinical continuities." Supplement, *Medical History* 27 (2008): 59–73.

Wang, Jiao, Lijun Pan, Song Tang, John S. Ji, and Xiaoming Shi. "Mask use during COVID-19: A risk adjusted strategy." *Environmental Pollution* 266 (2020): 115099.

Warner, Marin. "Intimate communiqués: Melchior Lorck's flying tortoise." In *Seeing from Above: The Aerial View in Visual Culture*, edited by Mark Dorrian and Frédéric Pousin, 11–45. London, UK: I. B. Tauris, 2013.

Whyte, Rebecca. "Disinfection in the laboratory: Theory and practice in disinfection policy in late C19th and Early C20th England." *Endeavour* 39, no. 1 (March 2015): 35–43.

Williams, Megan. "Five photographers interpret anxiety in Wellcome Covid-19 project." *Creative Review*, October 29, 2020. https://www.creativereview.co.uk/wellcome-anxiety-covid-project.

Woodward, Michelle L. "Between orientalist clichés and images of modernization." *History of Photography* 27, no. 4 (2003): 363–374.

Worboys, Michael. *Spreading Germs: Disease Theories and Medical Practice in Britain, 1865–1900*. Cambridge, UK: Cambridge University Press, 2000.

Worell, Dorothy. *The Women's Municipal League of Boston: A History of Thirty Five Years of Civic Endeavor*. Boston, MA: Women's Municipal League of Committees, 1943.

Yehya, Houssam. "La protection sanitaire et sociale au Liban (1860–1963)." PhD diss., Université Nice Sophia Antipolis, 2015.

Yeoh, Brenda S. A. *Contesting Space in Colonial Singapore: Power Relations and the Urban Built Environment*. Singapore: Singapore University Press, 2003.

Yıldırım, Nuran. *A History of Healthcare in Istanbul: Health Organizations—Epidemics, Infections and Disease Control Preventive Health Institutions—Hospitals—Medical Education*. Istanbul, Turkey: Ajansfa, 2010.

Zhang, Meng. "From respirator to Wu's mask: The transition of personal protective equipment in the Manchurian plague." *Journal of Modern Chinese History* 14, no. 2 (2021): 221–239.

Zulawski, Ann. "Environment, urbanization, and public health: The bubonic plague epidemic of 1912 in San Juan, Puerto Rico." *Latin American Research Review* 53, no. 3 (2018): 500–516.

INDEX